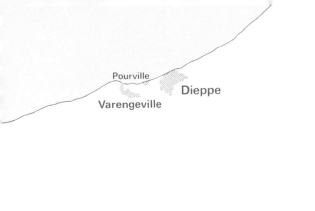

N

Pourville

Dieppe

Varengeville

Amiens

M A R I T I M E

O I S E

Rouen

Beauvais

R. Seine

R. Epte

E U R E

V A L D ' O I S E

Vernon

Giverny

Vétheuil

Paris

Evreux

Argenteuil

Asnières

Poissy

Chatou

GARE ST LAZARE

Louveciennes

Bougival

Y V E L I N E S

CLAUDE MONET

OBSERVATION AND REFLECTION

CLAUDE MONET

JOEL ISAACSON

PHAIDON OXFORD

Phaidon Press Limited, Littlegate House, St Ebbe's Street, Oxford

Published in the United States of America
by E. P. Dutton, New York

First published 1978

© 1978 by Phaidon Press Limited

ISBN 0 7148 1781 3
Library of Congress Catalog Card Number: 77-93079

Filmset in Great Britain by
BAS Printers Limited, Over Wallop, Hampshire

Printed in Switzerland by Paul Attinger SA. Neuchâtel.

CONTENTS

Preface 7

Chronology 8

Observation and Reflection 11

The 1860s: Nature and Style 12

The 1870s: Impressionism 18

 Argenteuil 19

 The First Impressionist Exhibition 20

The 1880s: From Description to Interpretation 22

 Vétheuil 22

The 1890s: The Series Paintings 39

 Haystacks 40

 Poplars 41

 Rouen Cathedral 41

 Mornings on the Seine and Falaises 42

 London 43

The Water-lily Garden 44

Nymphéas, paysages d'eau 45

The plates 49

Notes on the plates 193

Bibliographical note 234

Acknowledgements 236

Index 237

To my mother and the memory of my father

PREFACE

I would like to express my appreciation to the Horace H. Rackham School of Graduate Studies of the University of Michigan for a Faculty Research Grant that supported my work on this project. In the process I received help in many ways from many people, and I would like to thank some of them here: among museum personnel, Alexandra Murphy of the Museum of Fine Arts, Boston; John Maxon and John Keefe, the Art Institute of Chicago; David Rust and Charles Parkhurst, the National Gallery of Art, Washington, D.C.; Richard Dorment and Joseph Rishel at the Philadelphia Museum of Art; and Ellen Berezin of the Worcester Art Museum. For his role as both scholar and dealer I would like to thank Daniel Wildenstein; without his assistance with information and photographs the selection of works illustrated here would be far poorer. My appreciation extends also to members of his staff; Rodolphe Walter and Catherine Ferbos in Paris, Leonard Foster in London, and Jamie Maclean in New York. Other dealers who assisted me are William Acquavella, Richard Feigen, William Plomer of Thomas Agnew and Sons, and Nicholas Tooth. Mr and Mrs David Lloyd Kreeger and Paul Mellon were very generous in permitting me to view many of the Monet paintings from their collections; I thank them and the other collectors who have allowed us to reproduce the works in their possession.

Among others who have assisted me in various ways, I would especially like to thank Marla Morrison, Jeannine Ness and Robin Spencer, who shared with me some of his thoughts on Whistler; and, among colleagues and students at the University of Michigan, my gratitude to Phylis Floyd, Rogers McVaugh, Graham Smith, and Marjorie Swain. Still closer to home, I thank my wife Helen and children, Elisa and David, for their interest, patience, and understanding during the period of research and writing. And, perhaps above all, I would like to express my debt to the spirit and accomplishment of the late William Seitz, whose writings on Monet remain a model of lucidity and elegance.

CHRONOLOGY

1840 Oscar-Claude Monet born in Paris at 45 rue Lafitte on November 14.

c.1845 The family moves to Le Havre, where Monet's father joins a family business as a wholesale grocer.

c.1856 Monet begins to develop a local reputation as a caricaturist.

1857 Monet's mother dies, 28 January.

c.1857 Monet meets Eugène Boudin, who introduces him to outdoor painting.

1858 Has a landscape accepted at the annual municipal exhibition in Le Havre.

1861 SPRING Called up for military service, he joins the Chasseurs d'Afrique in Algeria.

1862 SPRING After one year he becomes ill and returns home on sick leave; his family decides to buy a substitute to complete the remaining five years of his military service.
SUMMER Meets Jongkind at Sainte-Adresse.
LATE AUTUMN Enters studio of Charles Gleyre in Paris.

1863 Meets Bazille, Renoir, Sisley, fellow students at Gleyre's studio.

1865 SPRING Makes his début at the Salon with two paintings (Plates 2 and 11). Begins his *Déjeuner sur l'herbe* (Plates 8–10).

1866 SPRING Once again has two paintings accepted at the Salon (Plates 3 and 18). Begins *Women in the Garden* (Plate 12).

1867 SPRING *Women in the Garden* and *Port of Honfleur* refused at the Salon; first Salon rejection. Paints views of Paris from the balcony of the Louvre (Plates 4 and 5).
SUMMER Forced by lack of funds to live with his family at Sainte-Adresse, while his mistress, Camille Doncieux, is expecting the birth of their child in Paris; a son, Jean, is born on 8 August. Paints *Terrace at Sainte-Adresse* (Plate 21).

1868 SPRING One painting rejected from Salon, one accepted. Paints *The River* (Plate 25).

1869 SPRING His two paintings rejected from Salon (including *The Magpie*, Plate 22).
SUMMER Paints with Renoir at La Grenouillère (Plates 27, 29 and Fig. 15).

1870 SPRING Once again his two paintings refused at the Salon (Plates 16 and possibly 27).
SUMMER Marries Camille, 28 June. Death of Monet's aunt and protectress, Sophie Lecadre, 7 July. France declares war on Prussia, 19 July.
AUTUMN Monet leaves for London. Meets his future dealer Durand-Ruel. Exhibits one painting at Durand-Ruel's gallery in December.

1871 WINTER Monet's father dies, 17 January. Armistice between France and Germany, 28 January. Monet remains in London until May; through Durand-Ruel, encounters Pissarro there. Both painters refused at the Royal Academy exhibition.
SPRING Exhibits at International Exhibition, South Kensington, in May. Paris Commune, March–May.
SUMMER Travels to Holland, works in Zaandam (Plate 36).
AUTUMN Returns to Paris. In December rents a house at Argenteuil on the Seine just to the west of Paris, where he is to live until 1878.

1873 WINTER Paints *Impression, Sunrise* in Le Havre (Plate 39).
AUTUMN Death of Camille's father, 22 September. Paints two views of the Boulevard des Capucines (Plate 41).

1874 WINTER Possible return visit to Holland to work in Amsterdam.
SPRING 15 April–15 May, first Impressionist group exhibition; Monet exhibits five oils (including Plates 16, 39 and 41) and seven pastels.

1876 LATE SUMMER AND AUTUMN Monet does decorative canvases for Ernest Hoschedé at his country estate in Montgeron (Plates 53 and 58).

1877 WINTER Paints approximately a dozen views of Saint-Lazare Station in Paris. Shows eight of them at third Impressionist exhibition in April (Plates 56–7 and 60).

1878 Birth of Michel Monet in March.
SUMMER Monet and his family move to Vétheuil and establish a joint household with the family of Ernest Hoschedé.

1879 Death of Camille Monet (see Plate 59), 5 September.

1880 SPRING Decides not to show at the fifth Impressionist exhibition. Submits to the Salon for first time since 1870; one work accepted (Plate 73), one rejected (Plate 64). First one-man show, at offices of the periodical *La Vie moderne*, in June.

1881 WINTER Paints at Fécamp on the Normandy coast (Plate 69).
AUTUMN Leaves Vétheuil and moves with his two children and Alice Hoschedé and her five children to Poissy.

1882 Paints at Pourville and Varengeville on the Normandy coast, February–May and July–September (Plates 70–2, 74–5 and 78–9).

1883 Paints at Etretat on the Normandy coast, January–February (Plates 80–1). Retrospective of fifty-six works at Durand-Ruel's gallery, March.
SPRING Rents a house at Giverny.

1884 Paints at Bordighera and Menton on the Riviera, January–April (Plates 76 and 82). Works at Etretat, August.

1885 AUTUMN Paints at Etretat (Plates 83 and 84–5).

1886 SPRING Spends two weeks in Holland painting the tulip fields (Plate 87).
AUTUMN Works at Belle-Ile off the south coast of Brittany (Plate 86).

1888 Returns to the Mediterranean, paints at Antibes and Juan-les-Pins, January–April (Plates 88 and 92–3).

1889 Paints in the Creuse Valley in central France, March–May (Plate 94). Joint retrospective exhibition with Rodin at Galerie Georges Petit, June.

1890 Works at Poplars and Haystacks series. Purchases his house at Giverny, December. Soon begins a new studio and makes considerable improvements in the garden.

1891 Fifteen Haystacks exhibited along with other paintings at Durand-Ruel's, May (Plates 95–8).

1892 WINTER Begins a series of paintings of Rouen Cathedral in Rouen. Exhibits fifteen Poplars at Durand-Ruel's, March (Plates 103–6). Marries Alice Hoschedé, 16 July.

1893 WINTER Continues cathedral paintings in Rouen. Purchases water-lily garden across the road from his property in Giverny.

1895 WINTER Working trip to Norway to visit his stepson (Plates 113–14). Exhibits twenty Rouen Cathedral paintings along with other works at Durand-Ruel's, May (Plates 107–10).

1896–7 During the winters of each year he returns to paint familiar sites on the Normandy coast—Pourville, Varengeville, Dieppe (Plates 116–19). Works at a series of Mornings on the Seine (Plates 111 and 112).

1898 Exhibits sixty-one paintings, including seven Cathedrals, eight Norwegian snow scenes, twenty-four *Falaises* and fifteen Mornings on the Seine, at the Galerie George Petit, June.

1899 Begins first series of paintings of the Japanese bridge (Plates 126–7). First of three trips to London (also 1900, 1901) to do a series of paintings of the Thames, September.

1900–1 Revisits Vétheuil and does a limited series of paintings (Plate 120). Undertakes project to enlarge water-lily pond.

1903 Begins new series of water-lily paintings.

1904 Exhibition of thirty-seven views of the Thames at Durand-Ruel's, May (Plates 121–2 and 124).

1908 Complains of difficulties with his eyesight.
AUTUMN Visits Venice with his wife. Second trip in 1909.

1909 Exhibition of forty-eight water-lily paintings at Durand-Ruel's, May (Plates 129–30 and 133–4).

1910 Further enlargement of water-lily pond; it is given its final shape.

1911 Death of Alice Hoschedé Monet, 11 May.

1912 Twenty-nine views of Venice at the Bernheim-Jeune gallery, May–June (Plates 135–9). Cataracts diagnosed on both eyes.

1914 Death of Jean Monet, 10 February. Begins large water-lilies decoration and inaugurates the construction of a new studio in which to carry out the project (Fig. 25). Studio completed in 1916.

1920 French government announces plans to build a pavilion on grounds of the Musée Rodin to house Monet's water-lilies cycle, 15 October

1922 A new contract specifies the Orangerie des Tuileries as the destined site for the cycle, 22 April.

1923 WINTER Operation for cataract on the right eye. In November he is fully back to work.

1926 Monet dies at Giverny, 6 December.

1927 Dedication of the water-lilies cycle in the Orangerie, 16 May (Plates 132 and 146–50).

OBSERVATION AND REFLECTION

The innovators in all things are only those who know how to observe and reflect. *Théophile Thoré, 1855*

The Impressionist sits on a river-bank; depending on the weather, his angle of vision, the time of day, and whether it is windy or still, the water takes on every possible tone, and he paints, unhesitatingly, the water and all its tones. When the sky is overcast on a rainy day, the painter paints sea-green, heavy, opaque water; when the sky is clear, and the sun shining, he paints sparkling, silvery blue water; when it is windy, he paints the reflections made by the lapping waves; when the sun is setting and darts its rays over the water, the Impressionist, to capture the effect, lays down yellows and reds on his canvas.

Théodore Duret described the procedure of the Impressionist painter in this way in his pamphlet of 1878 *Les Peintres impressionnistes*. It is a down-to-earth description of the practice of the Impressionist landscape painter, and in its matter-of-factness, in its realism, one might say, it comes as close as any verbal description to conveying the vision and approach of the Impressionist painting of the 1870s. It was above all the procedure of Claude Monet, who, during the decade, had emerged as the leading painter of the Impressionist group.

But consider the following description of Monet at work, in the middle of the following decade, the 1880s, on the rocks and beaches of the Normandy coast:

The lovers of the sea, who, when all the Parisians have long since packed their bags, remain in deserted Etretat to see the equinoctial tides battling with the cliffs, will tell you that on November mornings, when the spray flew thicker than torrential rain, they would see Claude Monet down on the beach. With water streaming under his cape, he painted the storm amidst the swirl of the salt water. He had between his knees two or three canvases, which took their place on his easel one after another, each for a few minutes at a time. On the same stormy sea, in the same cliff setting, different light effects appeared, sudden infiltrations of light coming through gaps in the clouds . . . to illuminate the surging darkness of the sea with islands of gold and emerald, streaks of livid lead. . . . The painter watched for each of these effects, a slave to the comings and goings of the light, laying down his brush when the effect was gone, placing at his feet the unfinished canvas, ready to resume work on another upon the return of a vanished impression.

In this account by Hugues Le Roux prosaic description has given way to poetic evocation, but its expressive imagery conveys with accuracy an important change in Monet's approach to his work. In choice of subject, a relatively domesticated nature has been replaced by something wild, unfettered. In the process of painting, receptive response has yielded to dramatic confrontation as pictures are multiplied in number, as the appearances and temperaments of nature are seized and captured upon the canvas.

But let us look once again. Monet, aged fifty-six, in 1897, works at an extended series of paintings of the River Seine, not far from his home at Giverny. Early each day, before sunrise, he goes down to the river-bank:

There he unties his skiff moored among the reeds along the shore and, with a few strokes of the oars, reaches the large anchored rowing-boat that serves as his studio. The peasant, a gardener's assistant, who goes with him, unwraps the packages—as he calls the stretched canvases tied in pairs and numbered—and the artist sets to work.

There are fourteen canvases begun at the same time, practically a complete range of studies, representing one single motif, which changes with the hour, the sun and the clouds.

Here, where the Epte joins the Seine, among small islands shaded by great trees, the arms of the river seeming to form solitary and peaceful lakes under the leaves, mirrors reflecting the green foliage, here has Claude Monet been working since last summer.

A new note is established in this passage by Maurice Guillemot, of a process close in temper to that described by Duret but more methodical, more meditative. The tone of Guillemot's description suggests reverie; the paintings reinforce the suggestion. Monet's career developed over a period of sixty-five years. The three descriptions chart stages in his evolution, from realistic observer to tenacious struggler to contemplative dreamer. But, of course, these are not so much stages as laminations; the three attitudes are there, layered—and interpenetrating—throughout his life.

At the beginning of his career, in 1864, Monet was engaged in his first full season of painting, working at several sites along

the Normandy coast, where he had grown up. In July he wrote to his friend and fellow artist Frédéric Bazille (1841–71), describing both the pleasures and the difficulties he was experiencing:

> All in all, I am pleased with my stay here, although my studies are far from what I would wish. It is indeed frighteningly difficult to do something that is complete in every respect, and I believe there are very few people who are satisfied with approximations. So, my friend, I want to struggle, scrape out, start again, because one can do what one sees and understands, and it seems to me when I am looking at nature that I am going to do everything, write it all down, but then just try to accomplish it . . . when you're there before the canvas. . . .
> All of which proves that we must think of nothing else. It is through observation and reflection that one finds.

Observation and reflection run like a thread throughout Monet's career, a thread that unravels and recombines, revealing along the way the complex of fibres from which it is spun and the way they intertwine. One of the essential strands of this thread is the artist's capacity to respond to, to interpret and transform, nature observed. The content of Monet's understanding of nature is difficult to grasp. He repeatedly disclaimed larger meanings for his work, but he affirmed, nevertheless, the validity of his personal experience. One day, late in his life, he was standing in his water-lily garden in conversation with his close friend the politician Georges Clemenceau, who recorded his remarks, one hopes faithfully:

Whereas you seek philosophically the world in itself, I am simply expending my efforts upon a maximum of appearances, which are in close correlation with unknown realities. When one is dealing with concordant appearances, one cannot be far from reality, or at least what we can know of it. I have done no more than look at what the universe has shown me in order to bear witness to it through my brush. Is that not something? Your mistake is to want to reduce the world to your measure, whereas by enlarging your knowledge of things, you will find your knowledge of self is enlarged.

Toward the end of his life Monet's tone had, understandably, changed from that of 1864, but the terms of his concerns were appreciably the same. During the intervening years he had constantly expressed self-doubt, but he had never lost faith in the discoveries that might be made through the interchange of observation and reflection. Observation was prolonged and intensified during the course of his career; nature was ever more minutely analysed, subdivided. Reflection was deepened at the same time. Originally, it had to do with measuring, with matching, with finding a means to record transient appearances; gradually it came to mean more and more—rumination, the internalization and storing of perceptual discovery, invention, self-reflection, even hallucination. In the process, observation would become seeing, reflection understanding. Through the act of seeing one would come to know not only the world but oneself.

The 1860s: Nature and Style

I have not forgotten that it was you who first taught me to see and understand. *Monet in a letter to Eugène Boudin*, 22 August 1892

In 1865 Monet submitted, for the first time, two paintings to the annual Salon exhibition, which took place each spring in Paris (Plates 2 and 11). Both these works, large seascapes developed from smaller canvases executed on the coast the previous year, were accepted by the jury and greeted warmly by the critics. Paul Mantz, in his exhibition review, praised Monet's 'taste for harmonious colour combinations through the play of analogous tones, the feeling for values, the striking effect of the whole, a hardy way of seeing things and forcing himself upon the attention of the spectator'. Another critic noted emphatically that among the seascapes Monet's were 'undeniably the best in the exhibition'. Other observers confused the work of the unknown Monet with that of the already notorious Edouard Manet, whose *Olympia* could be seen at the same exhibition. Whereas the *Olympia* was damned by the critics, Manet found himself praised for two other works that were not his.

Monet's paintings did not offend the critics or the public; they did not in any way challenge public taste or academic legitimacy. They were recognized as successful efforts within a minor but popular category of painting—the seascape or marine. They did not attempt to deal with subjects that were at the pinnacle of the academic hierarchy: history paintings—paintings of grand themes drawn from secular or religious history, myth or the Bible, often with a didactic content. They seemed content to assume a lower artistic horizon.

The works Monet chose to send to the Salon reflect the training that he had received—or, more precisely, that he had decided to emphasize and exploit—at the outset of his career. He had had a period of work in an academic studio, that of the distinguished painter Charles Gleyre (1806–74), beginning in 1862, but before that time his direction, as indicated by the two Salon paintings, had been fully established.

Monet was born in Paris in 1840. In or about 1845, his

family moved to Le Havre, where his father entered into business as a wholesale grocer and achieved a relatively prestigious commercial and social position. His mother, who was musical and endowed with a good voice, died in 1857. The young Monet learned the conventions of landscape and figure drawing in school (Figs. 1 and 2) and by the time he was fifteen or sixteen had established a local reputation as a caricaturist, a pursuit that brought him a small degree of financial success (Fig. 3). It also attracted the interest of Eugène Boudin (1824–98), who, impressed by the talent evident in the caricatures, undertook to persuade the young artist to devote himself to landscape painting. In the late 1850s, Boudin was still an unformed, somewhat awkward painter, working in the tonal manner of the Barbizon school. But he had refined his belief in nature as the artist's primary teacher, and he had established in his own mind—and soon in the mind of his chosen pupil—the conviction that nature, the outdoors, was the reservoir from which the pure artist should drink. After initial reluctance, Monet agreed to join Boudin as he went out to sketch in the neighbourhood around Le Havre (Fig. 4). From that point Monet's life changed. In later years he recalled this event as revelation: 'It was as if a veil had been torn suddenly away; I had understood, I had grasped what painting could be.'

Boudin's message was soon reinforced by the Dutch painter Johann-Barthold Jongkind (1819–91). Monet had just been released from the army due to illness, following a year of service in Algeria, when, in the summer of 1862, he met Jongkind, who was working on the Normandy coast near Le Havre. Jongkind, who had a long career of landscape painting behind him, demonstrated his sure sense of ordonnance, simple formulas for harnessing nature's irregularity (Fig. 7), whether through perspective schema or flattened dispositions of land, sea, and sky across the picture plane. Boudin had introduced Monet to nature; Jongkind taught him how to bend it to his will.

The year 1864 was the first fruitfully productive one of Monet's career. Stimulated by the work of Jongkind and the recent successes of Boudin, who, in 1862, had struck a rich vein of artistic facility and financial reward with small paintings of holiday-makers on the Normandy beaches, and very likely enjoying the leadership he had gained among a new group of young friends—Auguste Renoir, Alfred Sisley, and Frédéric Bazille, from the atelier Gleyre—he worked with great vigour. His paintings from the year include, in accordance with the range of Boudin's and Jongkind's subjects, still-lifes, small portraits, landscapes, and seascapes. It was the first period of his work in which he took full account of Boudin's legacy—the directive to devote oneself to nature, to study it with care. In a number of paintings he followed the lead of Boudin, who had at the end of the fifties made pastel studies of the sea and sky along the coast (Fig. 6), faithfully recording shifts in weather and time of day, and of Jongkind and the Barbizon painters, who would do variations on a single theme, often a particular site recorded in broad daylight and at sunset. During the summer and into the autumn Monet painted a number of paired beach scenes at high tide and low (the latter reworked on a larger scale for his Salon canvas *The Pointe de la Hève*; Plate 11) or with the sea alternately calm and rough and the light varied.

In other canvases worked out in pairs, he depicted a corner of the port of Honfleur and, as well, a view along a narrow street within the town. They are paintings without incident, the distinctions between them are not characterized by clear contrasts of light or weather. In the two scenes of the port, *The Lieutenance at Honfleur*, a slight but indeterminate shift in time is suggested by changes in figures and the passage of a sailing vessel; in his two perspective views, looking north along the rue de la Bavolle, not far from the harbour, he makes the indeterminate more precise (Plates 6 and 7). Fifteen minutes, perhaps half an hour, separates the two. The angle of shadow is almost imperceptibly but consistently altered, figures are seated or standing or seemingly engaged in prolonged conversation, retaining their position in both paintings, while others enter or leave. Certainly, this kind of precision presages the major effort of Monet's later career, when, in elaborating his series paintings, e.g., the Haystacks, Rouen Cathedral, the views of London, he had, at one time, as many as one hundred canvases under way, related to the finest differences of weather and light. The interests of youth and early maturity never simply vanish within an artist's, within a human being's life; they often become not only nourishments but imperatives in an artist's subsequent development. But, working in Honfleur, the great series of the 1890s were far away. In 1864, he studied the lessons of his teachers and that aspect of Realism which stressed fidelity to appearances and carried it to a logical conclusion. Jongkind's paintings of sunlight and sunset, even Boudin's more minute observations of the changing aspects of the coastal sky, were, in one sense, merely schematic polarities and, in another, preludes to pictorial drama, picturesque variations on the theme of nature's mutability. But Monet was not interested in drama; he was concerned to make a reasoned use of the evidence of his eyes. Rather than events played out upon a temporal stage, Monet explored the non-events of everyday life, the very ordinary, chance comings and goings in a contemporary village street. What one sees in this pair of views are the changes that could have happened (perhaps even did happen) in the course of no more than half an hour on a given afternoon on the rue de la Bavolle in the town of Honfleur. Nothing more, but nothing less.

Monet's reflection upon optical realism led him to the clearest expression of the dictum of fidelity to appearances provided by any artist up to that time. The English Pre-Raphaelites may have travelled as far as the Holy Land to capture effects proper to depicting faithfully a scene from the Life of Christ, they may have painted at night in order to record the true character of nocturnal light, but they did not and were not concerned to record the simple facts of a village street.

Monet did not submit his two views of the rue de la Bavolle to the jury of the Salon in 1865. Their small scale, their reticence, but, above all, I would suggest, their truthfulness

did not augur well for institutional or public understanding. Monet very likely did not trust his best achievement, perhaps did not fully understand its meaning. In any case, his ambition was to make his way at the Salon, boldly yet safely; the acceptance and critical approval of his *Seine Estuary at Honfleur* and *Pointe de la Hève* testify to the wisdom of his decision.

Monet's goal could have been nothing other than Salon acceptance in the middle of the 1860s. Private dealers were few, individual exhibitions rare, self-generated events like Courbet's retrospective exhibition of 1855 in his Pavilion of Realism far too costly. The Salon was the battlefield and Monet did not shy away from it. Initially, indeed, he had no reason to do so, no close model to follow. Boudin and Jongkind may have worked outside the official centre of artistic propriety, but they submitted their paintings regularly to the Salon. What the minor categories of painting—genre, still-life, landscape—lacked in prestige they made up for in numbers, dominating the Salons each year. Monet sought Salon acceptance as a matter of course, although his attitude began to change in 1867, when his *Women in the Garden* (Plate 12) was rejected by the Salon jury. At that time, he and Bazille and a dozen other artists immediately called for a revival of the famed Salon des Refusés of 1863, while, at the same time, projecting a separate organization that would exhibit free of institutional or Academic restrictions. Their immediate plans fell through, but they were renewed by Monet and his friends in 1873, resulting in the first Impressionist exhibition held the following year.

In 1865 Monet's focus was, indeed, on the Salon, but his immediate course of action reveals that he had no intention of pursuing the tack he had successfully taken in gaining acceptance in his initial attempt. Before the Salon of that year opened, before the approving reviews appeared in the press, Monet set out on a new and challenging project, for which his earlier work had not fully prepared him. He chose to pursue his interest in the nature of realism, to explore further the implications of open-air painting. The concern for optical, factual truth, which lay behind his paired views of the rue de la Bavolle, was joined to a design on the grand scale associated with major Salon painting and with Courbet's great manifestos of contemporary realism, the *Burial at Ornans* and the *Painter's Studio*. He thought, too, of Manet and his *Déjeuner sur l'herbe*, the notoriety of which had propelled Manet into the limelight at the Salon des Refusés. But, whereas Manet's *Déjeuner* was a quixotic and problematic painting, steering a precarious course between tradition and the new, Monet's painting was to be thoroughly modern, stripped of the past, of anecdote or symbol, and free of moral eyebrow-raising. The morality of Monet's painting was to be stressed through its claim to truthfulness.

He projected a simple outdoor picnic, a readily familiar subject, with a group of people gathered under the trees in a forest clearing and depicted life-size (Plates 8, 9 and 10). In establishing a one-to-one relationship through scale between the figures in the painting and the hoped-for viewers at the Salon, he sought to achieve a quality of verisimilitude, of continuity between the world of the painting and our world, that would clinch its realism and authenticate its modernity. He worked at the project for approximately one year, doing drawings and oil sketches, including a major six foot wide canvas of the entire group (Plate 8) that may have been painted in large part outdoors in the Forest of Fontainebleau, where Monet worked from April to September 1865. But to enlarge this sketch to the size he envisaged, a canvas fifteen by twenty feet, he had to resort to the studio in Paris. It was there, away from nature, that he completed his apprenticeship.

In the studio, he became forcibly aware of the relationship between an ideal of optical veracity and the facts of painting. As he approached life-size he retreated, necessarily, from nature. Enlarging his final study by roughly three times, he had to change from the flexible application of the sketch to the very different task of covering a wide area of canvas with a broad brush heavy with paint (Plates 9 and 10). Inevitably, he became more acutely aware of the brush and of the paint and of the resilience and tautness of the canvas. What was, in the sketch, but a touch, now became a shape, a shape became a field of paint. An essential lesson was learned, that one had to understand both the job of painting nature and the nature of the painter's means. Observation of nature would have to be locked into understanding of the nature of art as artifice.

Monet never fully resolved the problems that his large canvas presented. He failed to complete it in time for the Salon of 1866 and soon thereafter had to abandon it. In the end, rolled up and stored for many years and partly ruined by damp, it had to be cut into two parts; they remain as a fragmentary record of one of the most extraordinary projects of nineteenth-century art.

Realizing that his *Déjeuner* would not be ready on time but determined to provide a major Salon entry, he painted within a few days a large full-length portrait of his mistress Camille (Plates 18 and 19). It was accepted along with a landscape of the Forest of Fontainebleau, which, in its setting, provided a bare reminder of the abortive *Déjeuner* project (Plate 3).

Soon thereafter, in the spring, he moved to Ville-d'Avray, a small suburb to the south-west of Paris. True follower of Boudin and literal interpreter of his doctrine—'three strokes of the brush before nature are worth more than two days of work in the studio'—Monet was intent on completing a work entirely outdoors. In his case, however, it could not be the small canvas employed by Boudin and other devotees of *plein-air* painting but one that would allow the audacity of the *Déjeuner sur l'herbe*. He compromised a little, settling for a canvas eight feet high, upon which he would dispose, slightly less than life-size, four figures in a garden (Plates 12 and 13). Installing himself in the garden of his rented house, he dug a trench so that the canvas might be lowered into it to enable him to work at the upper portions without having to use a ladder or a chair. He was intent on providing a logical demonstration of *plein-air* principle, a faithful rendering of what the eye could see, from a fixed vantage-point from which he would not have to deviate. His *Women in the Garden* was to be the ultimate naturalistic painting.

It was to be something more, as well; along with his pursuit of nature, Monet intended to assert his newly developed awareness of the character of painting that had emerged during his work on the *Déjeuner sur l'herbe*. The *Déjeuner* project had foundered in good part because he could not resolve the conflict between traditional illusionism and his dawning concern for the decorative unity of the painted canvas. In the *Women in the Garden* he was determined to find a way, in his treatment of colour and form, to affirm that unity. He thus organized its setting so as to mitigate the reading of depth; he departed from the conventional ideal of mass and converted his figures into flattened silhouettes. Benefiting from his close observation of nature, he modified the play of form-creating shadow by emphasizing colour in shadow as well as in light. Through relationships of close-valued colours, inevitably more moderate in their space-defining effect than are contrasts of light and dark, he opened new possibilities for the definition of form, potentially flatter, more decorative, free of illusionistic necessity. The *Women in the Garden* spoke to concerns of the present and the future; Monet's experiments with decoration coincided with major efforts by Manet during the 1860s and outlined a first statement that would be elaborated by Gauguin, Seurat, van Gogh, and the Nabis in the next generation. A step towards freedom from nature—in the name of nature and its close observation—was taken when Monet decided to root himself to the spot in the garden at Ville-d'Avray.

The *Déjeuner sur l'herbe* and *Women in the Garden* taught Monet lessons in nature and painting. In pursuing both projects he focused considerable attention on the art of Manet. The *Déjeuner sur l'herbe* was initially conceived as a naturalistic challenge to Manet's painting of the same title, to what Monet later called Manet's 'classical' version of the picnic theme. The *Women in the Garden* brought Monet more squarely in line with Manet's concerns for artistic renewal. Manet had been exploring ways of reinterpreting the traditional systems of modelling and perspective at least since 1862. In 1866, his *Fifer* (Fig. 8), characteristically a reinterpretation of the work of an old master, in this case Velazquez, was rejected by the Salon jury but exhibited in his own studio. We can assume that Monet saw it on a trip to Paris from Ville-d'Avray. The *Fifer* exhibits a deliberate emphasis on silhouette, on an equivalence of figure and ground, a pure instance of Manet's concern for the interpretation of the canvas as a two-dimensional field. The *Women in the Garden* drew abreast of the *Fifer* just when Monet was seeking a resolution of the formal conflicts between illusionism and decoration created by his *Déjeuner*. Monet seems to have understood Manet's formal contributions better than any other artist of the 1860s. The *Women in the Garden* joins with the *Fifer* in establishing the two artists' shared concerns for developing a new style of painting by emphasizing its literal nature—its material existence—by closing the window on nature that Renaissance artists had thrown open five hundred years earlier and by which painters continued to be guided. Monet acknowledged, through the evidence of his work, the mastery of Manet, who is undoubtedly, within the perspective

of history, the most important artist of the 1860s. But in many ways Monet was a more complete painter than Manet. Unfettered by the latter's dialogue with the past and favoured by his own extra-academic training, Monet was free to pursue a direction that Manet largely ignored, one that was of the greatest consequence for the immediate future: Monet believed in nature.

By the end of the summer of 1866, Monet had achieved a modicum of recognition at the Salon, but he had not been represented there by his most adventurous and inquiring works. The uncompleted project of the *Déjeuner sur l'herbe* was not submitted to the Salon jury. In 1867, with the *Women in the Garden*, which did embody his major aims, he suffered his first rejection. Perhaps as a result of the jury's rebuff, or, as I think more likely, because of his artist's desire to know everything, he entered upon a variety of new investigations that lasted throughout the year.

In April, following his Salon rejection, he applied to the Superintendent of Fine Arts for permission to paint from the windows and colonnade of the east front of the Louvre. Three paintings resulted: a view of the church of Saint-Germain l'Auxerrois, directly to the east, and two paintings of the quay, the Seine, and the skyline of the Left Bank, looking to the south-east of the palace (Plates 4 and 5). The spring of 1867 was crowded with public and private events that must have stirred the feelings of the young artist: the World's Fair in Paris, the one-man exhibitions of Courbet and Manet mounted in opposition to the art section of the fair, the rejection of the *Women in the Garden* and its subsequent exhibition in a dealer's window, the pregnancy of Camille, and, in consequence, the refusal of support from his father. Monet's paintings do not reflect the turbulence suggested by these events, but they reveal the creative fever of the artist. The *Déjeuner* and *Women in the Garden* were large-scale, closed-in works, in which he could select and arrange as he saw fit, posing his models as he wished. In those paintings, he attempted to respond to nature's colours and surfaces, but he asserted the traditional control of the artist over composition and drawing. Perched on the balcony of the Louvre, facing the teeming world of Paris, he had to assume another stance, a new attitude. He would accept and attempt to capture what the scene offered in its entirety—its composition, its drawing, so to speak. Monet's three paintings differ in their notation of human form and activity, and from these differences one can discern a sequence which suggests that the working out of these paintings led, as with the *Déjeuner* and *Women in the Garden*, to a formal discovery, the product of a lively process of seeing and thinking.

The *Quai du Louvre* depicts the avenue along the Seine with strollers and carriages passing in the street. In attempting to paint the city, Monet may have drawn upon his only analogous experience, that of the town of Honfleur, which he had painted three years earlier; the figures in the *Quai* seem almost borrowed from the rue de la Bavolle. But Monet soon realized that the tempo of Paris required something more. He had never been challenged by movement before, except for the

flutter of leaves in the wind or the ripple of water; those effects he had managed to conquer through conventional shorthand or by stopping the action. He seems to have quickened to his task in the handling of figures in *Saint-Germain l'Auxerrois* and gained mastery in the *Garden of the Princess*. In that painting his deft hand scumbled, blurred, and blotted the moving forms (Fig. 10). His drawing was freed from the conventional rendering of contour and discrete mass; figures emerged from fragmentary touches, geared to the task of describing their fleeting relationship to the environment.

In capturing the effect of movement within the scene, Monet fulfilled one of the main criteria that had been suggested for painting that would truly come to grips with the dynamic character of modern life. Baudelaire had spoken of it in 1863, observing that 'in the daily metamorphosis of external things, there is a rapidity of movement which calls for an equal speed of execution.' In developing the speed of his touch, Monet was surely guided by what he could see from his vantage-point on the Louvre balcony, but in order to know how to render that scene he may have turned to pictorial models as well. There is a close correlation between Monet's recorded understanding of the depiction of movement and that provided by contemporary photography. Aaron Scharf has cited in this connection a photograph by Adolphe Braun (Fig. 9) and compared it with Monet's paintings of the Boulevard des Capucines of 1873 (Plate 41). Braun's photograph was taken in 1867 from the part of the Louvre where Monet worked, and one wonders whether the two men met and if Monet had an opportunity to see the results of Braun's activity. But even if that was not the case, Braun's photograph is characteristic of many pictures from the 1850s and 1860s, which, owing to a long exposure time, recorded moving figures as blurs and traces upon the film or plate. Monet's sketch-like patches for the hurrying figures in the *Garden of the Princess* suggest an awareness of that vision, a readiness to learn from and make use of it when it accorded with the nature of his task.

In composing these scenes abstracted from the pace of the city, he may have learned from the photographer as well as the photograph. In painting the rue de la Bavolle in 1864, Monet had matched two paintings, comparing their differences in terms of a shift in time, perhaps half an hour. The temporal difference provided in an undramatic way the housing, the frame for the 'events' within the pictures. In the paired views of the *Quai du Louvre* and the *Garden of the Princess*, he chose another kind of neutral housing, literally the frame of his two canvases of equal size. One canvas was held horizontally, the other vertically. Across the centre of each one, he ran the identically scaled ribbon of buildings representing the Left Bank. The remainder of the composition unfolded above and below this strip in an un-predetermined fashion. The scene simply ended when the edges of the canvas were reached. The procedure was much like that of the outdoor photographer, the physical content of whose picture was conditioned by the frame of film. By exploiting the vertical or horizontal disposition of his canvases, Monet achieved a similarly open result, surprising his composition in the process. In these small

paintings, Monet enlarged his repertory of contemporary subjects and emerged as a fully fledged painter of contemporary life. The call for contemporaneity had been a constant in the criticism and theory accompanying the rise of Realism during the 1850s. Baudelaire had been one of the leading figures in that critical effort, urging artists to find and give voice to the peculiar quality of their own times. He stressed the concept of 'modernity', and in defining the word he seems to define Monet's painting as well: 'By "modernity" I mean the ephemeral, the fugitive, the contingent.'

Monet spent the summer of 1867 in Normandy (Plates 17, 20, 21 and Fig. 18), living at his family's home in Sainte-Adresse, just above Le Havre, where his father agreed to take him in, while at the same time refusing to aid the pregnant Camille. Penniless, Monet felt that he had to accept this offer, confiding Camille to the care of a medical student in Paris. The *Terrace at Sainte-Adresse* (Plate 21) depicts members of his family on the terrace of a villa overlooking the sea. It is an artificial, carefully composed painting, a sudden shift from the impromptu character of the *Garden of the Princess* and the *Quai du Louvre*, closer to the studied quality of the *Déjeuner sur l'herbe* and *Women in the Garden*. He arranged the chairs and figures— his father seated on the right—in a foreshortened circle round the central flower bed; above the terrace the two flag-poles divide and control the area of the sky and sea, causing them to seem to rise vertically, parallel to the plane of the canvas. The naturalistic conviction of the receding terrace and the artful contrivance of the flattened sea and sky are part of the content of Monet's painting (see note on Plate 21). He seems to be ordering the world according to his lights, experimenting with attitudes, with formal modes, learning from different sources what he needs. One year later he referred to the *Terrace* as the 'Chinese painting with flags'. The terms Chinese and Japanese were often interchanged at the time, and Monet's reference gives us a clear idea of the source for some of the painting's formal characteristics (Fig. 11). The arrangement of the flags silhouetted against the sky, the clear, self-contained areas of colour, the flattened aspect of the upper half of the painting, indicate that Monet had joined Manet and other artists in turning to Japanese prints, learning ways in which Japanese art could teach an artist to heighten and stylize nature within the general pursuit of naturalism (Plate 14 and Fig. 12).

The year 1867 proved to be a period of restless activity and rapid development for the young Monet, who was, through ceaseless, clear-eyed investigation, gathering the experience, skill, and range that would shore up the experiments of a lifetime. The views of Paris and the *Terrace* illustrate the two poles of his inquiry. He assumed different attitudes toward perceptual experience and artistic translation, establishing at one moment—as in the *Terrace*—a clear control of nature's freedom and assuming at another—as in the Paris paintings— a receptive attitude, in which he attempted to ply his brush in ready response to the appearances and flow of the scene before him. He experimented with new modes of composition, organized according to a determined structural framework, or freely, fortuitously developed within the rectangular format of

the canvas. With photographs and Japanese prints he expanded his range of visual resources and grafted the lessons learned on to his direct experience of the visible world. From this point on he might pursue the receptive investigation of the world observed or he might make that world conform to his understanding of painting as an artificial construction in parallel with nature. Or he might attempt to integrate the two approaches more fully than he had ever done before.

The year 1868 saw such an amalgam take place. The key painting of that year, one that we may consider as basic to his subsequent development, is *The River* (Plates 24 and 25). Painted on the banks of the Seine, not far from his later home at Giverny, it depicts Camille seated on the near bank, looking across to the hills of Gloton. The theme is one that was dear to Corot and may have been inspired by the Barbizon master's work. There is a marked difference in style, however, between the work of the two men; a comparison with Corot's contemporary *Ville-d'Avray* (Fig. 13) points up the greater assertiveness and artificiality of Monet's rendering. Monet was at this stage thoroughly a *plein-air* painter, executing many of his works almost entirely before the subject. As his work outdoors progressed towards the end of the sixties, he became bolder in his interpretation of natural effects, and increasingly the painted equivalent of nature's apppearances grew in importance.

In *The River*, Monet attempted once again, in contrast to the fluid, atmospheric openness of the Paris views, to reassert his feeling for the tangibility of pigment and of the canvas on which he worked. Through composition and paint handling he creates a shifting relationship between the expression of pictorial depth and the affirmation of surface. The foliage of the foreground trees interlocks with the further shore. The *repoussoir* provided by the seated Camille in the foreground (Plate 24) is established and denied at one and the same time as her figure is linked in structure, substance, and palette to the water and the reflections within it. Impasto and colour value are uniform throughout the painting. Something of the deft, modulated character of the Paris pictures is retained, but the scale of units, of brushstrokes, is enlarged. An important shift in emphasis is effected. Variations in the application of the brush are not introduced with the realistic aim of conveying the range of natural appearances; rather, the data of nature seem warped to fit the kind of brushwork and pictorial structure that the painter has developed. Instead of serving nature he has annexed it to his pictorial ends. But the balance remains delicate. Much of the charm of the painting lies in the freedom with which the scene is recorded; its strength derives from the tension between hand and eye, between painted and optical reality.

During the autumn and winter of 1868 to 1869 Monet enjoyed a long period of relatively untroubled work. Aided by his first patron, M. Gaudibert of Le Havre, he rented a house at Etretat, where he lived with Camille and their son Jean, now more than a year old; landscapes, marines, and several views of the interior of their house, with family and friends seated about the dining-room table, register this activity (Plates 15

and 16). At the beginning of 1869, Monet selected a snow scene (Plate 22) and a painting of fishing boats for submission to the Salon, but both were rejected. In late May he returned to the area around Paris, settling with Camille and Jean near the town of Bougival on the Seine (Plate 23). In August and September he was joined by Renoir, with whom he had been closely linked since the time of their first meeting at Gleyre's studio in 1862. Together the two artists made repeated painting trips to the popular bathing and boating place La Grenouillère (Plate 27), on the isle of Croissy, just upstream from Bougival. They worked in close harmony, even sharing the same vantage-points for viewing the setting (Plate 29 and Fig. 15), and from their companionship arose the style that developed in succeeding years into the most characteristic of Impressionist approaches.

Both Monet and Renoir thought of their paintings of La Grenouillère as studies for a larger composition. On 25 September 1869 Monet wrote to Bazille: 'I have a dream, a picture, the bathing-place at La Grenouillère, for which I have done some bad sketches, but it's a dream. Renoir, who has been spending two months here, wants to do this picture too.' The goal of the *Déjeuner sur l'herbe* and *Women in the Garden* remained alive for Monet and his companion; they still wanted to project their sketches on a grand scale, to invade the Salon with large works devoted to the representation of modern manners. Monet considered his sketches to be bad attempts at what he had in mind, but the large work was never executed, by either artist. What remains are the sketches; they are the first paintings fully to express the Impressionist aesthetic.

Monet's and Renoir's paintings are more than notational sketches. They are the product of a far more comprehensive vision than that involved in scanning the natural setting. All that went before—the idea of *plein air* and the devotion to appearances, the interest in contemporary life, the dissatisfaction with academic conventions and the desire for a new style of painting—brought them to this point. For Monet, his Grenouillère paintings provided a further reconciliation, beyond what he had accomplished in *The River*, of his earlier attempts to respond to and give form to the world observed.

The character of the Grenouillère paintings is complex, but it is worth considering that complexity, for contained within it are almost all the formal and thematic ingredients that are to be found throughout the Impressionist painting of the seventies. They are works that take their stand outdoors, asserting the value of direct experience, emphasizing the visual—surfaces, movement, what the eye can see—and reducing the importance of body and structure. The touch is appropriately responsive, more flexible than in *The River*, and yet it reveals the character of the painter's means, the thickness of pigment, the shape of the flat bristle brush. It is in the Grenouillère paintings that Monet fully develops the fragmented, broken touch that, during the 1870s, he and the other Impressionists will be able to call to their aid in capturing shifting, chromatically complex phenomena. At La Grenouillère he applied it to render the shimmering surface of the water

as it catches and reflects the sunlight, shattering into a thousand parts the images of people, trees, and boats mirrored in its depths. Pigment is heavy, opaque; touches of light upon the water and the darks of reflections are given parity with objects of clear substantiality. Local hues are observed but each tint and shade is so repeated throughout the entire coloured fabric of the painting as to subordinate the identifiable hues of objects to a large scheme; mass and void, light and shadow, alternately assert themselves, creating an overall visual sensation. Line is not used to contain, it does not hold the key to the description of form but interacts with colour as a co-equal element. Line itself is given colour; it defines and disrupts, thickens and thins, disappears—only to reappear as an activating, accentuating agent.

The experience of space is multiple; in Monet's painting in the Metropolitan Museum, deep space is clearly— magisterially—established through perspective recession and minor but appropriate shifts in the colour and intensity of the palette, and yet the surface of the canvas is recalled through the uniformity of pigment thickness and the careful arrangement of horizontal and vertical elements, including the vertical panels of the reflections at the right. The action of light is observed with care: the way in which it reveals colour through reflection and absorption, the presence of colour in areas of shadow. Light is present in another, metaphorical sense as representing the light of day, the world of the present, immediate activities, which the artists of the Realist generation were determined to take as their subject-matter. La Grenouillère was a favourite spot for many Parisians, very much in the public eye as well as available to the directly inquiring gaze of the artist. Looking thus at the scene, Monet and Renoir sought to convey its activity through the action of the brush, to capture a sense of the fleeting, the immediate in time. The result is a record of the way things appear as they happen rather than something rehearsed or repeated. Change rather than stasis, the ephemeral in preference to the enduring, in recording this aspect of nature Monet and Renoir demonstrated an attitude towards reality that they were to

continue to develop throughout the following decade. They not only explore the appearances of the world but imply a new relationship of human beings to the world. In Monet's painting in the Metropolitan, for example, the bathers at the left are made all but indistinguishable from the water, the strokes for which cut into the figures and help to define their form (Plate 30). The figure is placed in a dynamic relationship with its environment; the human being is seen in its structure and presumably in its experience as part of a reality that must be interpreted anew each day.

The 1860s were a time of transition. Two constantly articulated themes are the search for style and the call for the direct observation of reality. These two seemingly irreconcilable drives proved to be complementary in nature. Increasingly close observation of the world brought a greater awareness of its colour, its movement, its visual complexity, and it was soon recognized that a new technique was required that would be equal to the task of translating these phenomena on to canvas. Monet was, along with Manet, the primary figure in forging a new style of painting during the sixties. His attempt to reinterpret space and colour and the definition of the figure's form, his root investigation of the nature of the artist's means, his assumption of alternately receptive and commanding attitudes toward the notation of nature's effects, led him to the amalgam between nature and style achieved in *The River* and furthered in the Grenouillère paintings. Earlier in the decade the Goncourt brothers had added their voices to the many that called for a direct approach to the modern world on the part of the artist, and they expressed their hope for a reconciliation of style and reality: 'There must be found a line that would precisely render life, embrace from close at hand the individual, the particular, a living, human, inward line.' By the end of the sixties, Monet had, in his own fashion, fulfilled this hope; in the Grenouillère paintings he had forged—from the observation of nature and a considered reflection on the nature of painting—a touch that precisely rendered life.

The 1870s: Impressionism

Monet and Camille were married in June 1870. Together with their son Jean, they spent the summer at Trouville, just below Honfleur, where Monet met Boudin and renewed work with him, painting, like Boudin, canvases depicting holiday-makers at that seaside resort. Interestingly, he ignored Boudin's frontal, horizontal compositions with figures strung across the canvas. In three paintings of the beach and hotel he chose the model of Jongkind, sighting easily along the beach, developing a simple perspective framework for the scene. Another group of paintings, however, take up a different angle; they are close-up portraits of Camille, in which she and usually one other

figure are seated on the beach, their bodies cut unceremoniously and unpredictably by the edges of the canvas (Plate 26). They provide a species of snapshot-like, informal framing, familiar to us today in photography and the cinema, but in 1870 there was no clear antecedent in painting or photography for this unrehearsed close-up view, and it was only later in the seventies that Degas and Renoir began to exploit a similar focus for some of their most adventurous works.

In July, 1870, France declared war on Prussia. In the autumn, apparently determined to avoid military service,

Monet left for England, Camille and Jean following soon after. During an approximately eight-month stay in London, he did a number of paintings of the Thames and public parks. Once again one finds among his works an oscillation from strict formal control to a much freer, explorative kind of composition. The *Thames below Westminster* (Plate 32) combines a secure perspective with a precise interpretation of the grid-like character of the small dock and reflections at the right. In *Green Park* (Plate 33) he presents a wide, horizontal panorama that is at the opposite pole from the close-up focus upon Camille seated on the beach at Trouville. Now focus is in a sense continuous, like a scanning across the surface; the view implies rotating the head from side to side to take in so wide an arc. In both the Trouville close-ups and the panoramic view of Green Park, Monet seems intent on finding ways to prize painting loose from the domination of perspective. Following the developed statement he had achieved at La Grenouillère, he did not cease to explore new possibilities for making fresh formal discoveries.

Monet left London at the end of May 1871. The war had ended in January, but he did not return directly to France, possibly because of news of the bloodshed that accompanied the last days of the Paris Commune. He travelled instead to Holland, perhaps with thoughts of Jongkind's painting in mind, and settled for several months in the town of Zaandam, just north of Amsterdam (Plate 36). In Zaandam, the town surrounded by water, he found an opportunity to further the efforts he had made at La Grenouillère toward the formation of a flexible manner of painting that would strike a balance between mimesis and painterly autonomy. In many of the paintings the atmosphere is dull and the execution broad and somewhat bland; in others, however, he would lay down staccato or regular patterns of almost brick-like strokes to register the ever present reflections of buildings, boats, and sky in the water. The range of formal possibilities provided by the broken touch was impressively demonstrated from picture to picture.

The major accomplishment of the Zaandam campaign, however, was the development of a palette that all but banished contrasts of light and dark. Earlier, in the *Women in the Garden* (Plate 12), he had reduced value contrasts and extended broad areas of pale blue shadow across his silhouette-like figures. In *The River* and the Grenouillère paintings (Plates 25 and 29), darks were minimized or made to play a different role, not as form-defining shadows but as active, lively accents within the chromatic arrangement of the composition. At Zaandam Monet went one step further, developing an interplay of hues derived mainly from the range of the spectrum and placing them within the perspective system to which the method of chiaroscuro had been traditionally allied.

ARGENTEUIL

Following his self-imposed exile in England and Holland, Monet returned to France in the autumn of 1871 and soon established himself and his family at Argenteuil, just to the west of Paris, on the Seine. Argenteuil was the centre of Impressionist painting during most of Monet's stay there from 1872 to 1878. From the middle of the sixties, as early as his first acquaintance with Sisley, Renoir, and Bazille at Gleyre's studio, Monet was recognized as the leader, as the strongest personality, and as the most astute painter among them. When he settled at Argenteuil he established a stability that must have been attractive to many of the young painters with whom he had become associated over the years, each of them in the process of resettling himself after the war and assessing the accomplishments of the volatile pre-war years. Sisley came to work there in 1872, Renoir in 1873 and 1874, and even Manet, who absented himself from the first Impressionist exhibition in 1874, came to work with Monet that same summer and produced a number of important paintings.

Monet's first views of Argenteuil were of the river. He attempted to measure the scene, to get to know it, often by painting two canvases related to a particular site. He experimented with the site and with different modes of comparing—most often he would maintain the same composition but record variations in light and weather; at other times he would choose a single motif but paint it from different vantage-points (Plates 34 and 35). It may have been during the summer of the first year, 1872, that he built his floating studio boat, which enabled him to explore close-up views of the craft on the river and provided him with an unparalleled opportunity to fulfil his vocation of *plein-air* painter, for under his protective canopy he could work at canvases all but completely from start to finish, maintaining his chosen vantage-point (Fig. 16). In other canvases he resumed the simple perspective formula he had used in earlier years on the beaches of Normandy (Plates 20 and 40). Sighting along the Argenteuil bank, he found a coincidence between the order of perspective and the natural conformations of the scene and succeeded in producing his first harmonious group of paintings of the place. These works assume an air of controlled naturalism, of measured distance, of classical repose. They introduce one side of his multi-faceted experience at Argenteuil, one that became especially prominent in 1874, a year filled with masterly views of the river.

During the summer of that year Monet was joined by both Manet and Renoir. Monet and Renoir worked closely together, occasionally painting a site from the same vantage-point, as they had done at La Grenouillère in 1869. Manet painted two portraits of Monet and Camille in the studio boat (Fig. 16) and, following Monet's lead, did several other views of figures and boats at the riverside site. Manet never pursued the possibilities of *plein-air* painting more assiduously than he did that summer; his paintings convey an air of sun-blessed leisure activity, of an Argenteuil devoted to the pleasures of the Parisian on holiday. Monet and Renoir depicted that Argenteuil as well, but it may be that the brief summertime excursions of Manet and Renoir have led to an over-emphasis on the pleasure-oriented aspect of Monet's work along the river. His survey was in fact more varied in aspect and mood.

Well over half his views of the river fail to include even a single boat under sail (Plates 46 and 47). The evidence provided by the works that remain suggests that when Monet was not painting in the company of his friends his view was less attuned to the pleasurable aspects of the setting than to its workaday, round-the-clock character.

That is not to say that Monet denied the beauties and delights of the place. The river provided him with some of the most serene, harmonious, and classically ordered paintings of his career. The sunlit charm of the river, the geometric solidity and measure imparted to the scene by the bridge arching its way in segments over the water, the linear play of masts and riggings, which lightly articulate and suggestively fragment the larger setting, are clearly set out in the *Bridge at Argenteuil* and a number of other paintings of 1874 (Plates 43 and 45). This year provided the classical high point of Monet's work at Argenteuil, classical in the traditional sense of order, clear structure, repose. The perspective framework of the *Bridge at Argenteuil* is precisely drawn and calibrated, and colour, though delicately free and flexible in application, is made to adhere to the linear divisions of the whole. Monet offers reticence and delicacy in touch and hue within a perfectly articulated geometric cube; neither Cézanne after him nor Corot before him provided works that surpass his in structural lucidity.

Other works, however, are less classically structured, more fragmentary or additive in composition. Some views of the river seem more responsive to separate parcels of activity, scatterings of objects, imbalances between the skeletons of masts and beams and the hulking solidity of the floating boat-hiring house (Plates 46 and 47). Often his view was turned away from the main river and off to a small channel between the Ile Marante and the opposite shore, slightly downstream from Argenteuil. There another world of private contemplation, of secluded reverie, replaced the public aspect of the full river with its combination of pleasure and commerce (Plate 44).

Although the river dominated Monet's concern at Argenteuil, it formed, nevertheless, only a part of his activity. Numerous views of the town—the fairground, the streets, the square, the area around the railway station, near which Monet lived—run throughout the six years spent there. In the winter of 1875, in particular, he explored the neighbourhood round his home (Plate 49). In a number of snow scenes, we find a somewhat disparate grouping of houses, loosely clustered in what would seem to be a pre-urban sprawl; one senses a neighbourhood in transition, possibly ready to be assigned to neglect, possibly on the threshold of the forced growth that could be expected for a village on the main railway line from Paris to the Channel coast. The Argenteuil that Monet inhabited was beginning to feel the first eddies of industrialization rippling in from Paris—occasionally in his paintings a smoking factory chimney appears on the horizon—and it is possible that the less than joyous mood that Monet often depicts in the river paintings captures the reality of an Argenteuil in the process of losing its pleasurable innocence.

One senses elsewhere, as well, in Monet's work from Argenteuil a complicated, subtle response to his situation and environment. Argenteuil provided him with his first opportunity for settled domesticity since his marriage in 1870. His interest in recording the situation of his family on canvas, already evident in his interior views of 1868 (Plates 15 and 16), is manifested once again in a major group of figure and garden scenes from 1873 to 1876 (Plates 42, 50, 51, and 54). In 1873-4 he painted ten canvases of Camille and Jean walking through the poppy-strewn fields beyond the town or seen within the large, flower-bedecked garden of their rented house. In a number of these canvases Camille and Jean are joined in the garden by other figures, a maid, perhaps neighbours. Monet offers no specific incident, but his observation hints at something behind the surface. One has the sense of being allowed to see both more and less than the painter sees. It is not narrative but suggestion; the view is oblique, not compositionally as with Degas, but psychologically. One does not know, for example, the identities of the two women who float behind the tree in *The Luncheon* (Plate 42), what their relationship might be, what their conversation at table during the meal now finished. One notes the child, almost lost in the left foreground, and senses a mood of isolation, of separation from the world of adult concerns; it is a mood that crosses the painting gradually, like the dappled patches of light and shade that move as slowly as the sun. One is invited to wonder.

The world of shadow assumes its appropriate, factual place in other paintings of the light-filled garden at Argenteuil. The enigmatic, somewhat disturbing quality of *The Bench* (Plate 50)—the oddly posed, agitated figure of the seated Camille, the sombre form of the man leaning in silence upon the bench—may be linked with the death of Camille's father in September 1873. In Monet's naturalistic world there is a place for innuendo and the evocation of mood, but there is no room for symbol that cannot be disguised by factual representation; if Death enters the scene (if, that is, we may indeed associate the man's presence with the source of Camille's mourning), he does so in the form of a caller who has first presented his visiting card.

THE FIRST IMPRESSIONIST EXHIBITION

There are few paintings by Monet from the autumn of 1873. Part of that season was taken up by the initial stages of protracted proceedings concerning the will of M. Doncieux. Other negotiations, in which Monet was professionally involved, were taking place as well. After a decade of intermittent talk, Monet and his friends were taking serious steps towards the formation of an association of artists who would join together to exhibit their works free of the constraints and caprices of the Salon jury. They had been encouraged to assume an independent position by the financial support of the dealer Durand-Ruel, whom Monet first met in London in 1870, and by the bare beginnings of a

private clientele for their paintings. Spurred, however, at this point, by a general economic downturn in 1873, which brought with it a temporary cessation of purchases by Durand-Ruel, the painters succeeded in opening on 15 April 1874 an exhibition of work by thirty artists held in the centre of Paris in space donated by the photographer Nadar, who had recently vacated his studio. It was from this site, possibly while attempting to locate a suitable place for the exhibition, that Monet painted two views of the Boulevard des Capucines during the busy autumn of 1873 (Plate 41). In these two canvases Monet repeated the procedure he had followed for the views done from the Louvre in 1867 (Plates 4 and 5). Once more, two paintings of the same size were paired in terms of variations in light and of the way in which the canvas was held—one horizontal, the other vertical—and once again he emulated the photographer, achieving the same angled view of the boulevard that one finds ubiquitously in nineteenth-century photographs of similar settings. The paintings may be considered almost as a homage to Nadar and as evidence of the freedom of composition that photography offered to painting in the third quarter of the nineteenth century.

The version of the *Boulevard des Capucines* illustrated here (Plate 41) was shown at the independent exhibition and attracted considerable critical attention, both positive and negative. It was overshadowed, so far as the history of art is concerned, however, by Monet's notorious *Impression, Sunrise* (Plate 39), a view of the harbour of Le Havre painted during the previous year. The title of the painting may have been no more than an afterthought—we are told that it was only on being prompted to specify a title for the catalogue that he offered 'Impression'—but the word caught on, appearing in the headlines for two reviews of the exhibition. From that time on, the anonymous society of painters, sculptors, and engravers, as they had called themselves, had a name. One cannot do without the word today, but it is unfortunate that this canvas, due to its title, has become so closely associated with the movement. The five oil-paintings Monet showed at the exhibition presented five different styles of painting. *Impression, Sunrise* comes no closer than the other four paintings, including *The Luncheon* (Plate 16) of 1868 and the *Boulevard des Capucines*, to anything we might term a norm of Impressionist painting.

In fact, a survey of Monet's work up to and including the year 1874 makes it clear that *Impression, Sunrise* is a highly atypical painting; except for two other canvases done at the same time, there are no paintings like it in the entire course of Monet's career (nor is it in any sense typical of the work being done by Monet's close colleagues). One possible reason for the appearance of these paintings at this date may be that Monet was responding to an immediate artistic stimulus with which the site of the harbour of Le Havre easily accorded. At the beginning of 1873, Durand-Ruel had held an exhibition of drawings and paintings by Whistler that included several Nocturnes—views of the Thames—and it is possible that Monet went to Le Havre soon after with the memory of Whistler's tonally reduced paintings fresh in his mind's eye.

The reduction of *Impression, Sunrise* to a limited range of greys, the brushstrokes for boats and wharfs almost the same tone as the misty atmosphere, suggests a close relationship to a number of Whistler's Nocturnes from the late sixties and early seventies (Fig. 17). If Monet indeed turned to Whistler at that time, then we may conclude that the name of the Impressionist movement derives from a work that had its immediate stimulus in a pictorial image rather than in nature, an image produced by an American expatriate living in London, who had been guided in his creation of that image by an abstract aesthetic ideal.

Following the first Impressionist exhibition, Monet worked during the summer with Manet and Renoir and in the winter produced the extensive group of paintings devoted to the snow-covered streets and houses near his home. In the summer of 1875 he returned to the Seine and, in a series of views of the river, many done from his studio boat, he struck a new note of chromatic intensity, emphasizing the complementary contrast of vermilion boats against the strong blue of the water (Plate 48). Ten paintings of 1875 and more than a dozen from the following year take up again the subject of figures in the fields and gardens (Plates 51 and 54). In these works he pursued his interest in enigmatic mood and extended his exploration of heightened colour. The interplay of intense patches of coloured pigment and the interweave of dappled light and shade create an optical activity that subsumes and overpowers the figures. In the *Women in the Garden* (Plate 12), the paintings of Zaandam (Plate 36), and during the first years at Argenteuil (Plate 44), he had explored relationships of colours, generally moderate in intensity, in close proximity to each other on the value scale. Now he became interested in the optical strength of colour, its qualities of vibration and scintillation, its seeming ability to disembody itself from the field of the canvas, to seem to dance free before our eyes. Thus, in painting the flower beds he would so heighten the saturation and contrast of the blossoms that they appear visually to overrule our awareness of the composition of the canvas.

A number of other paintings of the second half of the seventies reveal in different ways Monet's new concerns for freedom of colour and brushwork. In 1876 he was commissioned to do four paintings to decorate the home of the collector Ernest Hoschedé, one of his earliest patrons. The seriousness and skill with which Monet approached such commissions is demonstrated in *The Hunt* and *The Pond at Montgeron* (Plates 53 and 58). *The Pond* displays a remarkable freedom of brushwork, almost paradoxical for a large decorative canvas, the strokes skittering over the grey underpainted surface (which is allowed to show through the entire area of the water) with a dash and agility that goes well beyond the Grenouillère paintings of seven years earlier (Plates 27 and 29–30). The atmosphere, however, is quiet—a woman fishing, three young children looking on—conveying the contemplative calm with which Monet was later to approach his water-lily pond, a subject that absorbed his energies through the last three decades of his life. *The Hunt* depicts Ernest Hoschedé and his companions pursuing rabbits

and birds in a forest interior near his estate at Montgeron, where Monet spent the summer and autumn of 1876. The autumn setting provided him with his point of departure for a virtuoso display of colour and brushstroke. Above the rather heavily painted figures and the multi-hued forest floor floats, in response to the appearance of the half-bare trees, a feathery canopy of coloured strokes; they provide a *tour de force* of abstract invention that probably was not equalled in the long reach of Monet's career.

The relationship between the brilliance and volatility of colour and the secure spatial housing achieved through perspective occupied Monet throughout the years 1876–8. In the summer of 1878, he painted two views of Paris festively decorated for the opening of that year's World's Fair. Painting the rue Saint-Denis (Plate 55) from a vantage-point in the window of a building, he sketched the perspective funnel of the receding street and then proceeded to mask or rival that structure, translating the colour and tumult of flags and bunting into a hue and cry of strokes that seem to convey the visual, aural, and tactile essentials of the event.

Monet's engagements with the energies and charms of the city appear at irregular intervals during the 1870s. His painting of the rue Saint-Denis and a companion piece, the *Rue Montorgueil*, come at the end of a string of Paris views that include the Boulevard des Capucines of 1873 (Plate 41), the Parc Monceau and the Tuileries of 1876, and the great series of paintings of the Gare Saint-Lazare from the winter of 1877 (Plates 56, 57 and 60). Saint-Lazare Station must have meant many things to Monet. It was at the other end of the line physically and psychologically from Argenteuil. Argenteuil represented a rural past that was vulnerable to the urban present. Its situation was reflected in the fears of poets and landscapists throughout the mid-nineteenth century, fears of the loss of ancient values, of the impoverishment and despoliation of the landscape, of a material urgency against which the spirit was powerless.

Monet's position was ambivalent; although he lived and worked in Argenteuil for six years, he never cut his ties with Paris, with the world of exhibitions, dealers, collectors, and artist friends. Through the years he retained a studio in the city, near the Gare Saint-Lazare, primarily as a place to store paintings and to receive prospective clients. Manet and Gustave Caillebotte had painted the station and its immediate surroundings, and it was probably the example of Caillebotte, whose support was especially precious to Monet during the second half of the seventies, that prompted him to turn to the site in 1877. The Gare Saint-Lazare represented the modern city; its vitality, tempo, and atmosphere were challenges to his eye and the skill of his hand. Its architecture, too, may have inspired him. The great iron and glass roof that floated over the tracks represented the new in architecture. In the attitude revealed there toward structure and the use of materials it was not unlike Monet's own paintings; the architecture revealed the means by which parts were put together, showed materials undisguised, displayed a new relationship between mass and volume, form and atmosphere, one might almost say between line and colour. Monet's paintings of the site convey his fascination with both the practical and phenomenal aspects of the station.

The two largest paintings of the group are perhaps the most impressive. The painting in the Fogg Art Museum (Plate 60) forms a pendant, differing in palette and atmosphere but almost identical in composition, to the canvas in the Louvre. They continue in their structure the assurance of the Grenouillère painting in the Metropolitan (Plate 29) and the *Bridge at Argenteuil* of 1874 (Plate 45). The perspective is centred, recession carefully measured by the grid of guy wires overhead. Against that sure structure he demonstrates what he has learned about the depiction of intangibles—smoke and clouds that coagulate and disperse, interrupting and seeming to dissolve the certainties of line and mass. In these works he captures the interaction between atmosphere and pattern, between flux and regularity in the visual and human life of the station; he conveys its noise and movement, a sense of time, of frenzied and casual comings and goings that seem to hover about a timetable, just as the smoke floats within the shed roof and cancels its measured structure.

The 1880s: From Description to Interpretation

VÉTHEUIL

In the summer of 1878 Monet left Argenteuil and moved further out into the Seine valley, to the small community of Vétheuil, about fifty miles from Paris. The three and a half years that he was to spend there witnessed a succession of momentous events in his personal and professional life, events that cannot be ignored in considering the evolution of his work and attitudes during that time. In a large, rented house, Monet and Camille, the eleven-year-old Jean, and their second son,

Michel, who had been born five months earlier, established a joint household with Ernest and Alice Hoschedé and their six children. Hoschedé had commissioned *The Hunt* and *The Pond at Montgeron* (Plates 53 and 58) and two other paintings to decorate his country home at Montgeron, and it was during that summer of 1876 that an amorous relationship seems to have developed between Monet and Mme Hoschedé. Their liaison was apparently kept under control, for Ernest, whose extravagance had led him to declare bankruptcy in 1877, accompanied the move to Vétheuil and participated regularly

in the *ménage* during the first year. Camille's active role in these events was reduced by her almost constant illness following the birth of Michel. She died in September 1879, leaving Monet as the *de facto* head of a household including Alice Hoschedé and eight children; from that time on Ernest absented himself almost completely in order to pursue his business affairs in Paris, although he did not relinquish his claim on his wife during the entire Vétheuil period, which lasted until 1881.

The size of the household, coupled with Ernest's and Monet's uncertain financial situation, caused severe hardship and debt. Monet was, it seems, forced to paint almost in desperation, hurrying to Paris with newly completed canvases in repeated attempts to find buyers. A growing success in sales was tempered, however, by complaints from both critics and collectors of hastiness and lack of finish. At the same time dissension was growing within the Impressionist group. Monet was a reluctant participant in the fourth group show in 1879 and in 1880 absented himself from the exhibition for the first time. Frantically seeking necessary resources, he decided to return to the Salon (Plate 73) as Renoir had successfully done two years before. It was through the good offices of Renoir, as well, that he received his first one-man show, at the gallery of the periodical *La Vie moderne*, in 1880. Personal and professional losses, new-found commitments and allegiances, within a framework of financial crisis and negative criticism of his work, such were the circumstances that accompanied the elaboration of Monet's art in the turn from the 1870s to the 1880s.

Monet's approach to Vétheuil (Plate 61) echoed his early experience at Argenteuil. Initially, he employed familiar devices, approaching the town and surrounding hills and both banks of the river by dividing many of these views into contrasting pairs, occasionally recording variations in colour and atmosphere, at other times experimenting with differences in shape, size, and position of the canvas. By the following summer he had begun to take the measure of the broad expanse of river, painting a number of successful views of Lavacourt, on the other side, from the embankment in front of his house and, in turn, painting the massed buildings of Vétheuil, capped by the impressive church spire, from a vantage-point on the Lavacourt bank.

While he painted these views during the summer of 1879, Camille's health deteriorated; her death followed in September. Monet's grief and shock, felt despite, or perhaps guiltily because of, his liaison with Mme Hoschedé, are registered in a beautifully painful portrait of Camille on her deathbed after her decease (Plate 59), a portrait that he remembered with mortification thirty to forty years later, feeling that his artist's desire to record the colouring of her still features somehow compromised his feelings as a human being. During the autumn, after Camille's death, he painted nothing but still-lifes (Plate 62) and was galvanized into outdoor activity only by the most extreme of natural phenomena. The winter of 1879–80 brought unprecedented storms and freezing temperatures, which left Vétheuil disabled in a shroud of ice and snow. Ordinary communications and services were disrupted; Monet and Alice Hoschedé and the eight children were in

desperate straits. All the greater need, it seemed, to complete some canvases quickly and make his way to Paris with them.

In the frozen atmosphere of December, he did several pictures of the ice-bound river, and then, in January, perhaps after an emotional release following his direct combat with nature, he created his most successful paintings of the district to that date—scenes of the break-up of the ice along the river, in which the still threatening and dangerous conditions are transformed into compositions of the utmost assurance and serenity (Plate 64). If any of Monet's early works may be said to presage the structure and harmony of his long series of water-lily paintings at Giverny (Plates 126–7, 129–30 and 133–4), it is this first miniature series of débâcles, of the thawing of the ice. In these low-lying landscapes, the stretch of river extends across the horizontal canvas and recedes into depth as the floating 'pads' of ice diminish in size. Wispy verticals, trees reflected in the water, are cut by the horizontal ice floes; the surface area of the water is calibrated by this array of plus-and-minus notations at the same time that each floe measures in stately fashion the receding plane of the river. Consider the lower half of these canvases alone and we find the basic structure of Monet's horizonless paintings of the water-lily years.

From 1880 to 1882 Monet made several painting trips to the Normandy coast (Plates 68–72, 74–5 and 78–9). These changes of site generated changes in approach and composition that became basic to his future researches and proved an example for the painters of the new generation that came to the fore in the second half of the 1880s. His starting-point was always in nature. Working at Fécamp in 1881, he looked out from the tops of the cliffs towards the sea (Plate 69), using the information derived from his unusual viewpoint as he had done earlier working in Paris from the Louvre and along the Boulevard des Capucines (Plates 4, 5 and 41). The result, to use an expression that Michel Butor has applied to Monet's work, was a world turned upside down. Instead of the traditional passage from earth to water to sky—from foreground to distance—now, in a number of canvases, one could see the earth crawling cursively up the side of the canvas and stretching across the horizon, its foreground and its distance locked on to a single plane and containing the expanse of the sea in its parenthetical embrace. In these works, brought back from the sea in the early eighties—from Fécamp, from Pourville and Varengeville in 1882, from Etretat in 1883— Monet posited a new approach to the painted interpretation of nature's structure; he helped to free painting from the necessity for gravity and opened it out to the free fall of pictorial invention.

Such was the potential of Monet's canvases. His letters of the 1880s attest, however, to the difficulties he had in realizing his new artistic goals. He expressed an increasing concern for finish, for the time required for untroubled work in the studio, where he might develop several canvases in harmonic relationship to each other, but the problems of painting, of

aesthetic formulation, were never divorced from the activity of painting in nature directly. Monet's sense of the seamless connection between the two, between the studio and the site, is revealed in a letter to Durand-Ruel written from Belle-Ile on the Brittany coast in 1886 (Plates 86 and 89):

> I have nothing finished and you know I can really only judge what I have done when I see it again at home and I always need a moment of peace before giving the final touches to my canvases.
>
> I always work a great deal, I often have bad weather unfortunately, and for many motifs I have difficulty in finding the same effect again, and I will have much to do once I get back to Giverny.

Monet's views were never invented; they have their origins in the colour and conformations of nature. When he spoke, as he did in his letters throughout the eighties, of attempting to rediscover the same effect, he was speaking of the colour of rocks and sea, of the chromatic appearances of fog and spray and bright sunlight. As work continued, perhaps at the site but certainly in the studio, the process became one of comparing painting with painting. The effect of nature became an effect of colour and ultimately a question of one colour effect geared to a host of others. Initially, as we have noted, Monet confined his painted comparisons to pairs, for the most part linked to variations in weather and light or to changes in the format and position of his canvases. In the 1880s he began to develop juxtapositions of close-up and more distant views, and, occasionally, he tried alterations in vantage-point, slightly to the right or left. These comparisons were limited, most often involving no more than three or four canvases, but they are a constituent factor in all the groups of paintings that Monet brought back home from the many painting trips that ran throughout the decade. In the process of studio work the relationship between nature and the painted transcript was not ruptured, but it was attenuated as he moved towards artfulness and abstraction in his choice and application of colour and in his simplification of design.

Throughout the eighties Monet continued to push forward along two paths simultaneously, the path of nature, to which he was wedded and of which he remained the most acute of analysts, and the path of art, which he pursued with an all but unrivalled perspicacity. How shall we understand the link between the two, how does Monet travel from nature to art? Perhaps a move toward an answer can be made by considering two commentaries on Monet and Impressionism from the time. In 1883 the poet and critic Jules Laforgue (1860–87) lauded the accomplishment of the Impressionists by stressing their penetrating visual responses to phenomena of light and colour. 'The Impressionist eye', Laforgue wrote, 'is . . . the most advanced eye in human evolution, the one which until now has grasped and rendered the most complicated combinations of nuances known.' From this gift flowed the special achievements of the Impressionists, accomplishments that established a new stage in the history of art since the Renaissance. Laforgue's historical and anthropological view does not take sufficiently into account, however, Monet's continued development of his paintings once nature was left behind.

Three years earlier, in 1880, J.-K. Huysmans wrote of the Impressionists' eye in an entirely different way, as a diseased eye that violated nature's colour. But at the same time he seemed to recognize the complexity of the extended process carried out by the painter. In a damagingly negative review of the Impressionist exhibition of 1880—in which discussion he included Monet, although the latter was not a participant—Huysmans wrote of the Impressionist's attempt to recapture on his canvas, within the removal of his studio, what he had originally seen in nature, 'a certain tone perceived, and as if discovered, one beautiful day, a tone that the eye succeeds in seeing again under the pressure of the will . . .' Huysmans recognized the character of the transition from nature to art in Monet's work. From discovery to invention, from description to interpretation, as Georges Grappe has described it, that is the road that Monet travelled during the 1880s. Will, desire, memory, mind became active, formative processes grafted on to vision. Observation and reflection evolved during the course of Monet's career. In the 1880s observation was intensified and reflection extended as Monet sought to create works that would be faithful records as well as painting paradigms that might point the way to a new plane of formal inquiry.

During the decade of the eighties, Monet became an explorer, a hunter, as de Maupassant described him in 1886, a seeker after scenes and effects that would stimulate what he occasionally came to feel was his fading spirit and jaded palette. He sought places that would provoke his eye, provide new experiences of topography, light, and colour, and spark new compositional and chromatic arrangements in his canvases. He undertook an activity pursued by no other Impressionist to anything like the same degree as he mounted extensive painting campaigns on the Normandy and Brittany coasts, along the Mediterranean, in the Creuse Valley of central France, and, briefly, in Holland in 1886. His relationship to nature became more tense, taking on the quality of a struggle, a combat, and he continually asked himself if he could go off on a new campaign, perhaps to a new site, and return with a trophy, with a cache of paintings that he had succeeded in prizing loose from that site. Nature became not only his point of reference but his ally or foe depending on the weather—would it permit him to work outdoors, pursue a motif once started, or would it prevent him from doing so? He had to struggle against himself as well. As he reached his fortieth birthday in 1880, he began to express in letters to friends, collectors, and his dealer Durand-Ruel feelings of despair and elation that gradually assumed a cyclical pattern. At the worst of times he saw things black, cursed nature for its irregularity, complained of his inability to cope with tasks he had set himself. Numerous paintings were scraped out or destroyed in the process.

It is worth listening to Monet's words to see what they tell us about himself and his art. At the end of the seventies, when the

Right: Fig. 1 *Study of Trees*. About 1857. Drawing, pencil. Studio stamp bottom left. Inscription bottom right: à la mare du clerc/le 16 septembre. 11¾ × 9 in. Musée Municipal de Honfleur (gift of Michel Monet).

This sheet was detached from a sketchbook formerly in the collection of Michel Monet but unfortunately now missing. The sketchbook was used by Monet during 1857 (and possibly begun in late summer 1856, from when this drawing may date). In style it reveals the training in the conventions of landscape drawing which he probably received from his teacher, François-Charles Ochard, at the Collège du Havre. It conforms closely to the demonstration plates included in numerous handbooks on drawing technique; Monet may have learned from such books as well as from Ochard's instruction (see Fig. 2).

Below: Fig. 2 *Studies of Trees*. From A. Calame, *Etudes progressives de paysage*. Paris. About 1845.

This is a page from one of the instructional drawing handbooks available to Monet and his teacher during his student days. Works such as this inform the style of most of the landscape drawings found in Monet's early sketchbook (Fig. 1).

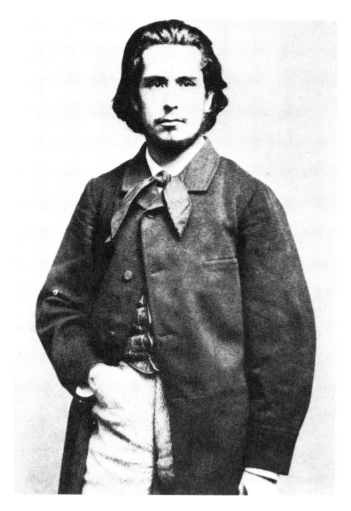

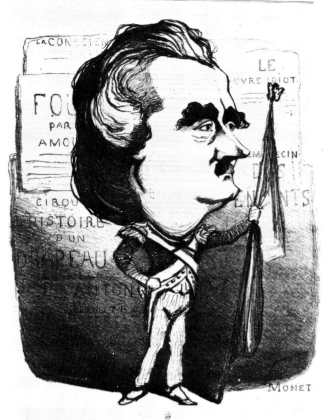

LAFERRIÈRE

Top left: Fig. 5 Monet at 19 or 20 years. About 1860. Photograph by Carjat.

Top right: Fig. 3 *The Actor Louis Fortuné Adolphe Laferrière.* Lithograph, published in *Diogène*, 24 March 1860.

Monet's skill as a caricaturist is already evident in several of the pages from his sketchbook of 1857. From about 1857 to about 1859, he sold his caricatures, mostly portraits of clients in Le Havre, for as much as twenty francs apiece, amassing savings of 2,000 francs from this pursuit. During his first stay in Paris in 1859–60, Monet's ability attracted the editor Carjat, who commissioned the present caricature for publication in his journal *Diogène*.

Bottom right: Fig. 4 *Eugène Boudin working at Le Havre.* About 1857. Drawing, pencil on grey paper, $11\frac{3}{4} \times 8\frac{5}{8}$ in. Musée Municipal de Honfleur (gift of Michel Monet).

According to Michel Monet this page was detached from the sketchbook of 1857 (see note for Fig. 1). A somewhat caricatured portrait of Boudin sketching outdoors, it suggests (although it does not prove) that their first meeting and the beginning of their working relationship took place at least by 1857; it is possible, however, that the first landscape pages of the sketchbook may date from summer 1856 and reflect Boudin's encouragement, by that earlier date, to work directly outdoors.

Fig. 6 Eugène Boudin. *White Clouds over the Estuary*. About 1859. Pastel, $6\frac{1}{4} \times 7\frac{3}{4}$ in. Musée Municipal de Honfleur.

Fig. 7 Johann-Barthold Jongkind. *Sainte-Adresse*. 1862. $13 \times 19\frac{1}{8}$ in. Private Collection.

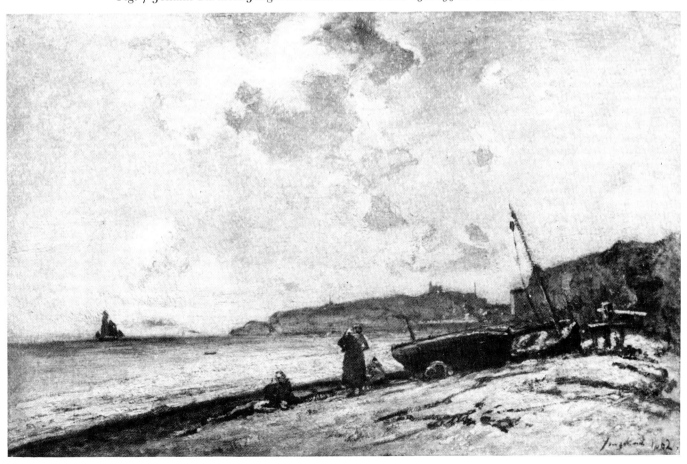

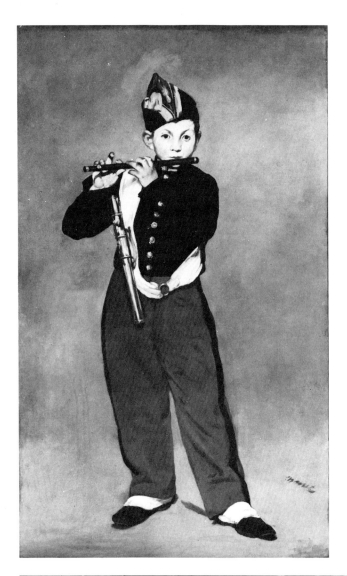

Opposite top left: Fig. 8 Edouard Manet. *The Fifer.* 1866. $64\frac{1}{2} \times 38\frac{1}{8}$ in. Musée du Louvre, Paris (Jeu de Paume).

Opposite top right: Fig. 9 Adolphe Braun. *The Pont des Arts*, detail from a panoramic photograph of Paris. 1867.

Opposite bottom: Fig. 10 *The Garden of the Princess*, detail of Plate 5, page 53.

Right: Fig. 11 Ando Hiroshige. *Azuma Bridge at Komagatudo*, from the series 'One Hundred Views of Famous Places in Edo'. 1857. Colour woodcut.

Below: Fig. 12 Ando Hiroshige. *Numazu*, no. 13 from the series 'Fifty-three Stages of the Tokaido'. About 1834. Colour woodcut.

 Compare Plate 14, page 62, *Ice-floes on the Seine at Bougival* (1867). The stylized grey-on-grey treatment of the trees at the left may derive in part from the model offered by Hiroshige in the handling of greys (in this case in the area of trees on the far shore) in this and numerous other prints.

Fig. 13 Camille Corot. *Ville-d'Avray*. 1867–70. 19⅜ × 25⅝ in. National Gallery of Art, Washington D.C.

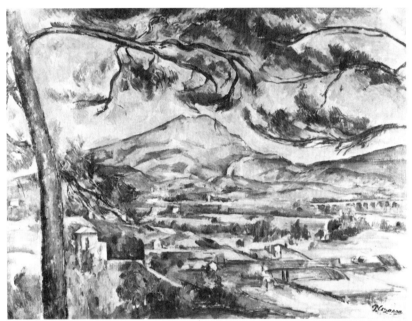

Fig. 14 Paul Cézanne. *Mont Sainte-Victoire*. About 1885–7. 26 × 35⅜ in. Courtauld Institute Galleries, London.

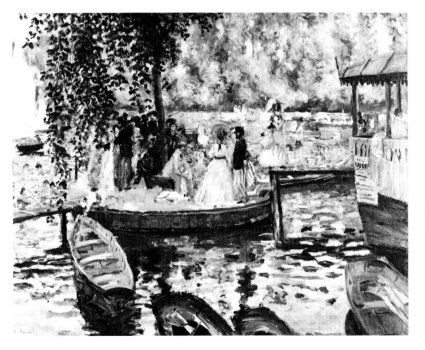

Fig. 15 Pierre-Auguste Renoir. *La Grenouillère*. 1869. 26 × 33⅞ in. Nationalmuseum, Stockholm.

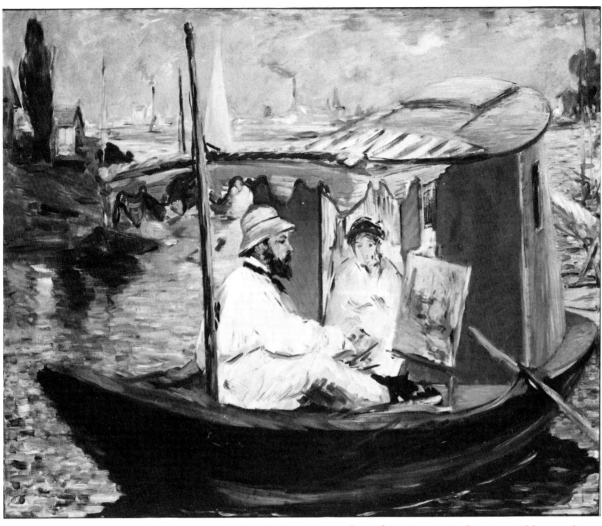

Fig. 16 Edouard Manet. *Monet painting in his Studio Boat*. 1874. $31\frac{5}{8} \times 38\frac{5}{8}$ in. Bayerische Staatsgemäldesammlungen, Munich.

Fig. 17 James Abbott McNeill Whistler. *Nocturne in Blue and Silver: Cremorne Lights*. 1872. $19\frac{1}{2} \times 29\frac{1}{8}$ in. Tate Gallery, London.

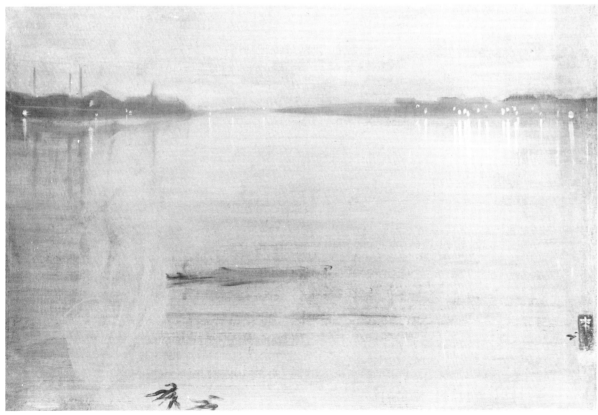

EXPOSITION DE LA « VIE MODERNE » ; *PAYSAGE.* — Dessin de Claude MONET.

Left: Fig. 18 *Hut at Sainte-Adresse.* 1880. Drawing, published in *La Vie moderne*, 26 June 1880.

This drawing, based on a painting of 1867 (W.94) that Monet included in his one-man show at *La Vie moderne* in 1880, was done by him to illustrate an article on the exhibition. In its frontal view the composition compares closely to the immediately contemporaneous *Terrace at Sainte-Adresse* of 1867 (Plate 21, page 69). The view from the top of the cliff out to sea is one that Monet began to exploit in an extended group of paintings done on the Normandy coast in the 1880s (Plates 69, 72, 74, pages 117, 120, 122), and it may be that the resurrection of the 1867 painting for the *Vie moderne* exhibition and the execution of this drawn copy served as a stimulus to his explorations of the early eighties.

Below: Fig. 19 Photograph of Monet in his garden in front of the house at Giverny. Collection Durand-Ruel. Compare Plate 125, page 170.

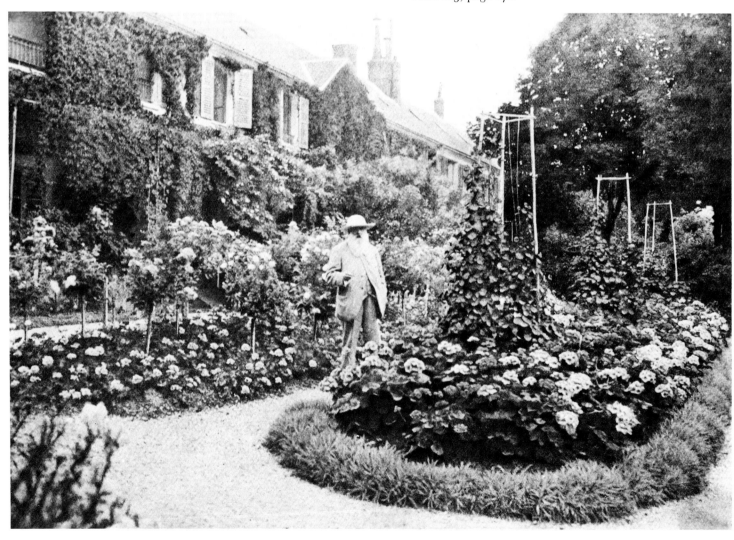

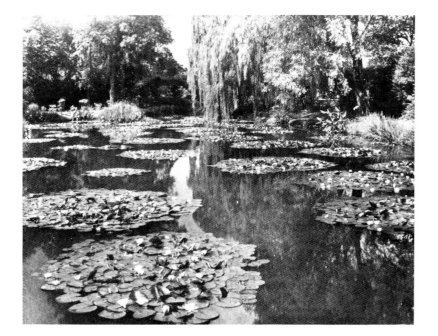

Fig. 20 Photograph of the water-lily pond, looking west.

Fig. 21 Photograph of the water-lily pond and Japanese bridge, from the west. Compare Plates 126, 128, 145, pages 171, 173, 189.

Fig. 22 Photograph of the water-lily pond, looking west. Compare plates 129, 130, 133, 134, pages 174, 175, 178, 179.

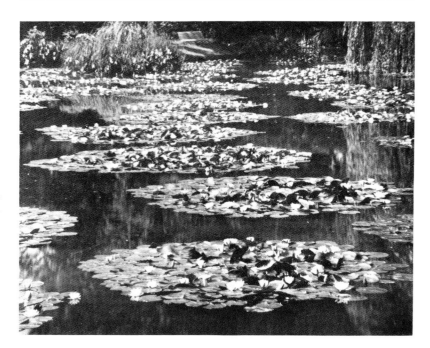

Left: Fig. 23 Henri Matisse. *Coffee-Pot, Carafe and Fruit Dish.* 1909. $34\frac{5}{8} \times 46\frac{1}{2}$ in. Hermitage, Leningrad.

Below: Fig. 24 Photograph of Monet painting in the water garden at Giverny, July 1915. Collection Piguet.

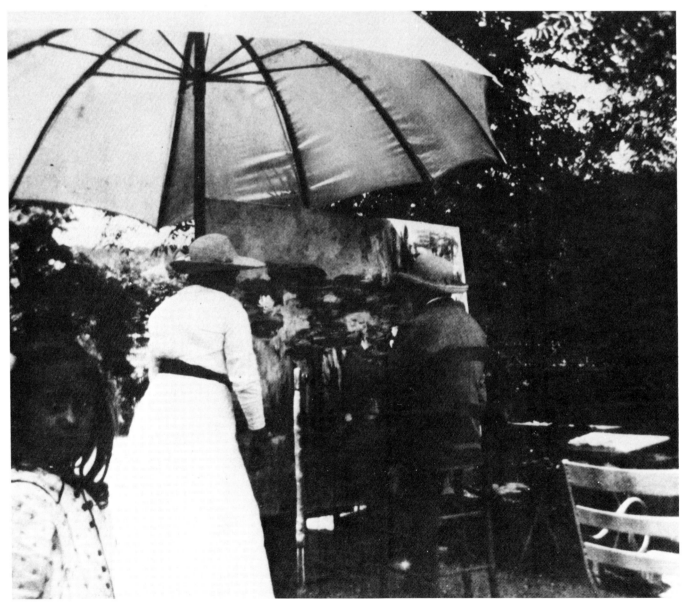

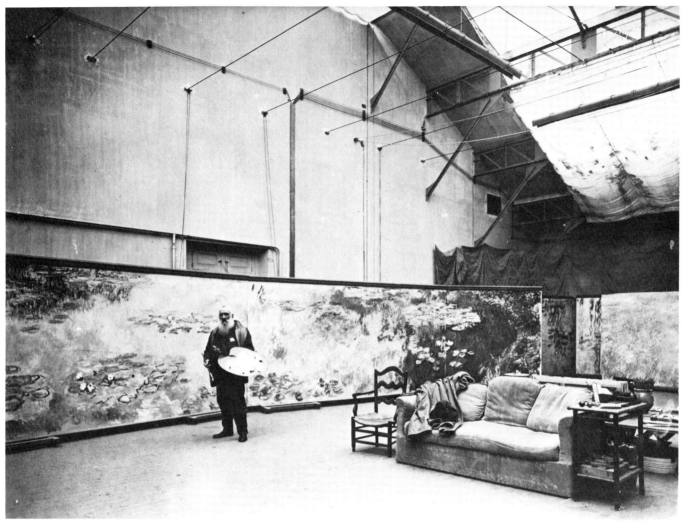

Above: Fig. 25 Photograph of Monet in the large studio completed in 1916 and built for the purpose of working at the water-lilies murals. About 1920. Compare Plates 132, 146–50, pages 177, 190–2. Collection Durand-Ruel.

Below left: Fig. 26 Photograph of Monet photographing the water-lily pond. Collection Piguet.

Monet and his family produced an extensive photographic record of the life and property at Giverny during the more than forty years in which they lived there together. Sometime after 1897 a darkroom was introduced on the ground floor below the second studio built just to the west of the main house.

Below right: Fig. 27 Photograph of the water-lily pond with Monet's reflection as he stood at its edge photographing the lilies. Collection Piguet.

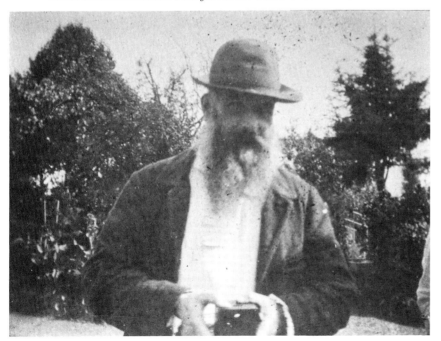

 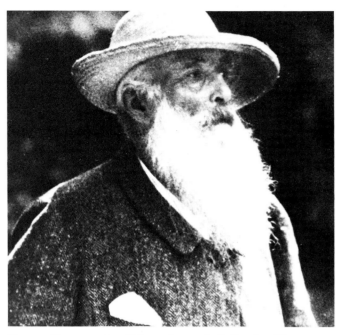

Fig. 28 Photograph of Monet after the operation on his right eye for cataract. 1923. Collection Piguet.

Fig. 29 Photograph of Monet in 1926. Collection Piguet.

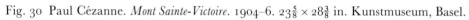

Fig. 30 Paul Cézanne. *Mont Sainte-Victoire*. 1904–6. $23\frac{5}{8} \times 28\frac{3}{8}$ in. Kunstmuseum, Basel.

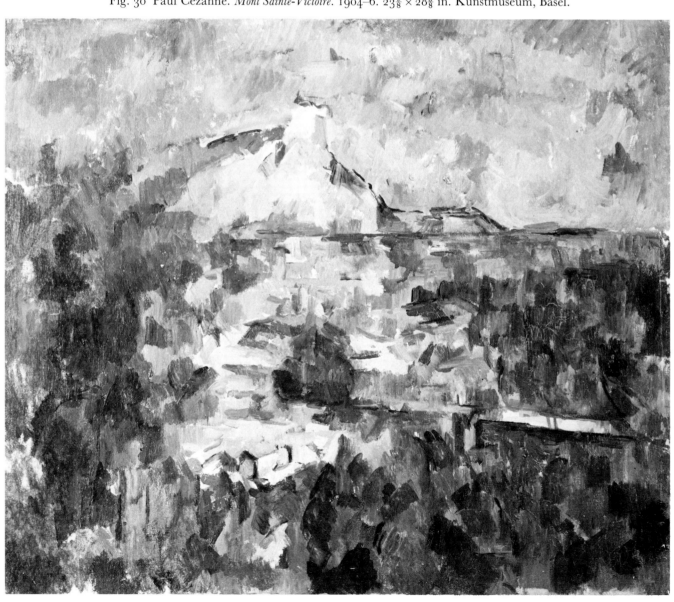

critics were accusing him of hastiness and lack of finish, he wrote to Hoschedé: 'I alone can know the inquietude and the trouble that I give myself in order to finish canvases that do not satisfy me and that please so few people.' In September, 1882, working at Pourville (Plates 70 and 71), he described his mood to Durand-Ruel:

I am completely discouraged. After several days of beautiful weather, the rain has started again, and once more I have to put aside the things I have begun. I am going crazy and unfortunately it's my poor canvases that I take it out on. A large still-life of flowers that I just finished I have destroyed along with three or four canvases that I have not only scraped out but slashed.... I see the future too black. Doubt has taken possession of me, I feel lost, I'll no longer be able to do anything.

He became more demanding of himself. To Durand-Ruel in December 1883 he wrote, 'I have more and more difficulty satisfying myself . . . in doing what I used to do easily.' He repeated the theme two years later, in July 1885: 'Several [canvases] are already abandoned, nature having changed enormously; it gets more and more difficult and it is exactly because I'm working and, I think, making progress, that I must be harder on myself.'

Determined to render the most intangible and fleeting phenomena, the most intense and vibrant of colours, he occasionally felt that his tools as well as his abilities were inadequate to the task. Facing the colours of the Mediterranean at Bordighera in 1884 (Plates 76 and 82), he wrote to Théodore Duret: 'It is terribly difficult, one needs a palette of diamonds and precious stones.' Testing and frustration continued throughout the decade and, if anything, increased in intensity. In 1890, he wrote to his friend Gustave Geffroy, possibly referring to a group of paintings of figures boating on the river, which he had begun earlier (Plates 99 and 100): 'I am again attempting impossible things: water with grasses undulating in its depths . . . it's an admirable sight but it can drive you mad to want to paint it. I always attack things like that.'

Monet's work of the eighties may be divided into three extended and alternating groups: paintings of the Normandy and Brittany coasts from 1880 to 1883 and 1885 to 1886, the Mediterranean in 1884 and 1888, and paintings of Giverny and the surrounding area, beginning with his move there in 1883. The paintings of Normandy meant a return to the scenes of his early youth and manhood. The sea viewed in conjunction with the cliffs and beaches upon which he stationed himself provided the dramatic occasions in which he could act out and give vent to the increasing tensions within him. They offered, as well, a topographical correlative for his evolving ideas on the decorative, abstract character of painting. At Varengeville in 1882, he renewed the investigation of composition and viewpoint he had made the

year before at Fécamp. For an extended group of paintings he seized upon the unusual, seemingly fortuitous, always surprising relationships between land and sea when viewed—as if suddenly—from varied vantage-points: from the clifftops, looking out to sea or precipitously down to the beach below (Plates 72 and 74) or across to distant hills (Plate 75), and from the wet shoals at low tide looking back toward the cliffs stretched above the beach (Plate 78). He took these views as he found them, frequently recording their features in quick pencil sketches in a notebook (Plate 79), and then tested ways to crop and simplify the scene, emphasizing the large curves of cliffs and seeking to adjust them to a trial frame, an appropriate shape of canvas.

The results of this procedure are recorded in a number of canvases done at Varengeville and at Etretat during the following year (Plates 78 and 81). The passage from physical contact with the site to the painted product is instructive. Monet's vantage-points were often difficult to reach, perhaps requiring the use of a boat or involving a strenuous, sometimes dangerous climb, the effort increased by the need to transport his painting equipment. In the final painting, Monet transferred the active experience of the hiker or climber, for whom, visually, rocks and beach and water were constantly exchanging relationships in unforeseen ways, to the rarefied world of the horizontally and vertically framed canvas. The uncertain conformations of the landscape were regularized into undulating arabesques, the experience of space was translated into pattern (Plates 72 and 74). Within the broad shapes of cliff and sea adjusted to the flatness of the picture plane, colour and brushstroke were allowed a freer, more inventive relationship to the particularities of a given site. The variable aspects of nature are stilled and caught and given form in a new world—that of the precious object. The aestheticizing of experience becomes a factor in all of Monet's paintings from this point through to the end of his career.

Etretat, with its dramatic cliffs stepping out into the ocean, was a favourite spot for landscape painters throughout the nineteenth century. Monet worked there in 1883 and 1885, developing a number of miniature series of views from the cliffs and beach (Plates 80–1, 83–4 and 85). It was in this setting that Hugues Le Roux found him at work in November 1885, when the beaches were deserted, equipped with several canvases so that he might capture the changes in light and the behaviour of the sea (see page 11). The works from Etretat display a mingling of two responses, to the elements and to the possibilities for design presented at the site itself. At the same time that he emphasizes the variations in light and weather from canvas to canvas, he explores the silhouette of a cliff or the flowing line of the beach, perhaps compares the compositional differences between distance and close-up. When he chooses to translate the conformations of cliffs and sea into reciprocally curving shapes upon his canvas, he never fails to provide an identifiable record of the light in which the scene is bathed. Among the most remarkable of the Etretat paintings are those of the Manneporte (Plates 84 and 85). Monet's vantage-point on a small strip of beach could be reached only by boat or by a

treacherous descent from the cliffs. Standing on the beach, he could not step back very far from the arched rock. Its looming presence dominates one's experience at the site; in the paintings it fills the format and its shape interlocks with that of the receding sea and distant sky to form one of the most powerful abstract designs that Monet ever achieved.

He carried that sense of and desire for design to Belle-Ile, a rocky island off the coast of Brittany, in the following year (Plates 86 and 89). In that rough and barren spot he found beauty and darkness, elegant curves and jagged contours that seemed to bear a parallel to the alternations of calm and torment that existed within himself. In his letters to Durand-Ruel, he said that the sombre and terrible aspect of the place appealed to him because it challenged him to do things that he was not used to doing. 'I may well be a man of the sun, as you say,' he added, 'but one ought not to specialize in a single note.' Monet sought both the light and the dark during the 1880s. The next two extended painting trips he made were to the sunlit Mediterranean in 1888 (Plates 88, 92 and 93) and to the richly coloured but dour Creuse Valley in central France in 1889 (Plate 94), where he became enamoured of its winter barrenness.

The Mediterranean offered a vast new world of experience to the sensitized eye of Monet. In January 1884 he travelled to Bordighera on the Riviera, just across the Italian border from France, a site that he had discovered only a month earlier on a holiday voyage with Renoir. Before his departure, he asked Durand-Ruel not to tell Renoir of his trip, saying, 'I want to do it alone . . . I have always worked better in solitude and following my own impressions.' Now, in retrospect, he preferred his earlier periods of isolation to the fruitful sharing of 1869 and 1874 with Renoir at La Grenouillère and Argenteuil. A number of paintings capture the twisting trunks of small trees against the hillside and sea (Plate 82), carrying forth the fascination with curvilinear energies already evident at Varengeville and Etretat. Monet was captivated by these ready-made rhythms, but the experience he stressed in his letters was that of colour.

The hues of Normandy were no match for the chromatic dazzle of Bordighera. Gaining access to the villa of a M. Moreno from Marseilles, he painted the gardens with their abundant flora and 'the most beautiful palm trees in Bordighera'. A long suite of canvases depicts the cluttered vegetation of the villa; compositionally undistinguished, their obsession is colour (Plate 76). On 9 February, two weeks after his arrival, he wrote to Durand-Ruel that he was 'more and more enraptured, and I am working hard'. By 11 March, he wrote of poor results but also good ones: 'They may excite a bit the enemies of blue and pink, because it is exactly the sparkle, this enchanted light that I am determined to render, and those who haven't seen this country, or who have seen it wrongly, will protest, I'm sure, the lack of resemblance, although I am well below the tone: everything is iridescent.'

The paintings of Bordighera seem, indeed, to have redirected Monet's palette towards the sun. During the seventies he had from time to time come near to using a palette

reduced to the colours of the spectrum (Plate 44), and in the garden paintings of Argenteuil (Plate 51) he had given himself to intensities of hue that threatened the coherence of the composition. The palette of Vétheuil and Normandy (Plates 73 and 74) was occasionally soft, geared to a delicate play of pastel tints or organized into complementary contrasts. But it is only at Bordighera that Monet reduced his chromatic choices to the colours of the spectrum. From that point on, although his colours changed to fit the character of the site he painted, he had a security with colour that enabled him to create an identifiable range of palette as one of the primary elements in the pairs, triads, and series of canvases that were to emerge from his various painting campaigns.

In the three years after Bordighera, Monet sought iridescence and strove for colour intensities that he had not yet reached in painting. The plains of Giverny (Plate 90) and the tulip fields of Holland (Plate 87), painted on a brief trip in 1886, must have fed his desire; he wrote to Duret from Holland that the tulips were 'unpaintable with our poor colours'. Red, green, and yellow are raised to a pitch that approaches a cry or shriek in these paintings of the mid-1880s. The poppy field at Giverny becomes almost a solid mass of red framed and stitched by greens of grass and foliage, the heightening effect of complementary pairs enhancing their bold saturation.

Monet's world of colour was extended towards pastel modulation and exploded into harsh, improbable contrast in 1888, when he made his second extended trip to the Mediterranean (Plates 88, 92 and 93). The paintings of Antibes are more powdery and confectionery in quality than those of Bordighera—pale pink, pale peach, intense tints of blue tend to govern the views across the bay from Cap d'Antibes (Plate 92). He was less concerned than in 1884 with the possible objections of his critics, more single-mindedly involved with the coloured atmosphere: 'Blue, rose, gold, but how difficult,' he wrote to Duret; and to Geffroy: 'I slave away but find it devilishly hard, I'm very anxious about what I have done. It's very beautiful here, so clear, so luminous! I swim in blue air, it's frightening.'

His stay at Antibes was marked by especially rapid fluctuations between elation and despair. Against the light-struck world that intoxicated and frightened him he attempted to defend himself by calling up that other side of his personality and his art, that darker aspect that had been unleashed at Belle-Ile. He wrote to Berthe Morisot of the conflict between the tenderness and delicacy required to paint the Mediterranean and what he considered to be the basic tenor of his personality, 'so inclined to brutality'. In some works from Antibes he drew upon the world of Belle-Ile and grafted it on to the blue of the Mediterranean. He was struck by the shapes of the umbrella pines at Juan-les-Pins, and in several paintings he profiled their darkly twisting trunks and deep green and rust-red crowns—like sombre complementaries—and set them with a discordant but satisfying power against the pale light of the sea and sky and distant hills (Plate 93).

During the 1880s Monet transformed himself and his art. Following the death of Camille and a difficult period of emotional reorientation, he established a new life with a secure base in the house at Giverny and with the continued devotion of Alice Hoschedé, who brought up Monet's children along with her own. The move to Giverny, about seven miles to the west of Vétheuil, in 1883 had strengthened his resolve to distance himself from the art world of Paris and from his Impressionist friends. At the end of the seventies and the beginning of the eighties, several of the Impressionists had begun to question their art and the continued viability of the group exhibitions they had begun in 1874. The Impressionist crisis, as it has been called, emerged when the flush of youth and early manhood, the energies unleashed by personal ambition and mutual support, had begun to fade. It was a crisis of personal growth, of social relations, of financial position, and a crisis of art.

The strongest questioning and redirection is found in the work of Renoir, Pissarro, and Monet. It was Renoir who raised the issue of Impressionism's formlessness, echoing the charges of critics in 1879 and 1880 that the movement had failed to live up to its promise, had given itself over to hasty, ill-considered execution. He sought during the first half of the 1880s for a return to tradition, the classical order and firmness of Pompeian wall paintings and of Raphael, the linear clarity of Ingres. Pissarro, increasing during the early eighties the meticulousness of his application of divided colour, was ready to join the young generation of Neo-Impressionists in 1886, eager to champion the new programmatic and scientific ordering of Impressionist *laissez-faire*. He looked back to his early work and that of his old friends as undisciplined and romantic. Both Renoir and Pissarro accompanied change with disavowal, almost a recantation of earlier sins. Not so Monet, and yet of the three artists his transformation proved to be the most profound and viable. It was the only one that pointed the

way to the new generation—it was Seurat, Gauguin, van Gogh who took *him* as a model, who learned from his curvilinear stylizations of nature and his exaggerated palette; and it provided as well an important base for his own future work, the great series paintings of the succeeding two decades.

Monet's development involved a reorientation of attitudes and goals. The period of the sixties and seventies had been governed by a process of filtering nature through the active but moderate screen of the artist's sensibility and sense of design: description, responsiveness to appearances, flexibility, a tendency toward objective inquiry dominated. With the turn to the eighties—one can locate the shift more particularly in the icy fields of Vétheuil in 1880 and on the cliffs of Normandy in 1881–2—Monet's role became more actively that of organizer and interpreter as he began to coax nature's conformations into the decorative play of forms on the canvas and as he sought to further his investigation of nature's colour by moving toward the limits of the pure spectrum range. The investigation *en plein air* was accompanied by more extended periods of inquiry and adjustment in the studio. Natural variations provided the occasion for artificial distinctions that were discovered in the process of comparison and invention carried out away from the site with the aid of memory and the desire to create new, internally consistent wholes. In the process, the definition of internal consistency was itself enlarged as he moved towards multiple statements, limited suites of paintings that became considered comments on each other. The idea of the ensemble, of a cluster of mutually related and reinforcing works, was, during the course of the eighties, grafted on to the basic—and enduring—concern for the painting as a picture of nature. The pursuit of an ever more precise notation after nature and the creation of a more extended and integrated ensemble of paintings are, in their combination, at the core of the series paintings that emerged at the beginning of the 1890s.

The 1890s: The Series Paintings

He is the anxious observer of the differences of minutes . . . *Gustave Geffroy*, 1891

As he reached his fiftieth year in 1890, Monet's ability and desire to travel were curtailed. During the second half of the eighties, between voyages, he had painted the fields around Giverny (Plates 90 and 101) and produced an impressive group of figure paintings of members of his family in the meadows and boating on the river (Plates 91, 99, and 100). In the early nineties he began to concentrate more deliberately on motifs available in the neighbourhood, an occupation undoubtedly furthered by his purchase in 1890 of the house at Giverny and his marriage to Alice Hoschedé in 1892, following the death of Ernest the preceding year. This new stability was in part made possible by a significant rise in sales during the late 1880s and

consolidated with the series paintings, first shown at Durand-Ruel's in 1891, when fifteen Haystacks were displayed, the entire group being sold in the first three days. The rest of Monet's life had the outward trappings of a well-to-do country squire, who, however, happened to have the peculiar vocation of a painter. In these favourable circumstances the dialogue between art and nature was pursued, albeit with no slackening of inner doubt, throughout his last thirty-five years.

The great effort of the 1890s for Monet was the elaboration of the series paintings. They were a factor at all his exhibitions during the decade. In 1891 the Haystacks (Plates 95–8) appeared at Durand-Ruel's, and fifteen paintings of Poplars

were included in an exhibition in 1892 (Plates 103–6). In 1895, twenty of the fifty paintings shown at Durand-Ruel's depicted the façade of Rouen Cathedral (Plates 107–10). Three years later, in 1898, he exhibited sixty-one paintings at the Galerie Georges Petit, including eighteen Mornings on the Seine (Plates 111 and 112) and twenty-four paintings of the coast at Varengeville, Pourville, and Fécamp (Plates 116–19), paintings that took up again some of the pictorial themes he had worked out in the early eighties, when the series idea was first being put together.

Monet's aim in the series paintings, taken as a whole, was to develop specific records of a chosen site, which would convey the changes of the seasons, weather, atmosphere, and the passage of light, its varied colour, warmth, and direction during the course of a single day. Each series was part of the same general endeavour, each belonged to the same species of effort. But to look at the various series is to realize that each one is unique, in the same way that people are. Each one contains within it the same shifts in mood, temperature, personality, and posture that we recognize in individuals. Each series is a complex of separate phases and attitudes, moments and emotions. And, beyond that, each is the product of a coordinated process of perception and imagination, of the projection of desire, rage, hallucination, and love on to a nature that presents itself simultaneously in its permanence and elusiveness.

HAYSTACKS

Monet probably began to paint the series of Haystacks (Plates 95–8) in the summer of 1890. At the time, his step-daughter, Blanche Hoschedé, was his assistant and frequent painting companion; late in her life she recalled the origins of the project in this way:

> Very early one morning, bent over his work, Claude Monet was struck by the reflection of the sun's rays on a haystack; at one moment the hay flooded with light appeared all white, at another the stack seemed aflame. For many months the painter tried to fix this marvellous spectacle. He would take me with him across the fields. I pushed a wheelbarrow carrying, according to his wish, as many canvases as there were different impressions to seize.

We have no more reliable witness than Blanche Hoschedé. But her account touches only the surface, perhaps deliberately, respecting the deeper, more intangible qualities of Monet's creative process. In response to her interviewer's question about whether Monet ever expressed what he felt while working, she replied, 'No, he was for the most part silent, juxtaposing the tones that he sought to blend together. If you knew how much those silences were charged with thought.'

Monet was not entirely silent during those years. In fact, it is precisely at the time that he began the Haystacks and Poplars

series that he spoke most clearly about his goals. On 21 July 1890 he wrote to Gustave Geffroy, expressing anguish over his paintings:

> It is decidedly a continual torture!... The little I've done is destroyed, scraped out or slashed. You can't imagine the terrible weather that we've had for the past two months. It's enough to drive you mad when you seek to render the weather, the atmosphere, the ambience.

And three months later he wrote, in the midst of his work on the Haystacks:

> I am working very hard, struggling with a series of different effects (haystacks), but at this season the sun sets so fast that I cannot follow it.... I have become so slow at working that I am in despair, but the more I continue, the more I see that a great deal of work is necessary in order to succeed in rendering what I seek: 'instantaneity', especially the *enveloppe*, the same light spreading everywhere, and more than ever I am disgusted with the easy things that come in one stroke. I am more and more driven by the need to render what I feel . . .

Both letters offer explicit and implicit information. Implicit is the inextricable flow from painting to nature and back to painting again: the experience of one is the experience of the other; both painting and nature, to realize both in the same act drives him to despair. Explicit is the desire to render change, flux, the ambient, the intangible. All the more appropriate that the first series to be completed was the Haystacks. Dumb monuments, ponderous sundials erected in the fields, they absorb and reveal the succession of instants, the play of hours, the colours and vapours of the months, the passions of weather and seasons. Monet seems to have worked at the Haystacks from the summer of 1890 to the winter of the following year. The colours of hour and season are recorded occasionally with power (Plate 95)—deep and fiery reds, oranges, purples, greens in the blaze of the sunset—but most often with delicacy (Plate 96). Through colour Monet bestows upon graceless mounds the gift of elegance. Ignoring their bulk, he inlays their surfaces with the most delicately nuanced harmonies that he had yet achieved, a delicacy more impressively wrung from his palette than the pastel whispers that emanate from the paintings of the bay at Antibes, more impressive because joined to the least accommodating of motifs. Monet dreamed upon the Haystacks: complex iridescences, indefinable, subtle hues combined with pinks, oranges, blues, and violets, place these paintings ultimately somewhere other than in the natural world.

At the opening of the Haystacks exhibition, a Dutch visitor named Willem Byvanck met Monet, who spoke freely to him of his methods and aims. Monet expressed his wish to be 'true and exact' in depicting nature, to record faithfully its aspect at each moment of change. He finished, however, by citing one painting among those exhibited that he considered to be the

only one which was perfectly successful, 'perhaps because the landscape then gave all that it was capable of giving'. Monet's statement would seem to place the major stress upon the role of nature in the understanding of his paintings, but the word 'capable' suggests that the greater emphasis should be given to the transforming action of the artist. For capability is not a quality of landscape; it is the possession of the painter who gives all that is in him in order to receive and then re-create what nature offers.

The series paintings record states of light and weather and states of consciousness; they reveal one of the most precious qualities sought for in the artist by the young writers and critics of the new generation of Symbolists, by whose standards Monet's work was being increasingly measured. Monet possessed the capacity—the critic Albert Aurier termed it a gift in his history-making article on Paul Gauguin and Symbolism in 1890—for '*émotivité*', the capacity to be moved. The landscape moved him and was then transformed, through the long, often frantic series process, into a multivalent, many-sided, but unified work of art, the result of the complex intertwining of the experience of nature and the long sessions of adjustment and invention pursued in the studio. The series paintings looked towards a decorative unity that went beyond nature and entered the realm of pure artistic creation. They embody the dominant understanding of the artists and writers who, beginning in the 1880s, strove to put realism aside and reclaim the age-old imaginative function of the artist. In the series, the Idea of the Symbolists—the pure form of artistic creation that soars above the ground of naturalistic contingency—is fully achieved.

POPLARS

Monet never came closer to an ornamental transformation of nature than he did in the series of Poplars, which were exhibited as a suite of fifteen canvases at Durand-Ruel's gallery in March 1892 (Plates 103–6). The series was probably begun during the spring of 1890 and continued throughout the following year. His examination of nature was more circum-scribed in scope than in the Haystacks series; there Monet was concerned with conditions of light and weather within the change of seasons, whereas the Poplars recorded variations that could be found within a single day—from dawn to sunset, from clear weather to grey and impending storm. Within that framework, his desire for veracity was intensified. Lilla Cabot Perry, who was Monet's neighbour at Giverny and saw him at work on the series, has reported that in one case an effect lasted only seven minutes—or until the light left a certain leaf—before he took up work on another canvas. Through such careful observation he developed clues that enabled him to give a precise chromatic stamp to each painting, with the result that, in the end, one gets the sense that the series provides less a range of responses to natural variations than a deliberate manipulation of the resources of the palette (Plate 106).

A move in the direction of artifice is evident in Monet's treatment of design as well. The poplars bordered a meandering stretch of the Epte, not far from his home. Their undulating passage through space was translated by Monet into looping S-curves upon the canvas (the American painter Theodore Robinson, who worked closely with Monet at Giverny in 1892, referred to the Poplars in his diary as the 'whirl' series). The lines of the slender trunks were developed as repeated, evenly paced verticals against the accelerating swirl of the receding trees. We can say of the Haystacks that they avoided design; Monet observed their plastic presence in the fields and emphasized or defeated the illusionism of their presentation by means of contrast or close-hued harmony. In the Poplars he had a motif that presented itself like an offering to his decorative intentions.

With the Poplars, Monet pushed the series idea further than he had in the Haystacks. When Octave Mirbeau saw Monet's exhibition just before it opened to the public, he congratulated his friend on having achieved 'absolute beauty in large-scale decoration'. Unlike the Haystacks, which were exhibited along with other paintings, the Poplars provided an intimate and self-contained whole. The exhibition comprised fifteen linked statements, fifteen paintings derived individually from nature but merged towards a unity through a process of comparison and cross-reference pursued in the studio. Monet's interest in the interactions among a number of closely related works had been stated as early as 1882, when he wrote to Durand-Ruel from Pourville: 'Five are already finished, but if it makes no difference to you I would prefer to show you the entire series of my studies at one time, desirous as I am of seeing them all together in my studio.' That desire guided him in his multiple studies of varied sites through the eighties, and he sought to keep related canvases together when they were placed before the public. At his joint retrospective exhibition with Rodin in 1889, paintings from Antibes, Belle-Ile, and the Creuse were hung in separate groups on the gallery walls. The Poplars exhibition provided Monet with his first opportunity to give a pure form to his idea of presenting a group of related works that would be seen as attaining, through the considered coordination of diversity, the unity of a single work of art. That this unity was achieved by artifice, by abstractions of line and colour, was recognized by critics at the time and presented no better than in Geffroy's description of his desire in the Poplars to 'represent by an arabesque the face of the universe, to unite all things in the pure incandescence of solar light'.

ROUEN CATHEDRAL

In *Art and Photography*, Aaron Scharf has quoted this excerpt from the report of the physicist John Robison to the Society of Arts of Edinburgh in 1839, regarding the first public viewing in Paris of the photographs of Daguerre. Robison noted

> a set of three pictures of the same group of houses, one taken soon after sunrise, one at noon, and one in the evening; in these the change of aspect produced by the

variations in the distribution of light, was exemplified in a way which art can never attain to.

When Monet installed himself in a room in a building just across the square from the west front of Rouen Cathedral in 1892 (Plates 107–10), he had already gone well beyond the intent of the photograph. His work of the 1880s and the series of Haystacks and Poplars should make it clear that he was not ultimately interested in a factual record of the changes of light as they might be periodically registered on the neutral surface of a light-sensitive material. The recording agent in Monet's case was his own sensibility, his own consciousness, as George Heard Hamilton has suggested in his study of the Cathedral paintings. In the Rouen series the history of the cathedral was collapsed into that of all but a single day, its objective structure taken as a foil for recording the history of the experience of a single individual.

But the achievement of the photograph should not be put aside entirely. It is in the relationship between the kind of factual record the photograph can provide and the transforming capacity of the percipient individual that the nature of Monet's accomplishment may be further recognized. The ordinary observer at Rouen Cathedral—or before a field of haystacks or a row of poplars—cannot realize or retain the changes of aspect that take place from hour to hour. The camera can register these changes and immobilize them for us; to peruse a series of photographs of the site taken at different times of day is to become aware of what we have not seen.

Monet did not attempt to vie with the camera—he must have had too great a respect for its power—but he did try to approximate its accomplishment. The goal of decorative unity, which was so clearly demonstrated in the Poplars series, should not blind us to the continued importance of direct reference to nature. It remained as the foundation-stone of his artistic process. He had told Byvanck in 1891 at the opening of the Haystacks exhibition that 'above all I wanted to be true and exact'. Truth and exactness were related to his conviction that a subject does not exist in a single state but that its aspect changes every moment and that change is revealed 'by its surroundings, by air and light, which vary continually'. Acting in this belief, Monet had to move in the direction of the camera's record. He knew that he could not provide instants but he could attempt to capture chunks of time. Thus for two winters running he worked in Rouen, following the passage of the day with unprecedented tenacity. Only direct observation coupled with the successive and repeated use of many canvases related to the passage of time could capture change.

Monet measured change carefully at Rouen. One can clearly read the progress of light and shadow across the façade from mid-morning to late afternoon (Plates 109 and 110), when the shadows cast from the houses on the west side of the cathedral square are seen to scale the building's height. The complicated iridescences of sunrise and sunset are more difficult to interpret (Plates 107 and 108), and it is precisely in their almost hallucinatory extravagance that one becomes aware of the transforming imagination at work. The transfor-matory process undoubtedly began at the site, born of the excruciating tension that his regime must have engendered.

Two years elapsed between his second and last campaign at Rouen and the exhibition of twenty Cathedrals at Durand-Ruel's in the spring of 1895. Once the cathedral had been left behind, work continued at Giverny, difficult work, which caused him to postpone the proposed exhibition by more than a year. Unlike the situation with the Haystacks and Poplars, where the sites were in easy reach of his home, once the Rouen paintings were brought back to his studio there was no opportunity for continued reference to the motif. The series proceeded under the pressure of other forces—memory, intuition, habit, experience—that had to be accommodated in the development of a multipartite but interrelated whole. During the studio stage of his work observation and reflection continued to operate, but their referent was no longer nature. Rather, it was all the paintings in relation to each other and the larger group, how they looked and felt together.

In reviewing Monet's exhibition in 1895, his friends Geffroy and Clemenceau divided the Cathedrals into sub-series, but each chose different categories. Geffroy cited circumstantial divisions related to the actual site and weather conditions: the façade, the façade plus flanking buildings, the façade in fog. Clemenceau cited divisions by colour, that is, aesthetically determined variations derived from the range of the palette: grey, white, iridescent, blue. Taken together, these two descriptions provide us with the poles and the unity of Monet's enterprise—based in nature and completed according to a personal, intuitive, and artificial process of artistic comparison in the studio. The factual record of the camera was approached and transcended in the creation of an integrated whole. Camille Pissarro wrote to his son Lucien the day after the exhibition closed: 'I would have so much wanted you to see it in its ensemble, because I find a superb unity that I have so often sought.'

MORNINGS ON THE SEINE AND FALAISES

The second half of the nineties was filled with new projects. Early in 1895 Monet travelled to Norway and developed a limited series of paintings from the trip (Plates 113 and 114). In 1896 and 1897 he worked at two series concurrently, paintings of the Normandy coast from Fécamp to Dieppe (Plates 116–19), works that took up themes and sites painted fifteen years earlier, and an extended series of Mornings on the Seine (Plates 111 and 112), fifteen of which were exhibited in 1898.

The Mornings on the Seine were painted at a spot where the Epte flows into the Seine near Giverny. As revealed by Maurice Guillemot in his description of Monet at work at the beginning of this essay (page 11), Monet could reach it easily each morning. He would go out often before dawn, his main desire to paint the confluence of mist and rising sun over the water, the atmospheric veil through which he perceived the curving shapes of trees and reflections. Reflections were given

parity with the forms that generated them in Monet's decorative design, the fog or haze serving to cancel for the eye distinctions between the material and the immaterial, the trees and their watery echo. The reflection doubled the shape of the trees, creating an entirely new image, a Rorschach figure elicited from nature. Upon this newly formed shape he projected extraordinarily subtle and nuanced associations of hue, suggested by his initial perception of the environment. He recorded the shrouds of early morning, purple against pink or green, detail blunted by the ever present envelope of moisture and reflected light. In a number of canvases the purple dominance of the foliage gave way to the almost subliminal resonance of palest pink, green, violet, blue, a decibel above silence. One could call it the palette of the poet Mallarmé, the Mallarmé who sought the absolute of nuance and suggestion over the contingency of factual description. Monet's evasive Mornings are firmly rooted in the terrain of the *fin de siècle*. One thinks also of the memory of Proust, the search among uncertainties for the diminished yet present vibrancies of the past. And, perhaps the most rarefied evocations of Art Nouveau, the chemical whispers of hue and spatter on the surface and in the depths of a Tiffany vase; these too are recalled by the dawning veils of Monet.

One senses in the Mornings the attainment of the highest degree of subtlety of which Monet was capable, a subtlety compounded of the finest attunement of sensibility, a heightened receptivity to what nature could give, and a willed, artistically determined goal of delicacy. It was a compound weighted on the side of that determined goal; in the Mornings on the Seine, more conclusively than in any other series, the imagination proved more subtle than the eye.

Memory and an aesthetically defined aim are the primary ingredients of the other series of 1896–7 (Plates 116–19). During the winters of these years, Monet revisited the sites of his youth and of his artistic redirection at the beginning of the 1880s. The looming shapes of cliffs against the sea and sky, the simplified, planar, cursive formations that he derived from the spatially extensive and disparate character of the sites he painted, reappear toward the end of the nineties in more easefully designed canvases. The compositional discoveries of the early eighties (Plates 69, 72, 74, 77 and 78) had now become decorative certainties; the experience of decoration governs the physical and visual responses to the site.

These paintings of cliffs and sea—they were called the *Falaises* series when shown with the Mornings on the Seine and other works in 1898—may have served something of a private function for Monet at the same time as they strongly affirmed the dominance of artistic invention over naturalistic imitation in his work at this stage in his career. They brought him back to his origins in Normandy and they allowed him to measure his present efforts against the evidence of his own past. By creating new works closely based in design on earlier ones (Plates 72 and 118; 74 and 116), he was able to demonstrate that nature could have different aspects, not only in relation to varying conditions of time, weather, and atmosphere but as a result of sheer aesthetic decision. The design of the later

paintings is more fluidly cursive, the colour more muted and subtle. The shift does not demonstrate greater ability or understanding; rather, it is a biographical and cultural shift, reflecting changes in taste and aesthetic direction that had emerged in the intervening years. Monet's paintings had earlier helped prepare the way for the development of an ideal of art that, through autonomies of line and colour, would free itself from the constraints of naturalistic description. During the nineties his concern for the relationship between nature and stylization placed him squarely in the camp of that outpost of Symbolism, Art Nouveau. The linear, decorative qualities of his curvilinear compositions of the eighties had been one of the generative forces behind the emergence of the animated arabesque favoured by Art Nouveau designers. In the nineties he came to share their taste for the precious, sophisticated, and refined in hue and sensibility. It is the integration into his own work of the artistic conception and goals of a new generation—to the formation of which he was a vital contributor—that accounts for the rarefied revision of his earlier paintings in the *Falaises* series of 1897.

LONDON

While the series of the nineties were being developed, Monet was also thinking of London as the site for a similar undertaking. He had considered the possibility as early as 1880, but it was not until September 1899 that he established himself in London and took a fifth-floor room at the Savoy Hotel, commanding an excellent view of the Thames. Below, to his left, was the massive Waterloo Bridge (Plate 124), to his right a view along the river including Charing Cross (Plate 121) and Westminster bridges with the Houses of Parliament in the distance. Those two views he painted from the balcony of his room; a third, which he probably began to paint on subsequent visits in 1900 and 1901, was painted from a room in St Thomas's Hospital on the South Bank, from which he could frame the silhouette of the Houses of Parliament hovering above and reflected in the river (Plate 122). From each view he developed an extended series of works which came to be part of a larger cycle of London paintings. Monet's three separate sojourns in England were followed by three years of intensive work in the studio at Giverny. Four and a half years after he began the project, thirty-seven paintings, a 'series of views of the Thames in London', were exhibited at Durand-Ruel's gallery in Paris.

The London cycle was the most extensive of Monet's series to date, both in terms of the number of canvases that he worked at and the number exhibited at Durand-Ruel's. We also have a fuller record of Monet's procedure than for any of the earlier series, and his progress can be followed with considerable accuracy. Monet's first campaign lasted from mid-September to the end of October, 1899. Back at Giverny on 6 November he wrote to Durand-Ruel that he might have five or six canvases ready prior to a second trip in the winter. 'For the others,' he added, 'I will do my best, as you know. Those that I

cannot finish off here, I will complete on the spot in London.' Having returned to the Savoy, he complained, in mid-February, of the variable nature of the setting and questioned whether he would succeed in achieving his goal. That goal continued to be, in the beginning, the faithful record of what he could see. The constant changes in light and weather caused him to have as many as a hundred canvases going at once, each attuned to a different aspect of the appearance of the setting. He would return to a single canvas perhaps twenty or thirty times, picking it up each time that the corresponding conditions returned in the scene before him. Confusion and exasperation accompanied the process, and he returned to Giverny in April at the end of his strength. A third trip to London would be necessary; what he had accomplished up to that point 'were only beginnings'. A year of work followed at Giverny and again in London from January 1901 into March, at which point he fell ill and had to curtail his stay. At the end of the year, he was still actively at work in Giverny, finding it was taking longer than he thought it would and postponing a promised shipment to Durand-Ruel. From the time of his last return from London until the exhibition finally took place in May 1904 three years elapsed. The greater part of the series was executed in the studio.

Letters to Durand-Ruel help us to follow major aspects of the process. In early March 1903, Monet was immersed in the paintings and looked toward an imminent conclusion to the project. But on 23 March he warned Durand-Ruel: 'I cannot send you a single London canvas, because, for the work I am now doing, it is indispensable that I have them all before my eyes, and to tell the truth not one is definitely finished. I develop them all together . . . and do not yet know how many I will be able to exhibit, because what I am doing now is very delicate.' From the beginning, due initially to a lack of finished canvases and then by design, Monet refused to send isolated London paintings to Durand-Ruel, despite the dealer's

urging. Increasingly, he came to think of his paintings as forming a discrete entity and he began to develop plans for a renewal of the kind of unified exhibition he had arranged for the Poplars in 1892, but now on a much larger scale. On 2 March 1904 he wrote to Durand-Ruel: 'I am far from regretting that I did not send some canvases to you, because the view of the series will have a much greater importance.'

Working in the studio, away from nature, his method of proceeding necessarily changed. Referring in later years to his work at the Savoy Hotel, he commented upon the intense but erratic character of his method as he attempted to keep track of one hundred separate canvases and as he strove to be faithful to the infinite nuances of the ceaselessly changing scene before him: 'Feverishly searching among these starts,' he recalled, 'I would choose one that did not differ too much from what I saw.' The process at Giverny was controlled and his aim was limited, not an open-ended series of matchings but a composed and finite entity that left no room for chance or error. On 15 April, one month before his exhibition, Monet invited Durand-Ruel to Giverny to help him make the final selection, for 'several are merely repetitions and I would be pleased to have your advice'. Working on a single canvas before the motif, his sole occupation was to match what he perceived out there. Away from nature, he shifted from observation to invention. The paintings could no longer be considered in terms of external reference but of internal coherence. Initially, coherence would lodge in the individual work; ultimately, each work was coordinated with the cycle of paintings spread out in his studio. Each painting had to blend or harmonize with, or in some way be accommodated to, its neighbours and the whole. His interest finally rested in the ensemble, as it had earlier with the series of Haystacks, Poplars, Rouen Cathedral, and Mornings on the Seine. And, as with the Poplars, the unified series became identified with the proposed exhibition; in the process the exhibition itself had become a work of art.

The Water-lily Garden

I work constantly, constantly at grips with nature. *Monet in a letter to Durand-Ruel*, 25 May 1918

It must simply be said that of all the painters, it is Claude Monet who observes with the greatest confidence and persistence. Academics in all periods are theoreticians. They have great thoughts and consider the eye a shameful part . . *Octave Mirbeau*, 1912

Following his purchase of the property at Giverny in 1890, Monet began an elaborate programme of improvements to the large garden that stretched before his house. In 1893, he acquired another plot of land just across the road and single railway track that fronted the property. This plot contained a narrow stream, the Ru, that opened into a small water-lily pond. During the first half of the nineties, he constructed a sluice at either end of the pond that enabled him to control the flow and temperature of the water within it, thus making a

receptive environment for the introduction of new, exotic species of water-lilies. At the same time, be built an arched bridge, inspired by Japanese designs, over the narrow west end of the pond (Fig. 21). These were the first in a series of structural and horticultural embellishments that were to continue throughout the succeeding years at Giverny. Enlargements of the pond took place in 1901 and 1910, at which point it was given the elongated oval shape that provided the setting for the large-scale *Nymphéas* decorations of

his last years (Plates 131–2, 140, 143, 146–50, Figs. 20–2 and 24). Similar intense concentration was given to the garden in front of the house (Fig. 19). As many as six gardeners worked full-time to create and maintain an environment that provided a never-ending source of motifs during the last thirty years of his career.

In November 1899, shortly after his return from the initial trip to London, Monet informed Durand-Ruel of that campaign and also mentioned that he had seven paintings of the water-lily basin ready for him. This first group of paintings to explore the pond took the Japanese bridge as its main motif (Plate 127). Following the emphasis upon surface decoration in the Poplars, Rouen, *Falaises*, and Mornings on the Seine series, Monet now returned in these works to the precise geometry and focused perspective of the Metropolitan Museum's Grenouillère painting of 1869 (Plate 29) and the great Saint-Lazare interiors of 1877 (Plate 60), seeking once more to achieve a balanced relationship between perspective depth and surface design. The picture plane is stressed or echoed by the perfectly frontal bridge, which arches symmetrically across the canvas. Beneath it a carefully foreshortened area of water recedes to a central vanishing point and punctures the surface irretrievably. Both surface and depth are surely established but so carefully weighed against each other as to achieve equilibrium. In his first series of Water-lilies, Monet established the air of order and serenity that was to pervade his paintings of the site until his very last years, when, hounded by problems with his eyesight and the miseries of old age, he seemed to lash back at his canvases in a fervour of expressionist colour and touch (Plates 128 and 144–5).

The Japanese bridge paintings were exhibited in 1900. The next three to four years were dominated by work on the Thames series, although Monet found time to complete a suite of paintings of the river at Vétheuil (Plate 120), to which he returned after eighteen years, and to begin an ongoing group of canvases based on the garden in front of his house (Plate 125). In 1903, the year before the London paintings were completed, he crossed the track once more and began a series of works that concentrated almost exclusively on the pond and the reflections within it. The resulting paintings were exhibited in 1909 as a coherent series of forty-eight '*Nymphéas, paysages d'eau*' (*Water-lilies, waterscapes*; Plates 129–30 and 133–4). As with the London series, it was exhibited as a unit, a practice he followed once again in the last exhibited series, the Venice paintings of 1912 (Plates 135–9).

NYMPHÉAS, PAYSAGES D'EAU

The *Paysages d'eau* state quite clearly Monet's retreat from the world into the realm of contemplation, reverie, peace, and delight that the water-lily garden was created to provide. The lifelong process of observation and reflection reaches a pure and harmonious state in these works. In the paintings of 1903 and 1904, the water area covers about seven-eighths of the picture surface, while a strip at the top represents the bank or hanging foliage (Plate 129). In those of 1905 to 1908 only the water surface is depicted (Plates 130 and 133–4). Although Monet developed several distinct compositional groupings within the series, the same elements were disposed within each group. The foreshortened ovals of the lily pads are clustered into floating islands on the receding surface of the water, the clusters organized into horizontal strata parallel to the top and bottom edges of the frame. Within the format, a countersystem of large, amorphous shapes—hovering, less distinct—represents the reflections of trees and sky beneath the water surface. These shapes represent depth, and yet they too participate in the affirmation of the picture plane. Subdued in tone but uniformly thick in pigment quality, they create a freeform, understated, yet insistent surface screen that harmonizes with the regular strata of the water-lilies.

In these carefully ordered rectangles, Monet achieved a high degree of decorative calm and equilibrium. And yet his aim and accomplishment were never more comprehensive. Within the small-scale format, he reached out for a world beyond his grasp, a shifting and indeterminate realm of trees, clouds, and sky known only through shimmering reflection. He depicts that natural world upon the canvas and transmits something of its temporal and spatial continuity to the artificial world of the series. Each canvas in the series represents a frame or slice of time that enters into duration when all the canvases are seen together. In spatial terms, so strong and so impeccable is Monet's handling of the receding plane of the water that the frame does not seem strong enough to contain it. Perspective foreshortening does not remain safely behind the picture plane but seems to expand forward and outward as the lily pads are cut by the edges at the bottom and sides. The illusionistic domain of the painting seems to overleap its boundaries and enter into the temporal and spatial world in which the observation of the artist took place and in which we reflect upon these discrete but uncontrollable paintings.

Monet used the 'medium' of foreshortening to expand, by implication, the physical limits of painting, to suggest its participation in the temporal flow of the series. In addition, within the separate canvases themselves, he directed foreshortening to play still another role that extended the possibilities of painting. Through it, he gave to the canvas field a relative life; he established a perception of the canvas as oriented not only vertically—as it was hung on the wall—but, also, as if it itself was foreshortened, adapted to the spatial thrust of the illusionistically receding lily pond painted upon its surface. To explain Monet's effort we must consider his work in relation to other manifestations in painting at the beginning of the twentieth century.

The exploration of the nature of painting had been one of the root inquiries of Monet's Impressionism. The relation between the matching of appearances and the making of a painting concerned him during the formative years of the 1860s, and it was to remain central to his investigations throughout his life. It was an inquiry that was equally vital to the career of Cézanne, and it continued to be a major issue

when a new generation of painters appeared after 1900. In the first decade of the century, Matisse, Picasso, and Braque were entering into a new phase of research, in which the respect for appearances was often mitigated by a concern for structures and essences beyond the surface of perceived reality. The Cubists, in particular, conceived of their investigation of physical structures in terms of their ideas about the structure of painting; a bottle or a body was broken down into lines and planes and arrangements of light and dark, i.e., in terms of elements of painting rather than in ways that might seem more appropriate to depicting the appearances of those objects themselves. Matisse, of course, retained appearances, local colour, the surfaces of things, but he, too, made his art out of the adjustment of such traits to a structure of colour and space that belonged to painting. Matisse's still-lifes done around 1908—contemporaneous with the last paintings of Monet's *Paysages d'eau* series—are instructive (Fig. 23). They are pioneering works by a member of a new generation, but they bear close similarities, for all their differences in appearance, to Monet's canvases in terms of their approach to the structure of painting. In his still-lifes Matisse would arrange a table-cloth so that it was parallel to the picture plane and angled into depth at one and the same time; objects, similarly, were developed as standing free from and adjusted to the cloth. Statements about position in space are clearly enunciated and confused as if in a single utterance.

The Water-lilies are no less inventive in their treatment of the relationship between illusionism and decoration, and in one key respect they go beyond Matisse. The paint on Monet's canvases is uniformly thick, the lily pads are carefully registered in horizontal strata, the reflections are organized into loosely rectilinear compartments; thus these elements are identified in tangibility and organization with the plane of the canvas. At the same time, the foreshortening of the lily pads and water surface is sure and forceful. If they are foreshortened and if they are identified with the canvas, then when we read foreshortening it is as if the canvas itself is foreshortened, tilting away at the precise angle of the receding plane of the water.

Monet consolidated this effect when, in 1905, he eliminated the strip of bank and foliage from the upper portion of his canvases and concentrated on the unbroken water surface alone. By running the water off evenly on all four edges of the canvas, he fully affirmed the coincidence of water surface and canvas surface. And in this respect he proceeded with a logic that took him beyond the young Matisse, for the latter pulled back from taking that step. In his still-lifes Matisse reminds us, by terminating the table-cloth short of at least one edge of the canvas, that the cloth is not coterminous with the picture plane but that it is, after all, safely ensconced in the fictional world of the picture. Despite this considerable difference in interpretation between the two artists, both Matisse and Monet may remind us with these works that a major effort of twentieth-century art, introduced at the very beginning of the century, is not so much an investigation of flatness—for the most part that was given by the year 1908—but an inquiry into new kinds, modes, and possibilities of illusionism.

The exhibition of 1909 achieved its full meaning as a unified whole, and several critics deplored the imminent dispersal of the paintings to the private precincts of individual collectors. They called for the preservation of the series as an unbroken ensemble. The idea of defeating the vicissitudes of the market place, of creating a permanent witness to Monet's comprehensive vision, had been hovering around the water-lily pond since the late 1890s. Now in 1909, with the appearance and certain disappearance of the Water-lilies ensemble, the idea was renewed in the press by Roger Marx, who attributed to Monet the dream of a room encircled by *Nymphéas* paintings that would create the sense of an 'endless whole', a realm of peace and contemplation, a respite from the world of affairs. In 1914, in the midst of the anguish accompanying his son Jean's death in February and the outbreak of the war, and with the urging of his long-time friend Clemenceau, Monet set to work on the paintings that were ultimately to be installed in two oval rooms, expressly designed for the purpose by the French government according to Monet's plans, in the Orangerie of the Tuileries in 1927 (Plates 146–50). For the purpose he had a new, large studio built at one end of his garden. By the time it was completed in 1916, the project was well under way. Specially prepared large canvases were placed in the new building, mounted just off the floor on movable easels, and disposed about the periphery of the room so that he might work at them in a setting that was as close as possible in size and character to their envisaged destination (Fig. 25).

From 1914 to about 1923, when the Orangerie canvases were essentially completed, Monet worked at numerous other paintings depicting varied aspects of the water-lily garden—in addition to focused views of the pond itself (Plates 131, 140 and 143), there are paintings of wisteria, weeping willows, the Japanese bridge, and the variegated flora that surrounded the water area (Plates 128, 141–2 and 144–5). Almost 150 canvases remain, many of them undoubtedly executed as studies for the *Nymphéas* cycle. The Cleveland canvas (Plate 131), nearly fourteen feet wide (the size of the individual panels that are joined together in the Orangerie) has the character of the late murals and points up their close relationship to the small-scale paintings shown at Durand-Ruel's in 1909. The increased size of the canvas permitted Monet to explore a more extended area of the pond and provide a greater breadth of sky reflected in the water (cf. Fig. 20). The lily pads float apart from each other like distant constellations in an expanding universe of paint. The experience of depth, so carefully nurtured in the earlier, smaller canvases, is reaffirmed but partly overpowered by the quality of lateral extension. The suggestion that the water flows outward and forward, potentially containing ourselves and our reflections, is abetted once again by the continuous foreshortening of the lily pads; clusters of pads near the lower corners, often cut by the frame, seem directed out beyond the edges of the canvas, as if the enlarged format is still too small to contain them.

According to Monet's own testimony, it was the encouragement of Clemenceau and the idea of the *Nymphéas* decoration

that kept him going from 1914 until his failing eyesight—he complained of difficulties with his sight as early as 1908, and the formation of cataracts on both eyes was diagnosed in 1912—necessitated an operation on one eye in 1922 (see Fig. 28). During those years the acuity of his vision was altered. According to Thiébault-Sisson, who visited Monet in 1920 when the cataracts were well advanced, the artist's ability to see details of colour and form was reduced, but his perception of atmospheric and tonal relations remained intact and he became more responsive to stronger accents of colour. The changed character of his vision accorded well, however, with the larger size of the canvases on which he worked, as the gauge of his brushwork was appropriately expanded. The detailed touch of the earlier Water-lilies series is not apparent in the works of before and after 1920, as Monet exploited the defect in his vision in accordance with the vigorous task of recording his surroundings in an enlarged framework. And yet as one looks at the vast late *Nymphéas* canvases, one cannot be sure of the relationship between eyesight and vision, for many of these works are as subtle in colour and as finely modulated in value as all but the most rarefied paintings from his earlier career. If the eye was failing him, his vision of a close-gauged harmony of subtly blended colours remained. Inevitably we must conclude that it came from within as well as from without—a lifetime of awareness, of accumulated experience, enabling him to strike a balance between visual power and artistic will.

After his operation, from perhaps late in 1923 until 1925, Monet returned to the Japanese bridge as his primary motif (Plate 128). The bridge no longer had the neat, spare form of 1900; now a trellis hung with wisteria provided a heavy canopy over the bridge, and the leaves cloaked the uprights in a thick mantle of green that made the structure seem almost one with the floral and vegetal abundance of the pond and its surrounds (Figs. 20 and 21). Its appearance was recorded both before and after the operation (Plate 145); in both campaigns clots of heavy pigment coat the surface and provide a seeming equivalent of the lavish vegetation. The canvases of 1924 and 1925 reach a crescendo of colour, of sharply clashing reds and greens, oranges and yellows that convey the sense of a savage yet ecstatic response to both the despair and the hopes that a partial renewal of vision had brought. In these works Monet continued to explore and extend the world of painting, creating an impassioned expressionism that carried further the achievement of earlier artists, of van Gogh, the Fauves, the artists of the Brücke and Blaue Reiter. He had moved in this last moment of his career in the same direction as had Cézanne (whose intense inquiry of nature had earlier been matched by no one but Monet) in the final phase of his artistic life. The Japanese bridge canvases, like the last paintings of Mont Sainte-Victoire (Fig. 30), transform the observation of nature into ecstatic visions.

The expressive force of the vibrant paintings of Monet's last decade probably derives in good part from his anguish over the failing powers of his old age, exacerbated in the main by the continuing debility of cataract—both before and after his operation—and generated, as well, by a lifetime's practice in fury and exasperation at his inability to render what he perceived and felt, even when his physical powers were marvellously intact. They are works that build, too, upon earlier paintings—the vibrant depictions of flower gardens at Argenteuil, the fields of tulips and poppies in Holland and Giverny, the scintillating rock surfaces of the Creuse Valley, the fiery sunset skies of Venice and London, and upon the years of coping in paint with the multi-hued brilliance and exuberance of the flower garden ranged before his house in Giverny. They bring to a climax an expressionist vision and vocabulary that he had formed during the preceding fifty years.

But we must return as well to that other side of his art that is monumentalized in the two rooms of the *Nymphéas* cycle in the Orangerie (Plates 132 and 146–50). These works, too, have their antecedents in Monet's earlier art, in the dominant aspect of that art which embodies painstaking perception and a reflective transformation of nature's appearances. If one was to assume that the flagrant expressionism of the late Japanese bridge paintings was due to defects in Monet's eyesight, how then is one to view the late Water-lilies? For they, unlike the paintings of the bridge, present a subtly shaded rarity and structural clarity that accords with the major achievements of his past. One must conclude that, whatever the very real difficulties with his sight, he proceeded with the assurance born of a lifetime of practice and understanding. Monet's eyesight may have been impaired—and there can be no doubt of that—but his vision, that vision that had been made internal through a lifetime of outward inquiry, remained in perfect control to the end.

The two oval rooms of the *Nymphéas* cycle in the Orangerie were officially opened to the public on 16 May 1927, five months after Monet's death. Installed according to his design, both rooms attempt to recapture the natural setting and experience of the water garden, but with one essential exception. Whereas Monet circles the pond in order to view it from vantage-points along its periphery, in the rooms of the Orangerie the pond encircles us. It is as if the eye of the beholder generates the beauty and the consuming fullness of that world that occupied Monet's thoughts and days during the last twenty-five years of his life. The panels, six and a half feet high, the lower edge placed about two feet above the floor, range from twenty to fifty-five feet in length. In both rooms the paintings are arranged with respect to the directions of the compass; in the second room to which one penetrates (Plate 147), the panel to the east represents the beginning of the day, that to the west, dusk (Plate 150). In the first room, through which, as Seitz has pointed out, one must retrace one's steps in leaving, the last panel before one's eyes is at the west end and depicts sunset. East and west, morning and evening, the decoration attempts to present the wholeness of time and the coordinates of space.

By comparison with the earlier series, the cycle of time is generalized and integrated with the spatial continuity of the setting. In the second room, in particular, it is as if a panoramic

day has unfolded (Plates 147 and 148), ushered in by the dawn—a panel fifty-five feet wide, the two flanking trees so far apart that they almost escape our peripheral awareness—passing through the more cadenced panels to north and south (Plate 149), and ending in the enclosing security of evening (Plate 150). The Orangerie decoration presents a lucid whole, an intersection of time and space within the ordered realm of the two oval rooms. It is the product of a goal of unity, and in achieving that goal it sums up and denies the experiments of the series. In the Orangerie the viewer is invited to respond to the murals, in their scale and placing, as one would to the actual setting outdoors; the paintings, surrounding one, are like nature itself. This reading of the experience is retained even when one goes up close to the paintings and becomes aware of their resistant surface and the artifice of the brushstrokes, for then one also becomes newly cognizant of lateral expanse, of a world that stretches to either side and defines one's horizon. The murals of the Orangerie provide a unity of place and continuity of time that differ in nature from the series.

In the *Paysages d'eau* of 1903 to 1908 (Plates 129–30 and 133–4), the spatial quality of each canvas, which makes it seem to flow beyond its borders, was linked to the temporally extended character of the series. Spatial and temporal expansion were joined in a unity that received an extra dimension through implication. Each canvas within the series is physically finite, abstracted from nature; the series is made whole by the receptive and projective action of the viewer. The murals of the Orangerie synthesize and encompass; they are a whole. The series, composed of moments, reaches towards completeness; in the strain between moments (the separate paintings) and the idea of an enduring entity, much of the tension and grace of the series is expressed. The series presents a unified group of individual paintings, a potential whole; the Orangerie murals present an achieved whole. What they take away from the exercise of the imagination, they compensate for in their encompassing breadth and in their all-inclusive survey of the world and its reflections. They are, indeed, a last statement, a fulfilment: they offer a seamless unity, an expression of peace, observation that has been subsumed by reflection, a contemplation from within on the wholeness of the world perceived.

1. *Still-life with Bottle, Carafe, Bread and Wine.* About
1862. 16 × 23½ in. Mr and Mrs Leigh B. Block, Chicago

49

2. *The Seine Estuary at Honfleur.* 1865. 35¾ × 59½ in.
Norton Simon Foundation, Los Angeles

3. **The Pavé de Chailly.** About 1865. $38\frac{7}{8} \times 51\frac{5}{8}$ in. Private
Collection, Switzerland

4. ***The Quai du Louvre.*** 1867. $25\frac{3}{4} \times 36\frac{1}{2}$ in. Gemeente-
museum, The Hague

5. *The Garden of the Princess.* 1867. $36\frac{1}{2} \times 24\frac{5}{8}$ in. Allen Memorial Art Museum, Oberlin College, Oberlin, Ohio

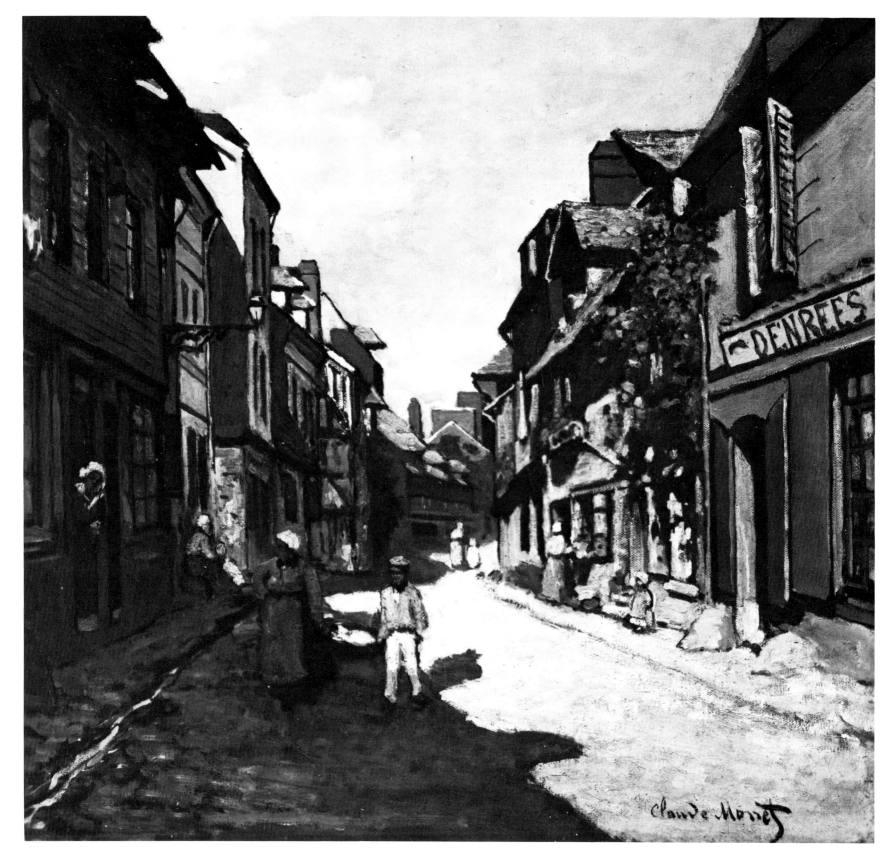

6. *Rue de la Bavolle, Honfleur.* 1864. 23 × 25 in. Kunst-halle, Mannheim

Opposite (page 55): 7. *Rue de la Bavolle, Honfleur.* 1864. 22¼ × 24½ in. Museum of Fine Arts, Boston

54

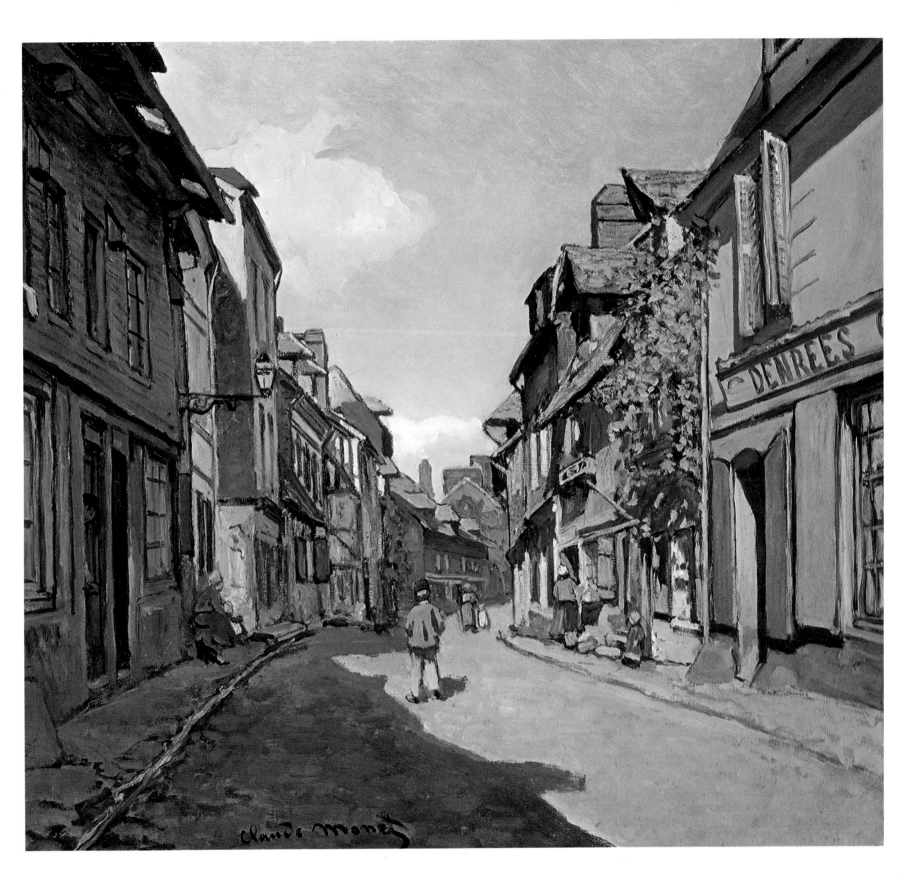

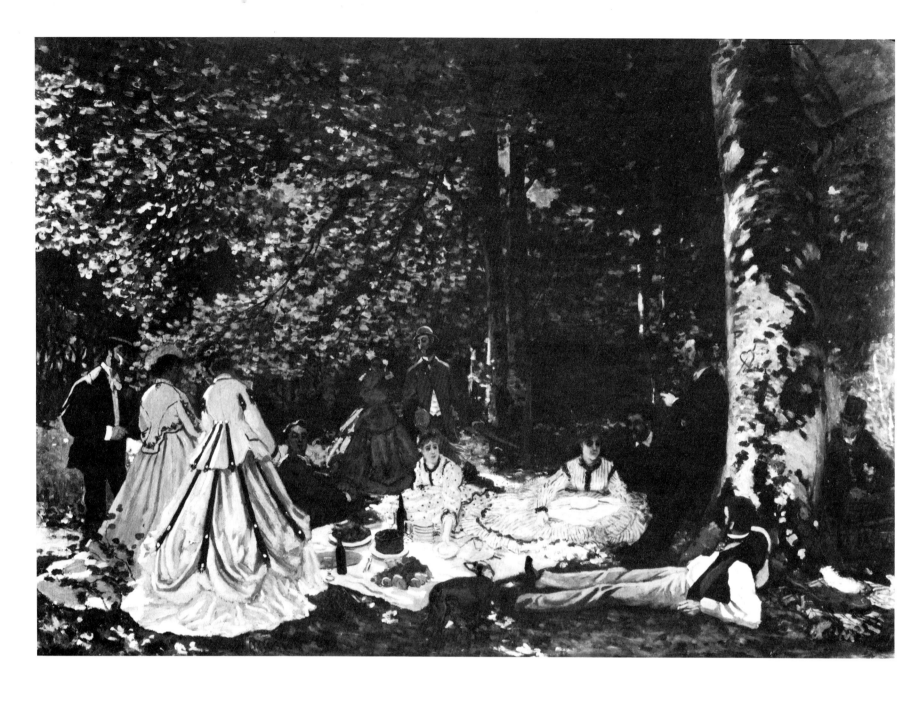

8. *Le Déjeuner sur l'herbe.* 1865–6. $51\frac{5}{8} \times 71\frac{7}{8}$ in. Pushkin
Museum, Moscow

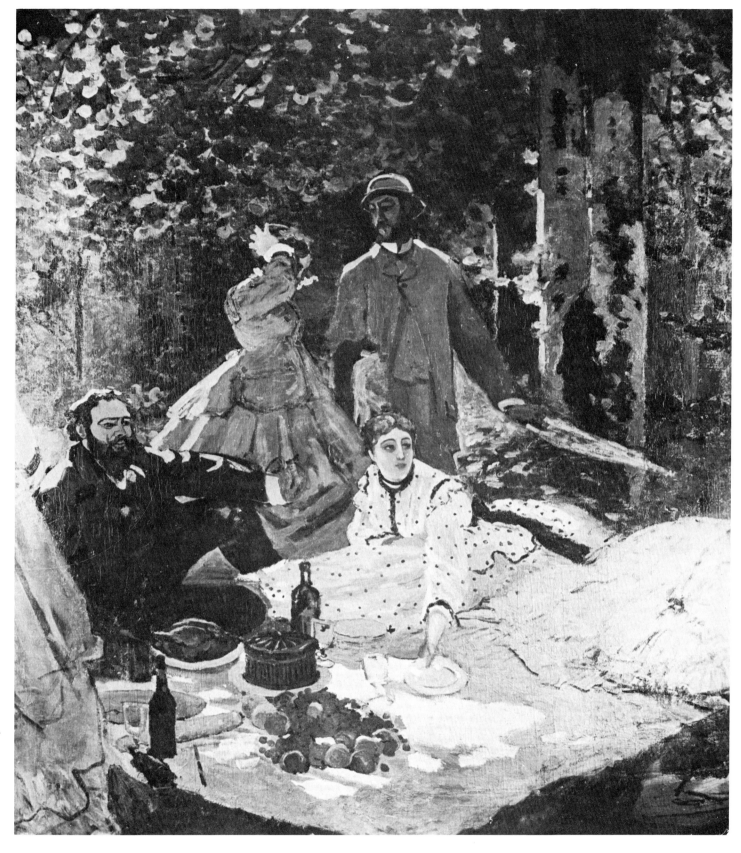

9. *Le Déjeuner sur l'herbe*, central section. 1865–6. 98½ × 86⅛ in. Private Collection, Paris

Overleaf (page 58) : 10. *Le Déjeuner sur l'herbe*, left section. 1865–6. 166 × 58½ in. Musée du Louvre, Paris (Jeu de Paume)

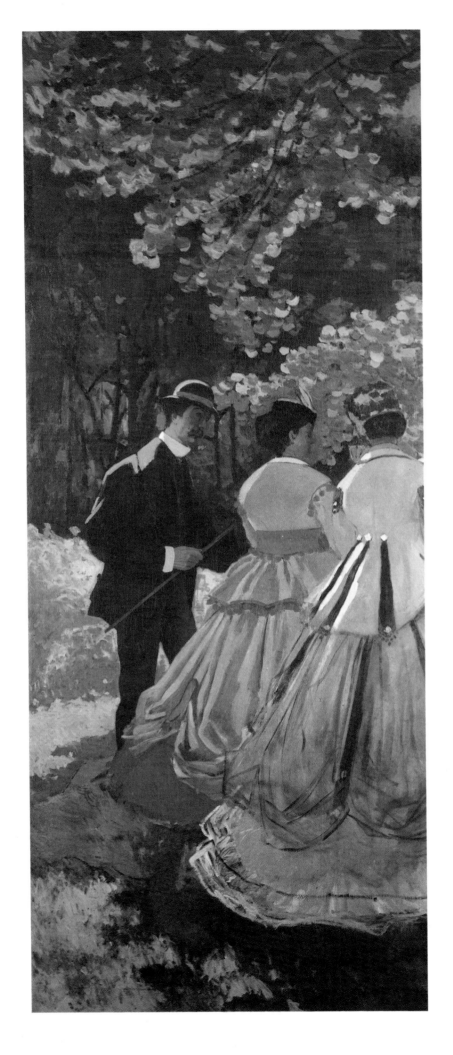

58

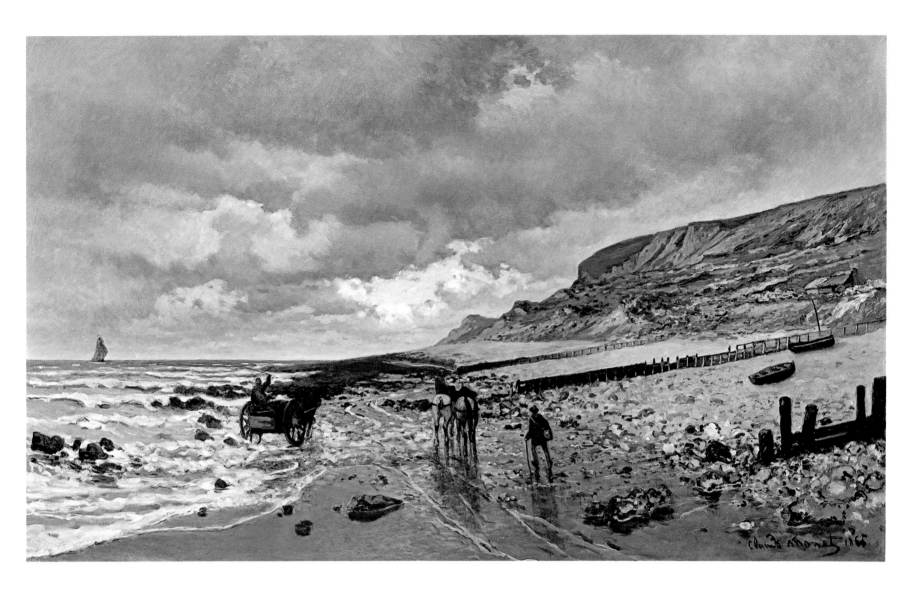

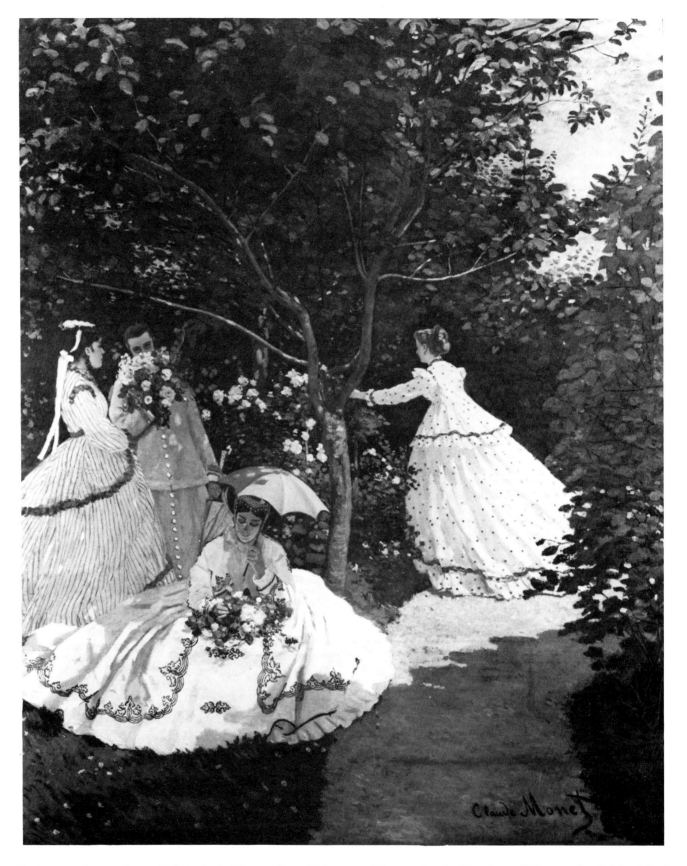

Previous page (page 59): 11. **Pointe de la Hève at Low Tide.** 1865. 35¾ × 59½ in. Kimbell Art Museum, Fort Worth, Texas

12. **Women in the Garden.** 1866–7. 101⅝ × 82½ in. Musée du Louvre, Paris (Jeu de Paume)

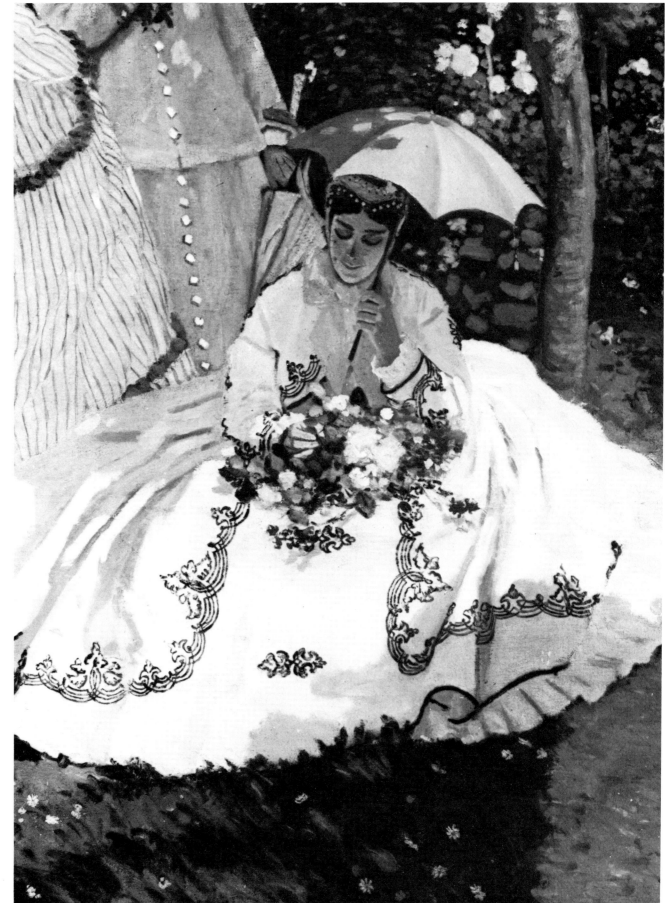

13. Detail of Plate 12

Overleaf (page 62): 14. **Ice-floes on the Seine at Boug-ival.** 1867. $25\frac{3}{4} \times 32\frac{1}{8}$ in. Private Collection, France

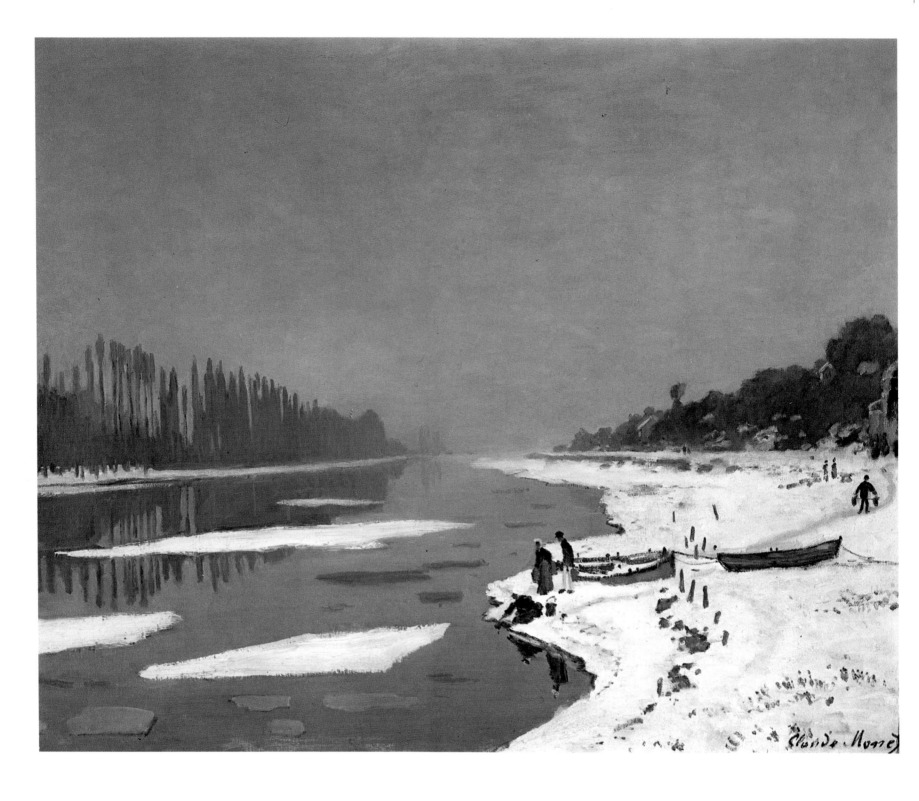

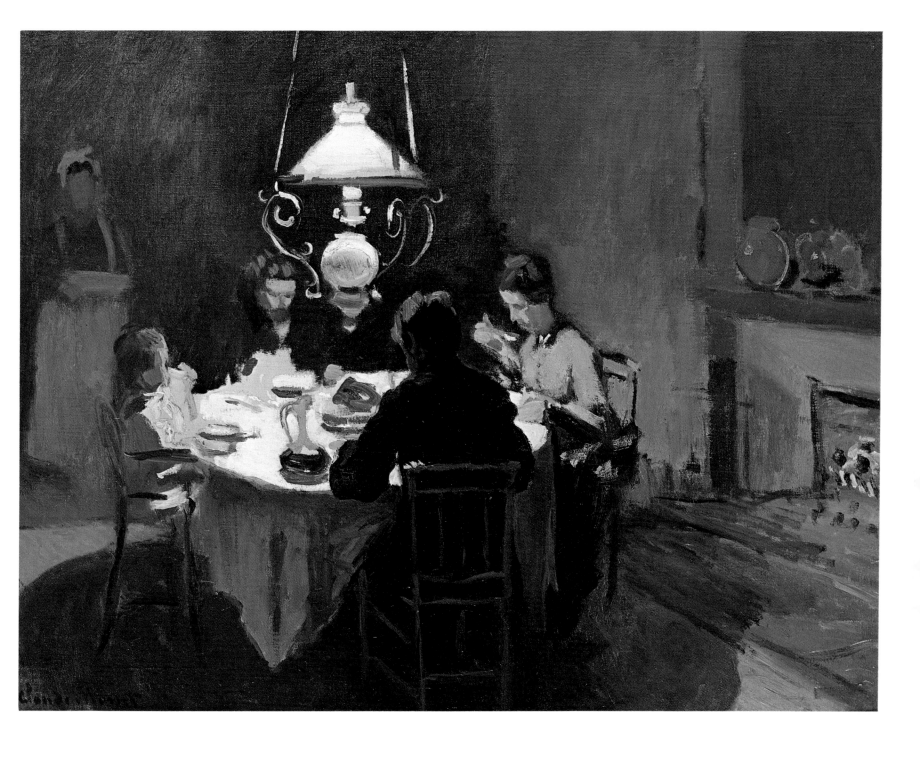

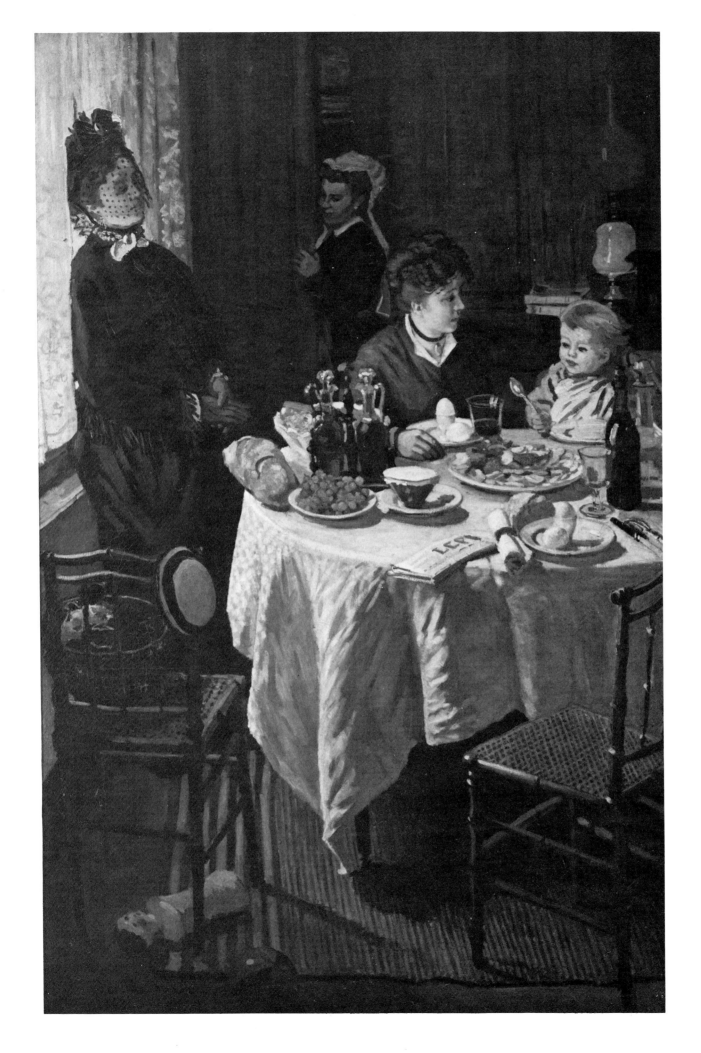

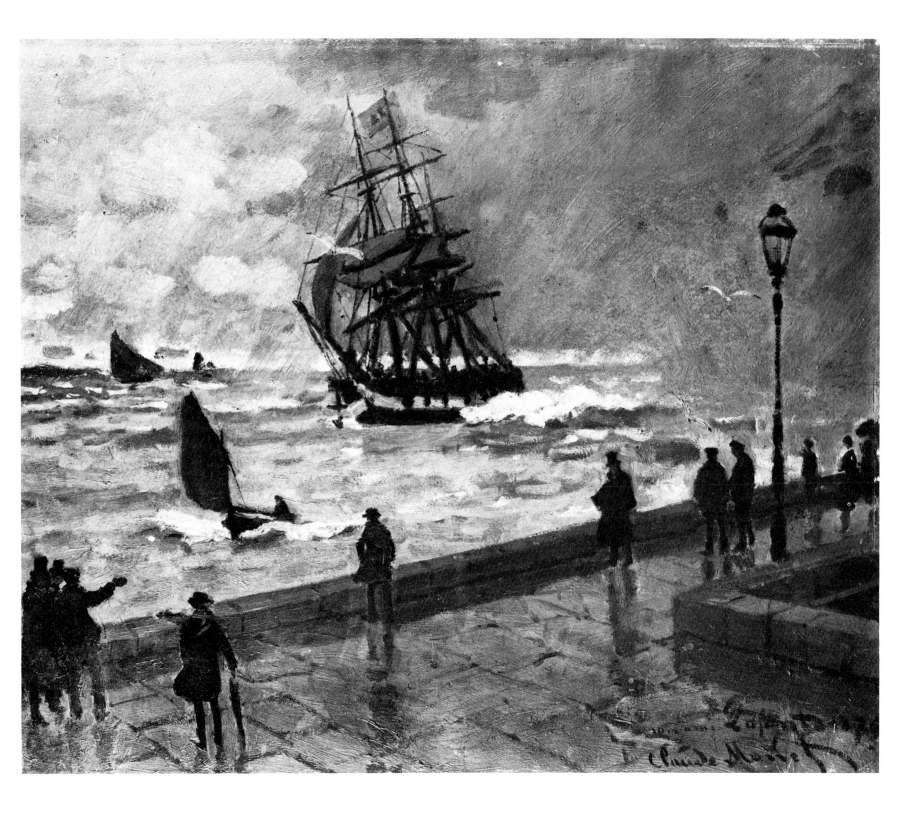

17. ***The Jetty of Le Havre in Bad Weather.*** 1867.
$19\frac{7}{8} \times 24\frac{1}{4}$ in. Private Collection, Switzerland

65

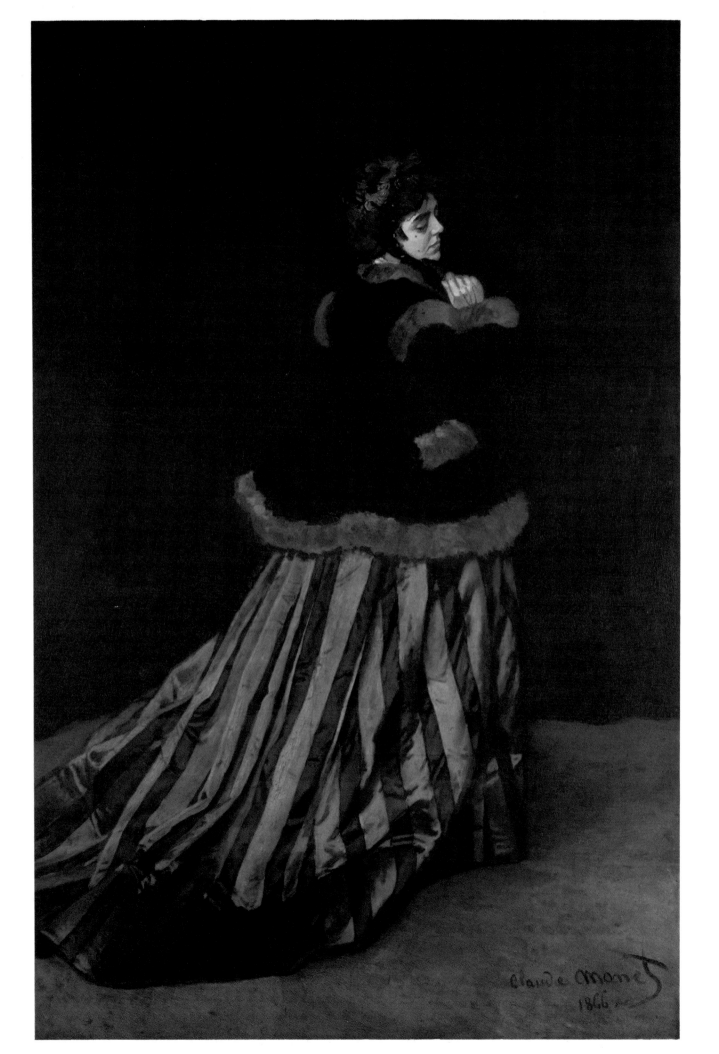

Opposite (page 66): 18. **Ca-mille.** 1866. 91¾ × 60 in. Kunsthalle, Bremen

19. Detail of Plate 18

20. ***Sainte-Adresse.*** 1867. $22\frac{5}{8} \times 31\frac{3}{4}$ in. F. and P. Nathan,
Switzerland

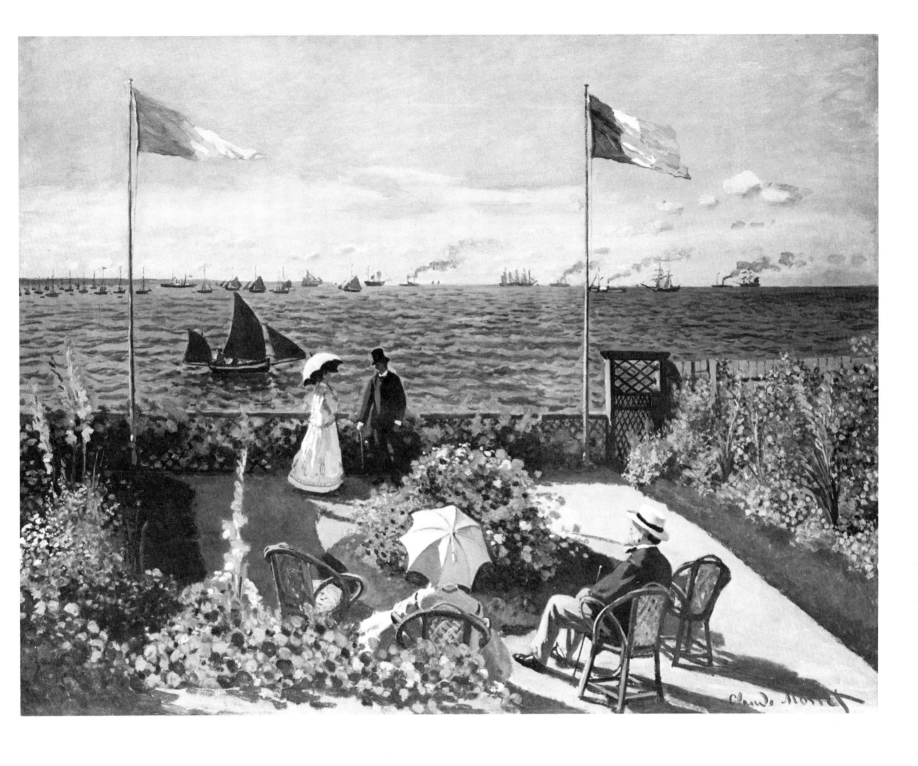

21. *Terrace at Sainte-Adresse.* 1867. $38\frac{5}{8} \times 51\frac{1}{8}$ in. Metropolitan Museum of Art, New York

22. ***The Magpie.*** 1869. $35\frac{3}{8} \times 51\frac{5}{8}$ in. Private Collection, France

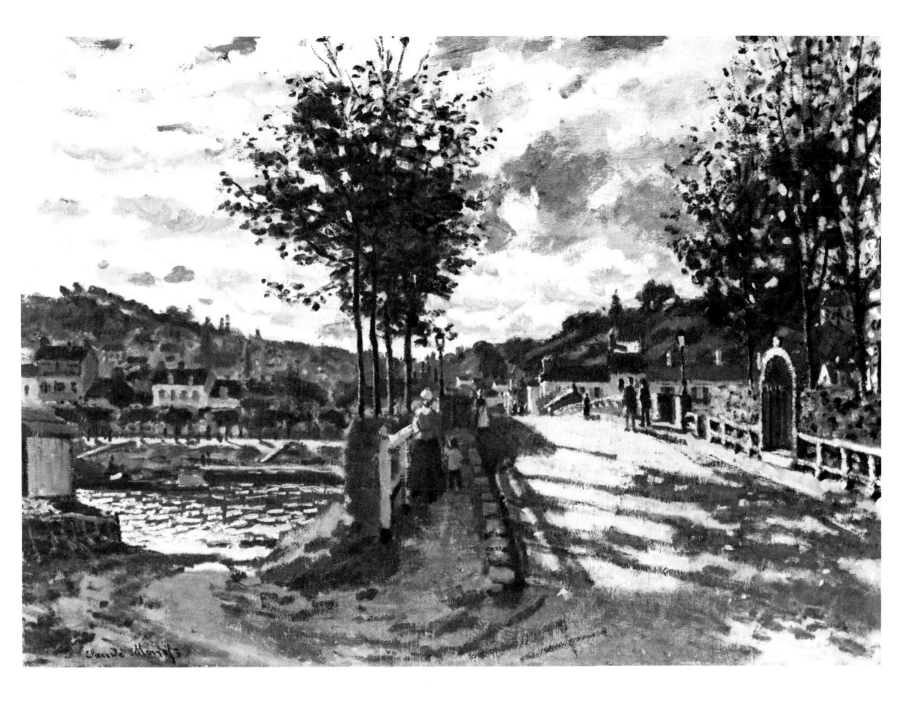

23. ***The Bridge at Bougival.*** 1869–70. $25\frac{1}{4} \times 36\frac{3}{8}$ in. Currier
Gallery of Art, Manchester, New Hampshire

24. Detail of Plate 25

Opposite (page 73): 25. **The River.** 1868. $31\frac{7}{8} \times 39\frac{1}{2}$ in. Art Institute of Chicago

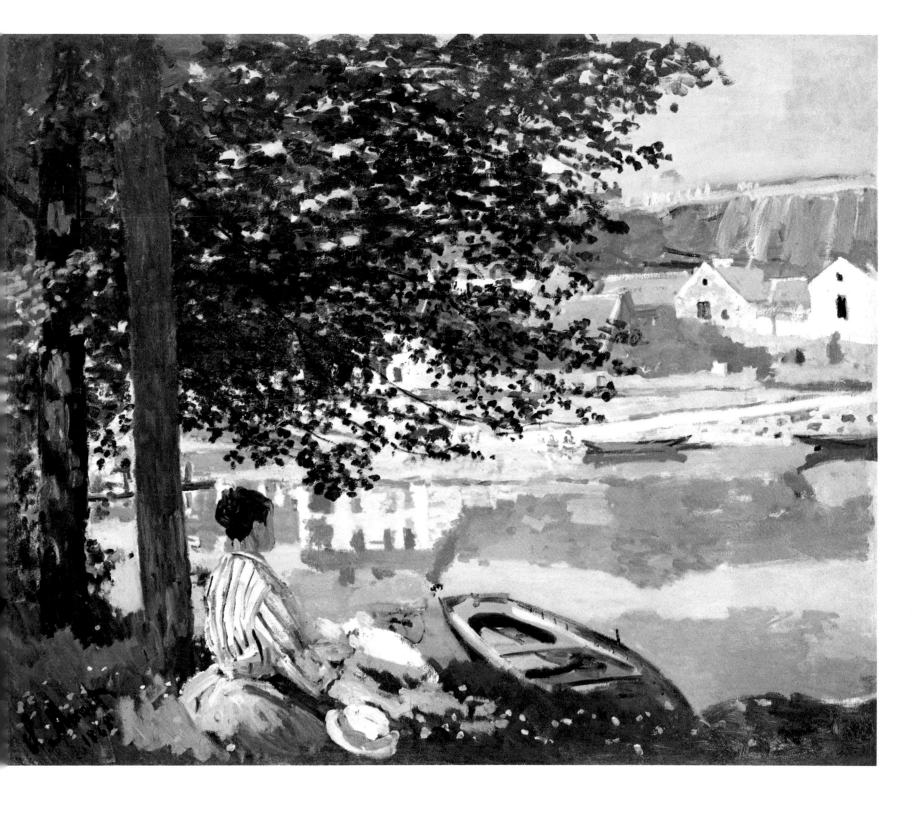

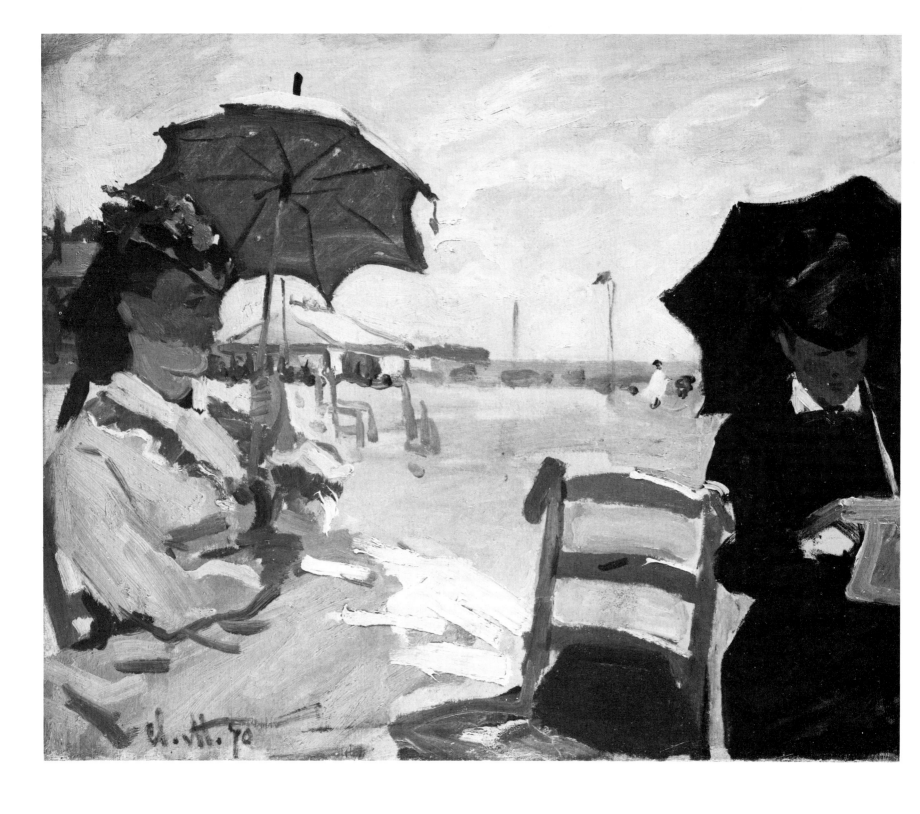

26. *The Beach at Trouville.* 1870. $15\frac{1}{8} \times 18\frac{1}{4}$ in. National
Gallery, London

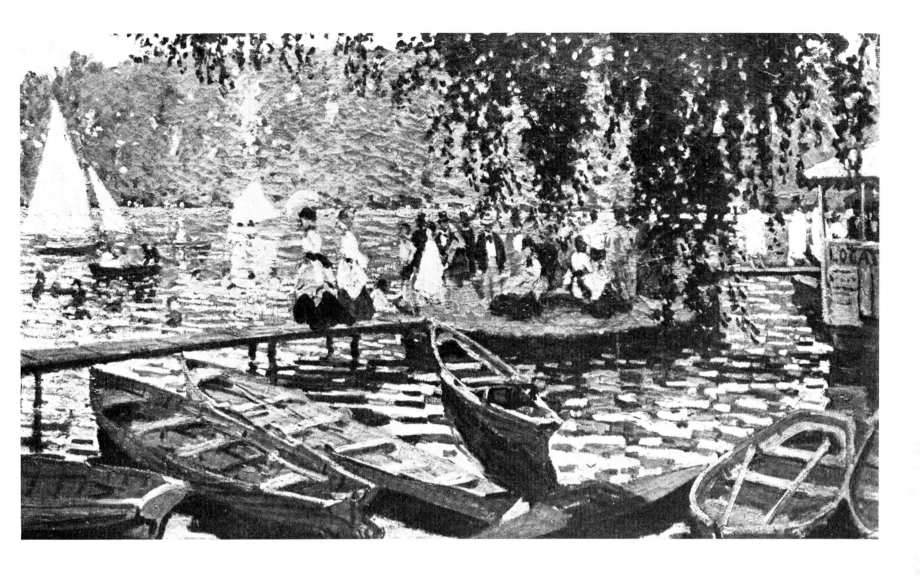

27. **La Grenouillère.** 1869. Present whereabouts unknown

Overleaf (page 76) : 28. **The Road to Louveciennes, Snow Effect.** 1870. $21\frac{7}{8} \times 25\frac{3}{4}$ in. Private Collection, Chicago

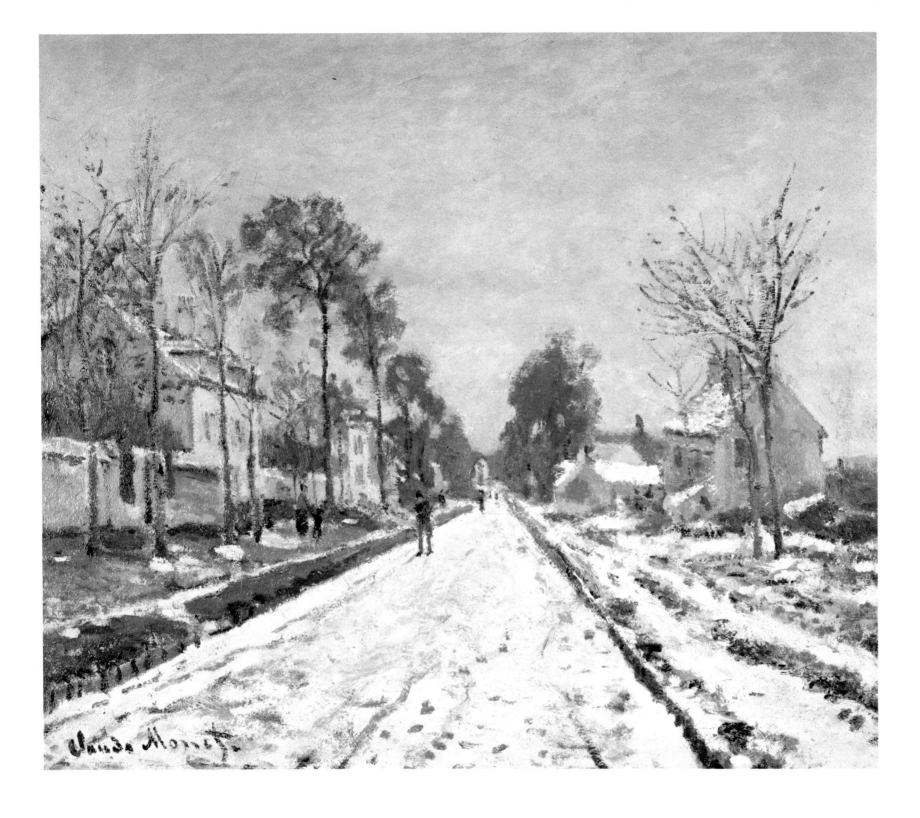

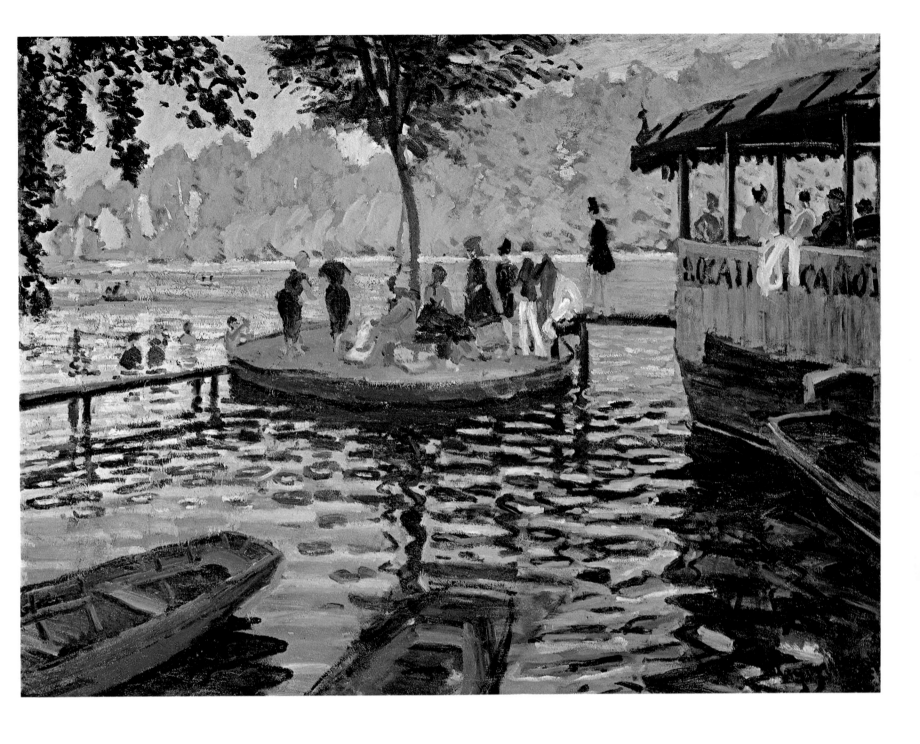

Previous page (page 77) : 29. **La Grenouillère.** 1869. $29\frac{3}{8} \times 39\frac{1}{4}$
in. Metropolitan Museum of Art, New York 30. Detail of Plate 29

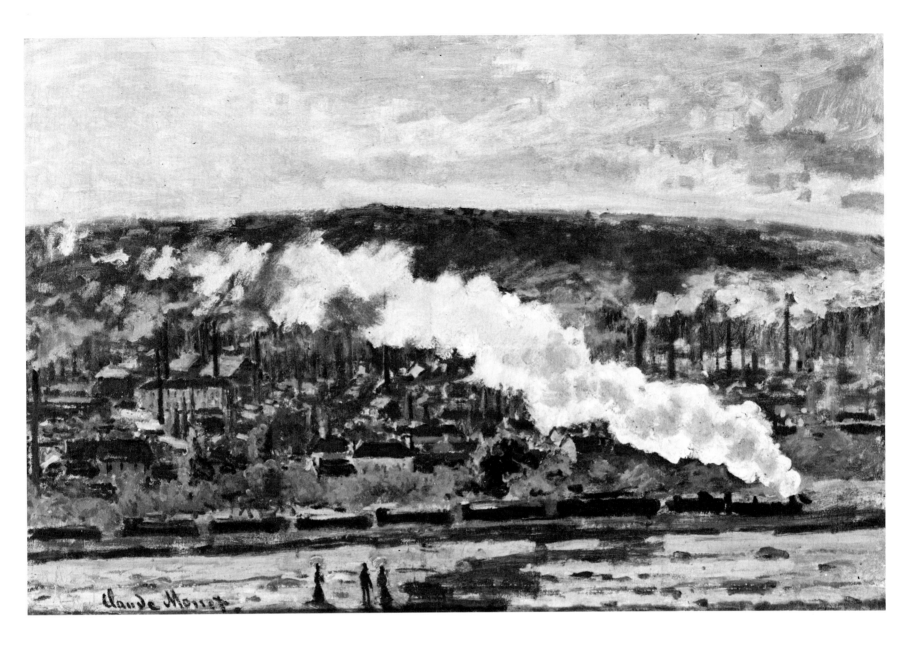

31. *The Train.* 1872. 18⅞ × 29⅞ in. Kemeys-Pennington Mellor Trust, London

Overleaf (page 80): 32. *The Thames below Westminster.* 1871. 18¼ × 28½ in. National Gallery, London

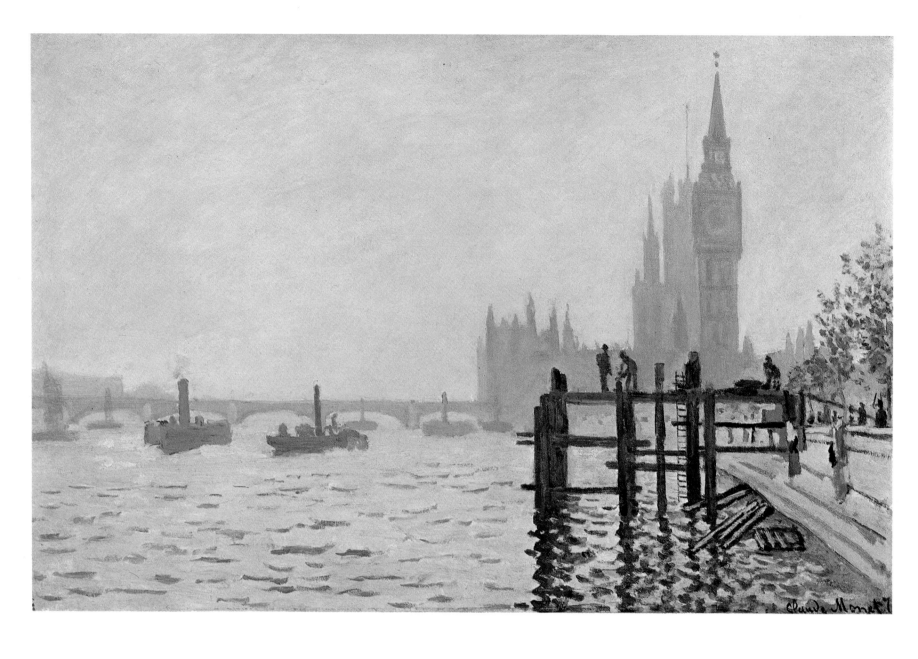

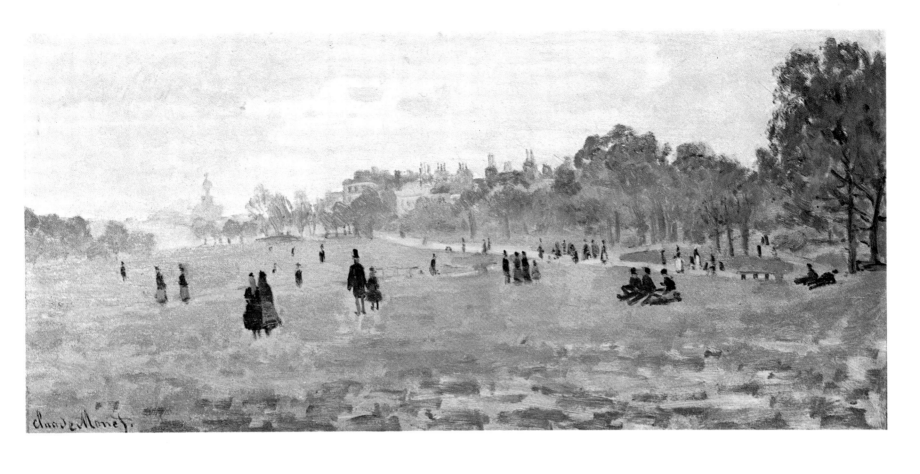

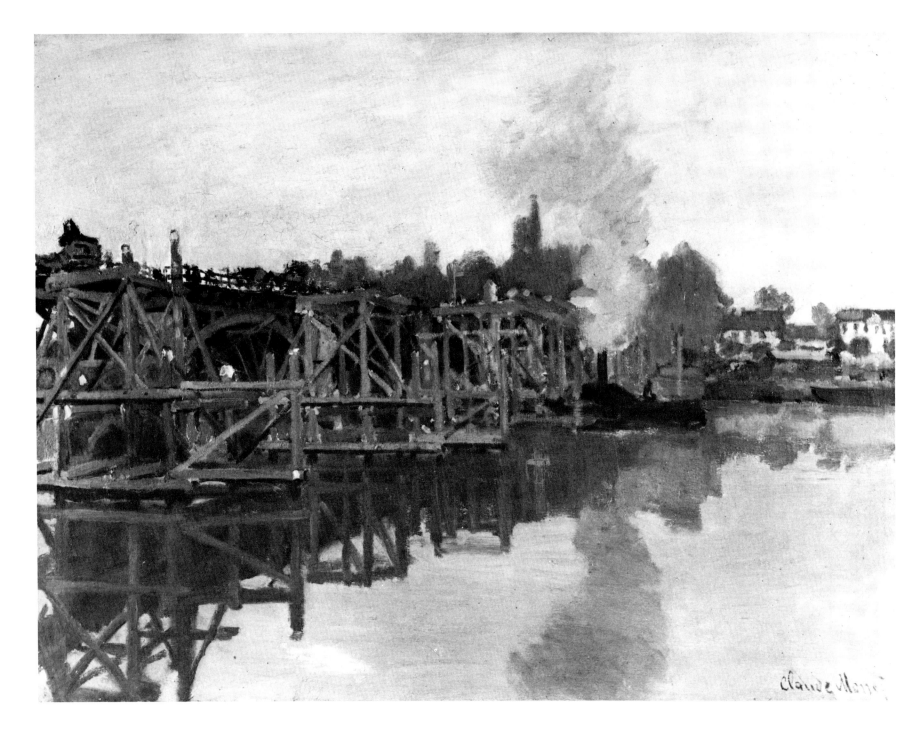

Previous page (page 81): 33. **Green Park.** 1871. $13\frac{1}{2} \times 28\frac{5}{8}$ in. 34. **Argenteuil, the Bridge under Reconstruction.** 1872.
Philadelphia Museum of Art $23\frac{3}{8} \times 31\frac{3}{8}$ in. Lord Butler, Cambridge

82

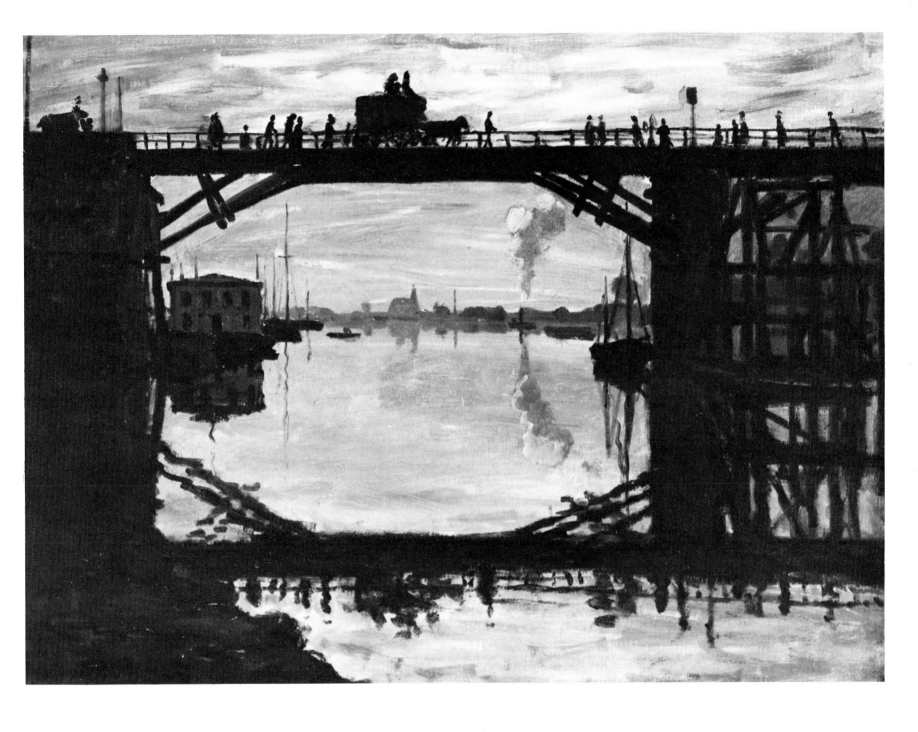

35. ***The Wooden Bridge.*** 1872. $21\frac{1}{4} \times 28\frac{3}{4}$ in. Private Collection, Switzerland

Overleaf (page 84) : 36. ***Zaandam.*** 1871. $18\frac{3}{8} \times 28\frac{1}{2}$ in. Musée du Louvre, Paris (Jeu de Paume)

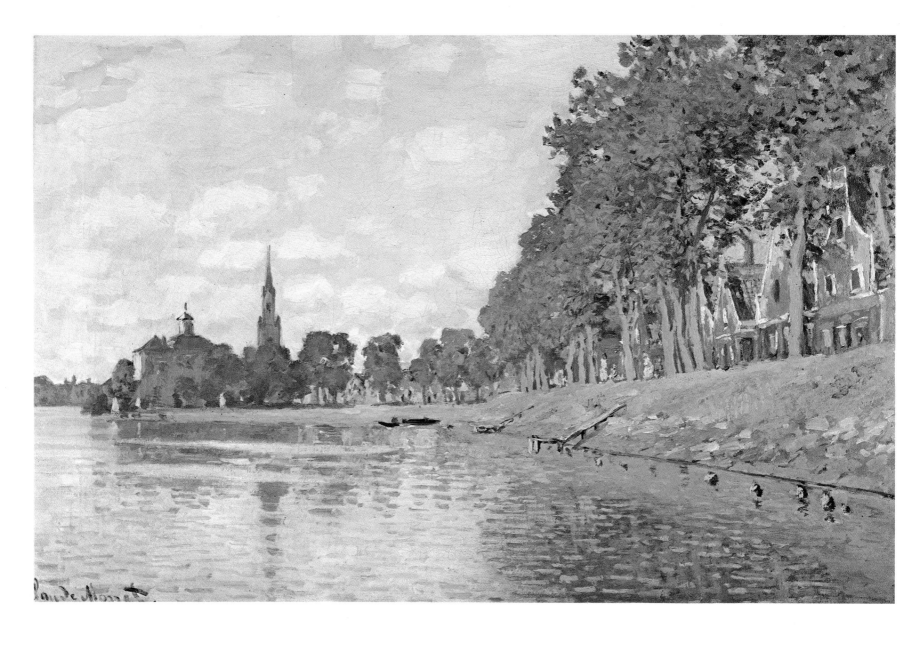

84

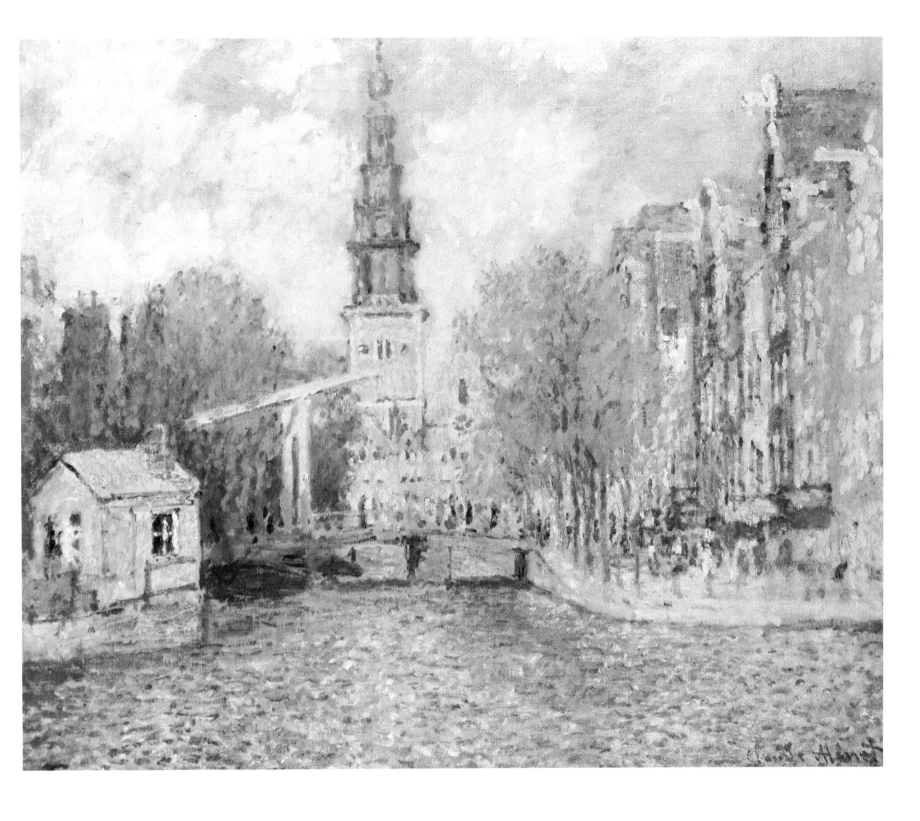

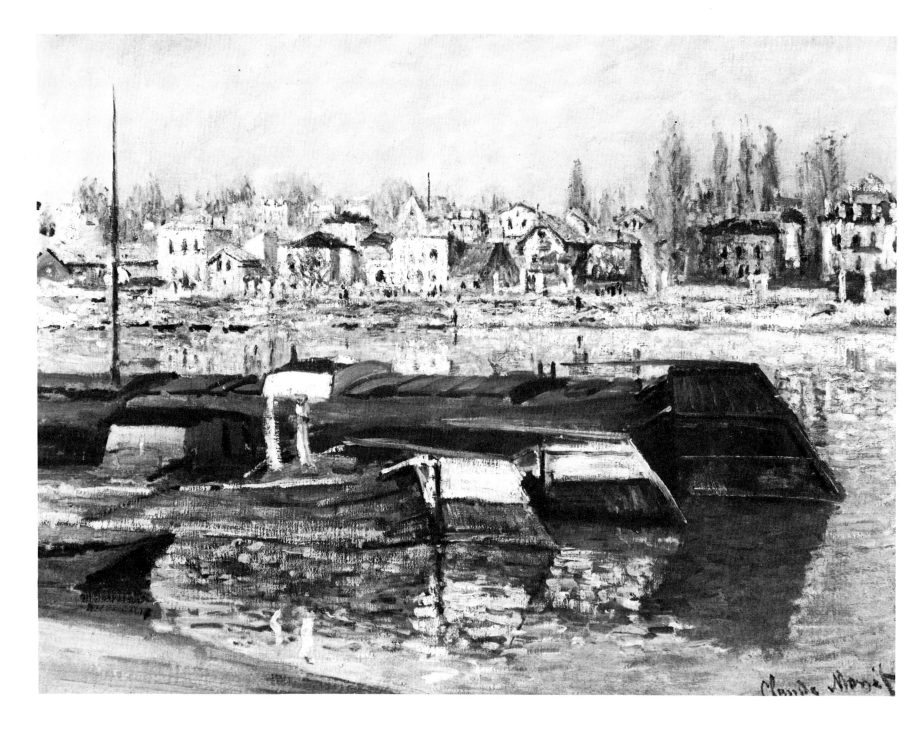

Previous page (page 85) : 37. **The Zuiderkerk at Amsterdam.** About 1874. $21\frac{1}{2} \times 25\frac{3}{4}$ in. Philadelphia Museum of Art

38. **The Seine at Asnières.** 1873. $21\frac{5}{8} \times 29\frac{1}{8}$ in. Private Collection, France

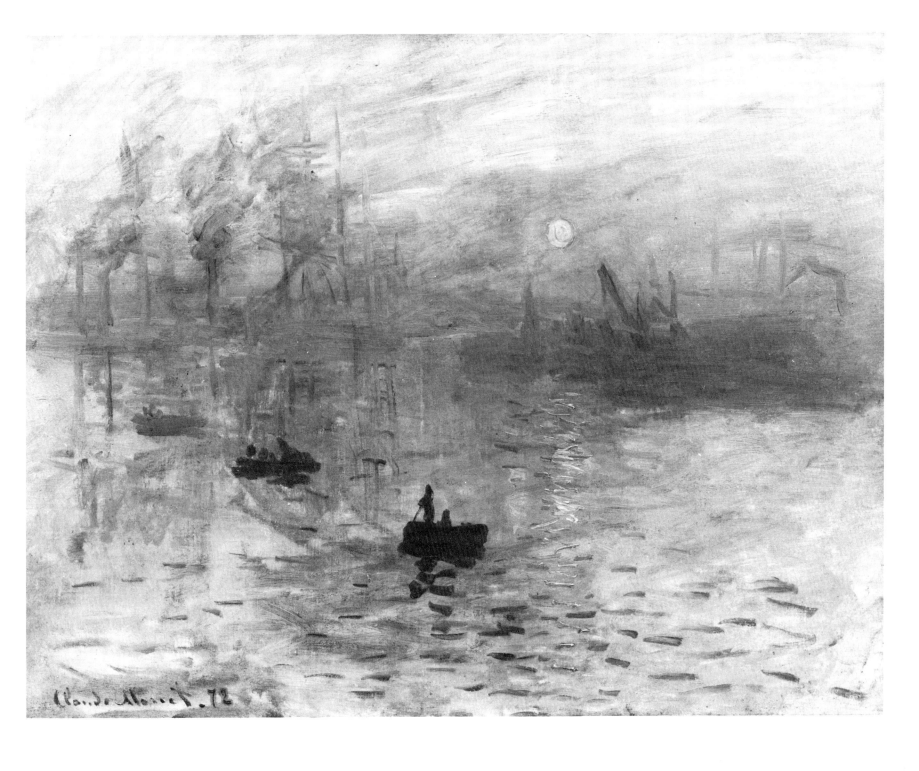

39. *Impression, Sunrise.* 1873. 18⅞ × 24¾ in. Musée Marmottan, Paris

Overleaf (page 88): 40. *The Promenade, Argenteuil.* 1872. 19⅞ × 25⅝ in. National Gallery of Art, Washington, D.C.

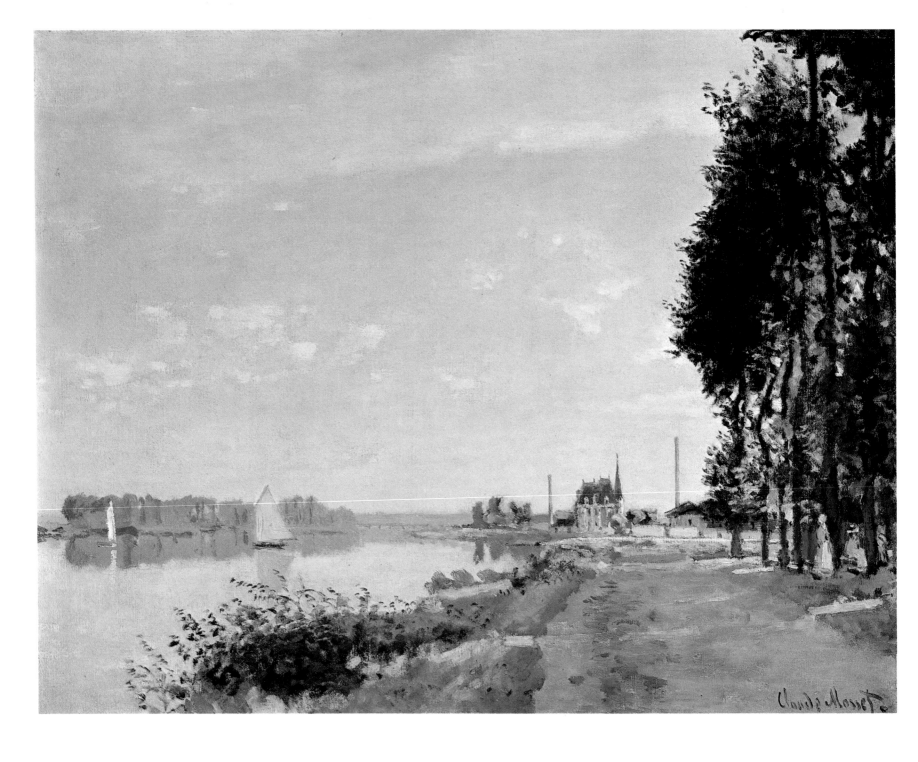

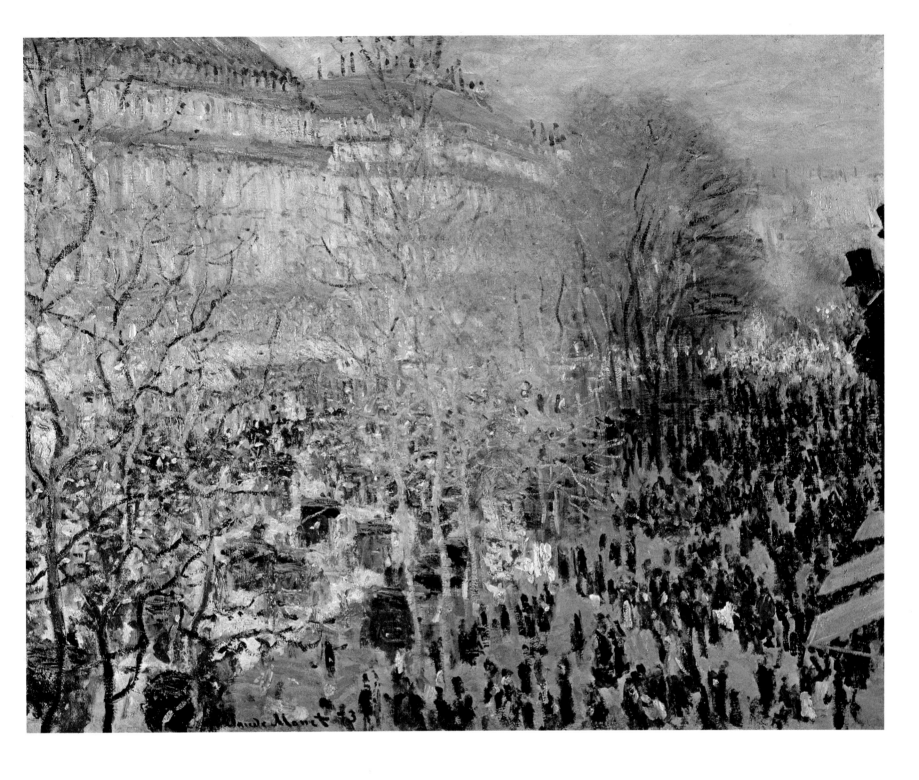

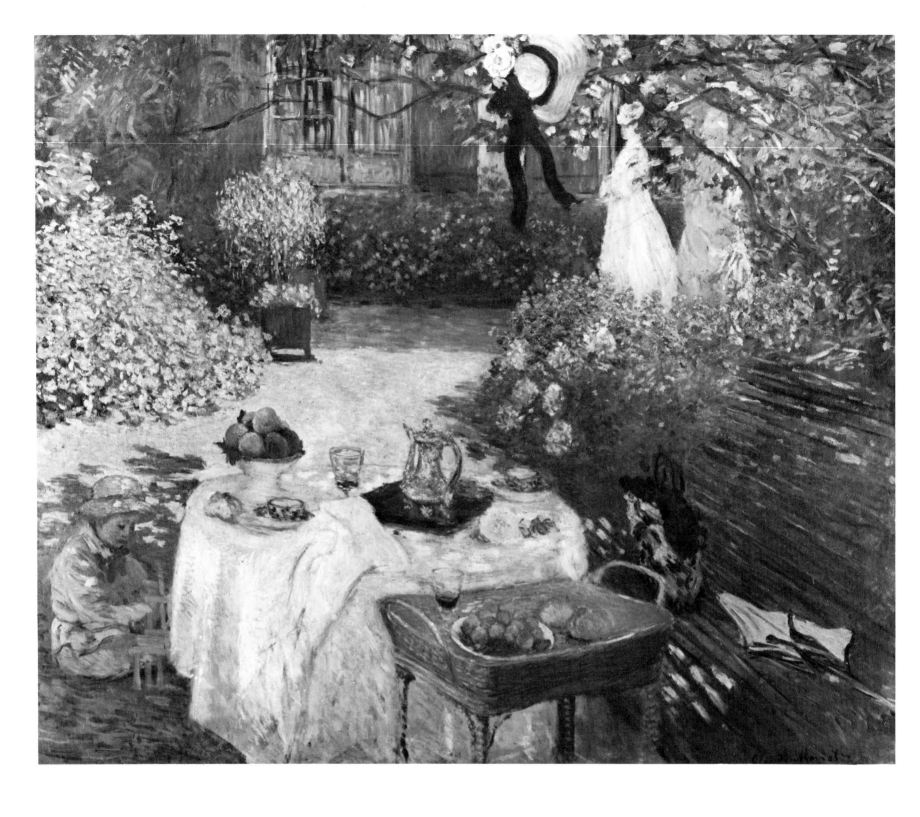

Previous page (page 89) : 41. **The Boulevard des Capucines.** 1873. 24 × 31⅝ in. Pushkin Museum, Moscow

42. **The Luncheon.** 1873. 63¾ × 79⅞ in. Musée du Louvre, Paris (Jeu de Paume)

43. _Boats at Petit-Gennevilliers._ About 1874. $9\frac{1}{2} \times 12\frac{1}{4}$ in. Musée Marmottan, Paris

Overleaf (page 92): 44. **_Autumn Effect, Argenteuil._** 1873. $22 \times 29\frac{1}{2}$ in. Courtauld Institute Galleries, London

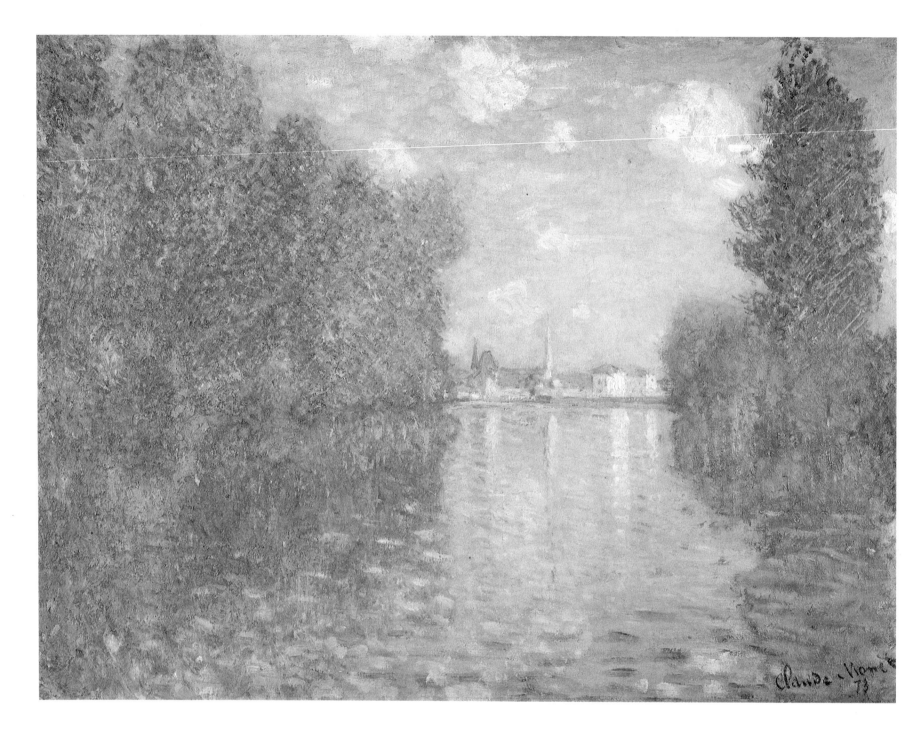

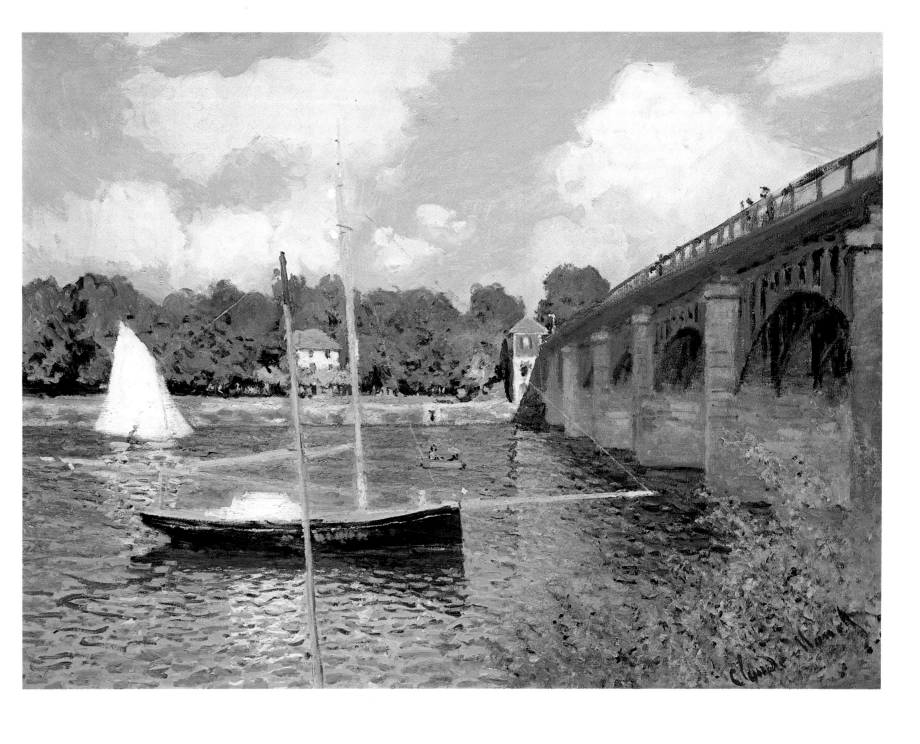

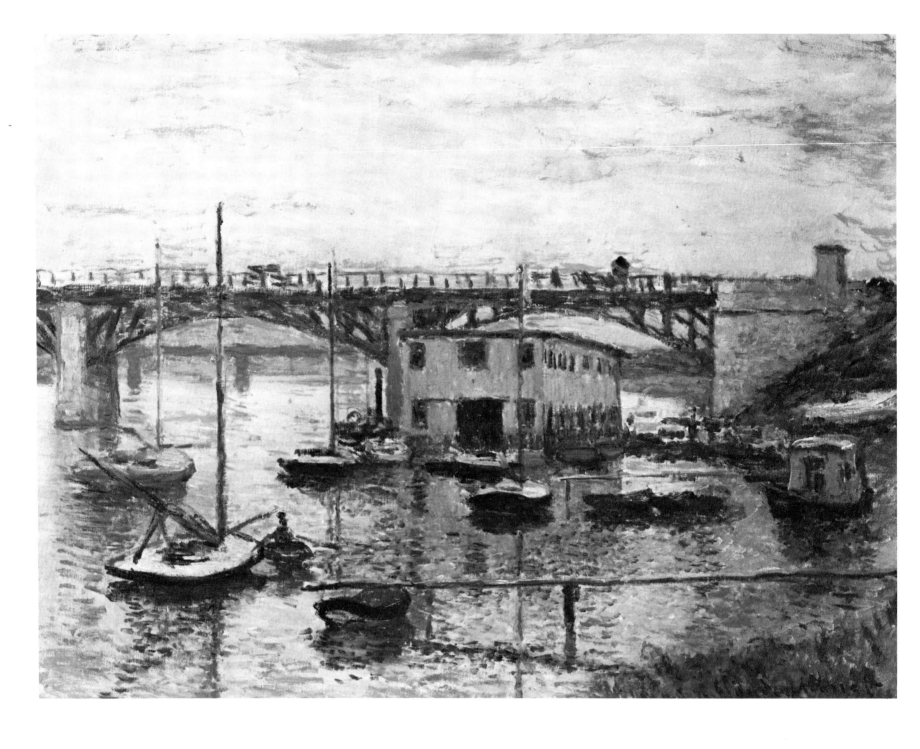

Previous page (page 93) : 45. ***The Bridge at Argenteuil.*** 1874.
$23\frac{3}{4} \times 31\frac{1}{2}$ in. Paul Mellon Collection, U.S.A.

46. ***The Bridge at Argenteuil on a Grey Day***. 1874.
$24 \times 31\frac{5}{8}$ in. National Gallery of Art, Washington, D.C.

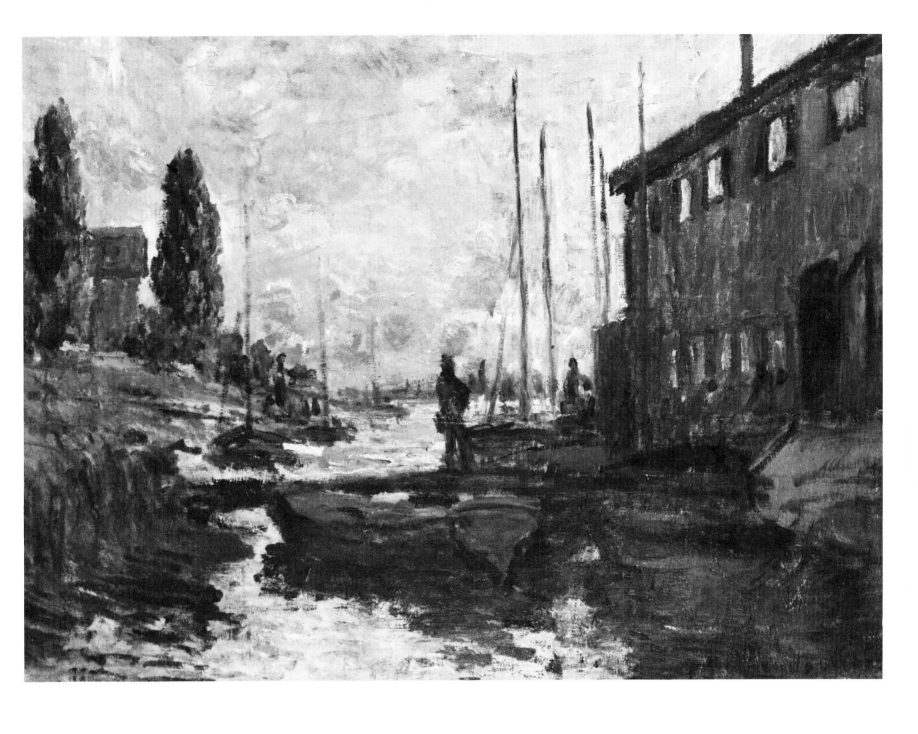

47. *The River Basin at Argenteuil.* 1875. $21\frac{1}{4} \times 29\frac{1}{8}$ in.
Private Collection, Madrid

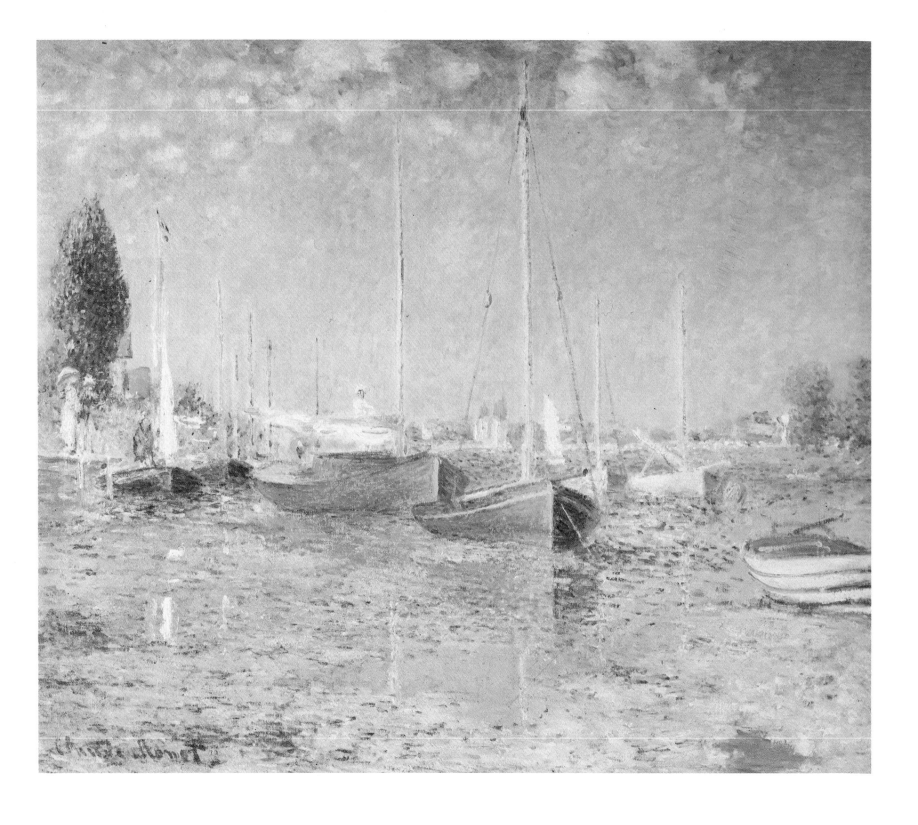

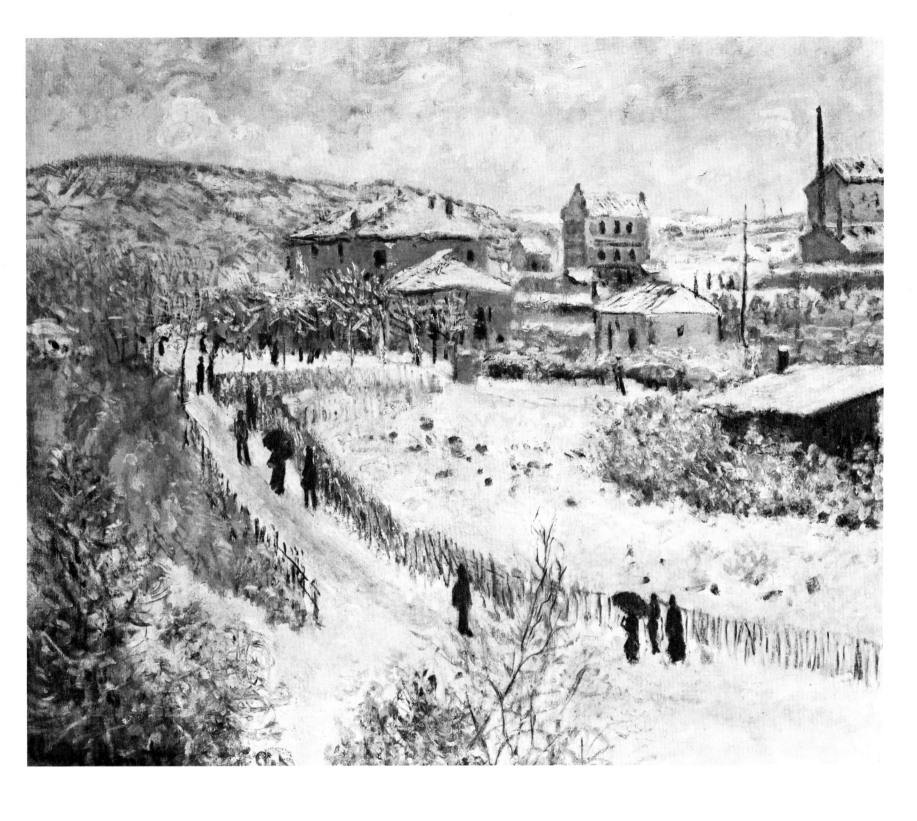

49. *View of Argenteuil, Snow.* 1875. $21\frac{5}{8} \times 26\frac{3}{4}$ in. Nelson Gallery-Atkins Museum, Kansas City, Missouri

Opposite (page 96): 48. **Red Boats, Argenteuil.** 1875. $21\frac{5}{8} \times 25\frac{5}{8}$ in. Musée du Louvre, Paris (Jeu de Paume)

Overleaf (page 98): 50. **The Bench.** 1873. $23\frac{5}{8} \times 31\frac{5}{8}$ in. Mr and Mrs Walter Annenberg, U.S.A.

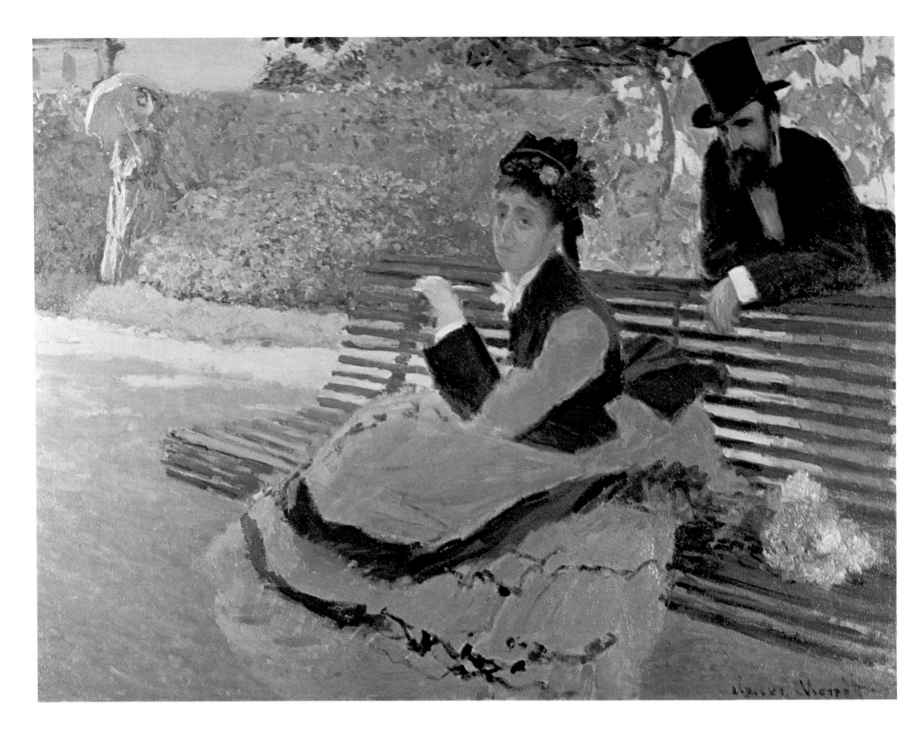

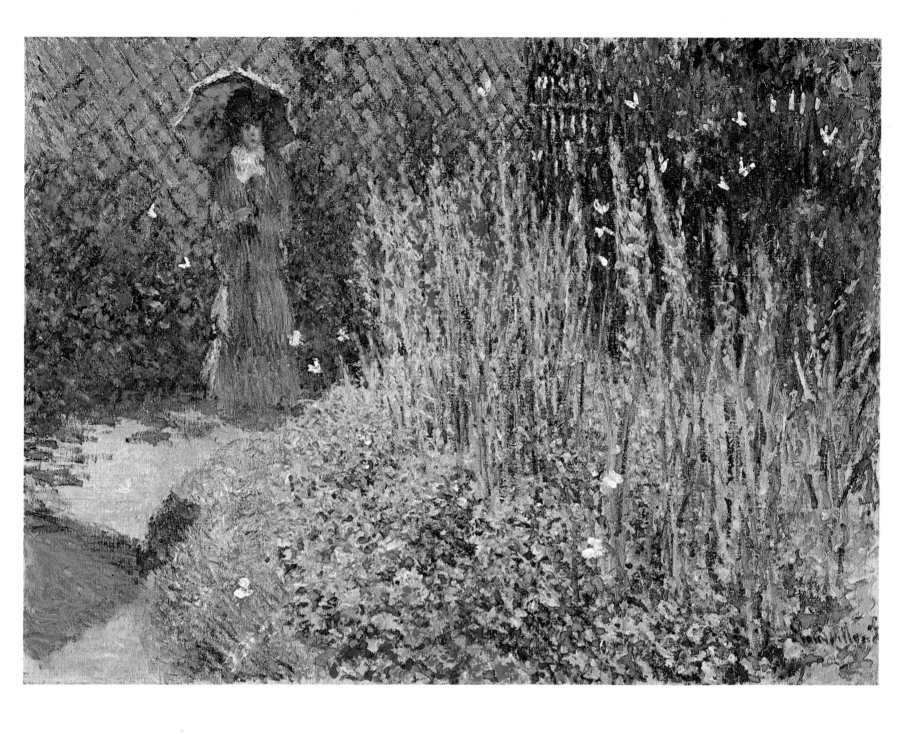

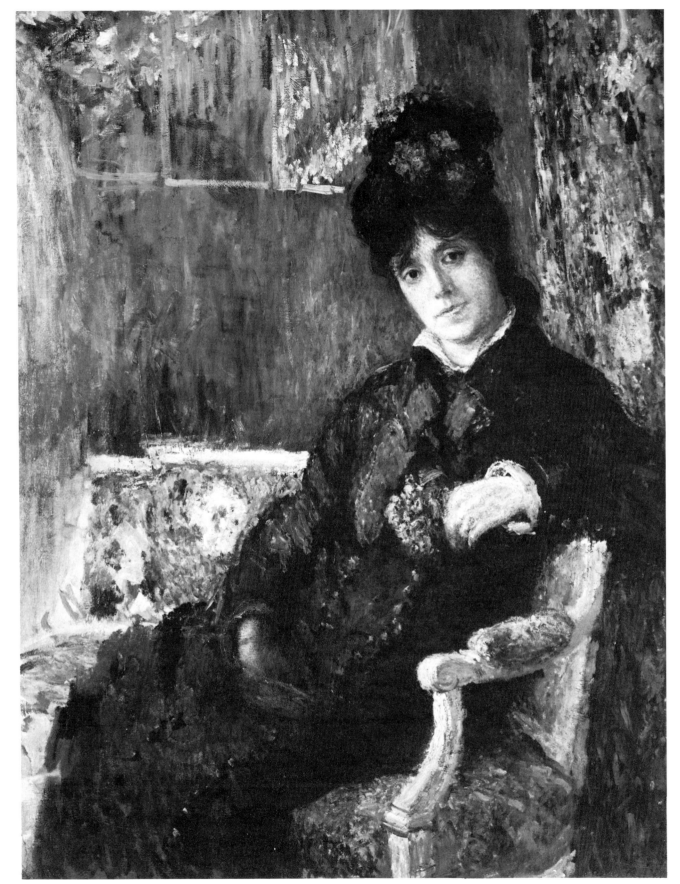

Previous page (page 99):
51. **Gladioli.** 1876. $23\frac{1}{2} \times 32$ in. Detroit Institute of Arts

52. **Portrait of Camille with a Bouquet of Violets.** 1876–7. $45\frac{5}{8} \times 34\frac{5}{8}$ in. Private Collection, U.S.A.

Opposite (page 101): 53. **The Hunt.** 1876. $68\frac{1}{8} \times 55\frac{1}{8}$ in. Private Collection, France

Overleaf (page 102): 54. **Promenade. Woman with a Parasol.** 1875. $39\frac{1}{4} \times 32$ in. Paul Mellon Collection, U.S.A.

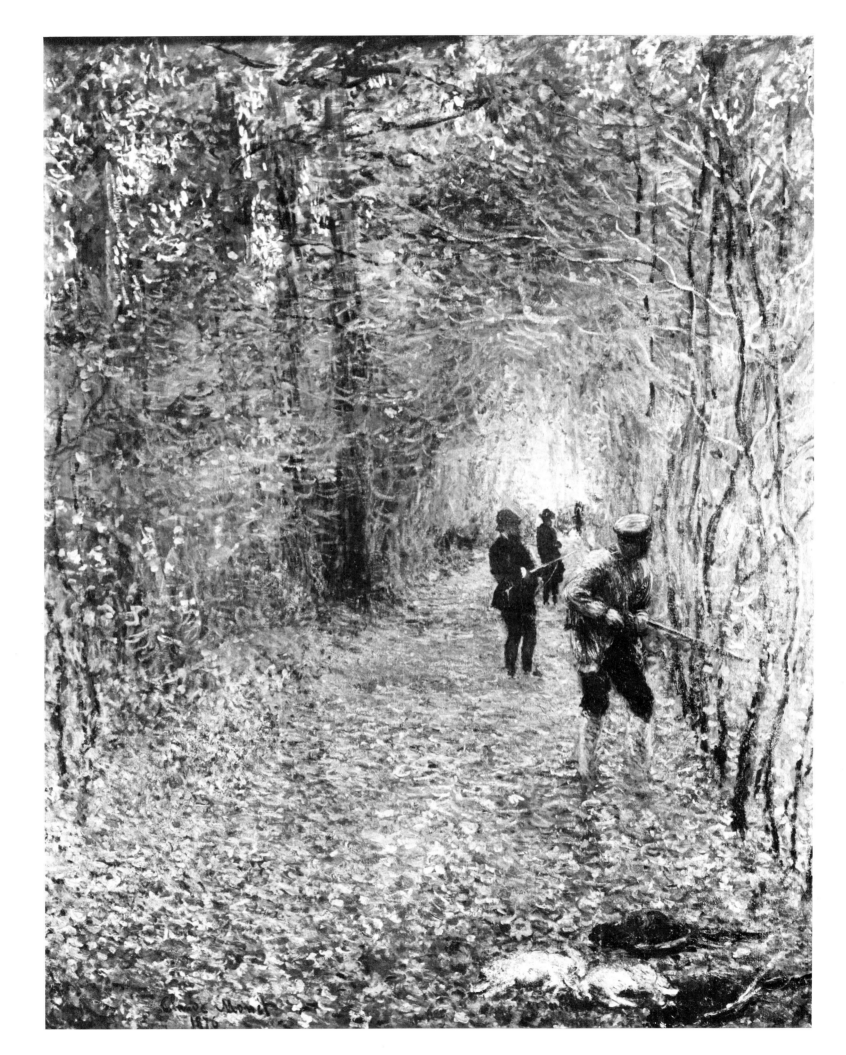

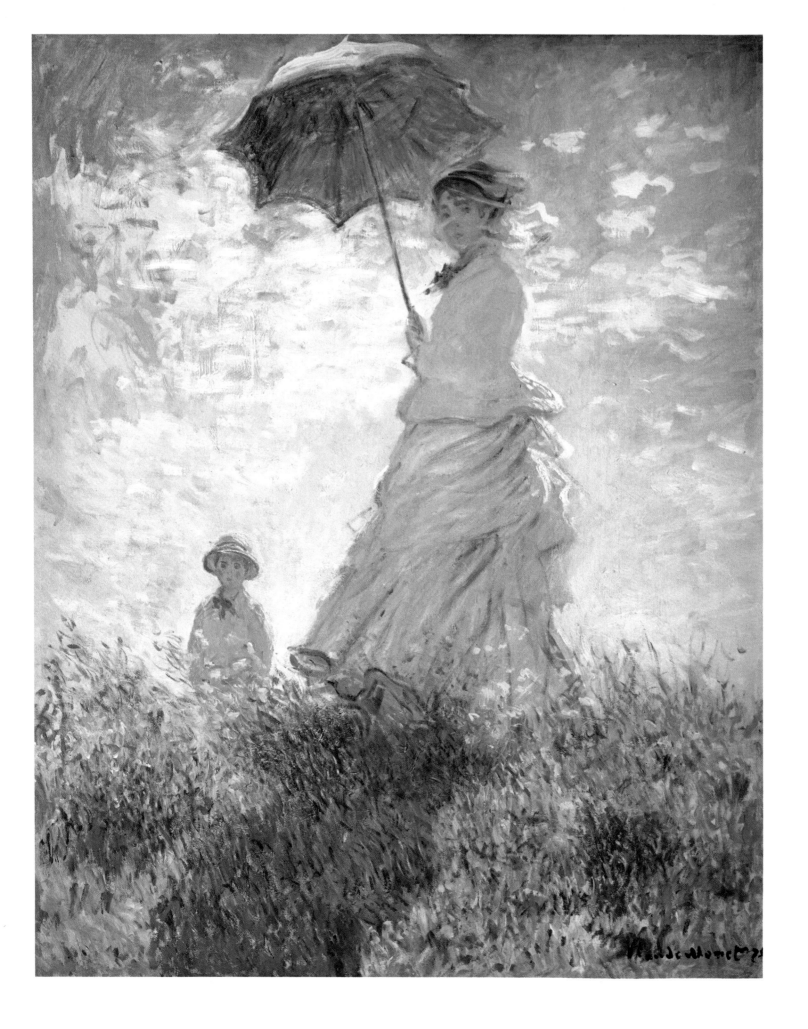

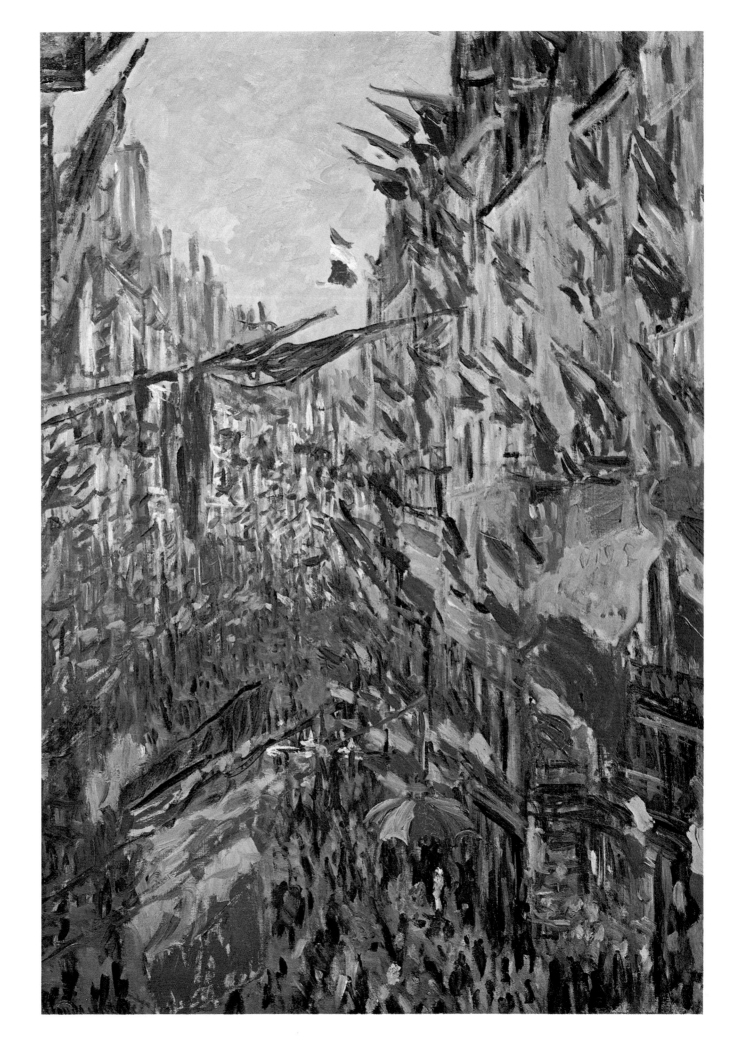

Previous page (page 103): 55. **Rue Saint-Denis, Celebration of 30 June 1878.** 1878. $29\frac{7}{8} \times 20\frac{1}{2}$ in. Musée des Beaux-Arts, Rouen

56. **Gare Saint-Lazare.** 1877. $9\frac{1}{2} \times 12\frac{1}{4}$ in. Musée Marmottan, Paris

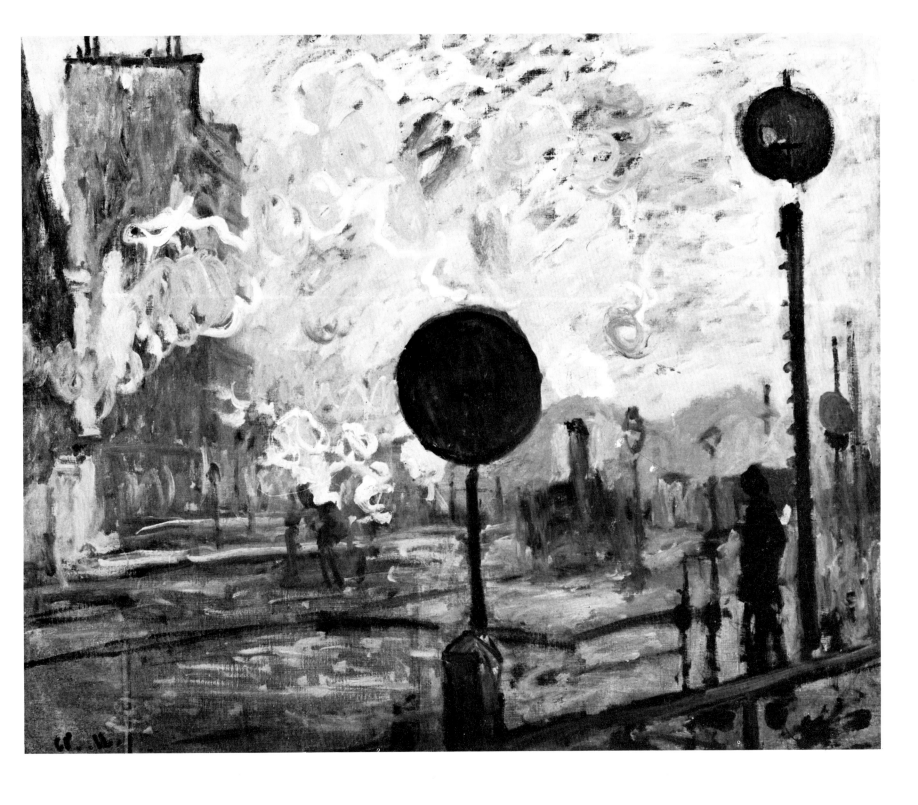

57. *Exterior of the Gare Saint-Lazare* (*The Signal*). 1877.
25⅝ × 32⅛ in. Private Collection, U.S.A.

Overleaf (page 106): 58. *The Pond at Montgeron.* 1876.
67¾ × 76 in. Hermitage, Leningrad

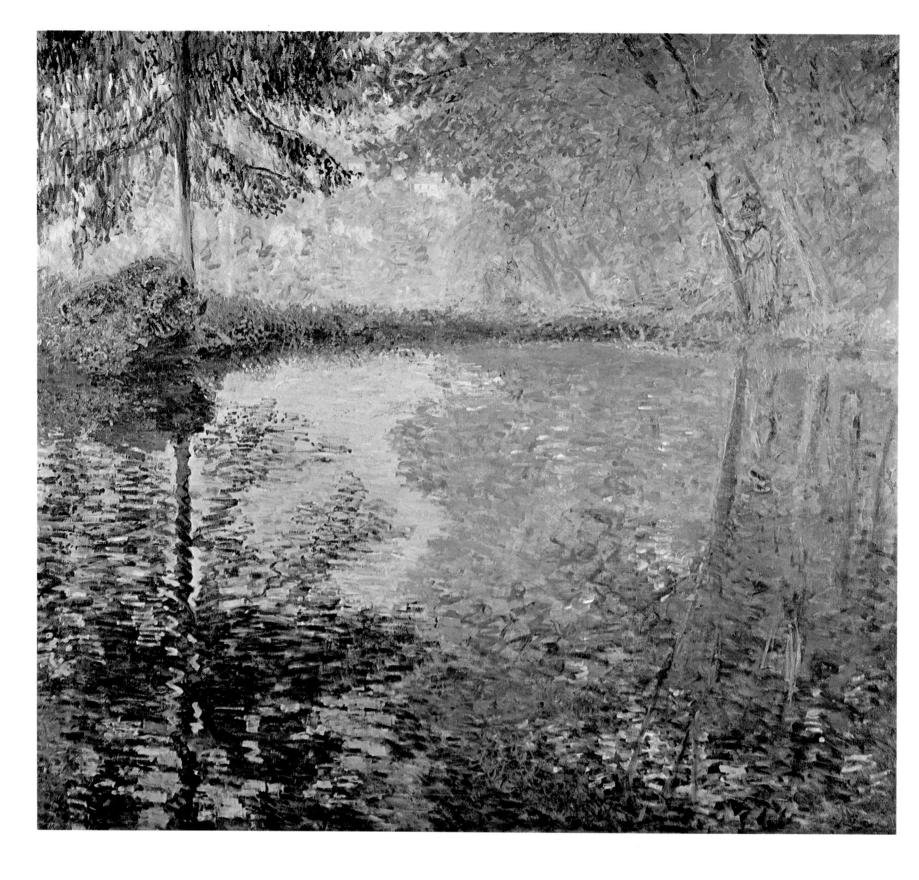

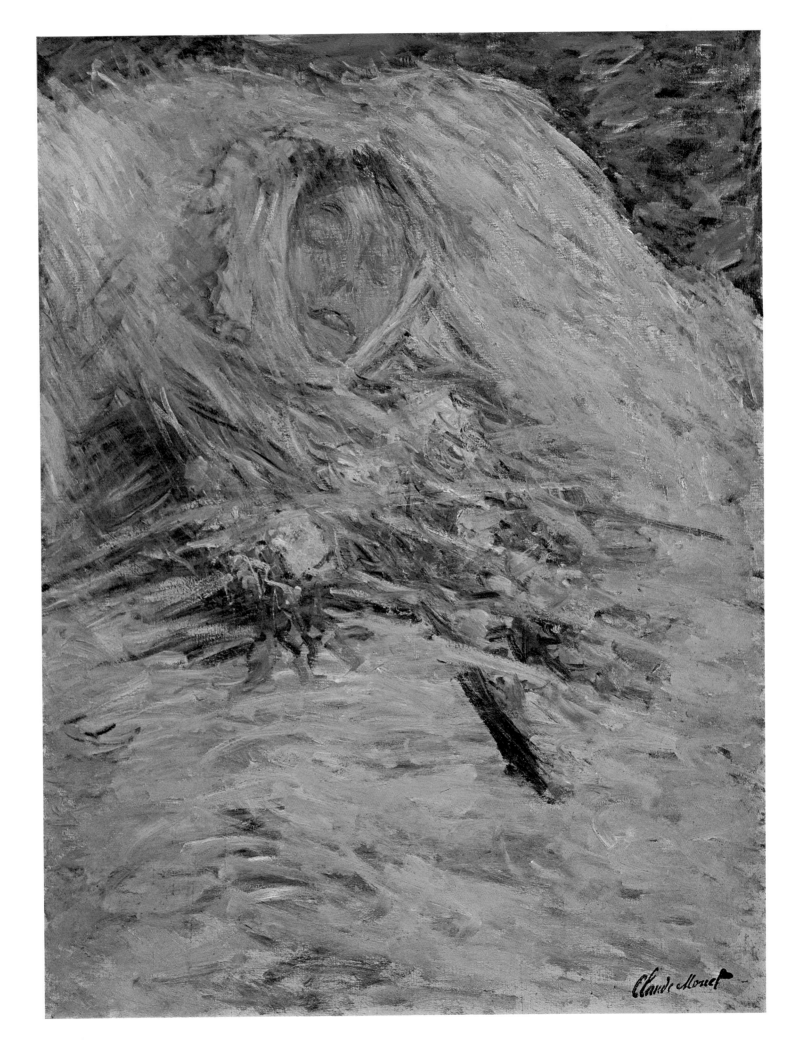

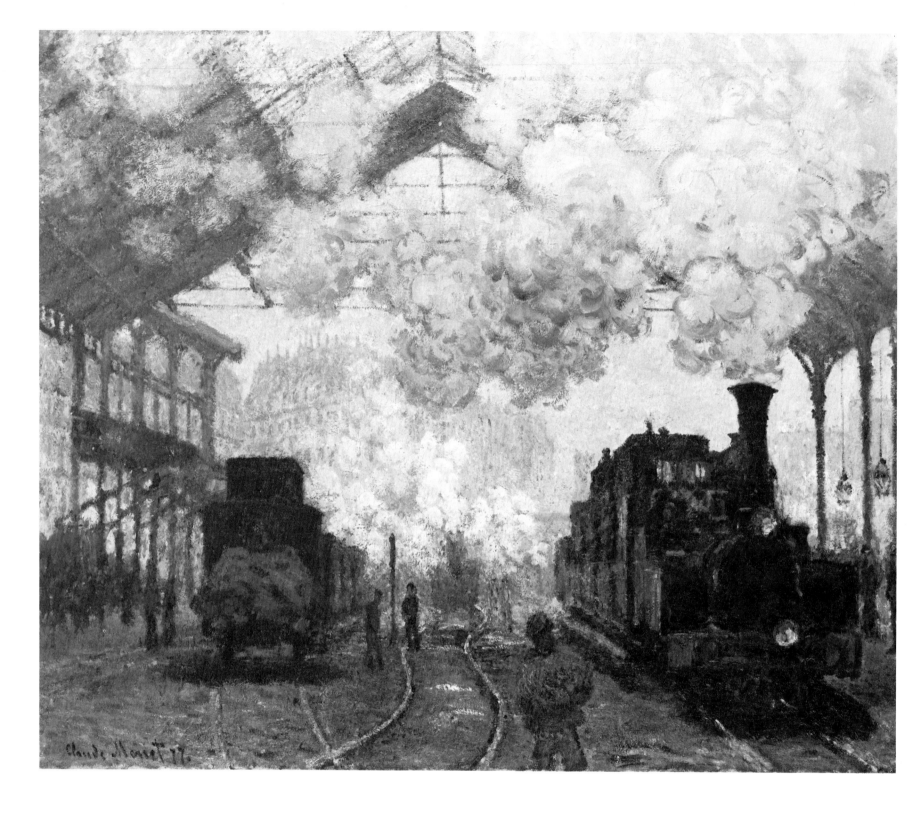

Previous page (page 107): 59. **Camille Monet on her Death-bed.** 1879. $35\frac{1}{2} \times 26\frac{3}{4}$ in. Musée du Louvre, Paris (Jeu de Paume)

60. **Gare Saint-Lazare, Arrival of a Train.** 1877. $32\frac{1}{4} \times 39\frac{3}{4}$ in. Fogg Art Museum, Cambridge, Massachusetts

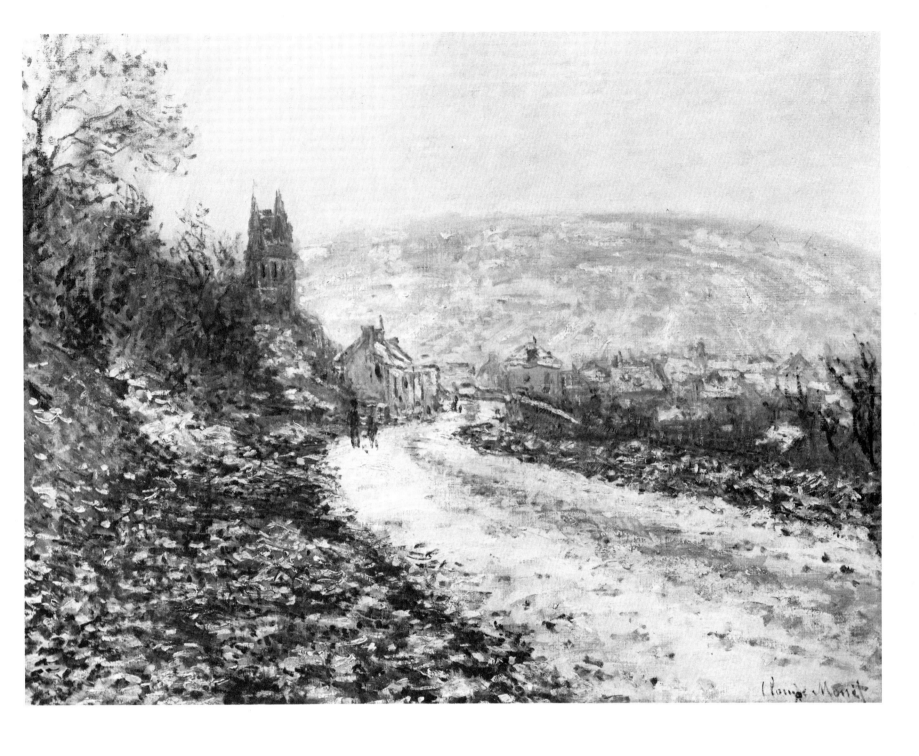

61. ***Entrance to the Village of Vétheuil, Winter.*** 1879.
$23\frac{5}{8} \times 31\frac{7}{8}$ in. Museum of Fine Arts, Boston

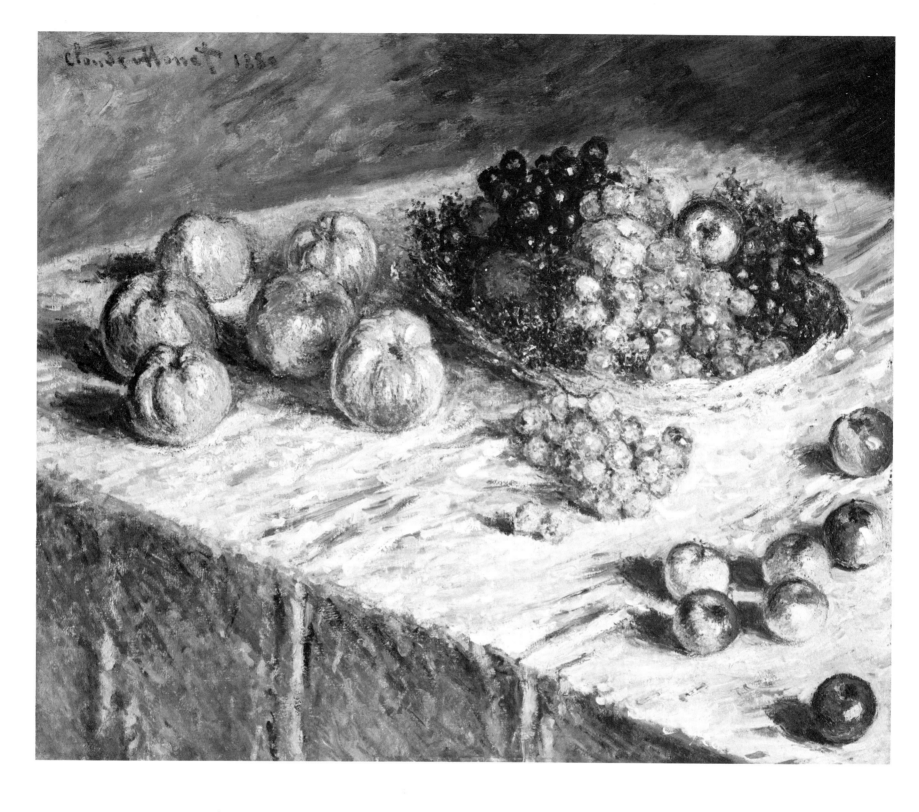

62. ***Still-life: Apples and Grapes.*** 1880. $25\frac{3}{4} \times 32\frac{1}{8}$ in. Art
Institute of Chicago

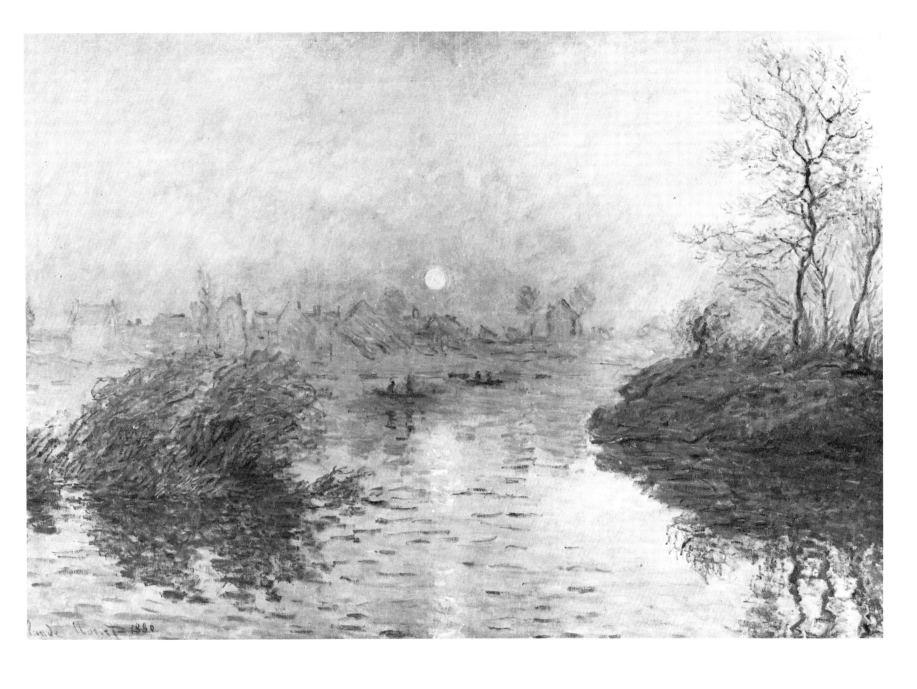

63. *Sunset on the Seine, Winter Effect.* 1880. $39\frac{3}{8} \times 59\frac{7}{8}$ in.
Musée du Petit Palais, Paris

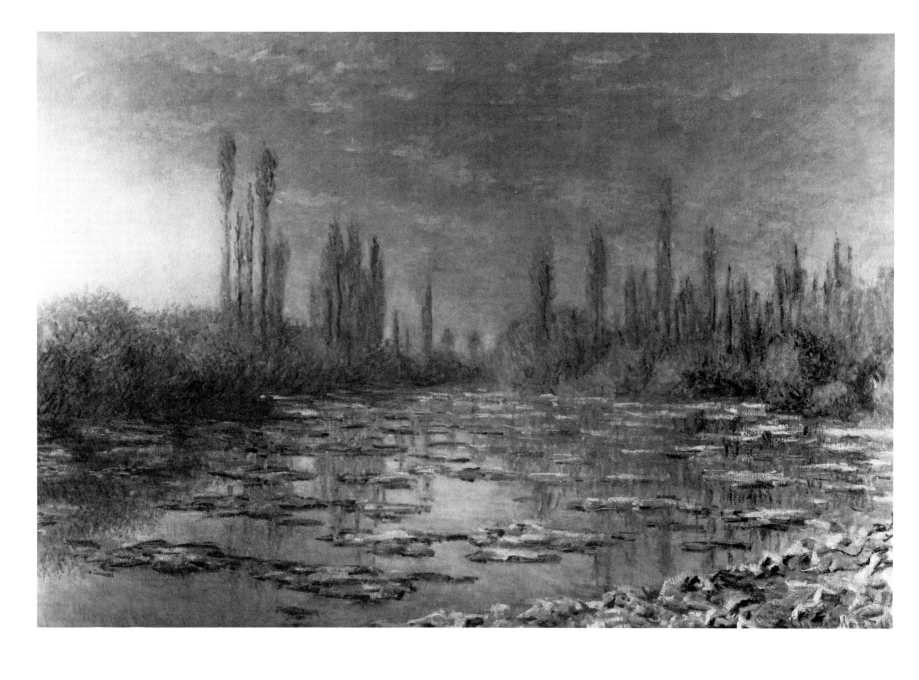

64. ***Floating Ice.*** 1880. $38\frac{1}{8} \times 59\frac{1}{4}$ in. Shelburne Museum, Shelburne, Vermont

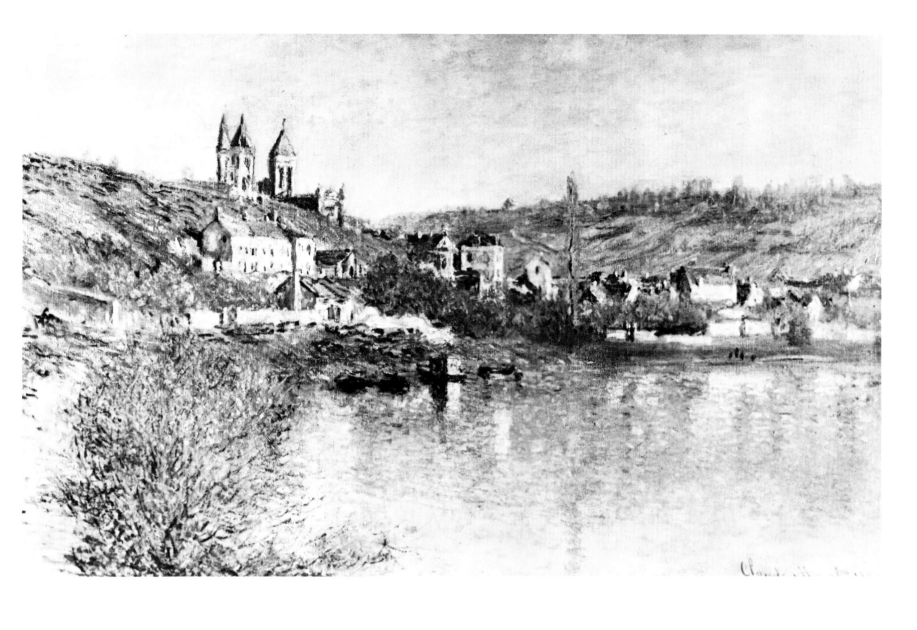

65. *The Hills of Vétheuil.* 1880. 24 × 35½ in. Private
Collection, U.S.A.

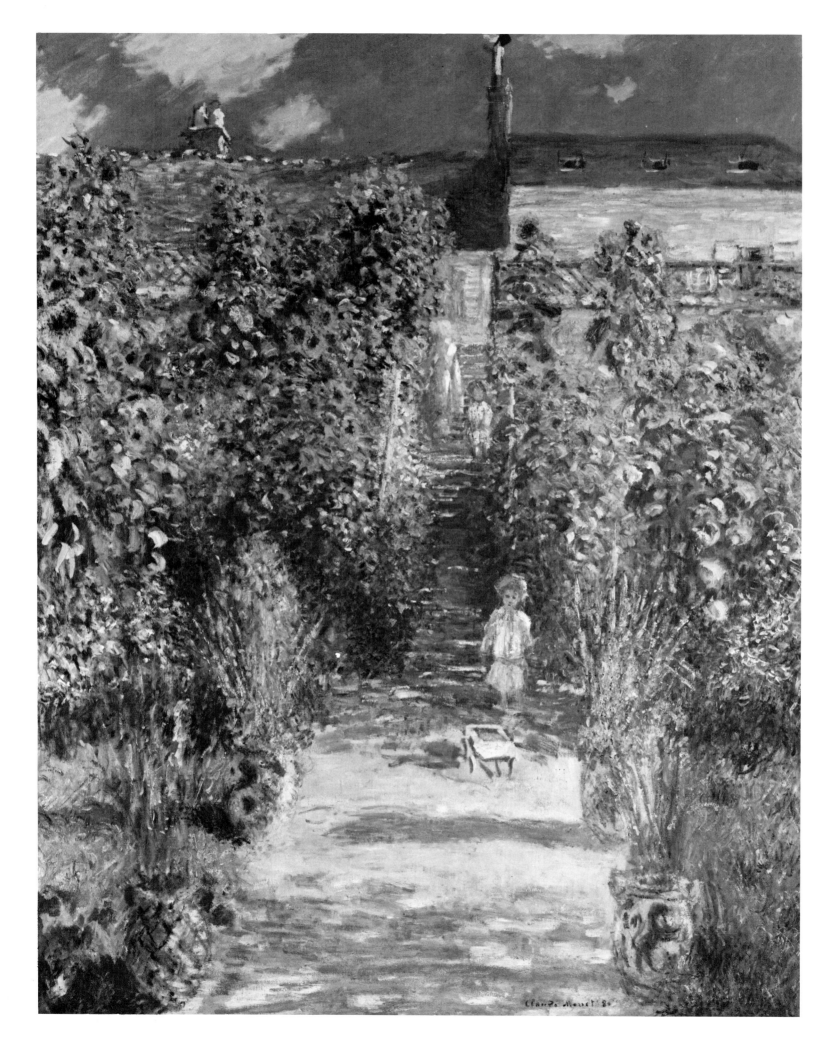

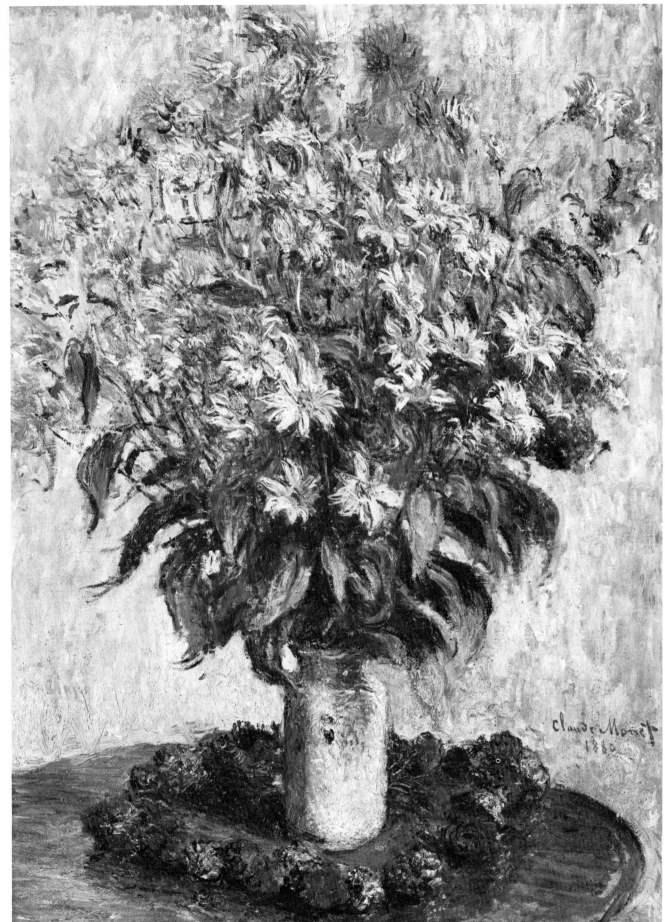

Opposite (page 114): 66.
Monet's Garden at Vétheuil. 1881. 59⅝ × 47⅝ in. National Gallery of Art, Washington, D.C.

67. **Sunflowers.** 1880. 39¼ × 28¾ in. National Gallery of Art, Washington, D.C.

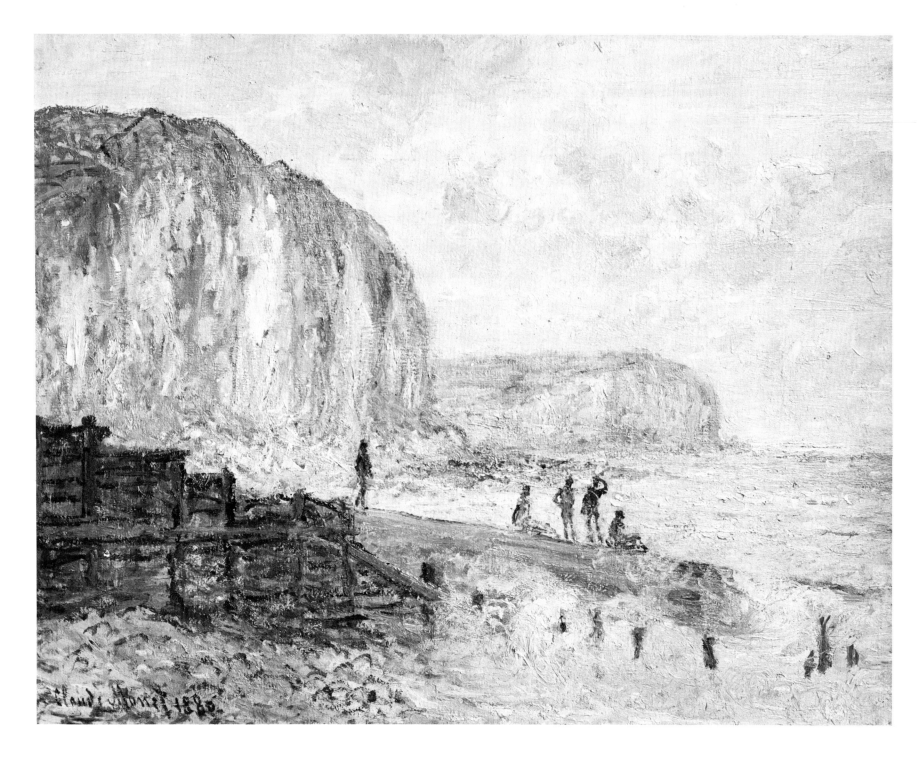

68. *Cliffs at Les Petites-Dalles.* 1880. $23\frac{1}{4} \times 29\frac{1}{2}$ in.
Museum of Fine Arts, Boston

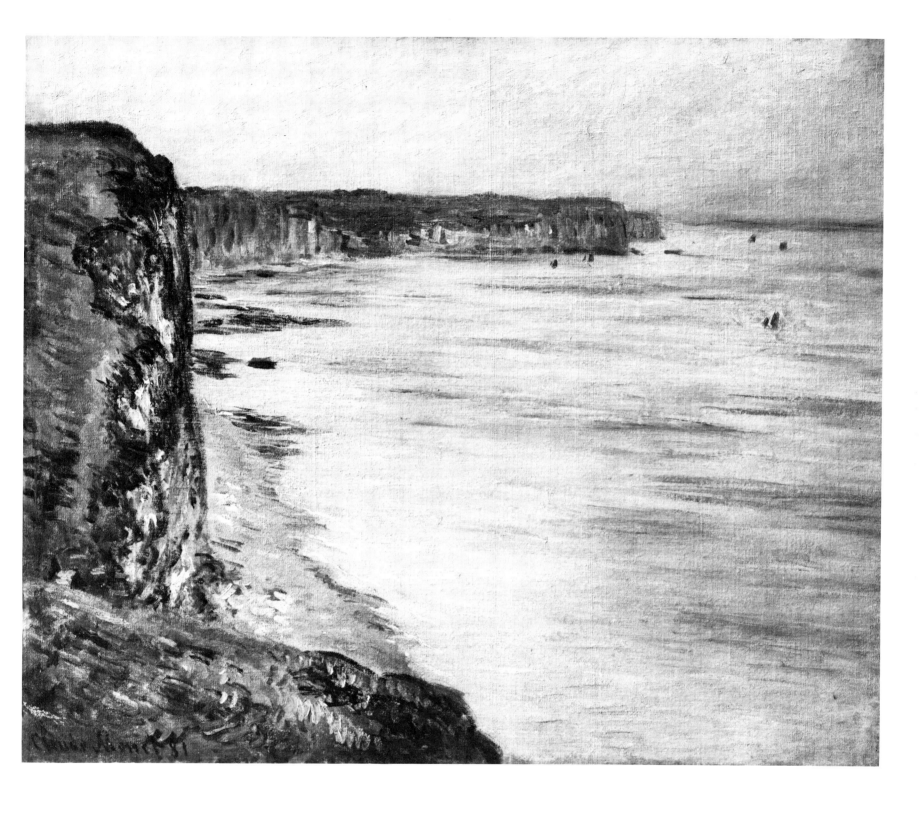

69. *Calm Weather, Fécamp.* 1881. 23⅝ × 29 in. Fondation
Rudolf Staechelin, Basel

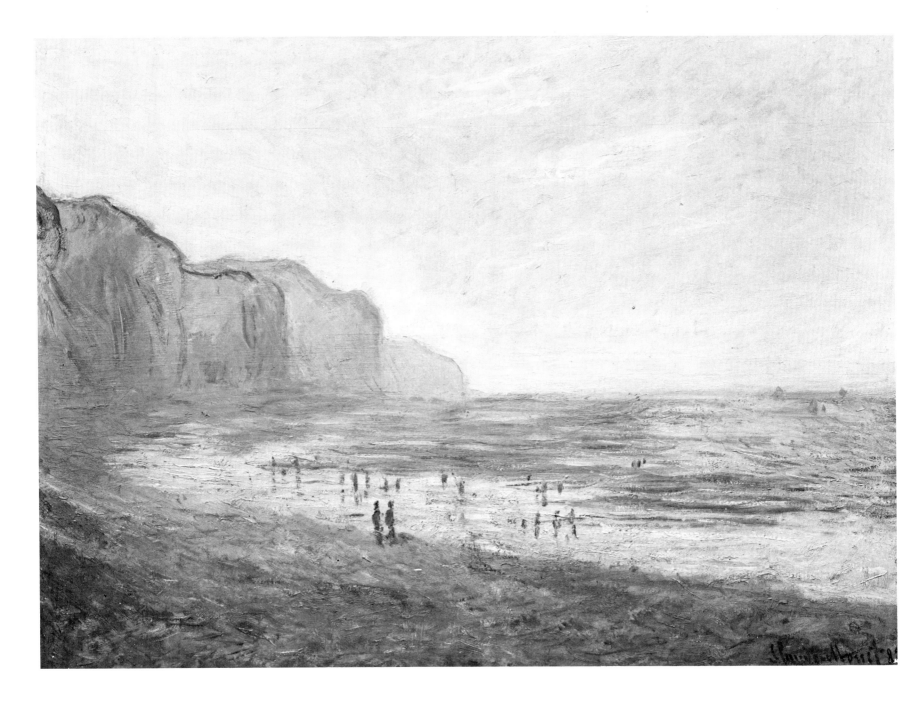

70. ***Cliffs at Low Tide, Pourville.*** 1882. $23\frac{1}{2} \times 32\frac{1}{4}$ in.
Collection of Mr and Mrs David Lloyd Kreeger, Washington,
D.C.

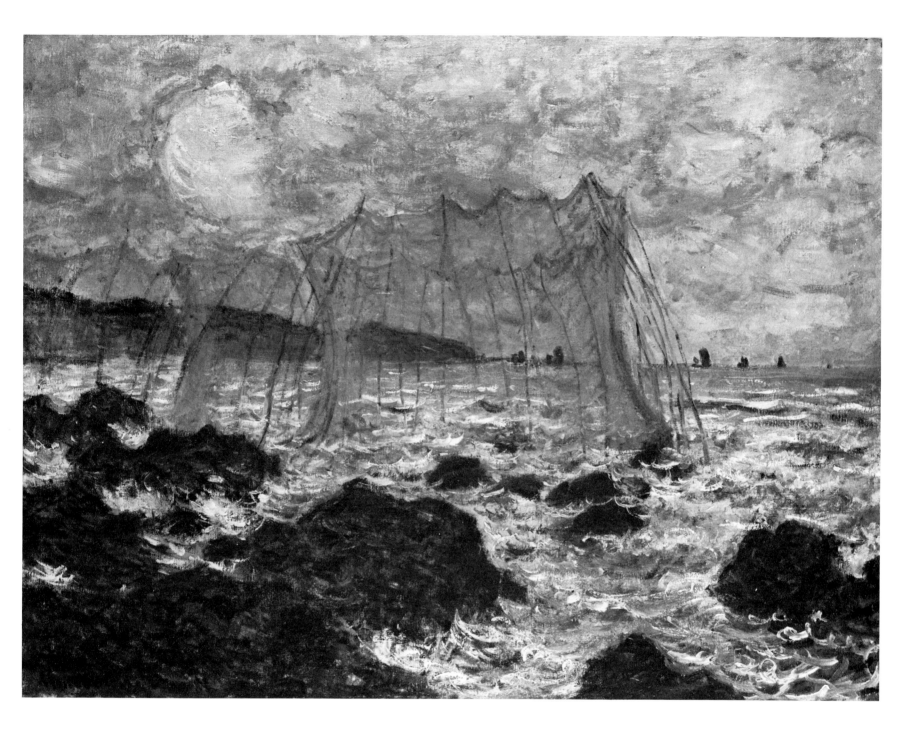

71. *Fishing Nets, Pourville.* 1882. 24 × 32 in. Gemeente-
museum, The Hague

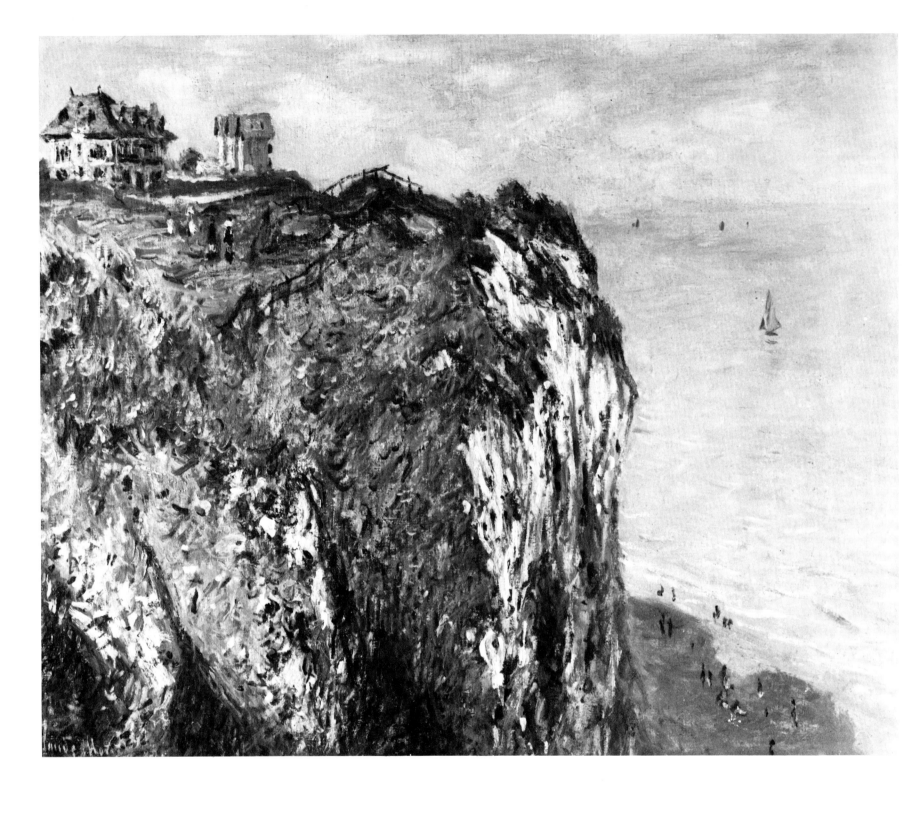

72. **Cliffs near Dieppe.** 1882. 26 × 32¼ in. Kunsthaus, Zurich

Opposite (page 121): 73. **Lavacourt.** 1880. 38¾ × 58¾ in. Dallas Museum of Fine Arts, Dallas, Texas

Overleaf (page 122): 74. **The Douanier's Cottage, Varengeville.** 1882. 25⅝ × 30¾ in. Museum Boymans-van Beuningen, Rotterdam

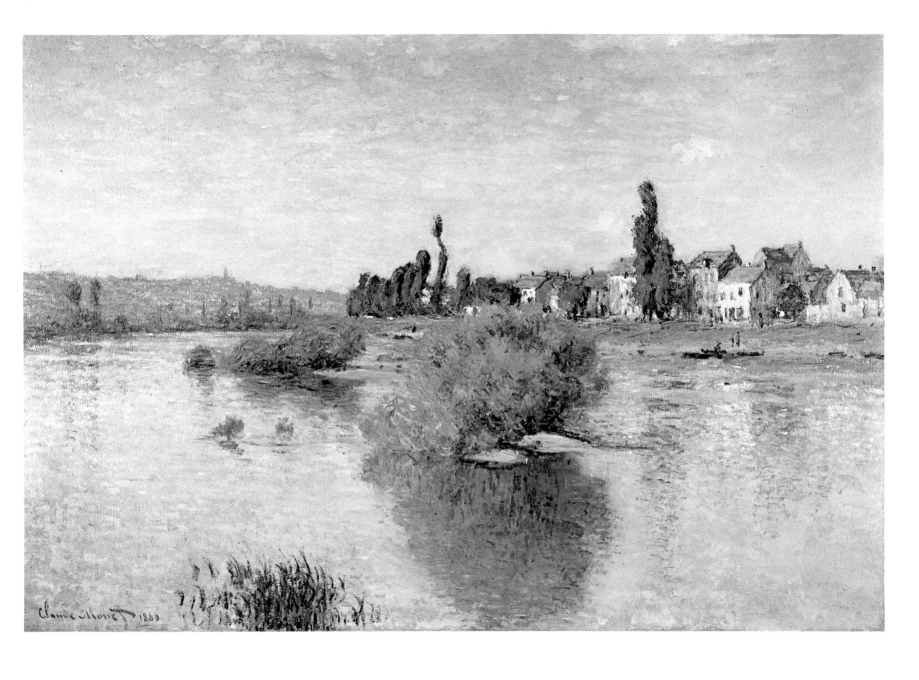

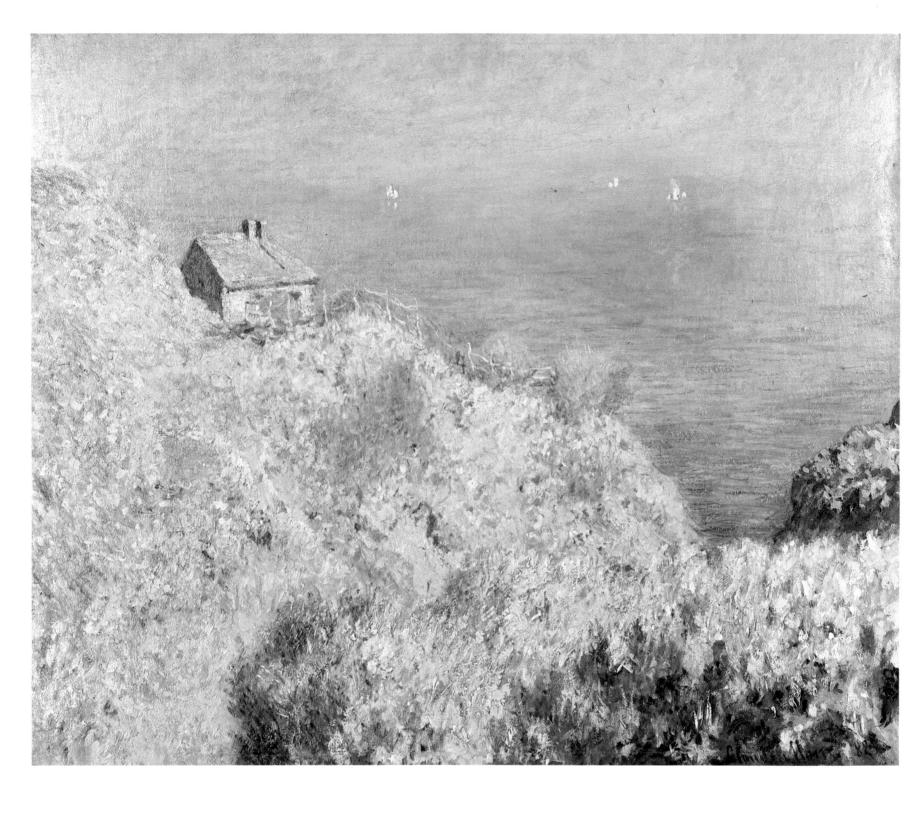

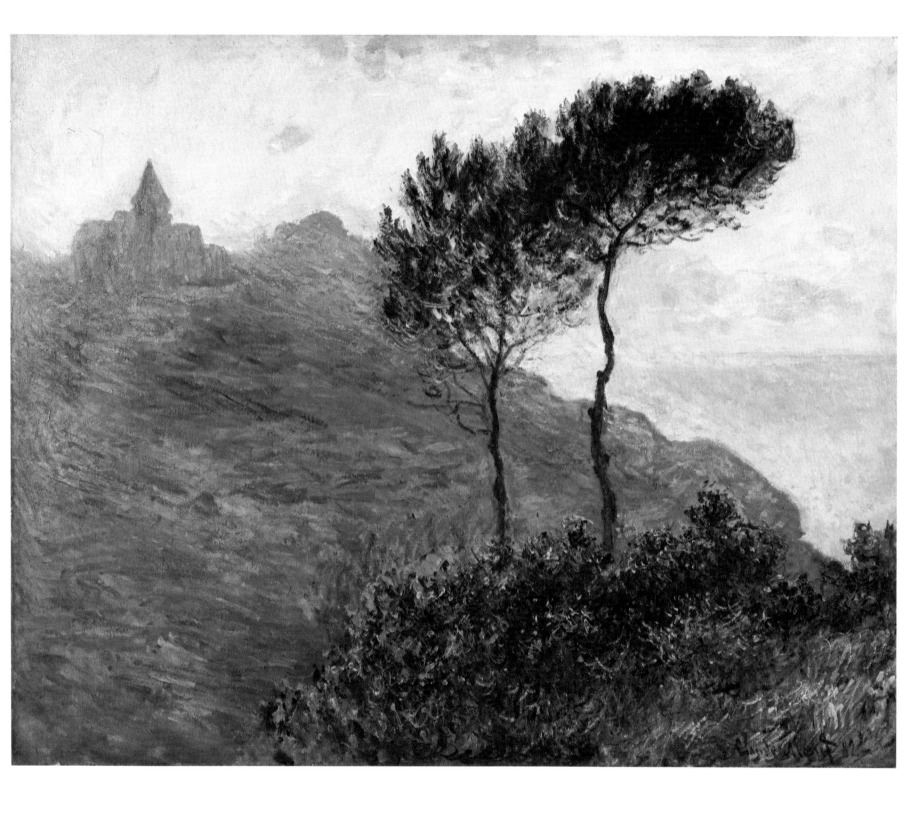

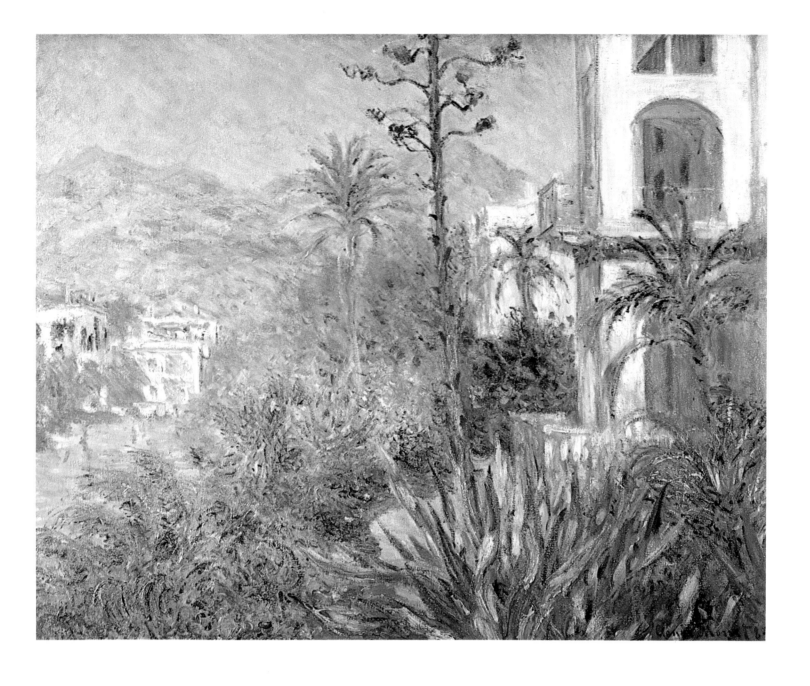

Previous spread (page 123): 75. **The Church, Varengeville.**
1882. $25\frac{1}{2} \times 32$ in. Barber Institute of Fine Arts, University of
Birmingham

Opposite (page 124): 76. **Bordighera.** 1884. $29 \times 36\frac{3}{8}$ in.
Santa Barbara Museum of Art, Santa Barbara, California

77. **Etretat, View of the Manneporte from the South.**
About 1883. Sketchbook pencil drawing. Musée Marmottan,
Paris

125

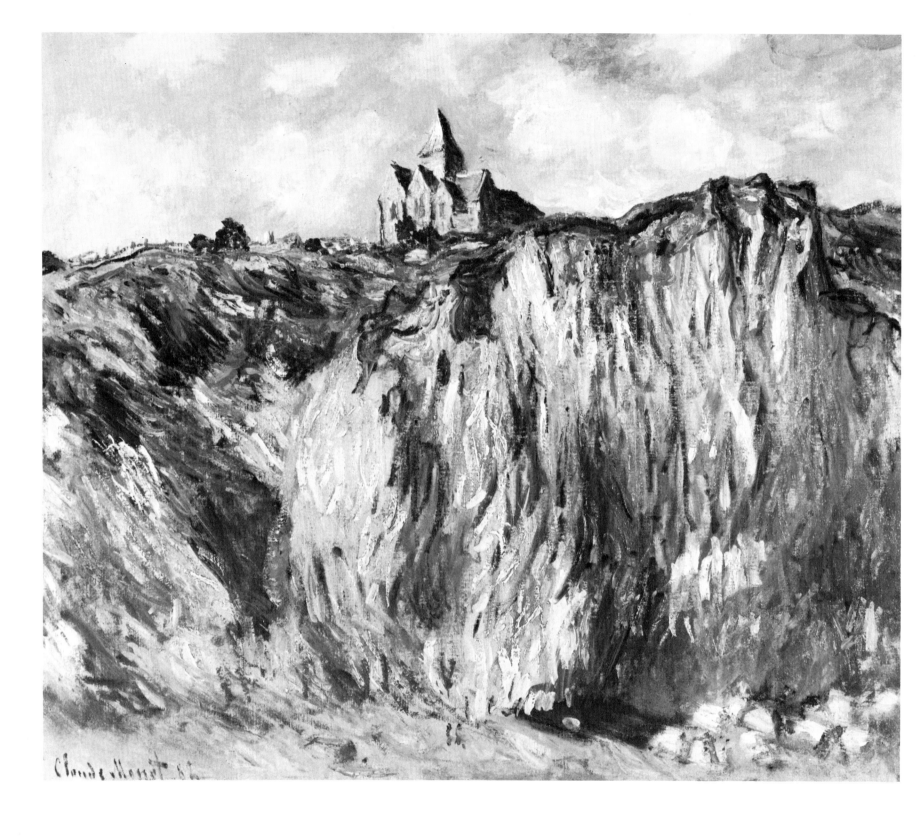

78. ***The Church at Varengeville.*** 1882. $23\frac{1}{2} \times 28\frac{1}{2}$ in.
Private Collection, Texas

79. ***The Church at Varengeville.*** 1882. Musée Marmottan,
Paris

127

80. **Etretat.** About 1883. Musée Marmottan, Paris

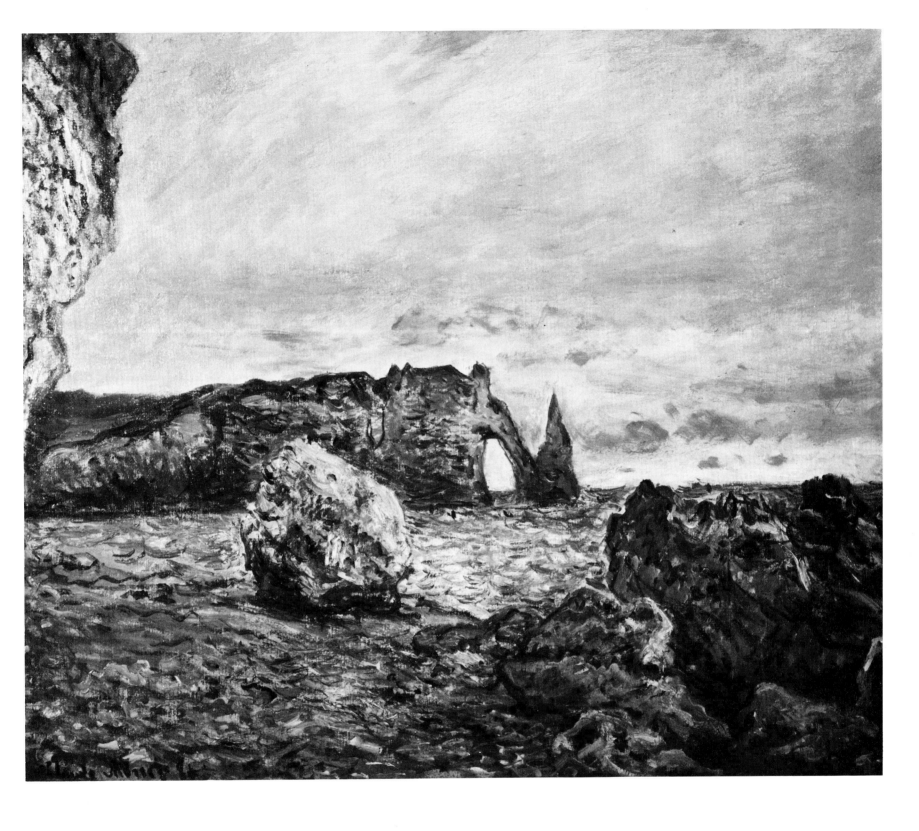

81. *Etretat.* 1884. 23½ × 28½ in. Mr and Mrs Samuel Dorsky,
New York

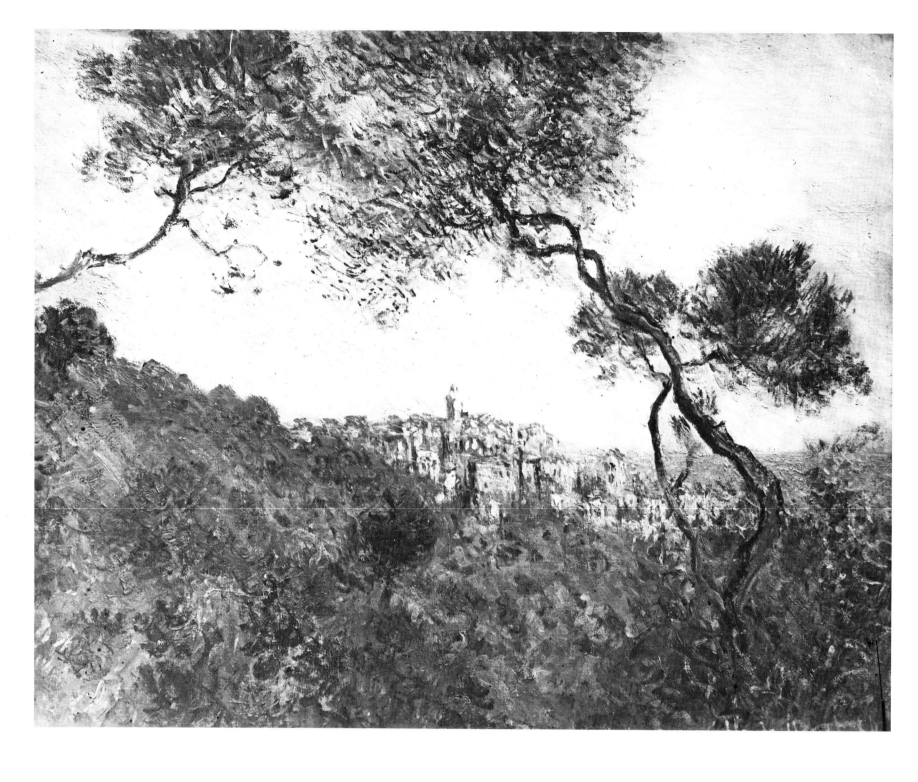

82. ***Bordighera.*** 1884. $24\frac{1}{4} \times 28\frac{3}{4}$ in. Private Collection, U.S.A.

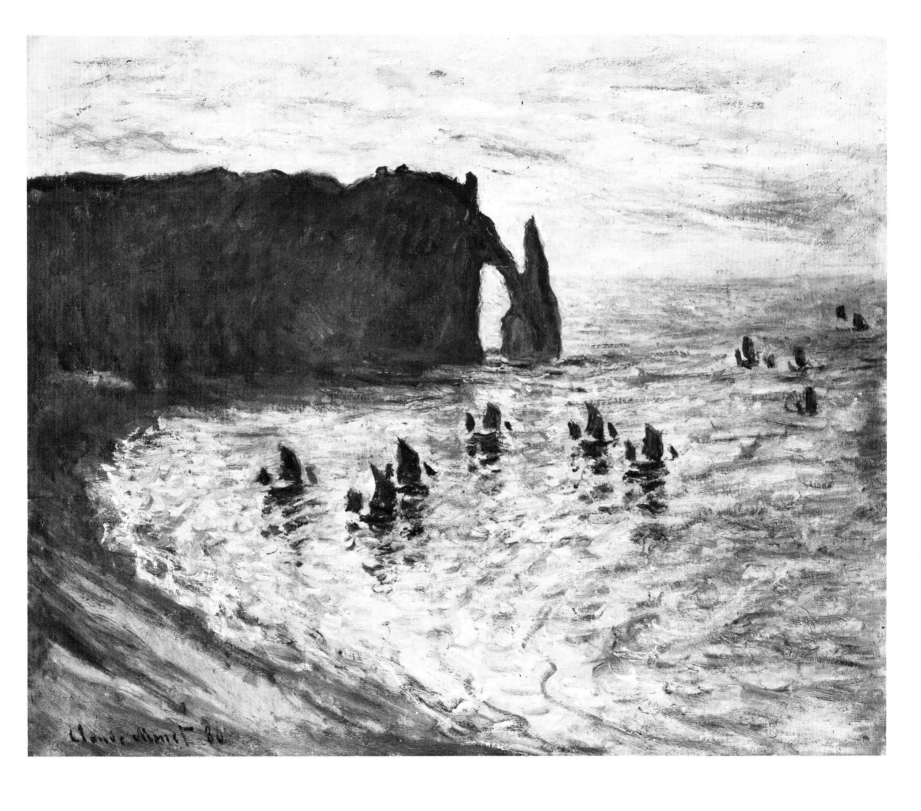

83. ***Rocks at Etretat.*** 1886. 26 × 31⅞ in. Pushkin Museum,
Moscow.

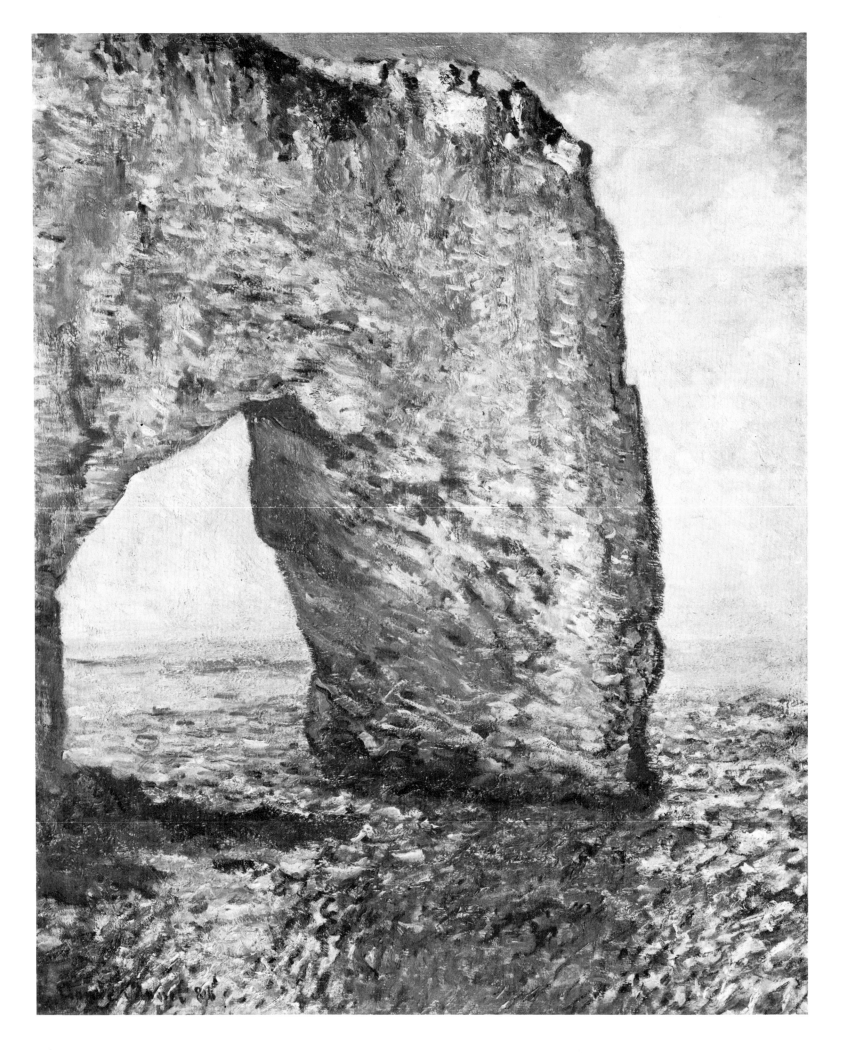

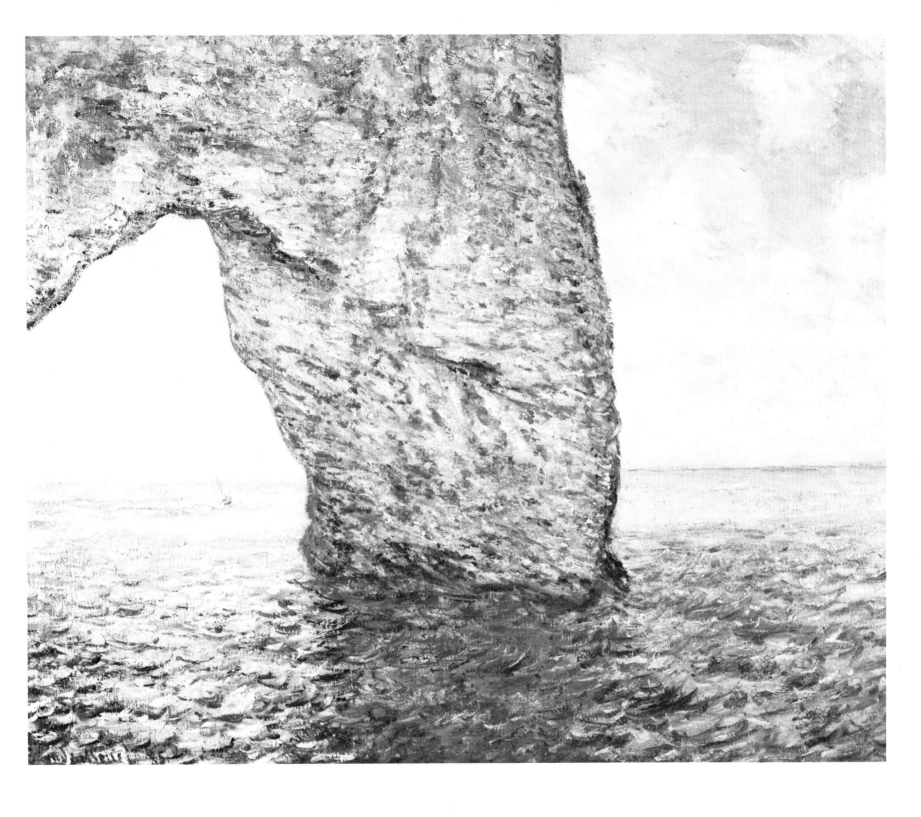

Opposite (page 132): 84. **The Manneporte, Etretat.** 1886. 32 × 25¾ in. Metropolitan Museum of Art, New York

85. **The Manneporte, Etretat.** 1885. 26 × 32¼ in. Mr and Mrs A. N. Pritzker, Chicago

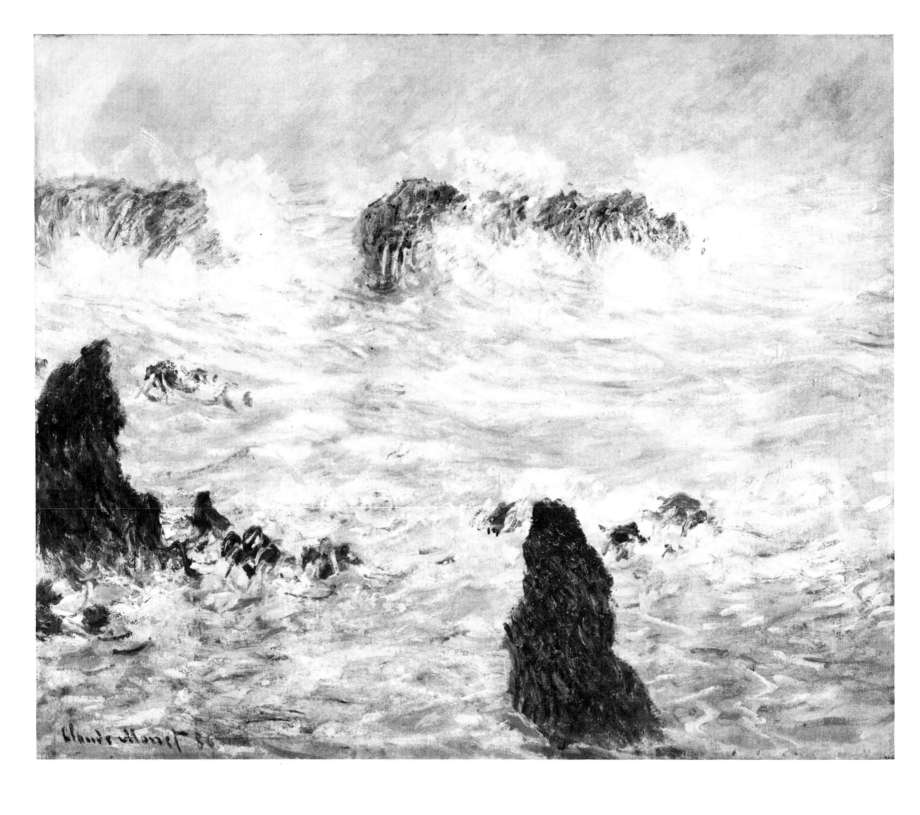

86. ***Storm at Belle-Ile.*** 1886. $25\frac{1}{4} \times 31\frac{7}{8}$ in. Musée du Louvre, Paris (Jeu de Paume)

87. ***The Tulip Field, Holland.*** 1886. 26 × 32¼ in. Musée du
Louvre, Paris (Jeu de Paume)

88. *View of Antibes.* 1888. $25\frac{3}{4} \times 36\frac{3}{8}$ in. Mr and Mrs Joseph S. Wohl, New York

Opposite (page 137): 89. **The 'Pyramids' at Port-Coton (Belle-Ile).** 1886. 25×31 in. Private Collection, Switzerland

Overleaf (page 138): 90. *A Haystack at Giverny.* 1886. $24 \times 31\frac{7}{8}$ in. Hermitage, Leningrad

Overleaf (page 139): 91. **Five Figures in a Field.** 1888. $31 \times 31\frac{1}{4}$ in. Private Collection, U.S.A.

(page 140): 92. **Antibes.** 1888. $25\frac{3}{4} \times 36\frac{1}{4}$ in. Courtauld Institute Galleries, London

(page 141): 93. **The Umbrella Pines.** 1888. $35\frac{1}{2} \times 43$ in. Private Collection, U.S.A.

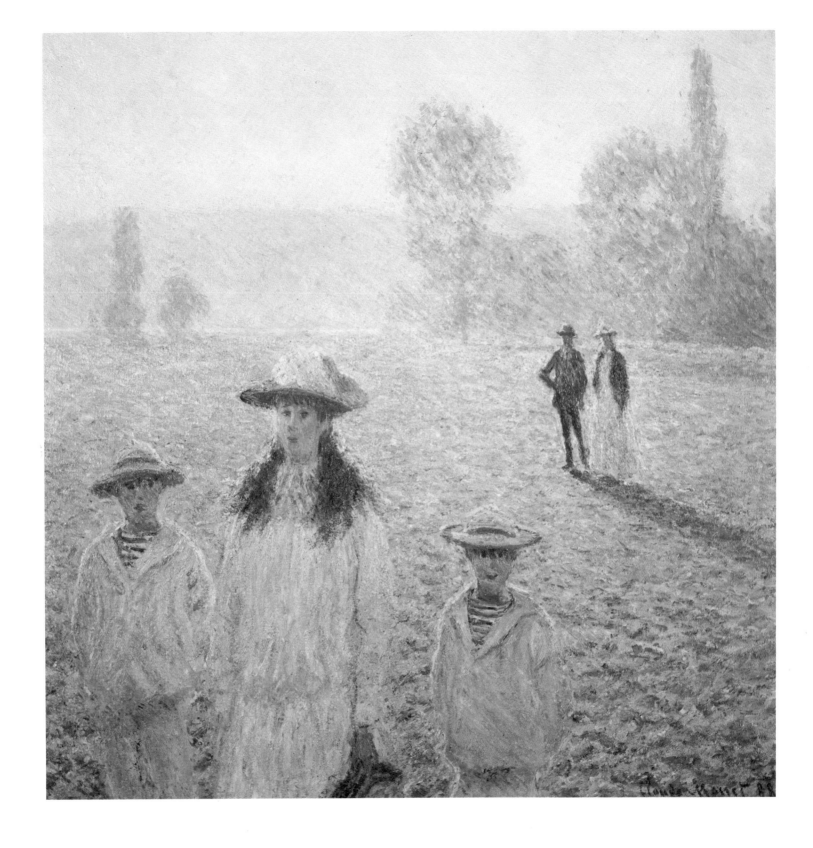

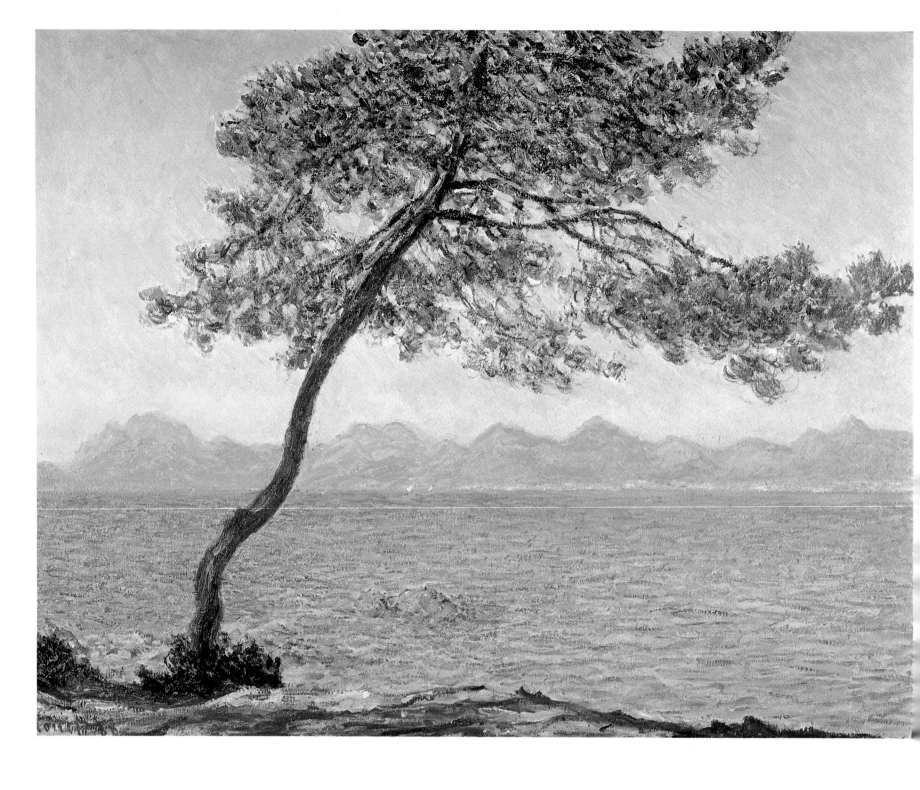

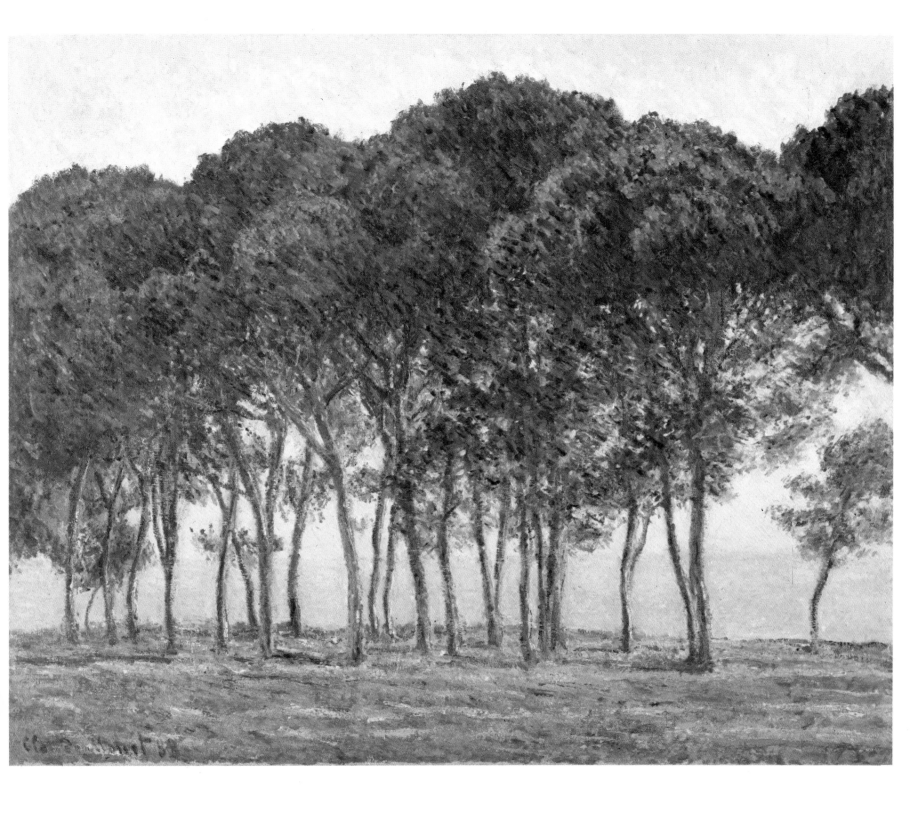

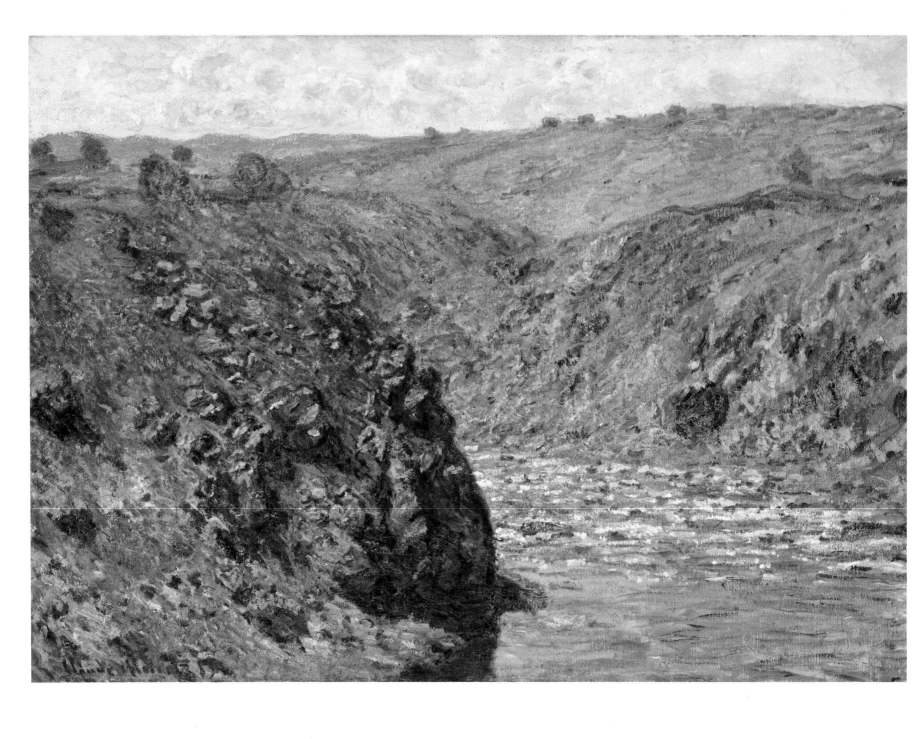

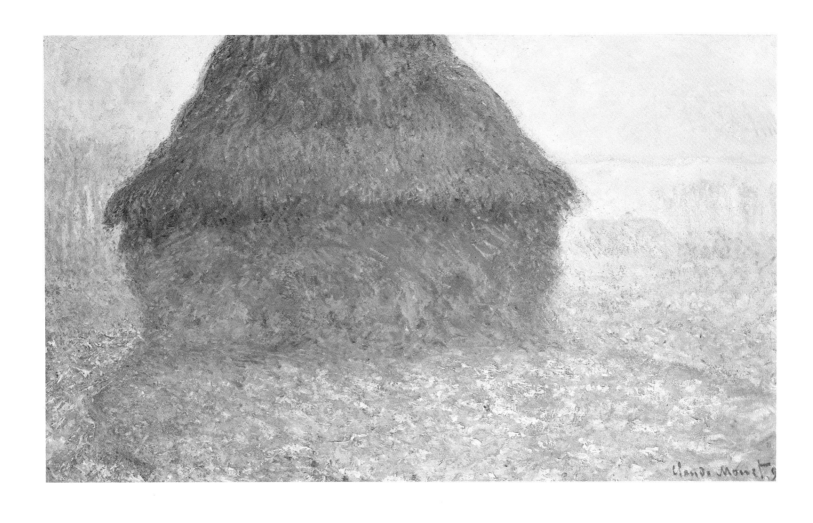

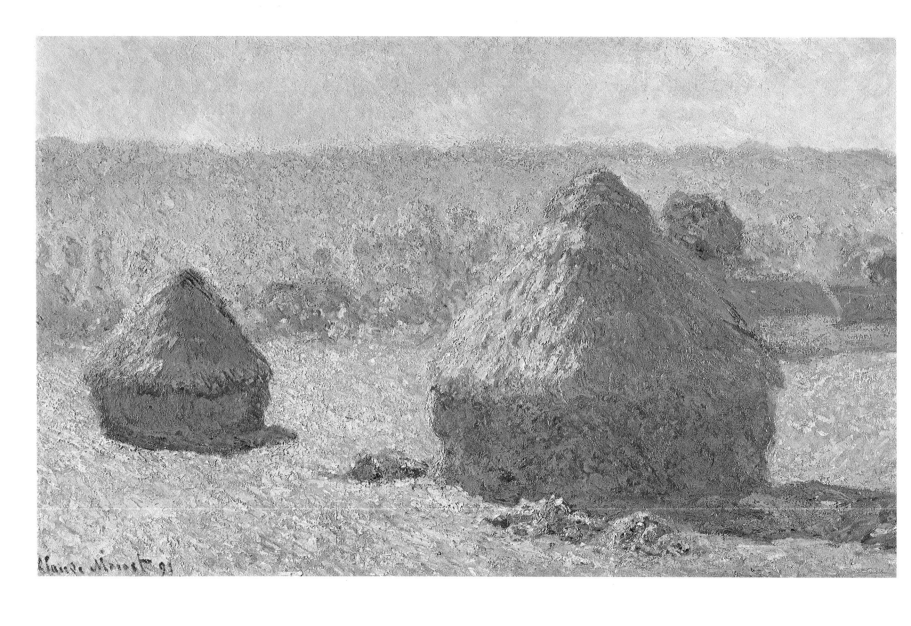

144

Previous spread (page 142):
94. **The Eaux-semblantes at Fresselines on the Creuse.** 1889. 26 × 36¾ in. Museum of Fine Arts, Boston

Previous spread (page 143):
95. **The Haystack.** 1891. 23⅝ × 39⅜ in. Kunsthaus, Zurich

Opposite (page 144): 96. **The Haystacks.** 1891. 23⅝ × 39⅜ in. Musée du Louvre, Paris (Jeu de Paume)

97. **Landscape with a Haystack.** 1891. 26 × 36¼ in. Museum of Fine Arts, Boston

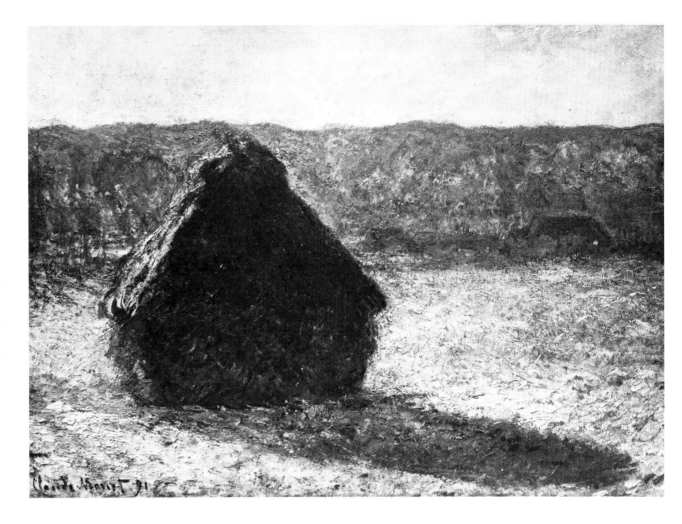

98. **Haystacks in the Snow.** 1891. 25½ × 39¼ in. National Gallery of Scotland, Edinburgh

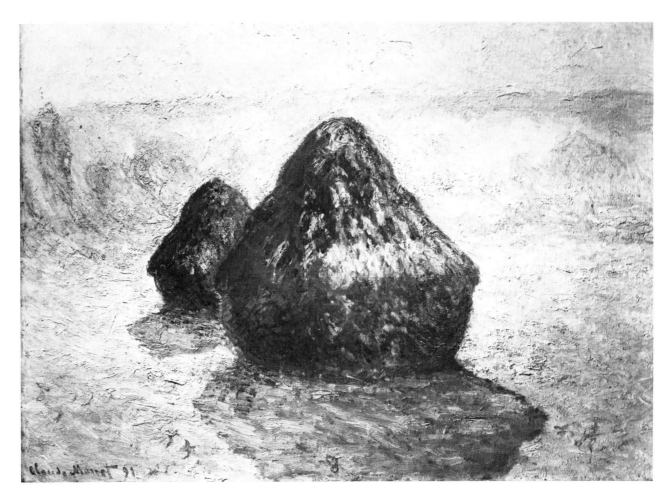

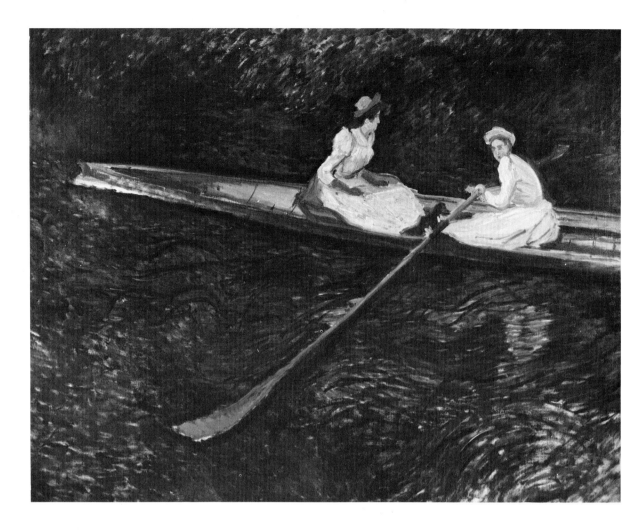

99. *The Pink Boat.* About 1887. 53 × 69 in. Mr and Mrs Richard K. Weil, Missouri

100. *Boating on the River Epte.* About 1887. $52\frac{1}{2}$ × 57 in. Museu de Arte, São Paulo, Brazil

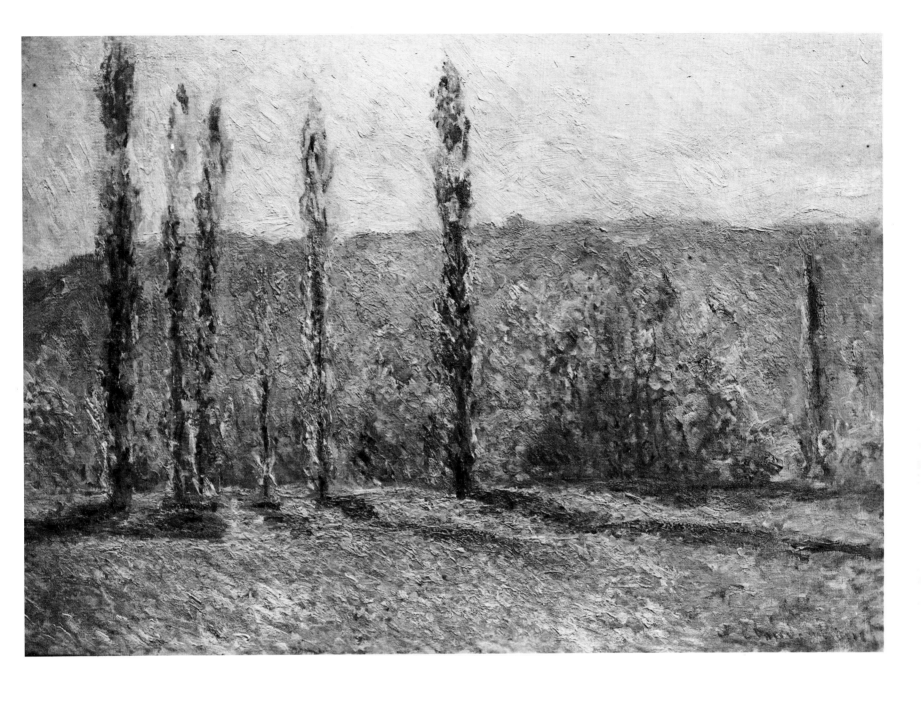

101. ***Poplars, Giverny.*** About 1890. $25\frac{1}{2} \times 35\frac{1}{2}$ in. Private
Collection, U.S.A.

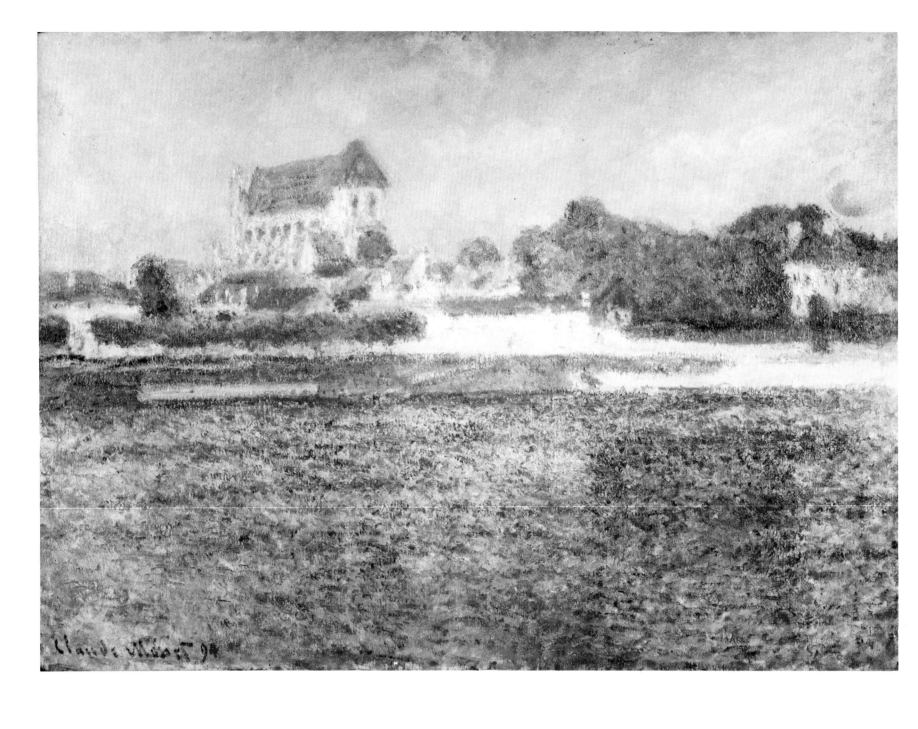

102. *The Church at Vernon.* 1894. 26 × 36½ in. Brooklyn
Museum, New York

148

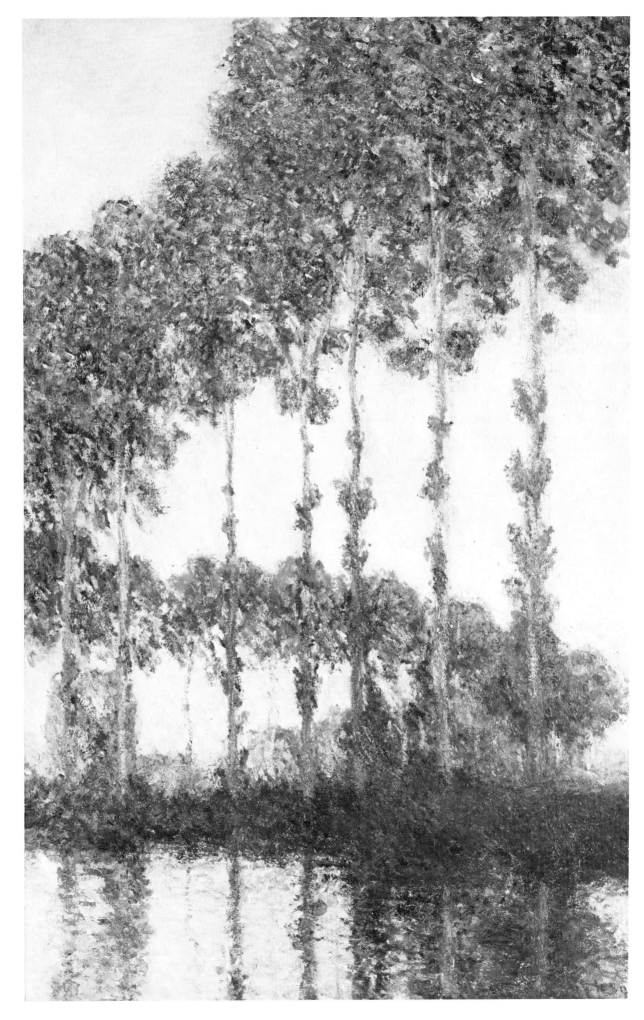

103. ***Poplars on the Epte, Sunset.***
1891. $39\frac{3}{8} \times 25\frac{5}{8}$ in. Mr and Mrs
David T. Schiff, New York

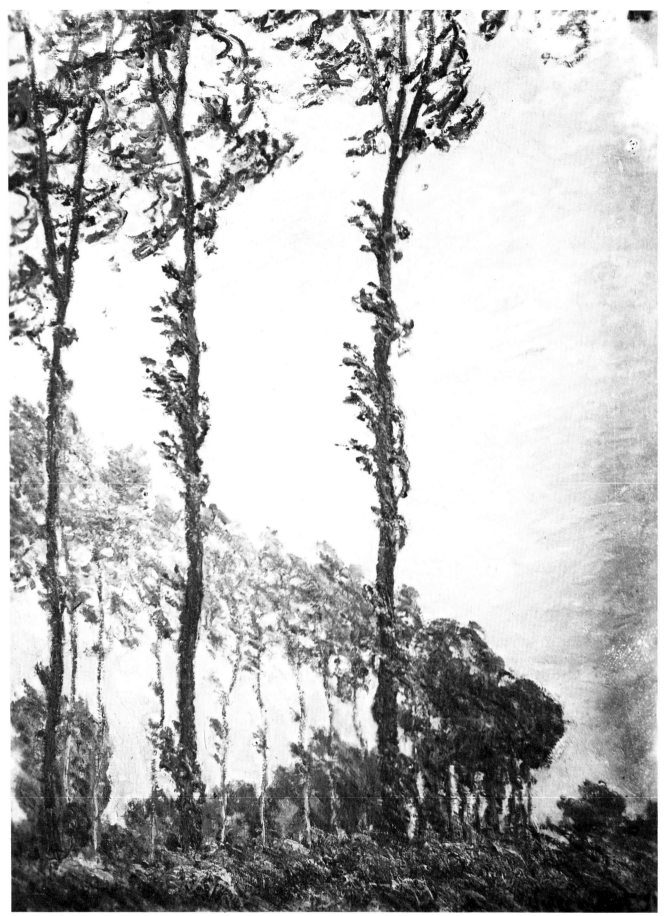

104. *Poplars, Wind Effect.*
1891. $39\frac{3}{8} \times 28\frac{3}{4}$ in. Durand-Ruel Collection, Paris

Opposite (page 151) : 105. **Poplars (Les Quatre Arbres).**
1891. $32\frac{1}{4} \times 32\frac{1}{8}$ in. Metropolitan Museum of Art, New York

Overleaf (page 152) : 106. **Poplars.** 1891. $36\frac{1}{4} \times 29$ in. Philadelphia Museum of Art

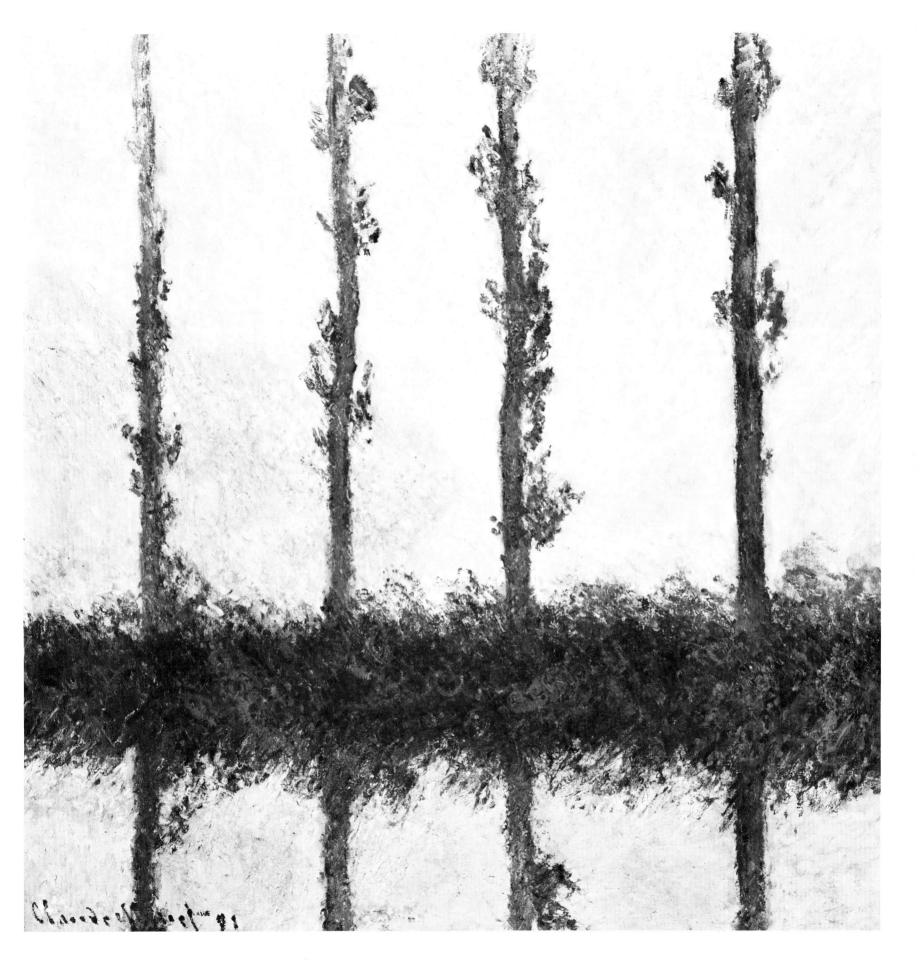

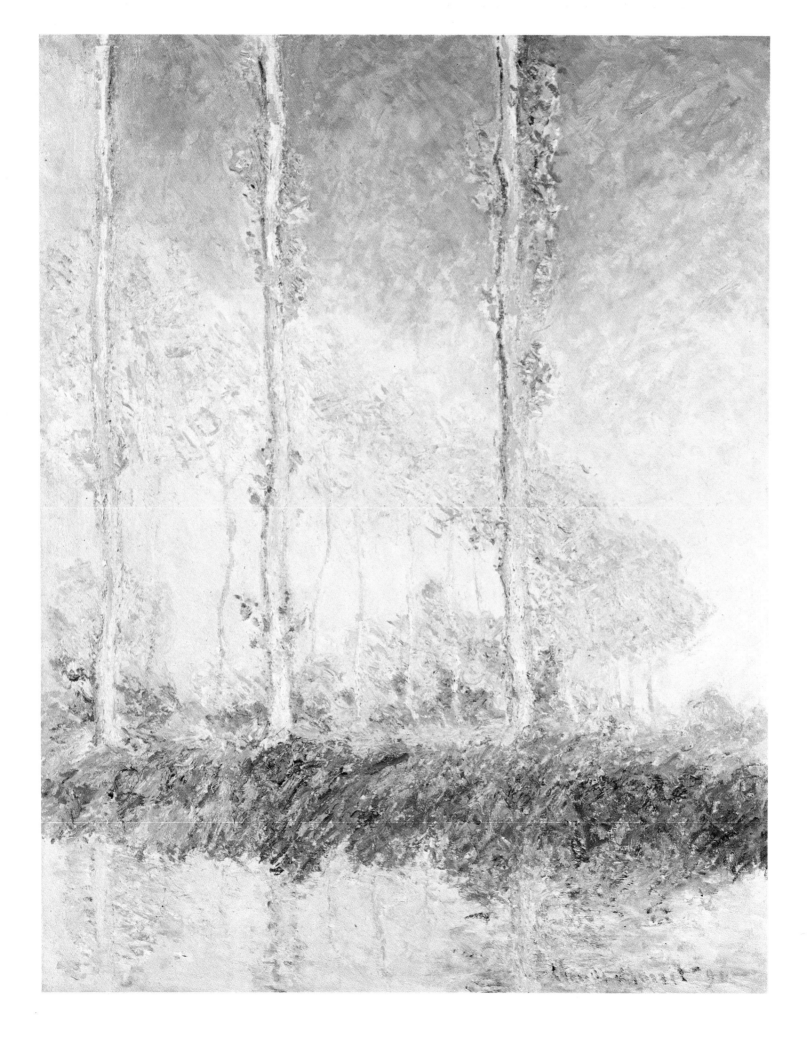

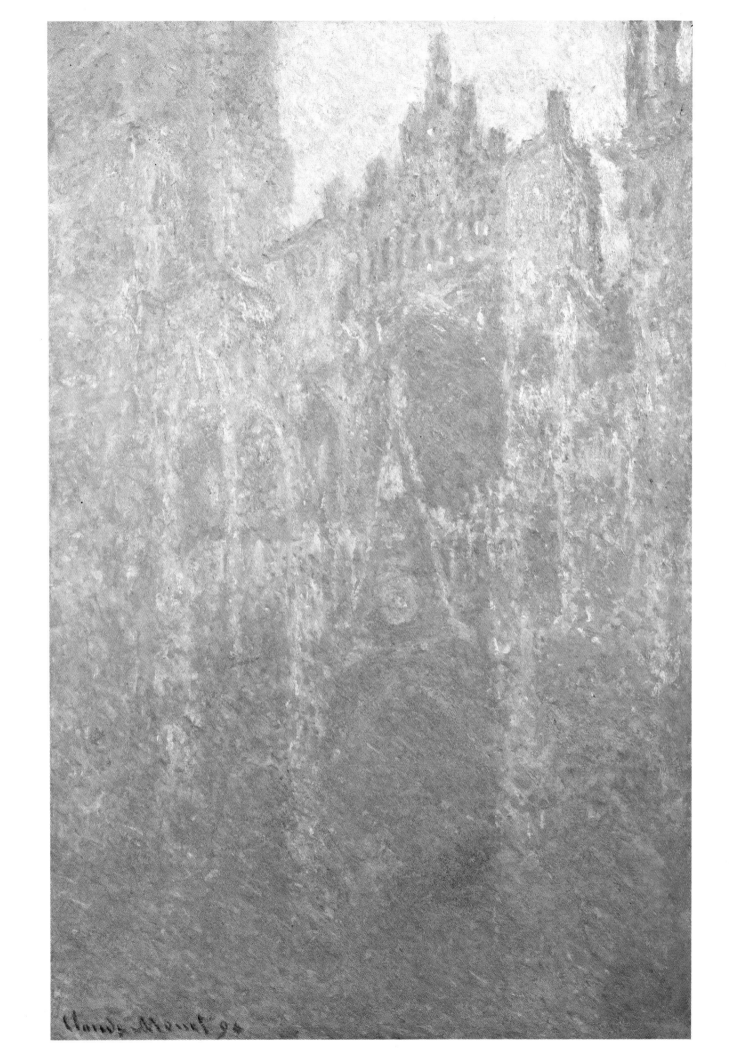

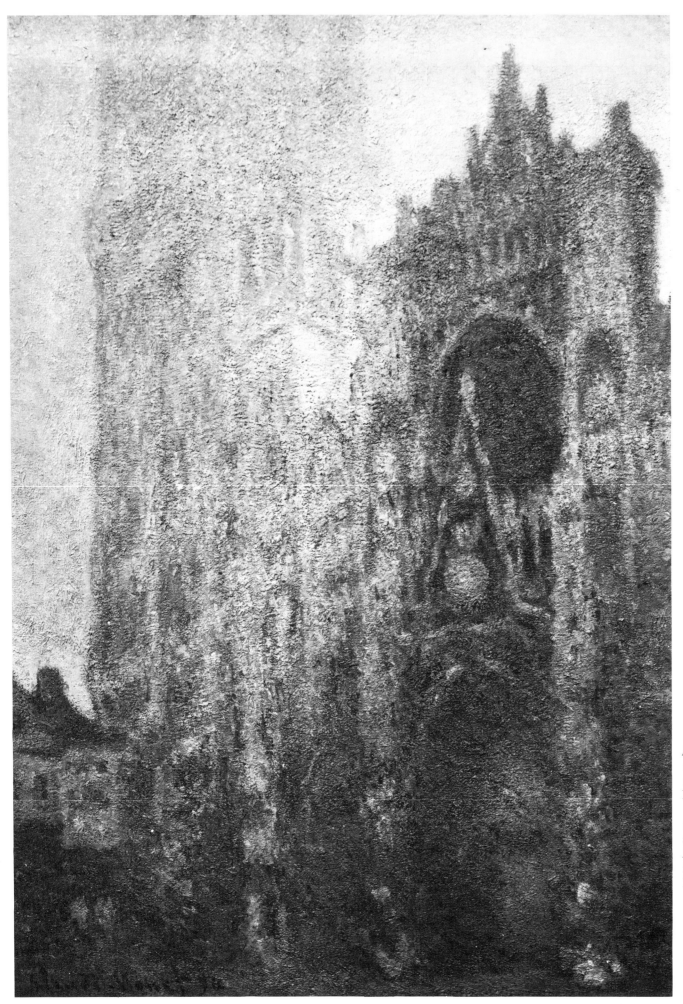

Previous page (page 153):
107. **Rouen Cathedral.** 1894. $39 \times 25\frac{1}{2}$ in. Museum Folkwang, Essen

108. **Rouen Cathedral and the Cour d'Albane, Early Morning.** 1894. $41\frac{3}{4} \times 29\frac{1}{8}$ in. Museum of Fine Arts, Boston

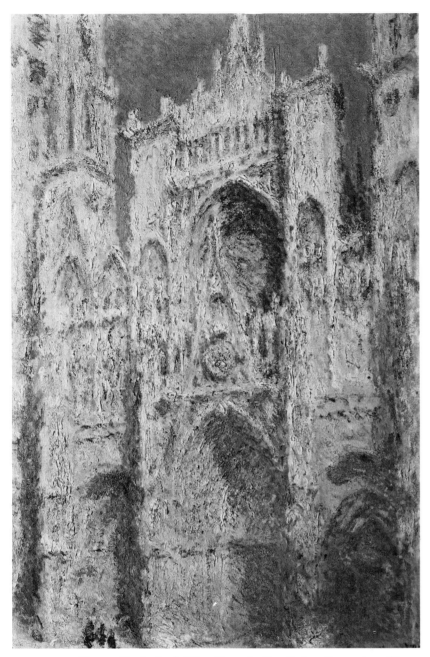

109. *Rouen Cathedral, West Façade, Sunlight.* 1894. $39\frac{1}{2} \times 26$ in.
National Gallery of Art, Washington, D.C.

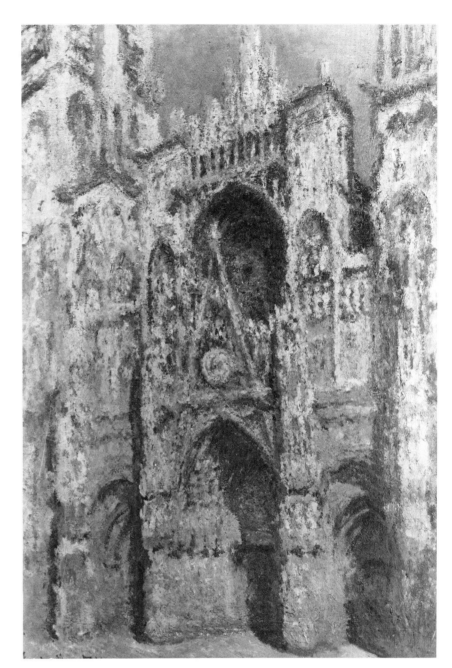

110. *Rouen Cathedral, Full Sunlight.* 1894. $42\frac{1}{8} \times 28\frac{3}{4}$
in. Musée du Louvre, Paris (Jeu de Paume)

Overleaf (page 156): 111. *Branch of the Seine near
Giverny.* 1897. $34\frac{1}{4} \times 38\frac{1}{2}$ in. Museum of Fine Arts, Boston

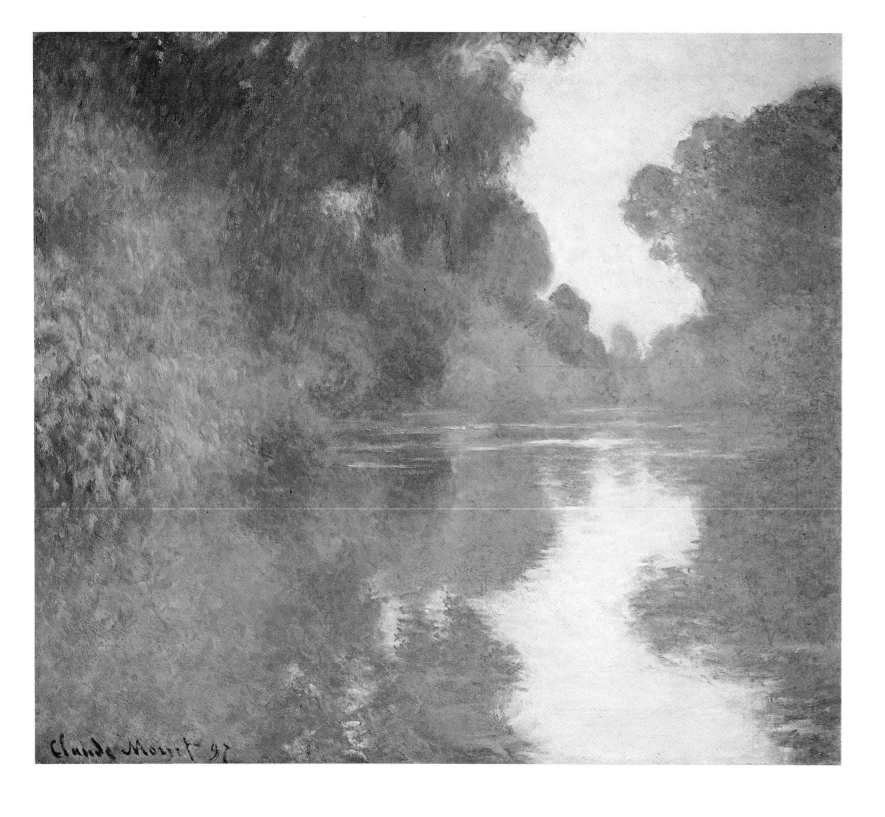

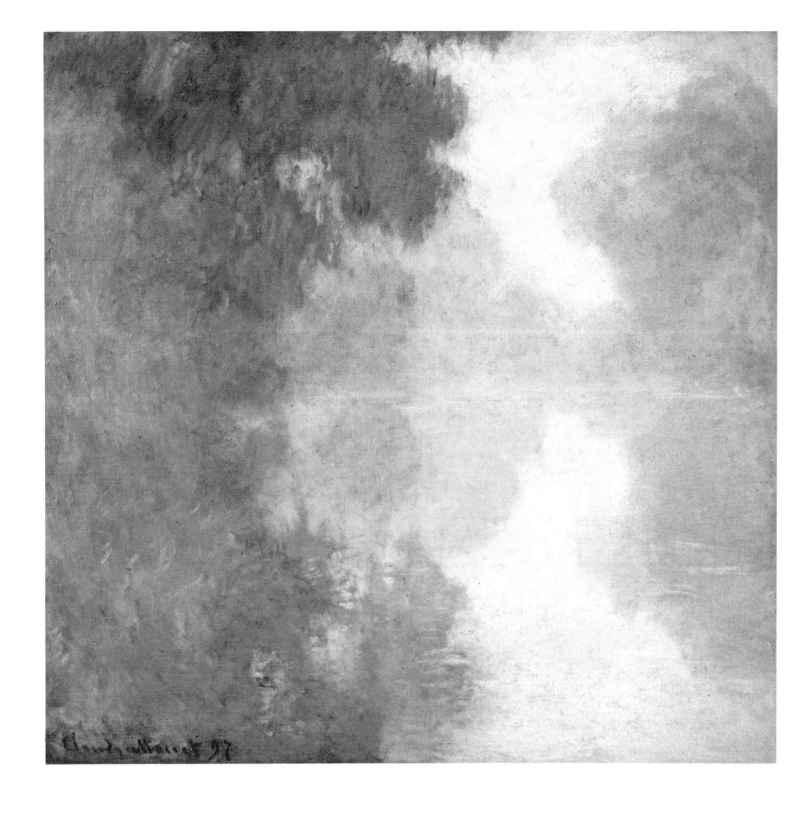

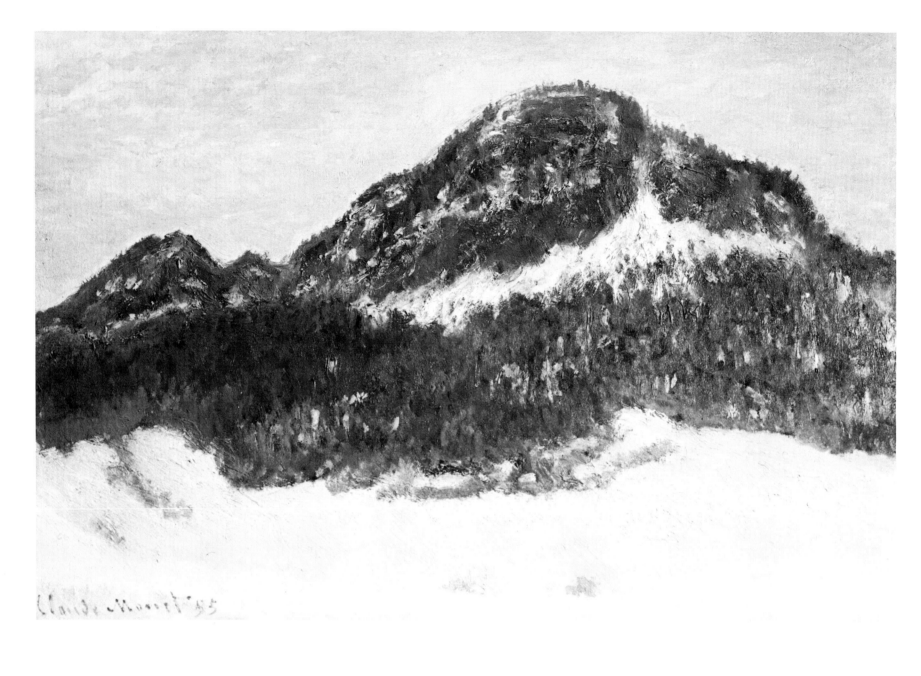

Previous page (page 157): 112. **Morning Mists.** 1897. 35 × 36 in. North Carolina Museum of Art, Raleigh

113. **Mount Kolsaas, Norway.** 1895. 25½ × 39 in. Mr and Mrs Nathan Cummings, New York

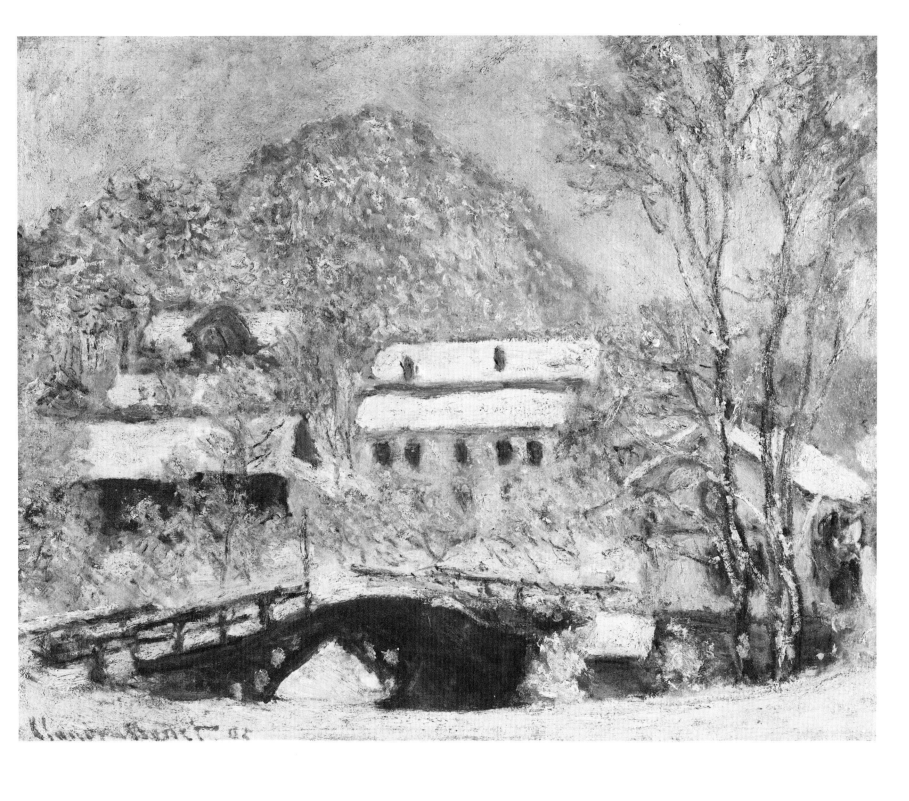

114. **Sandvika, Norway.** 1895. $28\frac{7}{8} \times 36\frac{3}{8}$ in. Art Institute of Chicago

Overleaf (page 160): 115. **The Seine at Port-Villez.** 1894. $25\frac{3}{4} \times 39\frac{1}{2}$ in. Tate Gallery, London

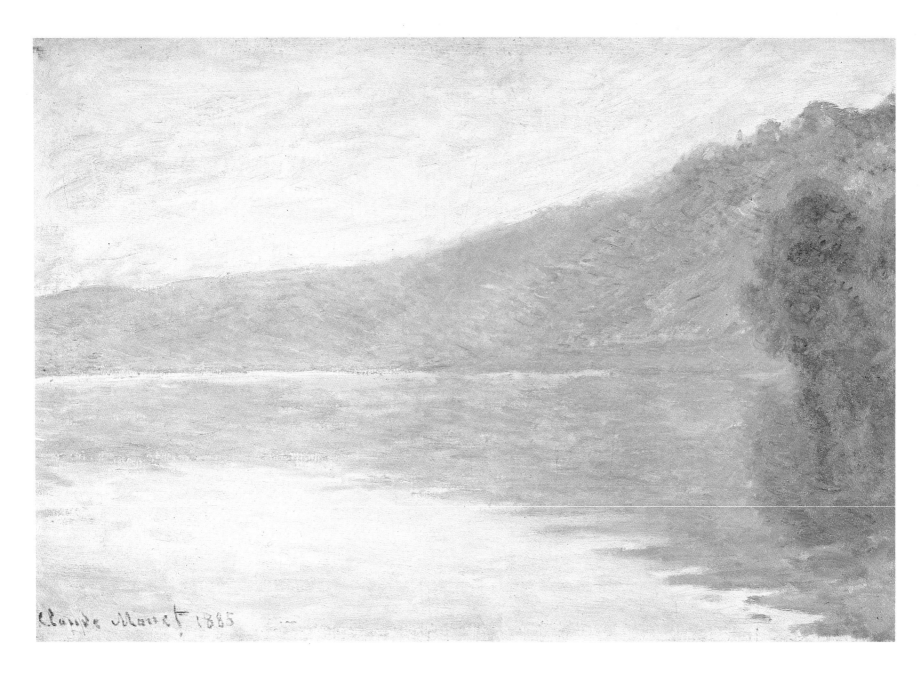

160

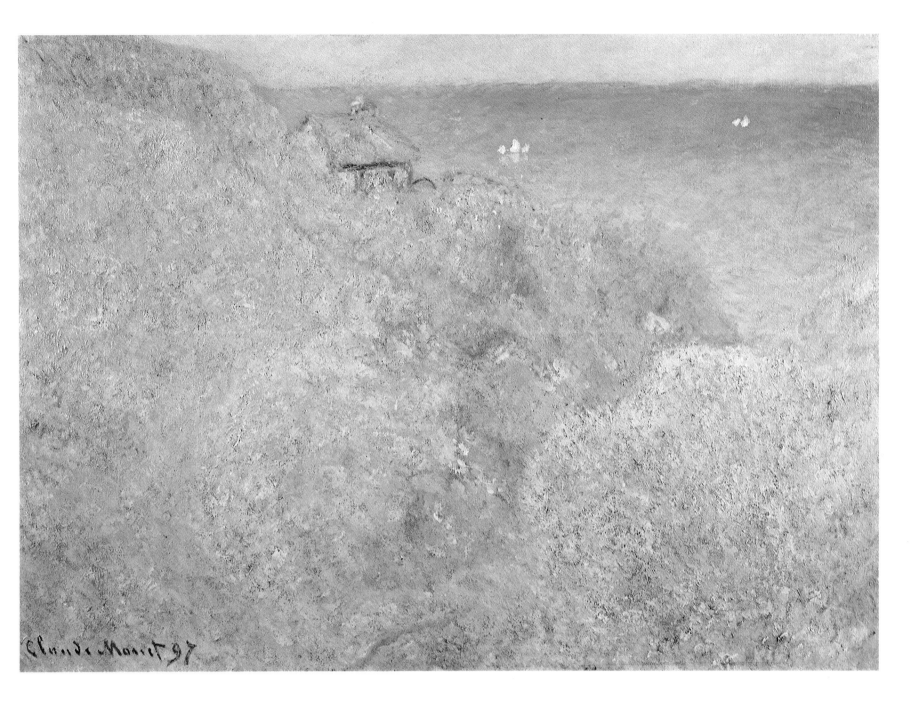

Previous page (page 161): 116. **Cliffs at Varengeville.** 1897.
25⅜ × 36¼ in. Musée des Beaux-Arts, Le Havre 117. **Cliffs near Dieppe.** 1897. 25 × 38¾ in. Private Collection

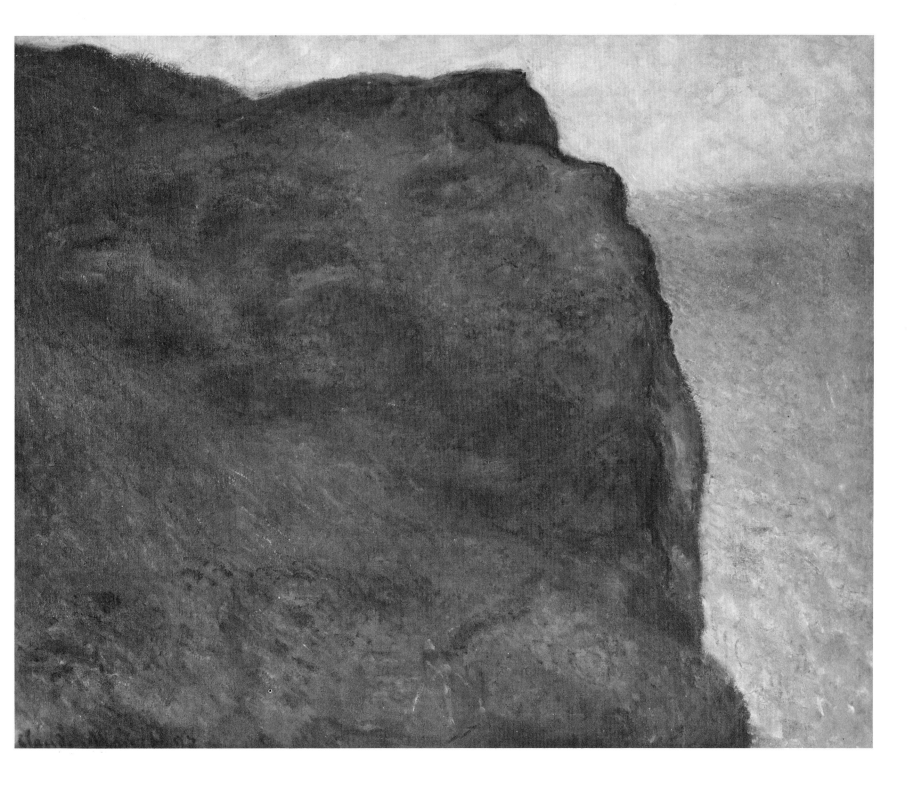

118. *The Cliff, Varengeville.* 1897. 29 × 36 in. Mr and Mrs
David Lloyd Kreeger, Washington, D.C.

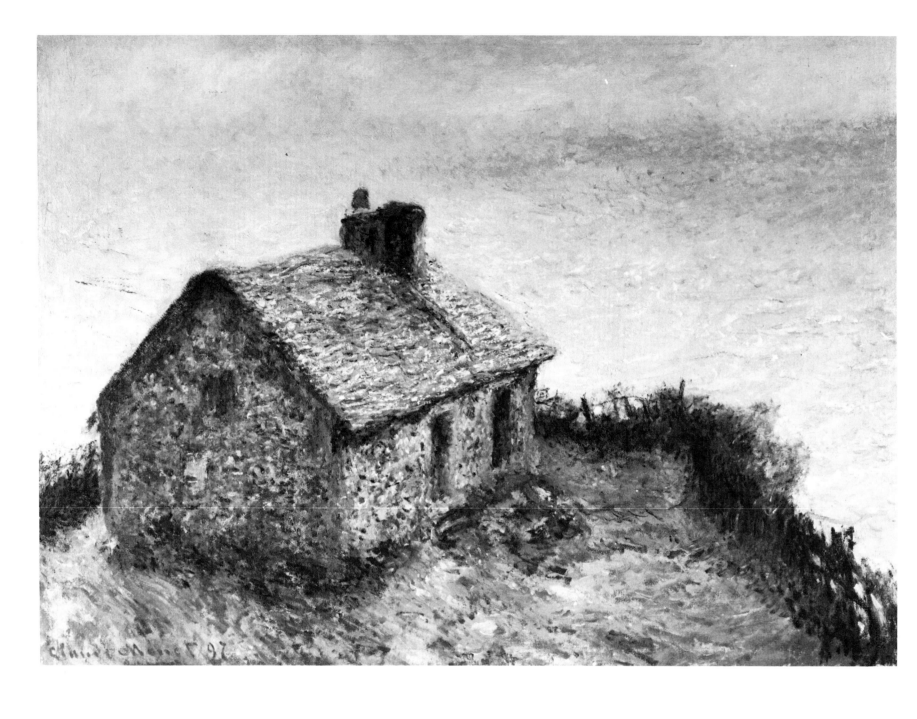

119. ***The Douanier's Cottage at Varengeville.*** 1897.
26 × 36½ in. Art Institute of Chicago

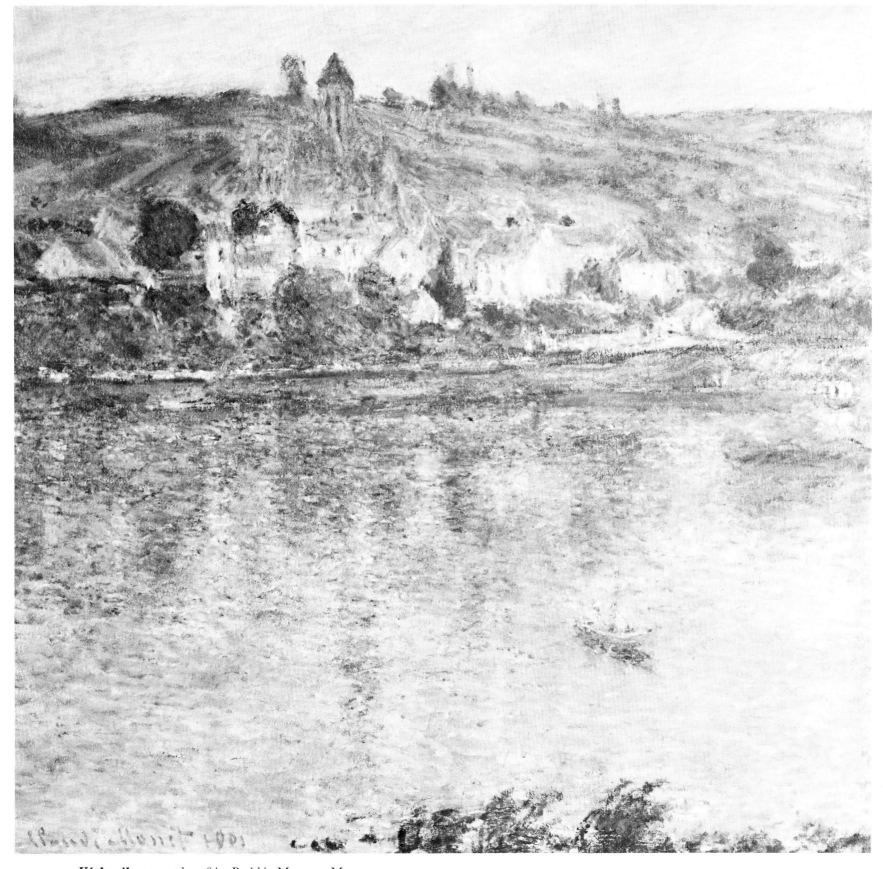

120. *Vétheuil.* 1901. $35\frac{1}{2} \times 36$ in. Pushkin Museum, Moscow

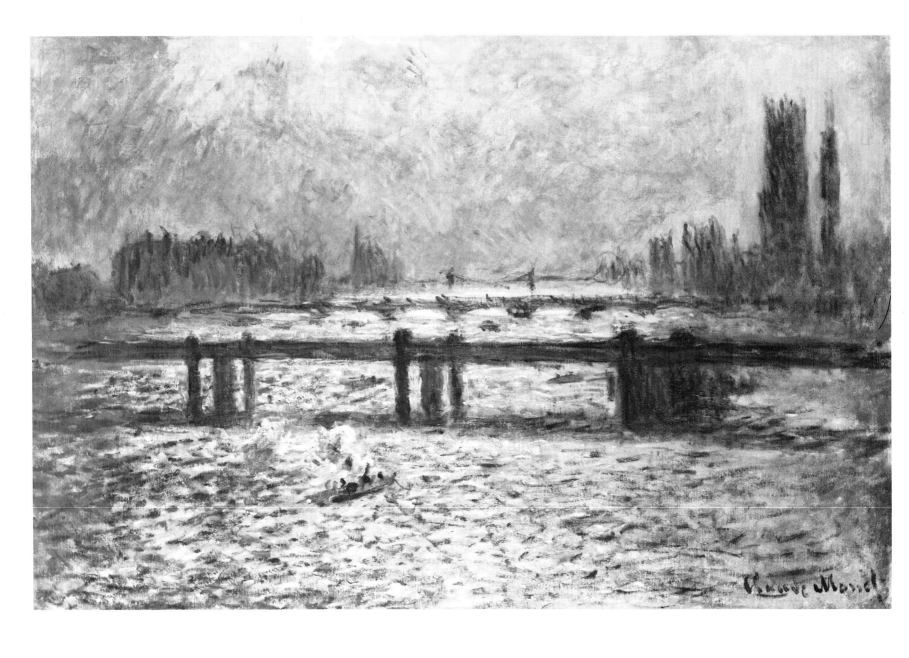

121. *Charing Cross Bridge and Westminster.* 1902.
$25\frac{3}{4} \times 39\frac{1}{2}$ in. Baltimore Museum of Art

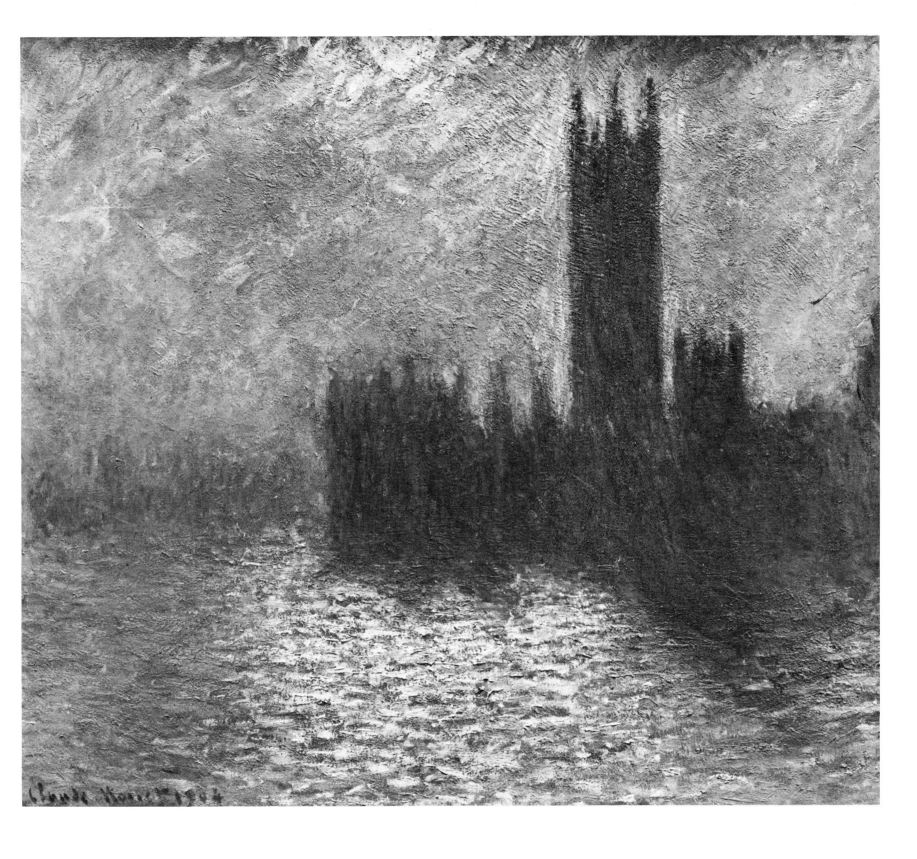

122. *The Houses of Parliament, Stormy Sky.* 1904.
$32\frac{1}{8} \times 36\frac{1}{4}$ in. Musée des Beaux-Arts, Lille

167

123. *Leicester Square by Night.* About 1901–4. $31\frac{1}{2} \times 25\frac{1}{4}$ in. Private Collection, France

Opposite (page 169):
124. *Waterloo Bridge, London.* 1903. $25\frac{3}{8} \times 39\frac{1}{2}$ in. Museum of Art, Carnegie Institute, Pittsburgh

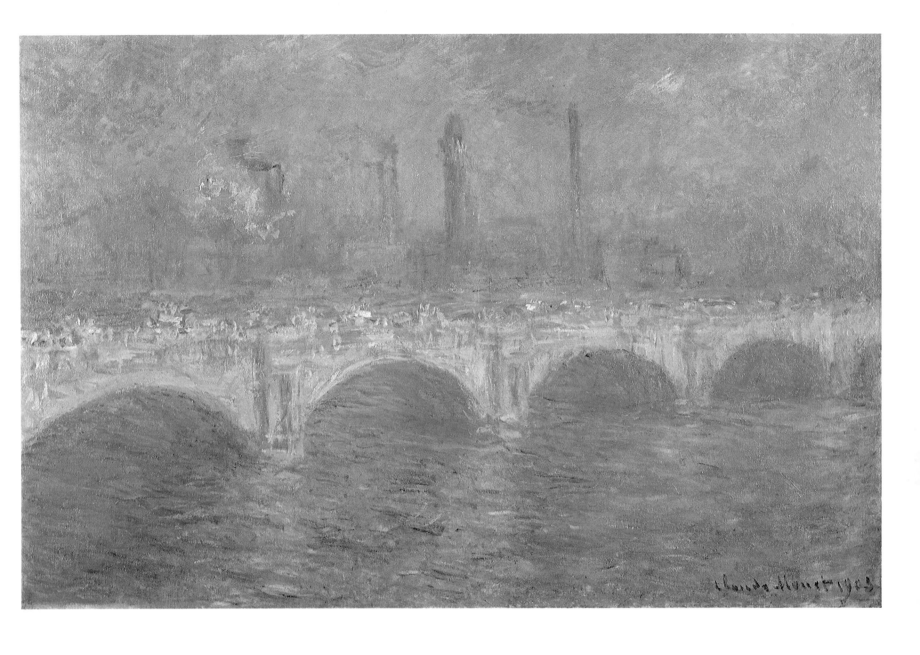

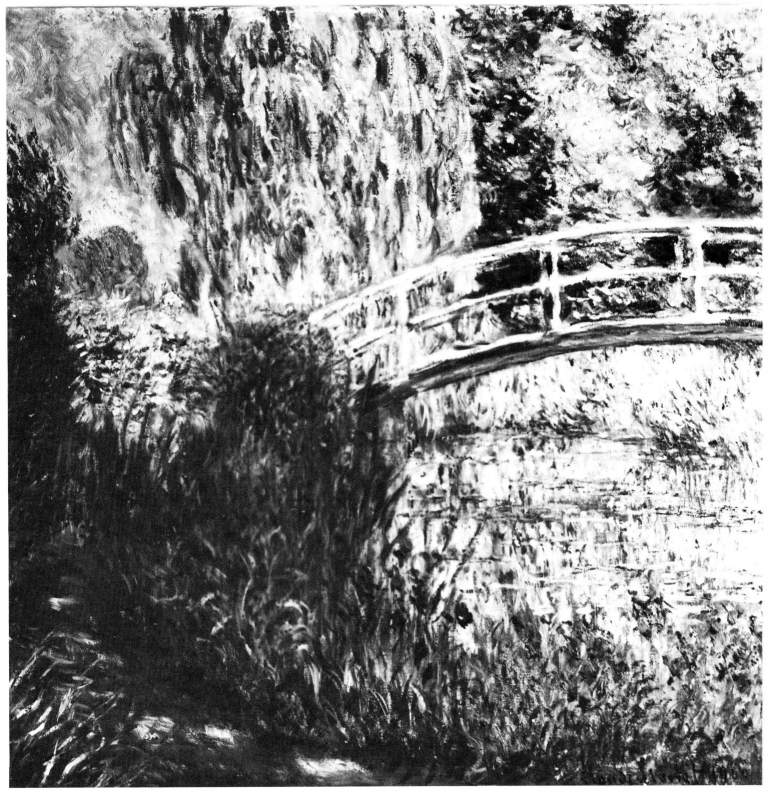

126. **Water-lily Pond, the Water Irises.** 1900. 35 × 36¼ in. Private Collection, Paris

Opposite (page 170): 125. **The Artist's House at Giverny.** About 1902. 28¾ × 28¾ in. Private Collection

Overleaf (page 172): 127. **The Japanese Bridge.** 1899. 35⅛ × 36¾ in. Philadelphia Museum of Art

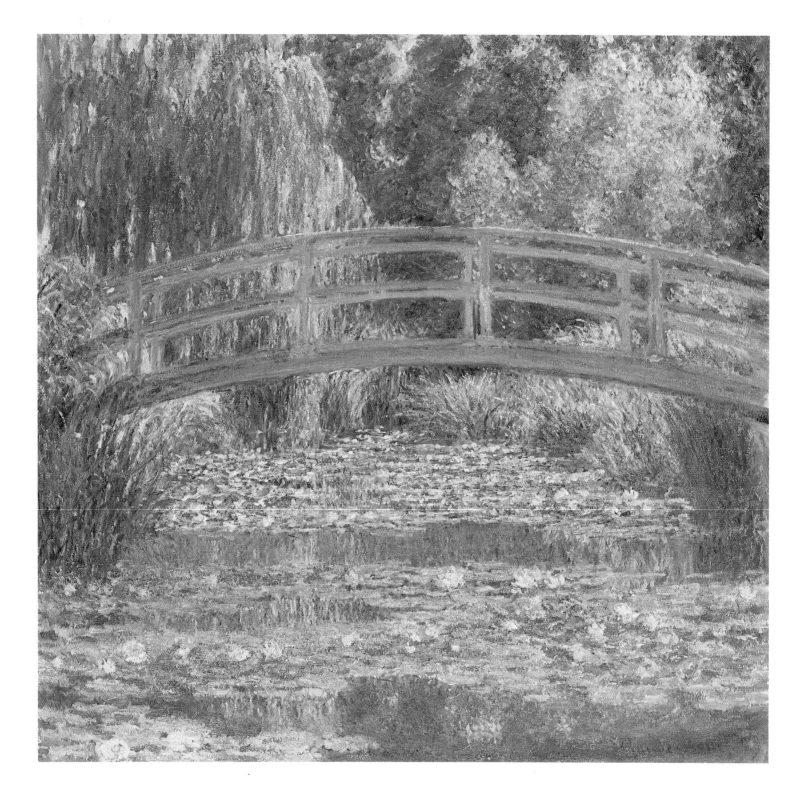

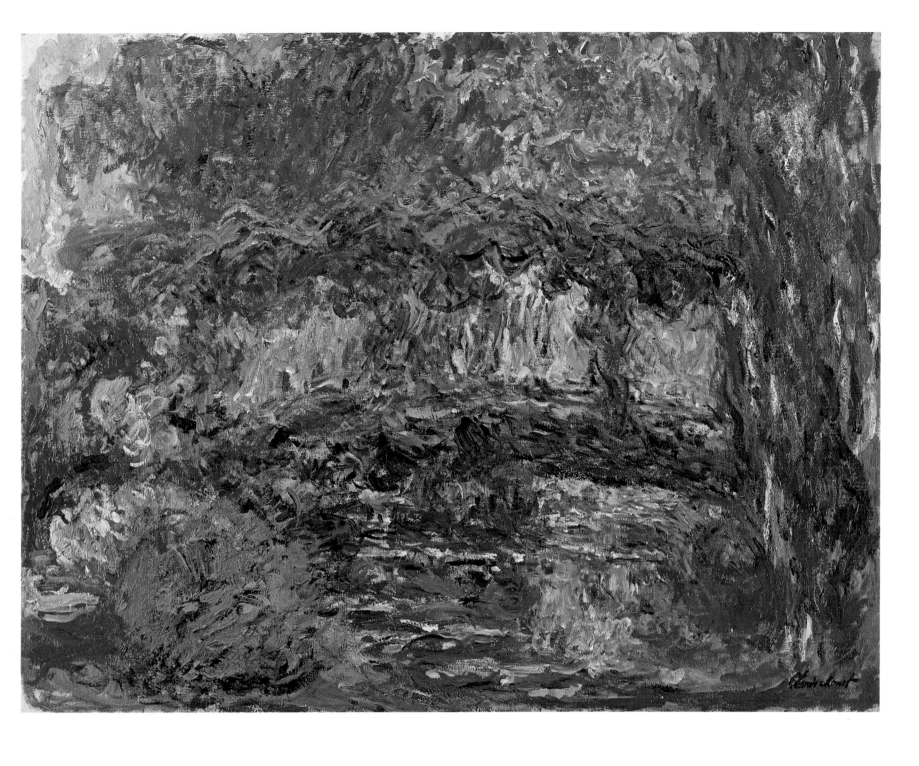

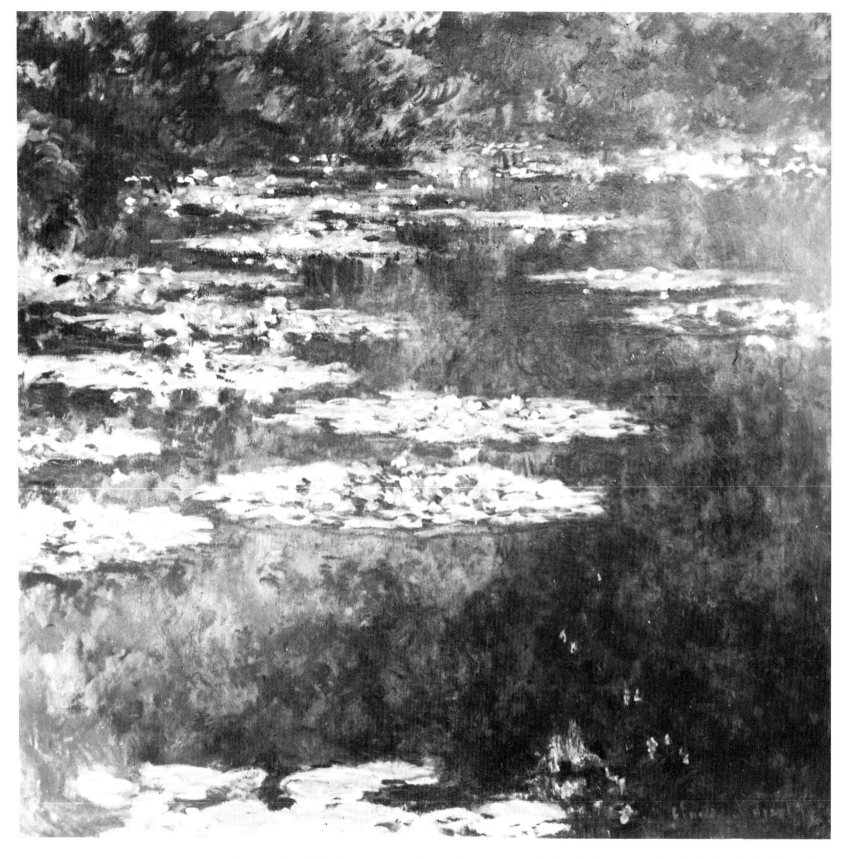

Previous page (page 173) : 128. **The Japanese Bridge.** About 1923–5. 35⅛ × 45¾ in. Minneapolis Institute of Arts

129. **Water-lilies.** 1904. 31⅝ × 36¼ in. Musée des Beaux-Arts, Le Havre

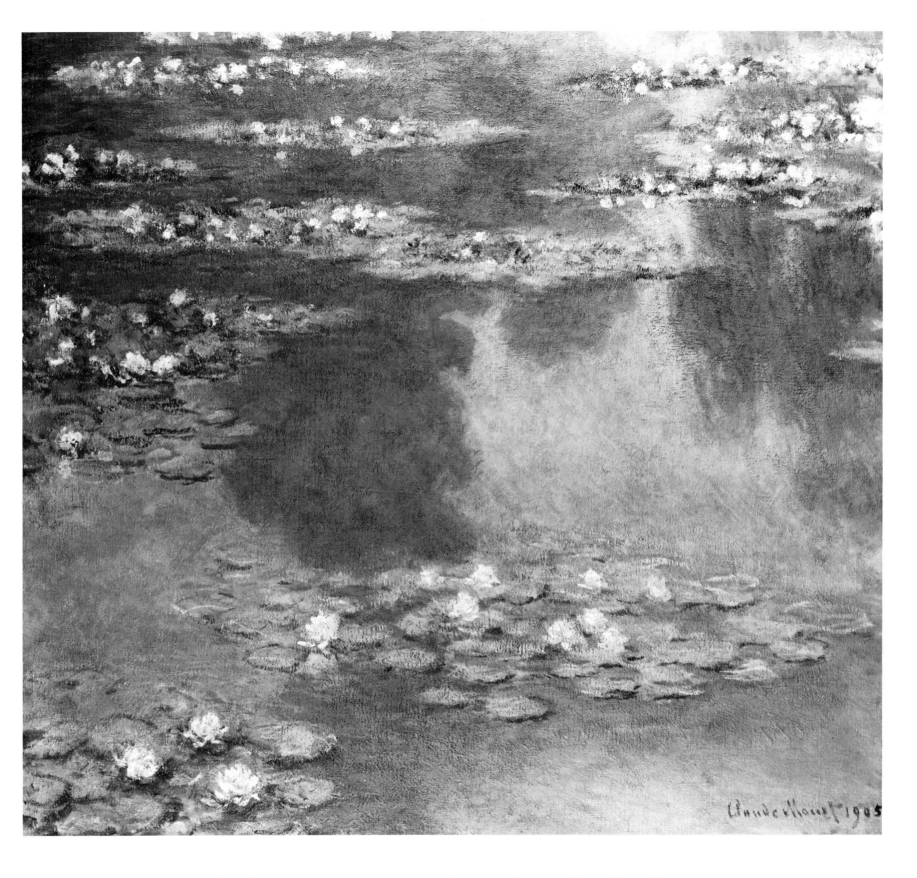

130. **Water-lilies.** 1905. $35\frac{1}{2} \times 39\frac{3}{8}$ in. Museum of Fine Arts, Boston

Overleaf (page 176): 131. **Water-lilies.** About 1920–2. $78\frac{3}{4} \times 167\frac{3}{4}$ in. Cleveland Museum of Art

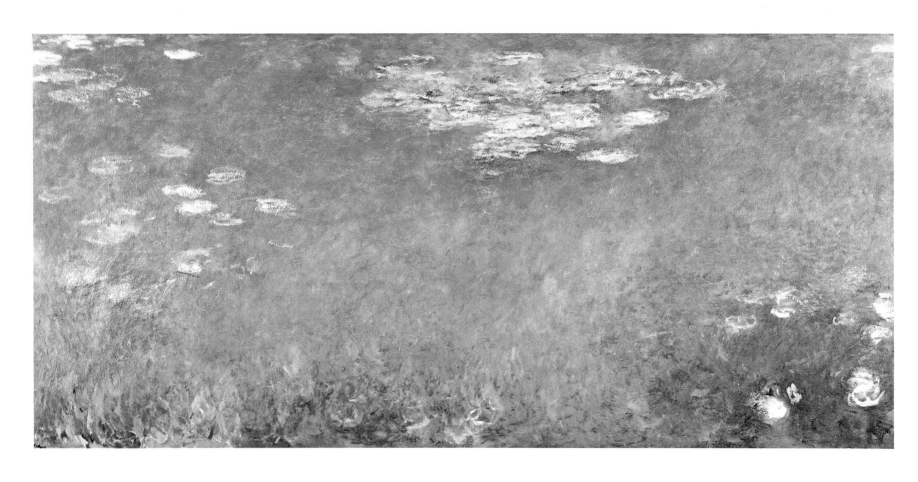

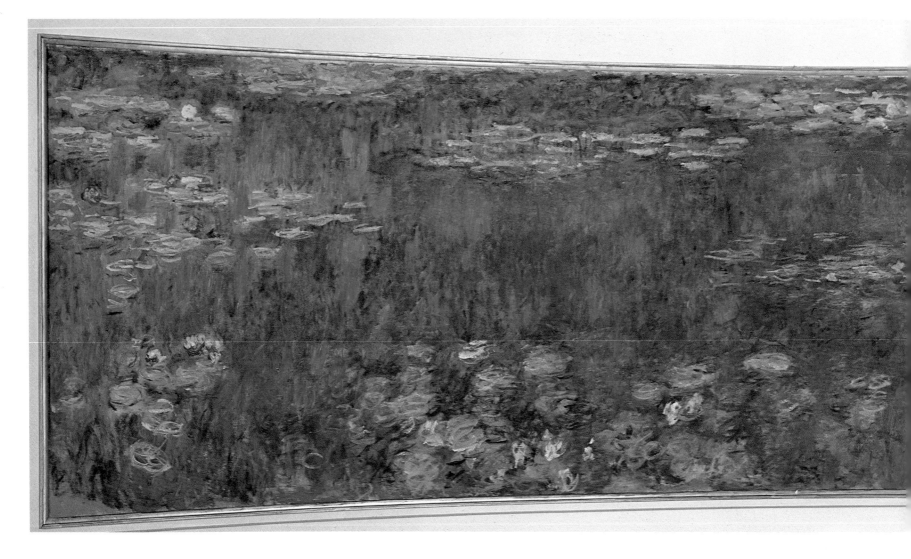

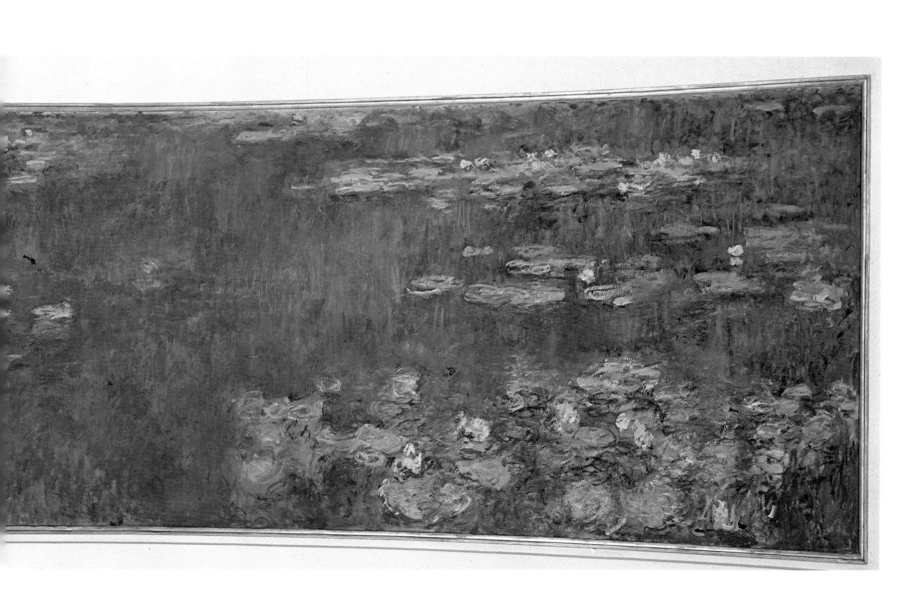

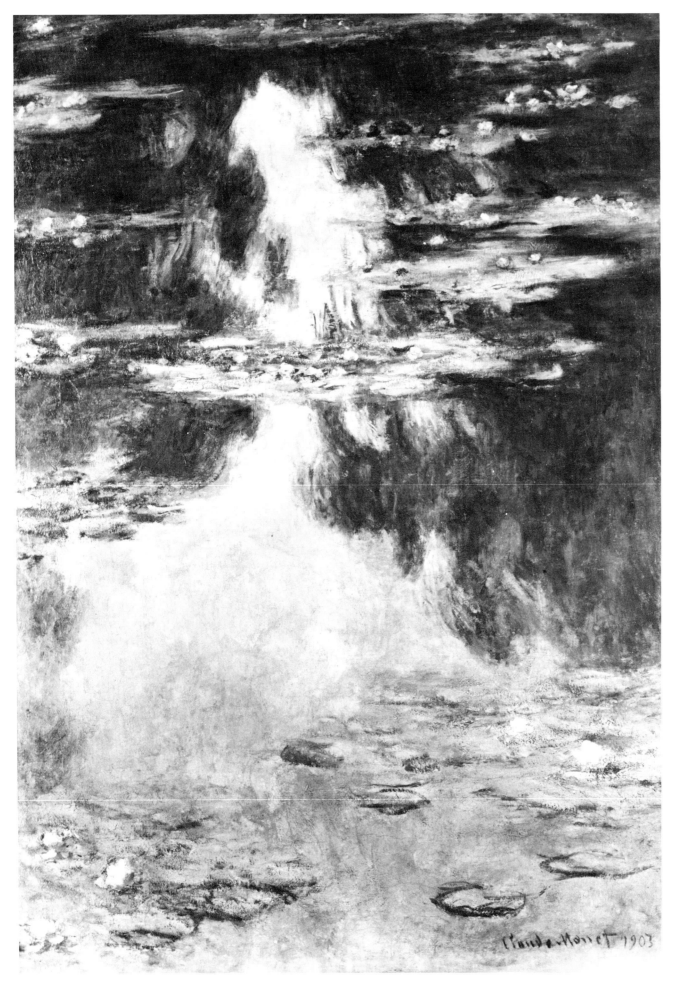

Claude Monet 1903

Previous page (page 177):
132. **Green Reflections.** (Room 1, east panel). 1916–23. $77\frac{1}{2} \times 27$ ft. $10\frac{1}{2}$ in. Musée de l'Orangerie, Paris

133. **Water-lilies.** 1907. $35 \times 28\frac{1}{2}$ in. Private Collection, New York

Opposite (page 179):
134. **Water-lilies.** 1908. $36\frac{1}{4} \times 35$ in. Private Collection, Zurich

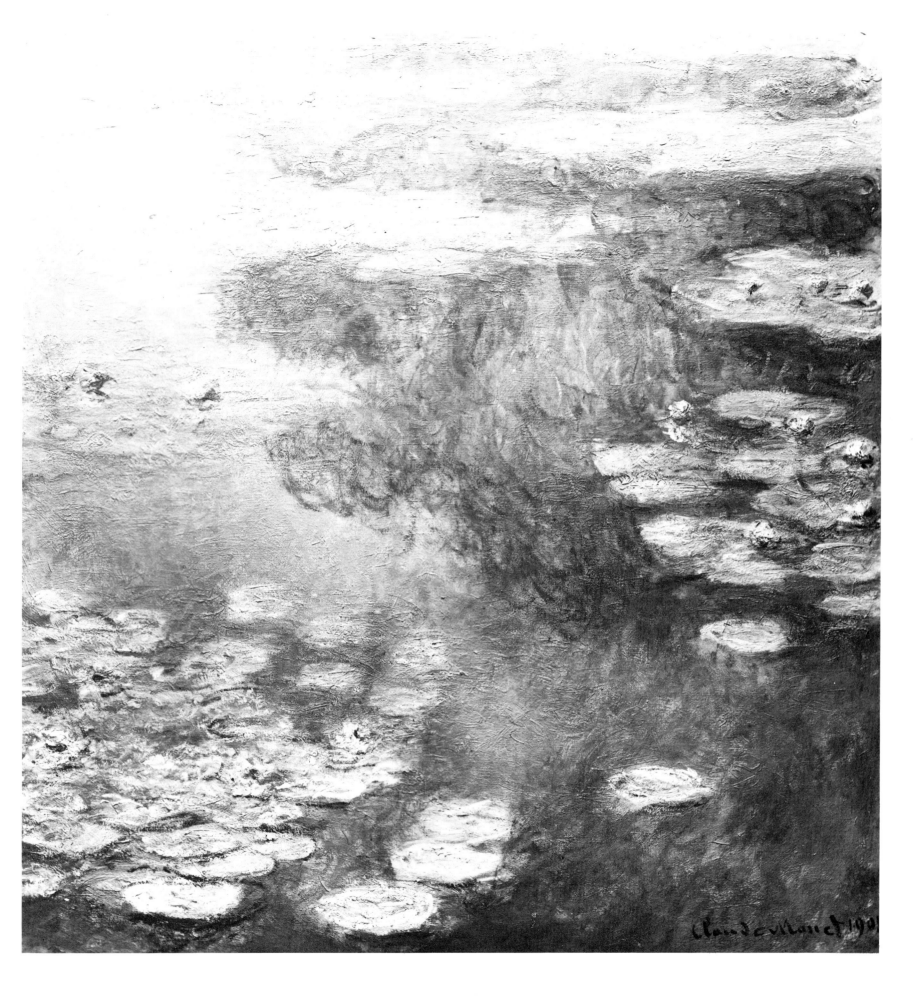

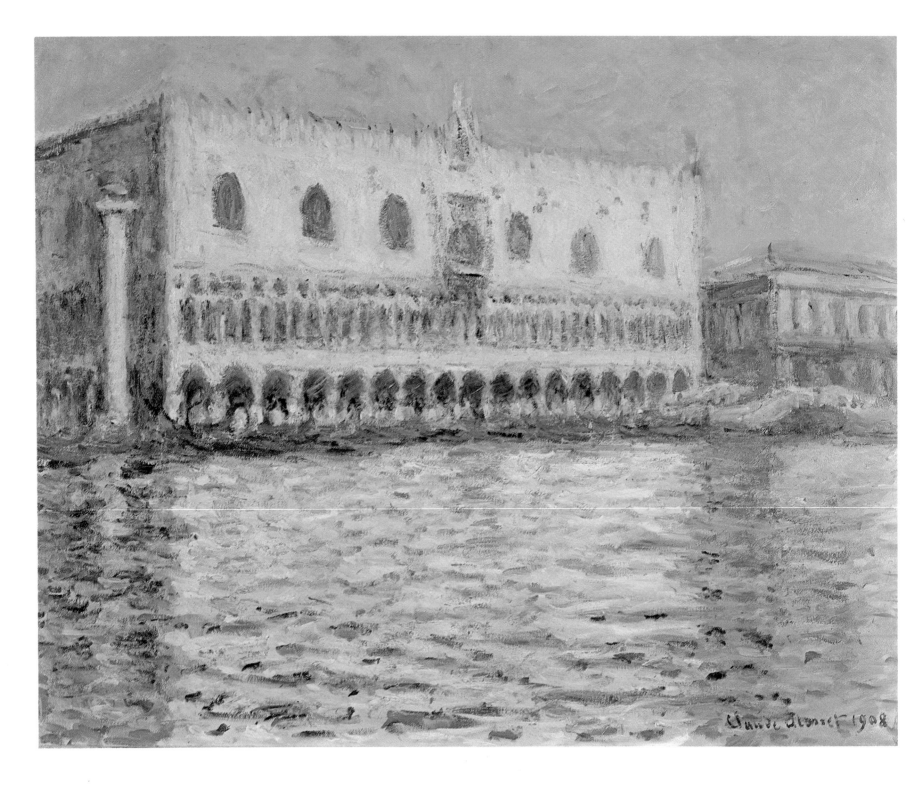

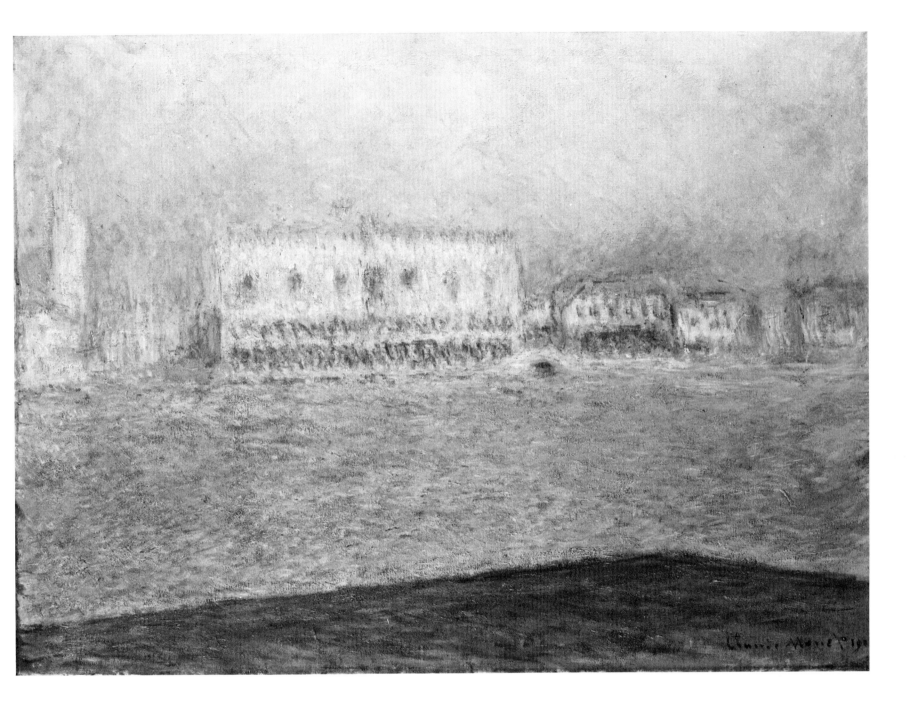

Opposite (page 180): 135. **The Doge's Palace, Venice.** 1908–12. $28\frac{1}{2} \times 36\frac{1}{4}$ in. Kunsthaus, Zurich (on loan)

136. **The Doge's Palace, Venice, seen from San Giorgio Maggiore.** 1908–12. $25\frac{3}{4} \times 36\frac{1}{2}$ in. Metropolitan Museum of Art, New York

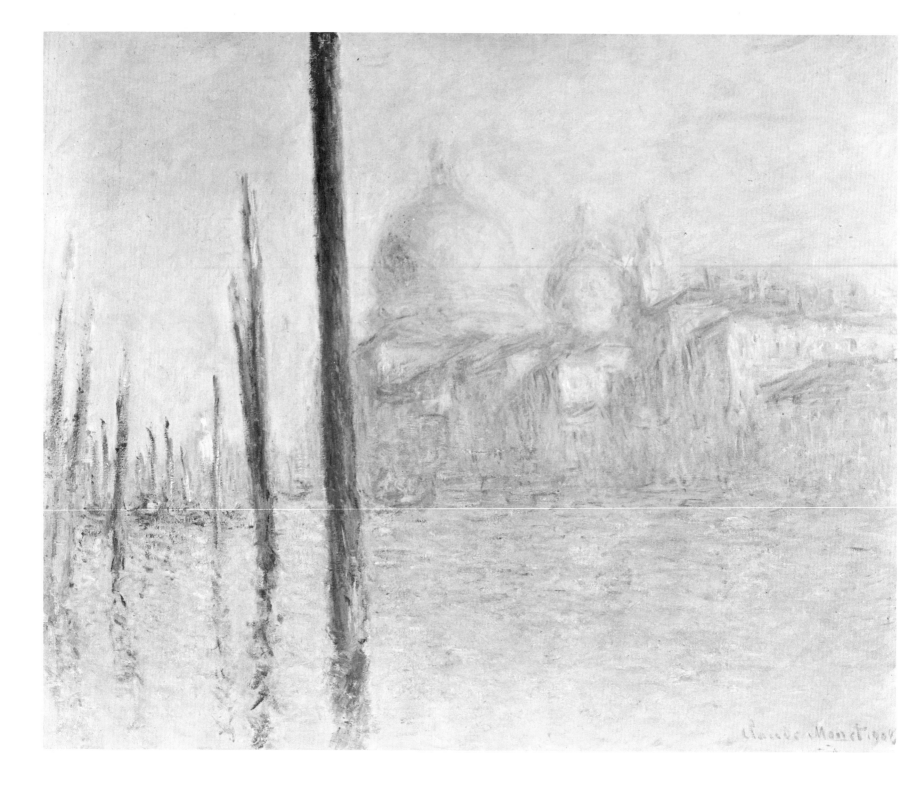

137. ***Grand Canal, Venice.*** 1908–12. 28⅞ × 36⅜ in. California
Palace of the Legion of Honor, San Francisco

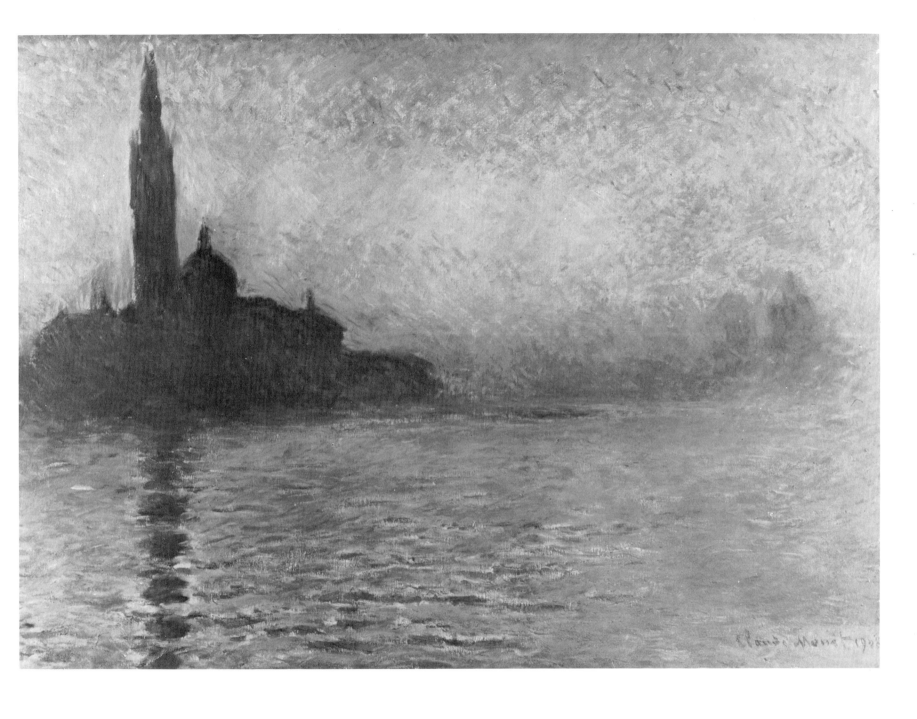

138. *Twilight, San Giorgio Maggiore.* 1908–12. 25¾ ×
36⅜ in. National Museum of Wales, Cardiff

183

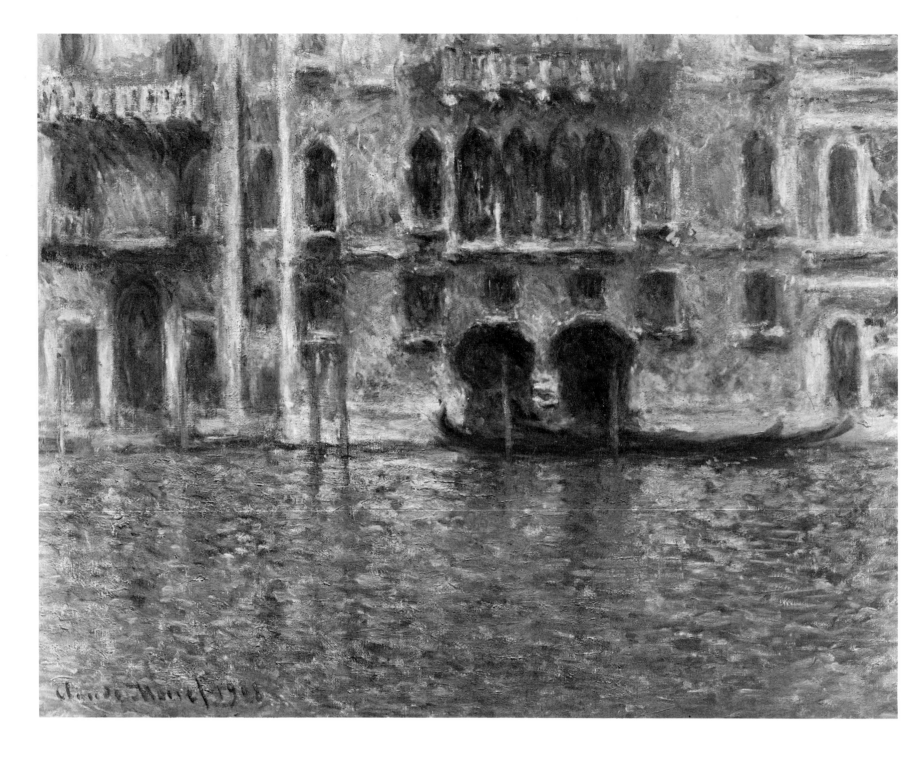

139. *Palazzo da Mula, Venice.* 1908–12. $24\frac{1}{2} \times 31\frac{7}{8}$ in.
National Gallery of Art, Washington, D.C.

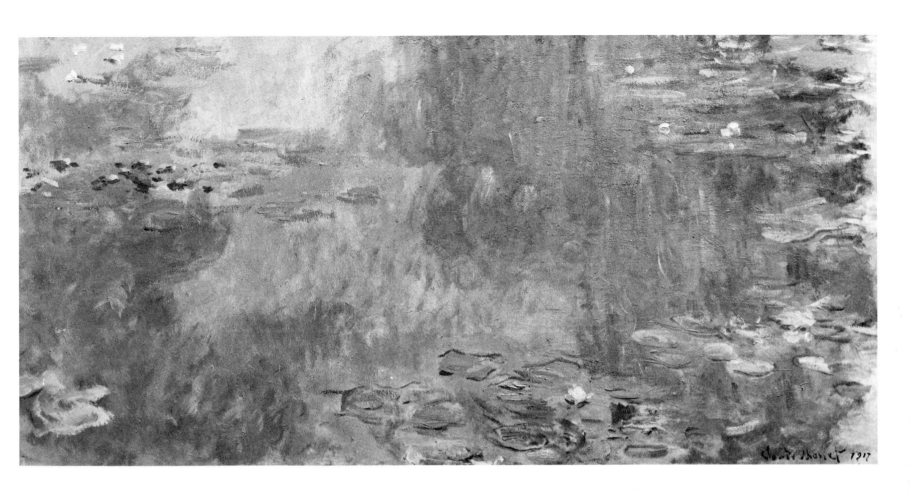

140. ***Water-lilies***. 1917. $39\frac{3}{8} \times 78\frac{3}{4}$ in. Musée des Beaux-Arts,
Nantes

185

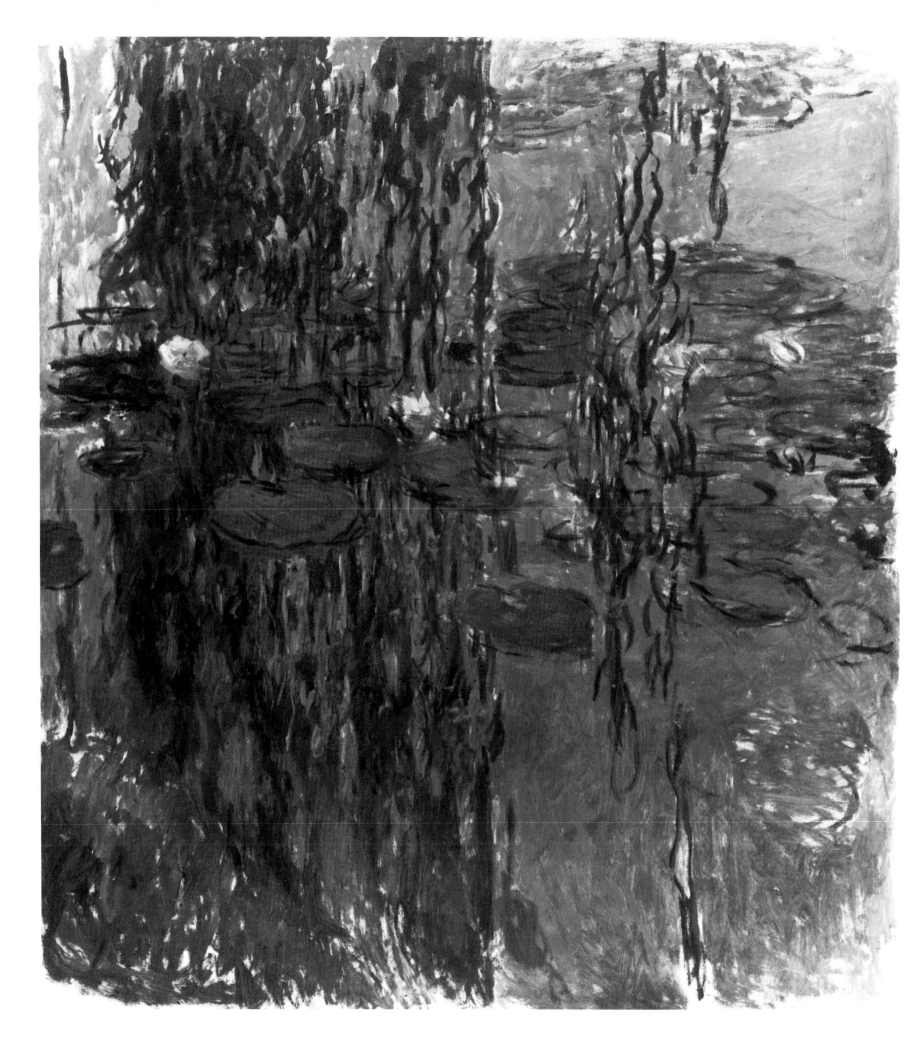

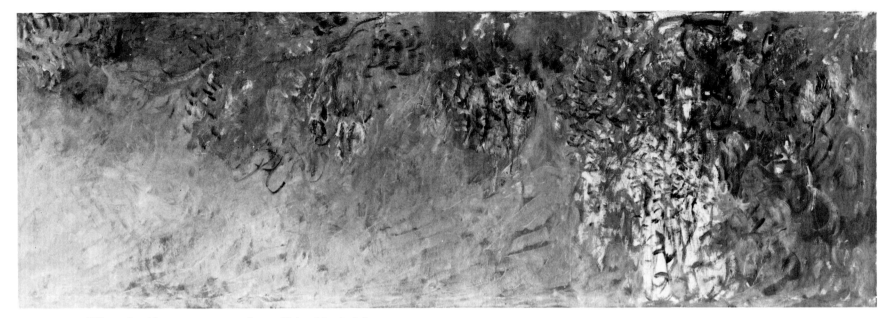

142. *Wisteria.* About 1919–25. $39\frac{3}{8} \times 118\frac{1}{2}$ in. Musée Marmottan, Paris

Opposite (page 186): 141. *Water-lilies.* About 1918–21. $78\frac{3}{4} \times 70\frac{7}{8}$ in. Musée Marmottan, Paris

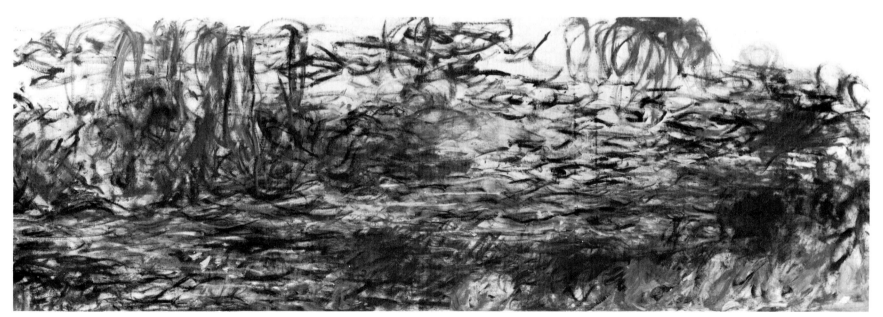

143. *Water-lilies.* About 1919–25. $39\frac{3}{8} \times 118\frac{1}{8}$ in. Musée Marmottan, Paris

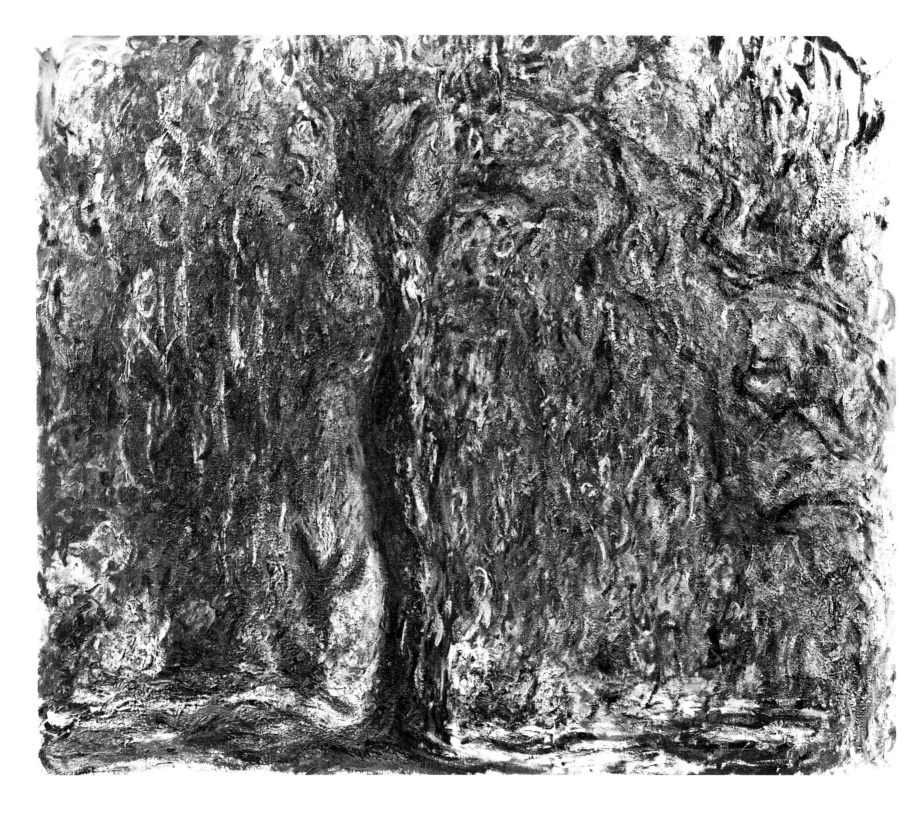

144. *Weeping Willow.* About 1919. 39⅞ × 47¼ in. Musée
Marmottan, Paris

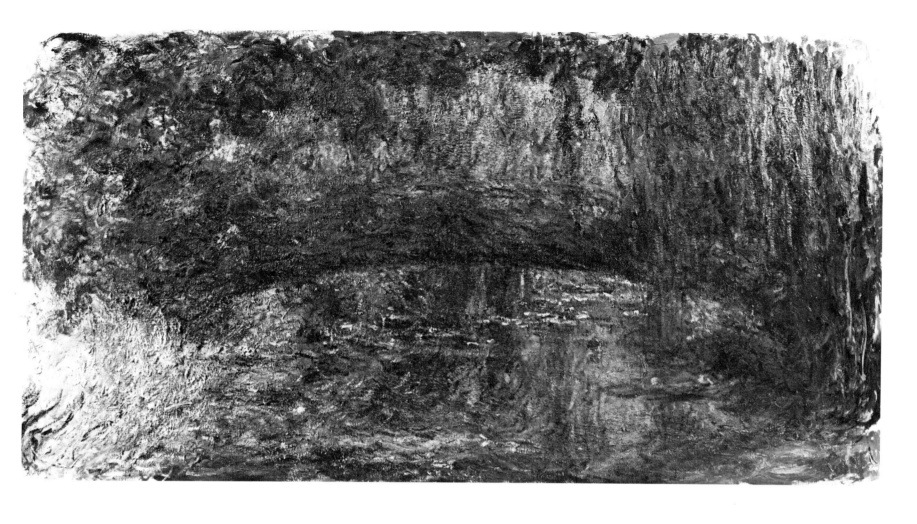

145. *The Japanese Bridge.* About 1919 or about 1923–5.
39 × 78⅜ in. Musée Marmottan, Paris

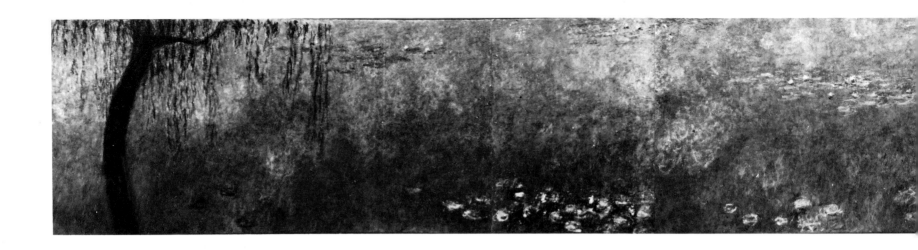

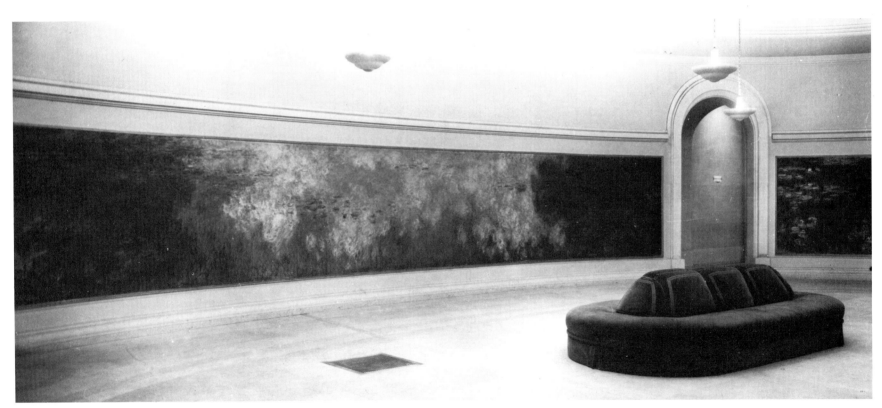

146. ***Water-lilies decoration*** (Room 1, looking north).
1916–23. Musée de l'Orangerie, Paris.

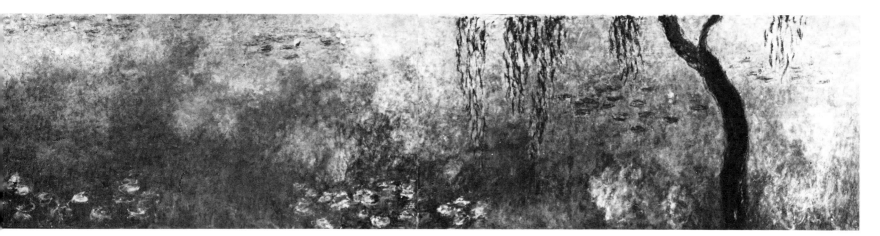

147. ***The Two Willows.*** (Room 2, east panel). 1916–23.
$77\frac{1}{2}$ in. × 55 ft. $9\frac{1}{4}$ in. Musée de l'Orangerie, Paris

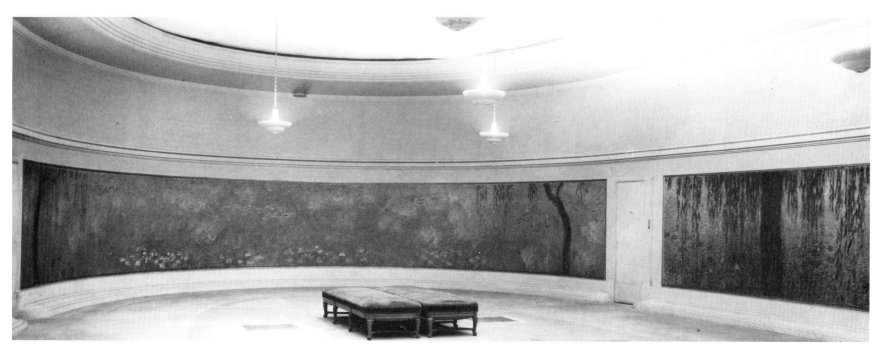

148. ***Water-lilies decoration*** (Room 2, installation view,
looking east). 1916–23. Musée de l'Orangerie, Paris

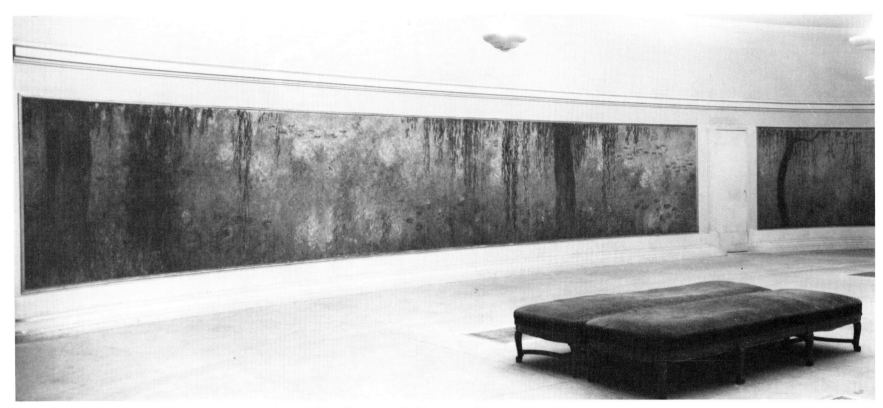

149. *Water-lilies decoration* (Room 2, looking north).
1916–23. Musée de l'Orangerie, Paris

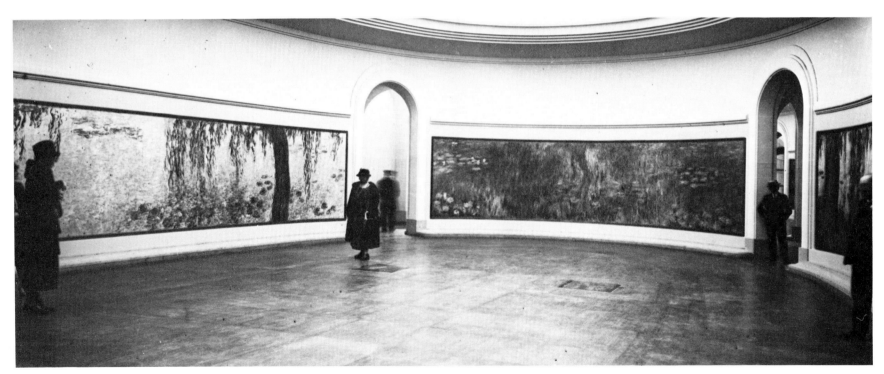

150. *Water-lilies decoration* (Room 2, looking west).
1916–23. Musée de l'Orangerie, Paris

NOTES ON THE PLATES

Daniel Wildenstein is preparing a three-volume catalogue of the complete paintings and drawings by Monet. Volume I covering the period to 1881 has already been published. In the entries below, for paintings to 1881, the French title given by Wildenstein has been included along with Wildenstein's catalogue number (following the date).

1. **Still-life with Bottle, Carafe, Bread and Wine**
(*Nature morte: bouteille, carafe, pain, vin*)
About 1862 (W. 13)
16 × 23½ in. (40·3 × 59·2 cm.)
Mr and Mrs Leigh B. Block, Chicago

Monet's earliest surviving works, prior to 1864, include several still-lifes. This is one of the simplest of them, modest in composition, low-keyed in colour, but indicative, nevertheless, of the precise observation that was to characterize his art throughout his career. The use of a white ground—an almost inexplicable choice as the base for a sober still-life at this date—provides an unexpected freshness, a welcome luminosity, for instance, to the thinly brushed ochre and grey wall panels to the right. The amber-coloured fluid in the decanter at the left and the modified hue of its shadow, the excellent dull olive bottle-green of the wine bottle, the pale yellow of the butter on the dish before it—these are captured as if observed for the first time; they seem more like colours sought and found on the palette for a specific job of description rather than conventionally appropriate hues. Monet's skill in mixing the most difficult colours in response to fine discriminations of observation is seen again, more complexly and skilfully developed, in the still-lifes in Plates 8 and 16.

2. **The Seine Estuary at Honfleur**
(*L'Embouchure de la Seine à Honfleur*)
1865 (W. 51)
35¾ × 59½ in (90 × 150 cm.)
Signed and dated bottom right: Claude Monet 1865
Norton Simon Foundation, Los Angeles

The Seine Estuary at Honfleur marked, along with Plate 11, Monet's first appearance at the Paris Salon. Among the several favourable reactions was that of the pseudonymous critic Pigalle, who called Monet 'the author of the most original and supple, the most solidly and harmoniously painted marine that has been exhibited in a long time. A somewhat dull tonality, as in Courbet; but what richness and simplicity of appearance! M. Monet, unknown yesterday, has immediately made himself a reputation with this single canvas.' Both Salon paintings derived from Monet's first successful year of painting on the Normandy coast during the previous summer and autumn, during which time he did numerous paintings of the beaches at Sainte-Adresse (Plate 11) and the town of Honfleur (Plates 6 and 7). Much of the summer was spent in the company of Jongkind, who, at the Salon of 1865, exhibited an etching of Honfleur harbour viewed from the same vantage-point as Monet's *Seine Estuary*. Monet did a related sketch of the site with calmer sea (*Le Phare de l'Hospice*, W. 38), a painting that shares much of the freshness and nervous flexibility of Jongkind's oils. The *Seine Estuary*, however, tends to be overworked, composed of a number of parts not well fitted together. The large sailing-boat at the left seems to belong to a more overtly dramatic seascape than the action of the waves here indicates.

3. **The Pavé de Chailly**
(*Le Pavé de Chailly*)
About 1865 (W. 19)
38⅞ × 51⅝ in. (98 × 130 cm.)
Signed bottom left: Claude Monet
Private Collection, Switzerland

This landscape of the road that links Chailly to the Forest of Fontainebleau was one of two paintings by Monet exhibited at the Salon of 1866 (see also Plate 18). It shows the place where Monet worked during his months of preparation for the definitive *Déjeuner sur l'herbe* canvas, which he had hoped to display at the same Salon. Two other paintings depicting roughly the same stretch of road also remain (Louvre and Ordrupgaardsammlingen, Copenhagen; W. 56, 57); all three are probably connected with the elaboration of the *Déjeuner* project. In his Salon review, the critic W. Bürger (Théophile Thoré) noted one of the most successful passages in the painting, the 'evening effect with the sun lighting the large trees. When one is truly a painter, one can accomplish everything one wants.' Daniel Wildenstein has recently dated the painting 1864, although the linking of this painting to the *Déjeuner* project has been generally assumed.

4. ***The Quai du Louvre***
(Le Quai du Louvre)
1867 (W. 83)
$25\frac{3}{4} \times 36\frac{1}{2}$ in. (65 × 92 cm.)
Signed bottom right: Claude Monet
Gemeentemuseum, The Hague

The Quai du Louvre is one of three paintings of Paris that Monet did from the east front of the Louvre in the spring of 1867. Plate 5, *The Garden of the Princess*, presents the same view within a different format; the third painting depicts the church of Saint-Germain l'Auxerrois, directly to the east of the palace (Nationalgalerie, Berlin, W. 84). These three canvases are all that remain from what must have been a larger body of paintings of urban settings and manners, for Monet had begun to achieve a reputation among his contemporaries as a painter of modern life. In his review of the Salon of 1868 Emile Zola wrote that Monet 'loves the horizons of our cities, the grey and white touches of houses under a clear sky; he loves the people in their overcoats, busy, scurrying through the streets, he loves the racecourse, the aristocratic promenades with the clatter of carriages; he loves our women, their umbrellas, their gloves, their ribbons, their wigs and face powder, everything that makes them daughters of our civilization.' Monet's surviving works do not accord entirely with this description, and it may be that a number of them—e.g., the race track, the fashionable promenade—were destroyed, painted over, or seized in payment for debt (and since disappeared) during the late 1860s and early 1870s, when he lost a number of his paintings (only four works that can be dated indisputably from the second half of 1866 and no works from the first half of 1869 remain). Monet's interest in the city was shared closely by Renoir during the spring of 1867, as witness his *Pont des Arts* (Norton Simon) and *Champs-Elysées en 1867*, both probably done when Monet was working at the Louvre.

rectangular format will allow; both paintings, but especially the *Garden*, possess the quality that Baudelaire observed in 1845 to be characteristic of good composition—they have 'the merit of the unexpected'.

Monet's works seem to respond to observations, requirements, stated by advanced critics of the period. Thoré, for instance, in 1863, wrote of the distinctions that ought to be observed in close-up and distant views; he described, in effect, the transition from *Camille* (Plates 18 and 19) and *Women in the Garden* (Plates 12 and 13) to the *Quai du Louvre* and *Garden of the Princess*: 'Let us grant that painting can reveal the minute details of a life-size figure against a neutral ground; but when the figure is distant, when groups become complex . . . *finish* disappears, and the artist has only to render the general aspect, the complex image in its significant accents.' This last term seems especially appropriate to the *Garden of the Princess*, in which Monet developed accents that respond to the complex movement of the hurrying figures and carriages within the setting: quick and indistinct touches for the people, dry-brush verticals for the grille fence (enhancing the visual vibration of passing forms), and blurred wheels on the carriages (Fig. 10). The last speaks directly of movement and attests to Monet's clear desire to depict its effects in painting. Velazquez, Rubens, and their contemporaries had portrayed movement in the seventeenth century—notably, in this connection, Velazquez's spinning wheel in *The Fable of Arachne* (The Tapestry Weavers, Prado)—but painters tended to neglect it thereafter. During the nineteenth century journalistic illustrators were occasionally alert to the phenomenon of the spinning wheels of moving carriages in the streets, and one finds numerous examples in the 1850s and 1860s. Monet, however, was almost alone in translating such effects into painting, in authorizing the quick, responsive technique of the painted sketch to capture the reality, the significant accents, of movement.

5. ***The Garden of the Princess***
(Le Jardin de l'Infante)
1867 (W. 85)
$36\frac{1}{2} \times 24\frac{5}{8}$ in. (91·8 × 61·9 cm.)
Signed bottom right: Claude Monet
Allen Memorial Art Museum, Oberlin College,
Oberlin, Ohio

The Quai du Louvre and *The Garden of the Princess* were developed as an interrelated pair; the two canvases are almost identical in size but one was held horizontally, the other vertically. They vary slightly in the vantage-point assumed—the *Quai* viewed from a position slightly to the south of that for the *Garden*—but are identically scaled—the size of the colonnade and dome of the Pantheon, centred on the horizon, is the same in both paintings; the Pantheon provides the fixed point for the extension of the skyline. From the establishment of the skyline across the format the rest of the composition is developed until the edges of the canvas are reached. The final composition is to a considerable extent unplanned, the result of what the

6. ***Rue de la Bavolle, Honfleur***
(La Rue de la Bavolle à Honfleur)
1864 (W. 34)
23 × 25 in. (58 × 63 cm.)
Signed bottom right: Claude Monet
Kunsthalle, Mannheim

7. ***Rue de la Bavolle, Honfleur***
(La Rue de la Bavolle à Honfleur)
1864 (W. 33)
$22\frac{1}{4} \times 24\frac{1}{2}$ in. (56 × 61 cm.)
Signed bottom left: Claude Monet
Museum of Fine Arts, Boston

As with the studies of high and low tide at Sainte-Adresse (see note to Plate 11), Monet here developed his paintings in pairs, providing two records of the same site (see p. 13). The view looks north along the rue de la Bavolle, the time is afternoon, as revealed by the direction of the light. The slight differences in

the angle of the shadows in the two paintings indicate that, in terms of the specific hour, the Boston canvas (Plate 7) slightly precedes the Mannheim version (Plate 6), by perhaps no more than fifteen minutes. The measurable differences in the setting are very slight, apparent in the clouds and in the arrangement of light and shadow (which, however, is not thoroughly consistent throughout). The greatest change is in the figures; several of them are altered while others remain the same. The latter is the case with the woman seated on the left, the child and the women engaged as if in prolonged conversation on the right, and the woman and child further down the street. In Plate 7 a man, barely visible, peers at us from a doorway in the left foreground; in Plate 6 he has been replaced by a woman, who, openly, curiously, looks out as if to verify the fact of the painting, as if she has been called to the door to look at the painter painting the scene.

Basically, the difference between the two paintings seems to be the difference of only a few minutes in time in which some people pass by while others remain. They record a factual, circumstantial shift of the most uneventful sort, occurrences of no interest save, perhaps, to someone confined inside who observes all from a window, changes that might be recorded only by the neutral, blinking shutter of a camera, if stationed there, or by the realist painter determined to explore with unswerving logic the implications of open-air painting. Monet eschews any reminiscence of Romanticism, even the limited drama that might derive from the contrast between noon and sunset. He chooses to deal with non-contrast, non-drama, with the factual ledger of everyday.

A second pair of paintings geared to the same inquiry depicts a corner of the port (*La Lieutenance à Honfleur*, W. 31, 32). In one of them a woman and child are depicted; one might think them on their way to or from the rue de la Bavolle.

8. **Le Déjeuner sur l'herbe**
 1865–6 (W. 62)
 51⅝ × 71⅞ in. (130 × 181 cm.)
 Signed and dated bottom left centre: Claude Monet 1866
 Pushkin Museum, Moscow

Early in April 1865, when Monet had learned of the acceptance of his first Salon submissions (Plates 2 and 11), he left Paris for the town of Chailly, not far from Barbizon, on the edge of the Forest of Fontainebleau. There he set into motion a plan for a large-scale figure painting of a picnic that would rival Manet's famous *Déjeuner sur l'herbe* of 1863. During the spring and summer he wrote repeatedly to Bazille, urging him to come to Chailly to pose for studies for the painting. The present canvas was probably executed in large part during the late summer, when Bazille spent several weeks with Monet, for it is he who posed for the standing male figures and the man stretched out in the right foreground. The principal female model was probably his future wife Camille. Three of the dresses depicted in the painting were still part of her wardrobe

when she posed for the *Women in the Garden* in the following year (Plate 12). Despite its considerable size, Monet may have worked on this canvas in part at his chosen site within the forest, or, at least, under similar conditions outdoors. The range and subtle variety of his palette suggest such a careful scrutiny of directly observed effects. In October he returned with the painting to his studio in Paris, where he undertook a vast fifteen-by-twenty-foot version of the picnic theme based on the present sketch (Plates 9 and 10).

9. **Le Déjeuner sur l'herbe**, central section
 1865–6 (W. 63b)
 98½ × 86⅛ in. (248 × 217 cm.)
 Private Collection, Paris

10. **Le Déjeuner sur l'herbe**, left-hand section
 1865–6 (W. 63a)
 166 × 58½ in. (418 × 150 cm.)
 Musée du Louvre, Paris (Jeu de Paume)

Monet began this large canvas in October or November 1865 after his return to Paris from Chailly. In the next several months we hear approving comments from Boudin and Bazille, attesting to Monet's progress. The painting was intended for the Salon, but difficulties in converting his sketch into a huge painting with life-size figures prevented him from making the Salon deadline. Soon thereafter, he found that he could not afford to continue the project and so put it aside, hoping to pick it up again at some future date. He rolled it up and kept it with him for more than twelve years, when, in 1878, in order to conclude his affairs at Argenteuil, he left it with his landlord as security for non-payment of rent. Six years later, in 1884, he managed to secure the funds necessary to retrieve it. Finding it partly ruined by damp, he cut away the damaged portion and then divided the remainder in half, framing the central section (Plate 9) and retaining a tall, narrow strip from the left side of the huge canvas (Plate 10).

The left-hand section clearly reveals Monet's concerns during the last stages of his project (according to Daniel Wildenstein the central section may have been partly reworked at a later date). He was in the process of shortening the dresses, changing their colour and design, creating a strongly faceted modelling, turning his figures into powerful sculptural entities that stand firmly within the deep space of the forest (X-rays of Plate 10 reveal that initially Monet had included the costumes as we find them in the Moscow sketch, Plate 8). At the same time he emphasized the large shapes of highlights, broad areas of colour in the costumes (Plate 10), and the clear, emphatic patches of light upon the picnic cloth and dresses of the seated figures (Plate 9), thus creating an awareness of the broad spread of pigment upon the two-dimensional stretch of the canvas. Both a powerful illusion of depth and an emphatic assertion of surface were established at one and the same time, and it is the difficulty of resolving the conflict between the two that must have been at the heart of

Monet's inability to bring the canvas to a conclusion under the pressure of the Salon deadline.

For the next several years Monet continued to strive towards the grand work that would monumentalize the world of the contemporary upon the walls of the Salon, but each time he failed, either through rejection by the jury, as with his *Women in the Garden* in 1867 (Plate 12), or due to material difficulties, as was the case at La Grenouillère in 1869 (Plates 27 and 29). Had the *Déjeuner sur l'herbe* been completed on time for the Salon, his later projects might have had a different history. Monet spoke of this aspect of the *Déjeuner* in an interview published in 1920 by Thiébault-Sisson:

> If I had submitted it and it had been accepted, who knows if my career might have been shaped differently? Having put it aside, I went on to other experiments that took me further than I had thought. I fell in love with light and reflections. After that, there was no reason to return to a canvas conceived and treated by other methods.

11. **The Pointe de la Hève at Low Tide**

(La Pointe de la Hève à marée basse)
1865 (W. 52)
$35\frac{3}{4} \times 59\frac{1}{2}$ in. (90 × 150 cm.)
Signed and dated bottom right: Claude Monet 1865
Kimbell Art Museum, Fort Worth, Texas

Monet developed this large painting for the Salon of 1865 from a smaller study done at Sainte-Adresse the previous summer or autumn. For the Salon canvas he chose a longer horizontal format and emphasized low tide while exaggerating the roll of the sea. It was at Sainte-Adresse, a northern extension of Le Havre, that Monet's family lived in 1864, and it is there that he had met Jongkind two years earlier. Numerous paintings by Jongkind from 1862 and 1863 attest to the close relationship between the two artists (see Fig. 7). The composition of the *Pointe de la Hève*, with the beach and sea adjusted to a simple, centralized perspective organization, is found repeatedly in Jongkind's views of Sainte-Adresse, and Monet surely adopted his viewpoint and composition according to the lessons and example of the older artist. In fact, both the perspective composition of the *Pointe de la Hève* and the frontal, horizontal organization of the *Seine Estuary* (Plate 2) make use of standard compositional conventions favoured by Jongkind. It is above all the latter's example that stands behind Monet's initial success at the Salon.

In frequently composing his paintings in pairs Monet, again, followed the example of Jongkind as well as that of the landscapists of the Barbizon generation, who would depict the same setting at different times of day or perhaps at different seasons. Monet's study of the beach at low tide (upon which the Salon canvas was based), was matched by a very similar painting of the beach at high tide, viewed from an almost identical vantage-point (W. 39).

12 and 13. **Women in the Garden**

(Femmes au jardin)
1866–7 (W. 67)
$101\frac{5}{8} \times 82\frac{1}{2}$ in. (256 × 208 cm.)
Signed bottom right: Claude Monet
Musée du Louvre, Paris (Jeu de Paume)

Towards mid-April 1866, in order to escape his creditors, Monet put aside 'for the moment' the major things he was doing, presumably the *Déjeuner sur l'herbe* above all, and left Paris for the nearby suburb of Ville-d'Avray, where he began *Women in the Garden*. Started, and deliberately pursued *en plein air*, it was ultimately completed away from the site in Normandy the following winter. Considerable reworking of the canvas is evident, especially in the area of the head and upper body of the seated woman, where the paint is heavy and badly cracked. X-rays reveal that her head and parasol were initially higher; in the process of establishing its final position he developed the face into a flattened mask, a highly artificial entity. And yet this face is the product of the most careful scrutiny: observing it in the half-light of the parasol's shade, Monet paints the face tan, pink, violet, and pale blue; the upper lip and bottom of the nose are highlighted, receiving the strong light reflected from the surface of the white dress. He employs the trim on the dress for decorative effect; on the right arm and shoulder it both appears as contour and disappears. Where it disappears, one tends to read the white or pale blue shaded areas across from the arm to the dress, losing for a moment their separate forms and positions. On the full, bell-shaped skirt he develops the decoration with a deliberate inconsistency, both observing and entirely ignoring its folds and volume, the ignoring of volume clearly evident in the vertical strips of braid descending from the flowers in the woman's lap and in the 'butterfly' design near the bottom of the skirt. In the neighbouring area of the left-hand edge of the path, Monet altered the original oblique angle of the edge and adjusted it to an almost pure vertical that serves to continue the line of the tree trunk above and helps to convert the path from being foreshortened to being nearly frontal. In these details both observation and decoration are made to interrelate; they dissolve their separate claims in a tense but bizarre balance, an integration of nature's flexibility and the firmness of design.

14. **Ice-floes on the Seine at Bougival**

(Glaçons sur la Seine à Bougival)
1867 (W. 105)
$25\frac{3}{4} \times 32\frac{1}{8}$ in. (65 × 81 cm.)
Signed bottom right: Claude Monet
Private Collection, France

During the autumn of 1867 Monet returned to Paris from Sainte-Adresse; there he took up domicile with Camille and their son, Jean, who had been born in July. *Ice-floes on the Seine* was painted at Bougival, to the south-west of Paris; on the left is the Ile de Croissy, where Monet was to paint the bathing place La Grenouillère during the summer of 1869 (Plates 27 and

29). The composition and activity suggest a translation of the interests of Normandy (Plate 20) to the banks of the Seine in winter. He had painted snow scenes earlier, in the winter of 1864–5 (W. 50, 79; the latter has been dated 1867 by Daniel Wildenstein, but it may well derive from the earlier campaign) and again at the beginning of 1867 (W. 80–2). The present painting is striking in its flat, dull tonality, appropriate to the heavy winter greyness. The range of trees at the left is painted as a screen of flattened greys, a somewhat artful and decorative interpretation of the natural scene that suggests the current influence of Japanese prints upon Monet's work in 1867. The grey-on-grey treatment of the trees in Hiroshige's *Numazu*, no. 13 of the series 'Fifty-three Stages of the Tokaido' (Fig. 12) provides a feasible model.

The painting has never been securely dated, but Daniel Wildenstein's recent dating to late 1867 (or early 1868) seems accurate. Monet was to return to the subject of the break-up of the ice at Vétheuil in 1879–80 (Plate 64).

15. **Dinner**

(Le Dîner)
1868 (W. 129)
$20\frac{5}{8} \times 25\frac{3}{4}$ in. (52×65 cm.)
Signed bottom left: Claude Monet
Bührle Foundation, Zurich

Whereas *The Luncheon* (Plate 16) is a highly evolved, large painting designed for the Salon, *Dinner* is small, intimate, a brief sketch. Nevertheless, it reveals the assurance and knowledge that Monet had gained by this date, despite the lament in the letter to Bazille (note to Plate 16) about how little he knew. The interior is the same as in *The Luncheon* but rearranged; Camille, in the foreground, and Jean are seated at the table with two friends. The strong light upon the table and the deep shadows, combined with the small size of the canvas, limits the scope for painterly subtleties. Monet took the limited palette imposed by the subject as his formal theme; stylistically, the painting is a study in blacks, whites, and greys, in the alternation of dark against light and light against dark. Description is minimal, brushwork is uniform, objects are presented summarily and fragmentarily, now emblazoned by light, now swallowed by darkness. Forms are suggested, to be completed by the eye and the mind.

The chandelier, a stark white against the deep grey field of the rear wall, illuminates the table-cloth, a larger island of brightness in the midst of darks and semi-darks. It, in turn, serves as a bright ground for the dark accents of the objects distributed upon it. The shape of the table is repeated in the expanded oval shadow on the floor, but the order of contrast is reversed: now the oval form is the dark area set in a ligher field. Whereas Camille, with her back to us, is a dramatic black shape against the white cloth, across the table the man's pink face is like a light emerging from the enveloping darkness. The relationships between the figures and their surroundings is cunningly varied: whereas the man's face stands forth from the

ground, his body is tonally and materially identified with it; although the body of Camille in the foreground serves as a powerful *repoussoir* before the table-cloth, her head practically blends with the far wall, the deepest plane in space; the child's body merges with the maid's skirt, while the back of his head stands out from it in strong contrast.

Further adjustments of depth and surface as well as a brilliant demonstration of stylistic shorthand are seen in the centre of the painting, over which Monet laid down an opaque, light grey underpainting to serve as a unifying ground for the table, chandelier, and figures. The white of the chandelier is brushed partly over this grey field, which appears again under the white of the table-cloth and emerges on its own at the left of the table, linking the table on a single plane with the figures of the man and child. In a display of painting economy, Monet brushes into this area a few strokes of heavy pigment that establish the form of the child's body, part of the table-cloth, and the dishes set before the two figures. In sharp contrast to the technique of *The Luncheon*, nothing is completely stated, as Monet displays a supreme awareness of how the viewer will complete what the painter may only indicate. The grey underlayer was applied in the initial stages of the painting; Monet knew full well from the outset the kind of stress he would place upon the relationship between illusion and painterly style, and between description and suggestion. Mastery of the sketch was a key component of the emergence of Impressionism (see Plates 27, 29 and 30). As *Dinner* and, earlier in the year, *The River* (Plate 25) suggest, Monet had achieved that mastery in 1868.

16. **The Luncheon**

(Le Déjeuner)
1868 (W. 132)
$91\frac{1}{4} \times 59\frac{1}{2}$ in. (230×150 cm.)
Signed and dated bottom left: Claude Monet/1868
Städelsches Kunstinstitut, Frankfurt

Through the beneficence of the Gaudibert family of Le Havre, Monet received commissions for two portraits, including the large, full-length *Portrait of Mme Gaudibert* in the Louvre (W. 121), and, as a result, was able to spend a brief period of untroubled domesticity and active work, living with Camille and Jean at Etretat during the winter of 1868–9. In a long letter to Bazille, written in December 1868, Monet wrote of his pleasure with his family situation and revealed some of his attitudes towards his work; the letter provides one of the clearest statements of his thoughts at this early stage of his career and is worth quoting at length:

> Thanks to the help of this gentleman from Le Havre I am enjoying the most complete tranquillity ... my desire would be to continue always this way, in a quiet corner of nature like this. I assure you that I don't envy your being in Paris, and I hardly miss the gatherings [at the Café Guerbois], although, of course, I would be pleased to see

some of the crowd, but frankly I believe that one can't do anything in such surroundings; don't you believe that directly in nature alone one does better? I am sure of it. Besides, I've always been of this mind and what I have done in these conditions has always been better. One is too much taken up with what one sees and hears in Paris, however strong one may be, and what I am painting here will have the merit of not resembling anyone, at least I think so, because it will be simply the expression of what I have felt, I myself, personally. The further I go, the more I regret how little I know, that is certainly what bothers me most. The further I go, the more I see that people never dare to express freely what they feel. It's odd. That's why I'm doubly happy to be here.

In the same letter Monet wrote that he was planning for the Salon 'an interior with a baby and two women'. *The Luncheon* is that picture; depicted are Camille and Jean at the table, a visitor at the window, and a maid. He submitted it to the Salon only in 1870, at which time it was refused. As if to make up for that rebuff, he included it among his entries at the first Impressionist exhibition in 1874, along with *Bateaux de pêche en mer* (Hill-Stead Museum, W. 126), which had been refused in 1869.

17. **The Jetty of Le Havre in Bad Weather**
(*La Jetée du Havre par mauvais temps*)
1867 (W. 88)
19⅞ × 24¼ in. (50 × 61 cm.)
Signed and later dedicated bottom right: à son ami
 Lafont 1870/Claude Monet
Private Collection, Switzerland

Monet submitted two paintings of the port of Le Havre to the Salon of 1868, one of which, *Navires sortant des jetées du Havre* (W. 89) was accepted; the rejected work, *La Jetée du Havre* (W. 109), was a large variant on the present work. It is a subject that once again, as with the Paris views (Plates 4 and 5), testifies to his continued interest in exploring modern subjects. In September 1868, Boudin wrote to his friend Martin, defending his own paintings of contemporary life and placing Monet at the head of a group of young artists who were interested in depicting such subjects. Boudin had himself painted the port of Le Havre in 1867 and, unlike Monet's, his painting of the *Jetée du Havre* was accepted by the Salon jury in 1868. In the letter to Martin he argued for the meaningfulness of such subjects, and one may take it that, at least in part, he conveyed the attitude of Monet as well:

The peasants have their painters ... that is fine, but, between ourselves, those middle-class people who are strolling on the jetty at the hour of sunset, have they no right to be fixed upon canvas, to be placed in the spotlight. Between ourselves, they are often resting from strenuous work, these people who leave their offices and

cubbyholes. If there are a few parasites among them, are there not also people who have fulfilled their task? There is a serious, irrefutable argument.

Monet's painting emphasizes the stormy weather, the angle of the large boat—not, however, all that convincingly placed in the water—set against the wind. The inscription and date were added when Monet gave the painting to the journalist Lafont, a witness at his wedding to Camille on 28 June 1870.

18 and 19. **Camille**
1866 (W. 65)
91¾ × 60 in. (231 × 151 cm.)
Signed and dated bottom right: Claude Monet 1866
Kunsthalle, Bremen

'I want to reveal to the jury that this opulent painting was done in four days,' wrote Théophile Thoré in his Salon review in 1866. With vigour and urgency, Monet acted to make up for his failure to complete the *Déjeuner sur l'herbe* on time for the Salon by creating, in its stead, another major work, a life-size, full-length portrait of Camille, executed in the manner of Courbet and with a touch of Manet's full-length portraits based on Spanish Baroque models. It was stylistically a considerable step backward from the *Déjeuner*, but was, nevertheless, an extraordinary demonstration of natural virtuosity. A number of critics hailed his success. The young Emile Zola confessed that 'the canvas that engaged me the longest is the *Camille* of M. Monet. ... I had just passed through the cold and empty rooms, tired of not finding a single new talent, when I caught sight of this young woman, trailing her long dress, penetrating into the wall, as if there had been a hole there.' He went on to admire the dress, as did most of the numerous critics who attested to Monet's success; Thoré wrote, 'Henceforth Camille is immortal and is dubbed the *Woman in the Green Dress*.' The dress, indeed, testifies to Monet's skill, his mimetic talents, his ability, demonstrated in the picnic still-life in the Moscow sketch for the *Déjeuner*, to discover pigment mixtures on his palette that could meet the most demanding situations. The greens are vibrant, saturated, assertive of greenness as well as of shimmering silk; the grey stripes are uncharacterizable, composed of several variations on grey that are descriptively so accurate that they seem almost to be the fabric itself.

Several reviewers criticized the painting's success as a portrait, remarking that the dress dominated the person, that one could read nothing of personality from the face. Unfair criticism, for the face, which could hardly be studied with care on the crowded walls of the Salon, shares in the mood and effectiveness of the portrait—a figure rushing away but held in check by the arch of the back, the turn of the cheek. The angle of the head, the lowered lids suggest the melancholy that was to become a characteristic of almost all the portraits that Monet did of Camille throughout her short life (Plates 12, 50, 52 and 54). The face is firmly modelled yet tastefully, judiciously

composed of warm and cool tones, lighted and faintly shadowed parts: a touch of greyed pink on the cheeks, nose, right eyelid, a dark pink for the lips, a warm grey for the shaded areas on the nose and around the eyes, cheeks, and mouth, made darker or lighter as necessary; the hair, eyebrows, and lashes are a dark, slightly greyed brown.

20. *Sainte-Adresse*
1867 (W. 93)
22⅝ × 31¾ in. (57 × 80 cm.)
Signed bottom right: Claude Monet
F. and P. Nathan, Switzerland

After completing his views from the Louvre (Plates 4 and 5), Monet was forced by poverty to accept the shelter of his family's home in Sainte-Adresse, leaving his mistress Camille alone in Paris just as the birth of their first child was approaching. Despite deep concern for her condition and a sense of remorse for having abandoned her at such a moment, he set to work with renewed energy. On 25 June, after fifteen days there, he wrote to Bazille saying he had 'twenty canvases well under way, some stunning marines, and figures and gardens, in a word, everything. Among my marines I am doing the regattas at Le Havre with many people on the beach and the ship lane full of little sails.' At least four pictures of the beach remain, including the present canvas. It attests to the continuity between his first major campaign on the Normandy coast in 1864 (Plate 11) and his concerns of 1867, and, as with the paintings of 1864, the example of Jongkind is still strongly evident (see Fig. 7).

21. *Terrace at Sainte-Adresse*
(*Terrasse à Sainte-Adresse*)
1867 (W. 95)
38⅝ × 51⅛ in. (98·1 × 129·7 cm.)
Signed bottom right: Claude Monet
Metropolitan Museum of Art, New York

Monet's stay in Sainte-Adresse was marked by personal conflict. On the one hand he was painting with great ardour and receiving—probably for the first time—willing and generous approval of his work from his family. On the other hand, he could not put from his mind an awareness of the terms upon which this favourable atmosphere was obtained—that Camille be relegated to the background, acknowledgement of her existence and condition forbidden within the family circle. Thus he once again had recourse to Bazille, repeatedly begging him to send money with which to aid the all-but-penniless Camille. The strain was considerable; in early July he told Bazille that he was 'losing his sight' and was advised by a doctor to give up outdoor work. One week later, the eye trouble not actually preventing him from painting, he explicitly stated the opposing poles and the nature of his conflict: '. . . all goes well here with my work and my family,

save for this impending birth I could not be happier.' The present canvas was probably painted, or at least begun, during the latter half of July, prior to Monet's trip to Paris to be present during the last stage of Camille's confinement. (The date 1866 often ascribed to the painting should be replaced, as Daniel Wildenstein has done in his Monet catalogue, by 1867, the date given it when it was shown at the fourth Impressionist exhibition in 1879.)

Monet's family occupied the foreground of his thoughts and activities, and it does so in the painting as well. His aunt, Sophie Lecadre, is seated in the centre with her back to us, his father is to the right. Monet's father properly oversees the terrace, in effect propels its spatial thrust. The angle of his gaze is consistent with that of the strong shadows cast upon the terrace floor. His view is directed from the open foreground back to the area between the two flag-poles—the power of his gaze seems sufficient to set them off centre—and then beyond to the horizon, where small and large boats manoeuvre at the harbour's mouth.

There is a disparity between terrace and sea, between the foreshortened assertiveness of the terrace floor and the flattened, decorative backdrop of the water and sky. The terrace is a protected place, immune to the gusts that whip the flags above and to the threat of storm that causes the sailing-boats at the horizon to turn against the wind. The terrace is the terrain of immediate, tangible reality—presented as unusually calm. The active sea and sky—plastically reduced to the plane of a theatrical backdrop—suggests the content of Monet's thoughts, the nagging facts of life that threaten to obscure his artistic horizon. The outsize boat with its swelling sails, moving—unlike the other craft—with the wind, reminds one of the disturbingly insistent presence of the pregnant Camille within the complex picture of his life at this time.

Monet's personal conflicts were not to be immediately resolved, but the artistic strain between illusionism and decoration—which was first made dramatically evident in the *Déjeuner sur l'herbe* (Plates 9 and 10) and which here may serve as surrogate for the struggle between his father and himself—proved to be capable of satisfactory resolution. Monet asserts quite clearly that he is, in this realm, the master, able to adjust illusionistic authority to the artificial demands of the painted organization. His vantage-point is above his father's, although it is not the high viewpoint often described. His perch was slightly above the terrace, his eye probably at the level of the upper edge of the right-hand fence and directly opposite the heads of the standing figures (he actually paints in the under edge of the lintel of the latticed door at the right). His viewpoint marks the dividing line between terrace and sea, between assertive spatiality and decorative harmony. The flattening of the upper register of the painting is not, however, a product of physical vantage-point but of willed manipulation. Monet's organization in this instance is artificial and arbitrary, as is his adjustment of depth and surface across the entire picture. For, finally, there is overall adjustment, established through such elements as the play of brilliant coloured touches for flowers and flags, the orientation of the

foreground flower bed parallel to the planes of sea and sky, and the continuation of a vertical division from the base of the flag-pole down the left side of the terrace.

22. *The Magpie*
(La Pie)
1869 (W. 133)
35⅜ × 51⅝ in. (89 × 130 cm.)
Signed bottom right: Claude Monet
Private Collection, France

In his letter to Bazille in December 1868 (see note for Plate 16) Monet wrote: 'I go out into the country which is so beautiful here that I find the winter perhaps more agreeable than the summer, and naturally I am working all the time, and I believe that this year I am going to do some serious things.' *The Magpie* was probably painted at that time—in January or February—and then submitted to the Salon, where it was rejected. After his initial Salon successes in 1865 and 1866 (Plates 2, 3, 11 and 18), his *Women in the Garden* (Plate 12) was rejected in 1867, only one of two entries was accepted in 1868, and now in 1869 and again in 1870, he was refused completely.

23. *The Bridge at Bougival*
(Le Pont de Bougival)
1869–70 (W. 152)
25¼ × 36¾ in. (63·5 × 91·5 cm.)
Signed bottom left: Claude Monet
Currier Gallery of Art, Manchester, New Hampshire

The site is just below La Grenouillère where the bridge links the Ile de Croissy to Bougival, seen on the far shore. Daniel Wildenstein has recently dated it to the spring or summer of 1870, but the brown and olive tones of the foliage may indicate a date slightly later than the Grenouillère paintings, during the autumn of 1869 (although the slightly dulled tonalities of the painting may be a product of the quality of light associated with a suggestion of impending storm). This secure and serene painting is given stability through an integration of horizontals and verticals with a centrally organized·perspective construction. The palette is appropriately subdued yet enriched with areas of grey blues, violets, brick red, and pinkish tans. A close link in palette and structure to Pissarro's road paintings (see note to Plate 28) is evident, although Monet here develops a more complicated perspective—looking down to the river at the left and up and across the bridge at the right—than in any immediately contemporary Pissarro. William Seitz has called this work 'one of the masterpieces of Monet's early period'.

24 and 25. *The River*
Au bord de l'eau, Bennecourt
1868 (W. 110)
31⅞ × 39½ in. (81 × 100·3 cm.)
Signed and dated bottom left: Claude Monet/1868
Art Institute of Chicago

In the spring of 1868 Monet stayed with Camille and Jean at an inn in the village of Gloton on the Seine, a place probably recommended to him by Zola, who had sojourned there with Cézanne in 1866 and was to do so once again in 1868. Structurally, *The River* is one of the most important paintings of his career. Monet's viewpoint is low, close to that of Camille seated on the near bank; with her he looks across the river to the houses and hills of the far shore. Deep space is there, but it is controlled by the regularity of horizontal and vertical elements across the canvas and by the similarities of colour and brush touch for elements that one recognizes as spatially distinct from one another. The grey of Camille's dress, for example, is close in colour to the patches of grey reflected in the water, her face is painted with the same brevity of touch, given the same shape and almost the same colour as the adjacent tan patch that represents something entirely separate in spatial position and character (Plate 24). They are separated and yet linked upon the surface. The experience of depth is akin to that one receives from a photograph taken through a telephoto lens—a sense of overlapping, of juxtaposition, of the collapsing of spatially disparate phenomena. In the likening of Camille's painted substance to reflected elements, in the interweaving of leaves from the foreground trees with the barely glimpsed elements of the far shore, Monet achieves a reciprocity between the experience of depth and of surface that is characteristic in almost every respect of the structural dynamics associated with the mature Cézanne. *The River* offers a paradigm for the kind of structural, compositional, and spatial complexity—the integrated to and fro between the space of nature and the flat field of the canvas—that one finds in such classic landscapes by Cézanne as the Courtauld Institute's *Mont Sainte-Victoire* of the mid-1880s (Fig. 14).

As a counterpoint to the security and repose of *The River* there are the financial and personal woes that plagued Monet's early years, exacerbated at this moment by his decision to embrace Camille and Jean and thereby jeopardize his relations with his family. He was without money at the end of his stay in the Gloton-Bennecourt area; in a letter to Bazille of 29 June, he wrote of their being thrown out of the inn at Gloton, unable to pay their bill, and of an impulsive attempt at suicide: 'I was so upset yesterday that I had the stupidity to throw myself in the water, but fortunately nothing came of it.'

26. *The Beach at Trouville*

(*La Plage de Trouville*)
1870 (W. 158)
$15\frac{1}{8} \times 18\frac{1}{4}$ in. $(38 \times 46$ cm.)
Signed and dated bottom left: Cl. M. 70
National Gallery, London

Monet and Camille were married in Paris on 28 June 1870. In July he deposited some of his canvases with Pissarro at Louveciennes and left Bougival for Honfleur, where he, Camille, and Jean spent the summer, part of the time in the company of Boudin, with whom Monet resumed painting. Daniel Wildenstein has suggested that the woman dressed in black at the right might be Mme Boudin; one may wonder, however, whether she is a member of Monet's family in mourning for the death of his aunt, Sophie Lecadre, who died on 7 July. Mme Lecadre had been the main moral and, occasionally, financial support of Monet's career from the time that he started as a caricaturist; her death could not have left him indifferent despite any feelings of estrangement that may have been caused by the general rejection of Camille by his family. If this speculation is correct, then two opposite poles of Monet's life at the time are represented in this picture: his new wife dressed in white, with flowers on her hat, the beginning of a new life; the woman in black, symbolic of the passing of the main sympathetic force within his family. Between the two women is an empty chair with what appears to be a wooden shoe, perhaps a child's shoe, hanging on the chair back. It provides a chromatic link between the two, but may represent the child, Jean, whose existence had contributed to the threat of rupture between himself and his family from the time of his birth in 1867. The close-up view seems to confirm the intimate nature of his subject. Degas and Renoir were to develop similar close-up compositions with figures cut by the frame only in the next few years.

27. *La Grenouillère*

1869 (W. 136)
Present whereabouts unknown

The whereabouts of this painting have not been recorded since its exhibition at the Galerie Thannhauser in Berlin in 1928, and it is almost certain that it is destroyed. Even its dimensions are unknown, but it appears that it is larger than the two existing sketches (Plate 29, Metropolitan Museum, and Walzer collection, Oxford, W. 135), and it may have been submitted, along with *The Luncheon* (Plate 16), to the Salon of 1870, where it would have been rejected, for Monet was not represented at the Salon that year. One would want to know its dimensions and how close it may have come, in Monet's mind, to the large painting of the site that he envisaged (see introduction, p. 17). In relation to the Metropolitan and Walzer sketches this painting does have the quality of a more comprehensive statement, depicting a wide-angle view of the river from the shore, combining, in effect, the information in those sketches. On the other hand, the character and gauge of

brushwork seems very close to those works and suggests no great discrepancy in the size of the canvases. A fourth small sketch of rowing-boats (W. 137), whose present whereabouts are also uncertain, completes the known studies of the site.

28. *The Road to Louveciennes, Snow Effect*

(*Route à Louveciennes, effet de neige*)
1870 (W. 147)
$21\frac{7}{8} \times 25\frac{3}{4}$ in. $(55 \times 65$ cm.)
Signed bottom left: Claude Monet
Private Collection, Chicago

Monet lived at Saint-Michel near Bougival for approximately one year from the spring of 1869 into the summer of 1870. During the summer of 1869 he joined Renoir at La Grenouillère, and during the winter 1869–70 he may have occasionally worked with Pissarro, who lived nearby in Louveciennes. *The Road to Louveciennes* depicts the Versailles road looking north; Pissarro lived at number 22 on the left-hand side. Monet had painted several perspective road scenes in the snow in 1864 and 1867; this one is especially precise in its treatment of recession towards a central vanishing point. Pissarro painted the same site in the snow and in the rain (L.-R. Pissarro and L. Venturi, *Camille Pissarro*, Paris, 1939, nos 71, 76) and explored the pictorial idea in numerous other road paintings between 1868 and 1872.

29 and 30. *La Grenouillère*

1869 (W. 134)
$29\frac{3}{8} \times 39\frac{1}{4}$ in. $(74·6 \times 99·7$ cm.)
Signed bottom right: Claude Monet
Metropolitan Museum of Art, New York

La Grenouillère was a very popular bathing and boating place on the Seine, just south-west of Paris. During August and September 1869, Monet and Renoir worked there together, painting from the same vantage-points. Two pairs of canvases remain to provide a record of their joint efforts: Renoir's painting in the Reinhart Collection, Winterthur, compares closely with Monet's version in the Walzer collection, Oxford; and Monet's Metropolitan painting, reproduced here, may be paired with Renoir's canvas in Stockholm (Fig. 15).

In both of the latter two paintings we see boats in the foreground, before the small, circular island—the '*pot aux fleurs*' as de Maupassant called it—crowded with people. A short ramp connects the island to the floating boathouse on the right, another, longer one, leads to the unseen shore on the left. Renoir's painting is more densely foliated and populated than is Monet's. We are closer to the scene, the leaves hang down before our eyes, the boats fall away at our feet, we can, in effect, reach out and touch the figures. Renoir's scene is closer and directed towards the surface. The far bank seems especially proximate; the hanging foliage both masks and interweaves with the trees across the river. Renoir offers us separate patches

of observation: the boats which drop from the island to the lower edge, the post-and-lintel catwalk at the right that frames a stretch of shimmering green water, the river area just above the plank, spattered with the multi-hued touches of boats and boaters; there is, as well, no consistent or coherent scale relationship between the foreground boats and the figures on the island. Renoir adds part to part and cumulatively arrives at a painted composition, perhaps more disposition than composition, a felt arrangement of elements first isolated then commingled. The painting matches the free activity of the setting; it records the separate awarenesses which normally characterize our perception of such a multifarious scene.

By comparison, Monet's *Grenouillère* is distanced, aloof, austere, formal, and rational. Deep space is clearly indicated, starting with the almost radial distribution of the boats in the foreground and abetted by the empty expanse of water in front of the island. The entry to the painting is open, centrifugal, effecting by contrast a strong sense of contraction to the island, which serves as the spatial hub of the composition. Beyond the island the water continues its thrust, unobstructed, towards the far shore; the horizon is lower than in Renoir's painting and the area of the sky above the trees reveals still further reaches. Monet's picture is less populated, less devoted to local colour; his figures are abstract and simplified, adjusted to the painted character of the whole. He adapts the reflections of his figures to the overriding surface activity and panelled formations of the shimmering water before the island; Renoir paints reflections that carry the colour of costume and flesh, almost recapture the poses of the two standing figures at the right side of the island in his painting. Monet's brushstroke is firmer, cleaner; contrasts of colour and value are more emphatic. In almost every detail Monet's painting displays a precision that distinguishes it from Renoir's softer, more relaxed and irregular rendering of the scene.

Up to this point Renoir's development had been more discursive than Monet's, and in his painting of La Grenouillère one sees a compound of delicate sensibility and innate skill adapted to a task and a vision that Monet had been elaborating in a more probing experimental fashion during the second half of the sixties. The differences between their two works are characteristic of their production during the sixties (and, for the most part, throughout their careers); Monet's picture is purer, more thoroughly controlled, more intellectually penetrating than is Renoir's canvas.

31. **The Train**
(*Le Convoi de chemin de fer*)
1872 (W. 213)
18⅞ × 29⅞ in. (48 × 76 cm.)
Signed bottom left: Claude Monet
Kemeys-Pennington Mellor Trust, London

In March 1872 Monet participated in the twenty-third municipal exhibition in Rouen, where his brother Léon lived. Monet spent some time there painting, producing about a dozen canvases almost exclusively devoted to the Seine and its banks. *The Train* depicts the valley of Déville, where his brother lived. The foothills of this industrialized suburb, dominated by factories and smoke stacks, are partly obliterated by the thick volume of smoke from the locomotive of the passing train, the trailing smoke from the train and the wind-blown puffs from the factory chimneys moving in opposite directions. In composition, in the simple disposition of the setting viewed from across the river, this painting is not at all unusual, but in no other work did Monet depict a landscape so completely transformed by man's industrial presence; that he considered it in some way—whether positively or negatively he does not say—a source of wonder is indicated, however, by the inclusion of the three tiny figures on the near shore, commentators of a sort that ordinarily have no role in his paintings.

32. **The Thames below Westminster**
(*La Tamise et le Parlement*)
1871 (W. 166)
18¼ × 28½ in. (47 × 73 cm.)
Signed and dated bottom right: Claude Monet 71
National Gallery, London

On 19 July 1870, while Monet was at Trouville, France declared war on Prussia. The Third Republic was formed on 4 September, attempting to carry on the defence of the country. At some time in the autumn, Monet decided to cross the Channel to England, possibly to avoid call-up for military service. He was joined, soon after it seems, by Camille and Jean. In this painting, done from the Victoria Embankment, Monet employs the kind of structural lucidity he demonstrated in *La Grenouillère* and *Bridge at Bougival* (Plates 23 and 29), but here he stresses the organization of horizontals and verticals, which rule the surface and give the painting measure. The long view up-river is established but oddly collapsed, as if seen through a telephoto lens, each element—parallel to the picture plane—overlapping another. The atmosphere is grey, subdued, a pink glow appears in the lower sky. The arrangement of greys on greys suggests, as William Seitz has observed, that it is the example of Whistler more than Turner that is evoked as a model for this restricted tonal interpretation. Although there is no record of Monet and Whistler meeting in London or of Monet's seeing Whistler's paintings there, the *Thames above Westminster* suggests that Monet may well have known his work.

Pissarro and Daubigny were also in London during the Franco-Prussian War, and it was through Daubigny that Monet met the dealer Paul Durand-Ruel, who opened a gallery in New Bond Street in December 1870.

202

33. *Green Park*

1871 (W. 165)
$13\frac{1}{2} \times 28\frac{5}{8}$ in. (34×72 cm.)
Signed bottom left: Claude Monet
Philadelphia Museum of Art

During the winter or spring of 1871, Monet painted *Green Park* and *Hyde Park* (Rhode Island School of Design; W. 164). The painting of *Green Park*, reproduced here, represents a view looking west in the direction of Hyde Park Corner. Both canvases are long, horizontal rectangles. *Hyde Park* presents a rise in the foreground from which several figures view the scene and can be included in a long tradition of engraved panoramic views of famous sites; it is not unlike Manet's *View of the Paris World's Fair* of 1867 (National Gallery, Oslo), which itself derives from the same tradition. *Green Park*, however, seems entirely fresh and informal; like the Manet, it gives the impression of a close-up and a panorama at one and the same time, although Monet's painting is far more delicate and distanced, a finely attuned response to the breadth and muted atmosphere of the scene.

34. *Argenteuil, the Bridge under Reconstruction*

(Argenteuil, le pont en réparation)
1872 (W. 194)
$23\frac{3}{8} \times 31\frac{3}{8}$ in. ($60 \times 80 \cdot 5$ cm.)
Signed bottom right: Claude Monet
Lord Butler, Cambridge

Monet returned to Paris from Holland in the autumn of 1871 and almost immediately began to look for a place to settle in the area just outside the city. At the end of the year he moved to a small house, equipped with a studio, at Argenteuil on the Seine, about six miles to the west of Paris. Among his earliest views of the site are two paintings of the bridge, which had been destroyed during the war; when Monet painted it during the winter, its reconstruction was drawing to a close, but it was still sheathed in an elaborate wooden scaffolding. The dull winter weather is emphasized in the restricted range of the palette—cool greys of sky and water, warm browns of the scaffold, taken from around and below the middle of the value scale.

35. *The Wooden Bridge*

(Le Pont de Bois)
1872 (W. 195)
$21\frac{1}{4} \times 28\frac{3}{4}$ in. (54×73 cm.)
Signed bottom left: Claude Monet
Private Collection, Switzerland

Monet frequently did paintings in pairs, but he would develop the terms of those pairs in a variety of ways. *The Wooden Bridge* and *The Bridge under Reconstruction* (Plate 34) are paired paintings that take the bridge as a shared motif but view it from two different angles. It is as if in selecting a common motif he was interested in finding out what could be learned about that subject (in this case the bridge in relation to its surroundings) as a result of changing one variable. Here the two paintings are vastly different in the information they offer about the site. This is a continuation of the kind of pairing he did from the balcony of the Louvre in 1867 (Plates 4 and 5), where the view of the Quai du Louvre remained essentially the same while the main variable was the horizontal or vertical position of the canvas. In the present instance, Monet also offers a comparison of two different compositional ideas—the clear perspective view of *The Bridge under Reconstruction*, so like *Zaandam* (Plate 36), and the strictly frontal aspect of *The Wooden Bridge*. For a more extensive discussion of Monet's pairs and other groupings see Steven Levine's articles in *Arts Magazine*, June 1975 and February 1977.

The title *The Wooden Bridge* is something of a misnomer. In the painting we see two sections of the bridge supported by temporary wooden trusses prior to the installation of a permanent cast-iron arched support, which may be seen in Plate 34.

36. *Zaandam*

1871 (W. 183)
$18\frac{3}{8} \times 28\frac{1}{2}$ in. (47×73 cm.)
Signed bottom left: Claude Monet
Musée du Louvre, Paris (Jeu de Paume)

Monet went to Holland directly from London and settled at Zaandam, where he worked with extraordinary energy through the summer and into the autumn, producing approximately twenty-five canvases (compared with the six that remain from the London trip). In that body of work he demonstrated the full range of styles that he was to develop during the high years of Impressionism at Argenteuil from 1872 to 1878. The brief sketch and the elaborated picture, the informal and the formal, the muted and the multi-coloured, broad, flat painting and active, broken brushwork—all of these are explored in different combinations. *Zaandam* is the most classically ordered painting of the campaign, secure in its perspective and composition, closely and carefully interwoven in brushwork; it brings clarity and serenity to the complex visual activity of the scene. Compare the Metropolitan's *Grenouillère* of 1869 (Plate 29) to see how far Monet has moved in the direction of a colour system restricted to the middle range of the value scale. In January 1872, shortly after his return to Paris, he was visited by Boudin, who then wrote to a friend: 'He has brought back some very beautiful studies from Holland and I believe that he is called to take one of the leading places in our school.'

37. The Zuiderkerk at Amsterdam

(La Zuiderkerk à Amsterdam)
About 1874 (W. 309)
$21\frac{1}{2} \times 25\frac{3}{4}$ in. $(54\cdot5 \times 65\cdot5$ cm.)
Signed bottom right: Claude Monet
Philadelphia Museum of Art

Only two of Monet's Holland paintings are dated, both 1872, and yet there is no evidence that Monet worked in Holland in 1872. Daniel Wildenstein has recently suggested that those works belong to the campaign of 1871 at Zaandam and that the dozen paintings of Amsterdam that remain should be assigned to 1874 on stylistic grounds. Two of the Amsterdam paintings are snow scenes and necessarily must be separated from the summer stay in Holland of 1871. Wildenstein's suggestion may very well be correct. The *Zuiderkerk*, for example, bears a close stylistic resemblance to *Les Barques régates à Argenteuil* (Louvre, W. 339), traditionally dated 1874, and the figures on the path at the right in *Zuiderkerk* are very adeptly, sketchily treated in a way that may well be considered a development from the *Boulevard des Capucines* (Plate 41). In both *Les Barques régates* and the *Zuiderkerk*, Monet demonstrates a technique basic to Impressionist painting, evident in numerous paintings of the 1870s and later by Monet and his friends, Alfred Sisley above all. The canvas is painted a ground tone of tan (the tone varies from painting to painting; usually it is a light, warm grey), and upon that ground the broken touches are deployed either abundantly or sparingly. In the *Zuiderkerk* the strokes are most sparse in the water area, centre and left, the exposed tan ground serving to register the reflections of the church and the small buildings at the left. In other areas the tan serves as a filler, giving body to an area then to be painted in in the most brief and suggestive way.

38. The Seine at Asnières

(La Seine à Asnières)
1873 (W. 269)
$21\frac{5}{8} \times 29\frac{1}{8}$ in. $(55 \times 74$ cm.)
Signed bottom right: Claude Monet
Private Collection, France

Asnières was part of Monet's experience of Argenteuil. On the left bank of the Seine, half way between Argenteuil and Monet's gateway to Paris, the Gare Saint-Lazare, this rapidly growing industrial suburb could be seen just to the north of the railway line that linked Paris to the villages of the north-west region. This canvas, with its large river barges in the water, is like a counterpart of the Argenteuil paintings, which tend to stress the recreational aspect of that setting (Plate 45). In a companion painting of Asnières (W. 270) Monet included a sailing-boat along with the barges, effectively contrasting the earlier boating reputation of Asnières with its newer industrial character. Monet's fascination with angular forms and reflections, which create geometric shapes within the painting, is evident in this composition and in the more open, transparent shapes of *The Bridge at Argenteuil* (Plate 45).

39. Impression, Sunrise

(Impression, soleil levant)
1873 (W. 263)
$18\frac{7}{8} \times 24\frac{3}{4}$ in. $(48 \times 63$ cm.)
Signed and dated bottom left: Claude Monet. 72
Musée Marmottan, Paris

This small view of the port of Le Havre is the painting from which the Impressionist movement received its name. It was shown as number 98 at the first exhibition of the group in 1874. Titled *Impression, soleil levant*, painted in a broad, sketchy manner that yielded an indistinct definition of forms in the early morning haze, it was singled out by several critics who seized upon the word '*impression*' both negatively and positively. Louis Leroy's famous review in *Le Charivari* had a visitor to the show exclaim: '*Impression*, I was sure of it. I was just telling myself that since I was impressed, there had to be some impression in it. ... And what freedom, what ease of workmanship! Wallpaper in its embryonic state is more finished than that landscape.' Emile Cardon criticized the painting but borrowed its title to speak of 'l'Ecole de l'Impression'. Jules Castagnary, old defender of the Realists, subtitled his review '*Les Impressionnistes*' and used the word to describe a new artistic tendency he saw in the work of Monet, Sisley, Pissarro, Renoir, Degas, Guillaumin and Morisot, which he defined in this manner: 'They are *impressionists* in the sense that they paint not the landscape, but the sensation that the landscape produces.' This definition, in many variants, was to become a common characterization of Impressionism and it applies well to the present picture, and yet it must be recognized that *Impression, Sunrise* is not representative of Monet's work by and large. Perhaps just such a recognition coupled with the realization that Monet's painting was less an impression of nature than a variant on a pictorial theme found in the Nocturnes of Whistler (see introduction, p. 21, and Fig. 17) was offered inadvertently in Ernest Chesneau's review of the exhibition: at the end of his discussion of Monet's work he excused himself for not being able to devote more time to '*Impression* (Sunrise on the Thames)'—a slip of the pen that reveals his instinctive linking of Monet's painting with the Whistler Nocturnes, which he, too, like Monet, may have seen the previous year at Durand-Ruel's gallery.

In recent years, John Rewald and others have questioned the traditional identification of this canvas with the painting exhibited in 1874. That identification has since been maintained, however, by other historians and by Daniel Wildenstein (who originally questioned it) in the first volume of his *catalogue raisonné* of Monet's work. He establishes an unbroken list of owners, which takes the painting back to the first Impressionist exhibition, and he indicates the likelihood that the view is of the old outer harbour of Le Havre (now the inner harbour) looking towards the south-east, hence affirming the consonance between the title and what the painting depicts. Rewald's proposed candidate (W. 262) and one other canvas (W. 264) share the style of *Impression, Sunrise*. Wildenstein has also redated the canvas to Monet's sojourn in Le Havre in March or April 1873, considering, no doubt

rightly, since its brushwork differs from that of the signature, that the date on the canvas was added incorrectly at a later time.

40. ***The Promenade, Argenteuil***
(*La Promenade d'Argenteuil*)
1872 (W. 223)
$19\frac{7}{8} \times 25\frac{5}{8}$ in. (50·5 × 65 cm.)
Signed bottom right: Claude Monet
National Gallery of Art, Washington, D.C.

This is one of four paintings from the spring of 1872 devoted to the view looking downstream along the riverside promenade from the direction of the bridge. The trees to the right border the wooded fair-ground, the island to the left is the Ile Marante, which provides a prominent part of the setting in a number of the paintings (see Plate 44). The house in the distance with its small tower is a conspicuous feature of the landscape in many of the Argenteuil paintings, as are the industrial chimneys that flank it. In a second painting, with which this one is closely paired (W. 222), the sky is heavy with clouds, the sailing-boat has disappeared, and the chimneys are smoking as Monet stresses differences in atmosphere, time of day, and use of the site in developing his comparison.

41. ***The Boulevard des Capucines***
(*Le Boulevard des Capucines*)
1873 (W. 292)
$24 \times 31\frac{5}{8}$ in. (61 × 80 cm.)
Signed and dated bottom left centre: Claude Monet 73
Pushkin Museum, Moscow

In the autumn of 1873 Monet did two paintings of the Boulevard des Capucines looking in the direction of the Place de l'Opéra. They were possibly painted from the studio of the photographer Nadar, in the same place that Nadar made available for the first Impressionist exhibition, at which this painting appeared. Well known is the criticism of Louis Leroy, who wrote deridingly of the 'black tongue-lickings' used to brush in the passers-by on the street, less well known the judgment of Jean Prouvaire, who found the painting excessively tumultuous and multicoloured. It is, however, the acute and sympathetic, if eventually qualified, response of Ernest Chesneau, who recognized in this canvas attributes which are at the base of Impressionist painting and make the *Boulevard des Capucines* a far more deserving canvas to represent Impressionism than *Impression, Sunrise* (Plate 39), that should be remembered:

> Never has the prodigious animation of the public thoroughfare, the swarming of the crowd on the pavement and the carriages in the street, the movement of the trees in the dust and light along the boulevard; never has the elusive, the fleeting, the instantaneous character

of movement been caught and fixed in its wonderful fluidity as it is in this extraordinary, this marvellous sketch.

This canvas, which is horizontal, emphasizes the strong action of the sun, causing the shadow of the buildings to cover half the street in the right half of the picture and illuminating the left half in a warm golden glow. The avenue is jammed with pedestrians and carriages. The companion painting, in Kansas City (W. 293), is the same size but held vertically, the weather is grey, the sun cloaked in a cold, pale blue sky, the activity somewhat thinned out. In both paintings Monet includes two top-hatted men on a balcony at the right-hand edge. They stand for the perceiving eye of the artist, who assumed a similar vantage-point in order to view the scene in this way. This kind of angled view was a necessary aspect of such scenes as taken by the camera, where the viewpoint could not be hypothesized or invented but had to be factually established at a certain place (that was evident from the very beginning of photography, when we find almost identically angled shots of Paris streets by Fox Talbot and Daguerre, the latter's view of the Boulevard du Temple dating from as early as 1838). Monet accepted that premise and attempted to authenticate the view and, as Chesneau observed, convey the fleeting aspect of movement, of rapid tempo, that is part of the experience of such an environment.

42. ***The Luncheon***
(*Le Déjeuner*)
1873 (W. 285)
$63\frac{3}{4} \times 79\frac{7}{8}$ in. (162 × 203 cm.)
Signed bottom right: Claude Monet
Musée du Louvre, Paris (Jeu de Paume)

The Luncheon was exhibited at the second Impressionist exhibition in 1876, where it was designated in the catalogue as a 'decorative panel', which probably accounts for its large size in comparison with most paintings by Monet of the seventies. We are ignorant, however, of its function and of the circumstances of its origin. But it is a thoroughly worked, elaborately detailed painting, exhibiting a specific and minute description that also sets it apart from most of Monet's canvases of this time. That quality of detail extends to the subject of the painting, which suggests a story or event or a pause between events, perhaps a note of autobiography. Monet did eight paintings of figures in the garden in 1873; in four of them Jean, who was six in July, appears along with Camille, and in each case he is seen in a decidedly isolated relationship to her: in the Chicago *La Maison de l'artiste* (W. 284) he stands before the house alone and frail, while Camille (or perhaps another woman, a maid possibly) peers out at him from the doorway; in *Camille au jardin avec Jean et sa bonne* (Bührle Collection, W. 280) Camille poses in a grey and black dress and with black parasol (possibly in mourning for her father; see Plate 50), while Jean squats nearby next to the

maid; in the large canvas *Camille et Jean Monet au jardin d'Argenteuil* (W. 282) the self-absorbed Camille and the self-abandoned Jean are placed in the same setting but are physically, psychologically, and even stylistically remote from each other (Camille's body and especially her face are quite finished, Jean is sketchily painted; the canvas is not signed, however, and was probably left unfinished). The evidence adds up to a commentary upon estrangement within the fabric of the family, an estrangement that involves Monet himself, for his presence is nowhere indicated in these domestic settings.

43. ***Boats at Petit-Gennevilliers***
(Bateaux au Petit-Gennevilliers)
About 1874
Sketchbook drawing, pencil (MM5130, sheet 8 recto)
$9\frac{1}{2} \times 12\frac{1}{4}$ in. (24 × 31 cm.)
Musée Marmottan, Paris

This is a page from one of eight sketchbooks that have recently entered the Musée Marmottan as part of the legacy of Michel Monet in 1966. The album in which this drawing appears (MM5130) was used by Monet during the 1870s; among diverse subjects it contains several drawings of Argenteuil and the Gare Saint-Lazare in Paris (Plate 56). This drawing was probably done in 1874, at the time when he painted the *Bridge at Argenteuil* (Plate 45). Here, too, he displays his interest in the rigging and masts of the sailing-boats anchored off the Petit-Gennevilliers bank, the site from which he viewed the scene for the oil-painting. The light, straight lines of the rigging are set in counterpoint to the somewhat heavier, irregular shapes of the trees and houses on the shore. The precise relationship between such drawings and Monet's paintings of the site is not known, but it can be readily assumed, at least in the case of the Argenteuil drawings, that they accompanied his work in oil outdoors rather than that they served as a preliminary to work in the studio.

44. ***Autumn Effect, Argenteuil***
(Effet d'automne à Argenteuil)
1873 (W. 290)
$22 \times 29\frac{1}{2}$ in. (56 × 75 cm.)
Signed and dated bottom right: Claude Monet/73
Courtauld Institute Galleries, London

For the most part, Monet's palette at Argenteuil made use of a full range of pigments, including black and earth colours. This painting is an exception in that it displays a scale of hues almost completely derived from the spectrum, concentrating on a restricted coupling of warm and cool and of complementary colours, in this case yellows and blues. The palette is composed of yellows, pinks, greens, blues, turquoise, violet. Olive and yellow ochre are the only earth colours present. In the heavy working of the paint, the resulting puckered surface, and in the purity and iridescence of its palette, it is a painting far closer to

the canvases of Bordighera of 1884 (Plate 76) and to the close-hued, close-valued series of paintings of the nineties, e.g., the Haystacks (Plate 96), Poplars (Plate 106), and *Falaises* (Plate 116). In format, emphasis upon reflections, and delicacy, it also bears a close relationship to the Mornings on the Seine series of 1897 (Plates 111 and 112).

The view is of the channel between the Ile Marante and the Colombes shore across from Argenteuil. In the gap between the trees in the distance on the Argenteuil side is the small house with tower evident in the background of Plate 40. There is a painting of the same size and composition (J. H. Whitney, U.S.A., W. 291) with the date 1874. Daniel Wildenstein says that that date is incorrect and that it should be 1873 as in this painting; the date here, however, is in a different colour from the signature and was probably added later.

45. ***The Bridge at Argenteuil***
(Le Pont routier, Argenteuil)
1874 (W. 312)
$23\frac{3}{4} \times 31\frac{1}{2}$ in. (60 × 80 cm.)
Signed bottom right: Claude Monet
Paul Mellon Collection, U.S.A.

The summer of 1874 saw numerous paintings of the river and its bridges come from Monet's easel. The present work is one of several devoted to a stable and tranquil depiction of the setting (e.g. W. 311–15), the composition of each work established in a careful and orderly fashion. The structural lucidity of Impressionist painting was never more clearly demonstrated than in these paintings. The bridge is made to measure its recession with care, each vertical pier stepping back to the far shore, where we find the vanishing point for its perspective centred laterally; the shore, which depicts the promenade and trees of the fair-grounds on the Argenteuil side, then extends horizontally to the left edge, equally dividing the sky from the water. The shape of the water mirrors that of the sky save for the foreground triangle of foliage in the lower right corner. That near triangle disrupts the decorative symmetry of the composition as one reads it from top to bottom. It breaks the self-contained assurance of the picture and suggests continuity with the painter's vantage-point. The foreground mast acts in the same way; it belongs to a boat that we do not see, yet implies the inclusion of that boat within the picture's spatial frame of reference. At the same time it also explores the surface by means of the play of line and shape (the verticals of the piers and the horizontals of the far bank, the triangular divisions created by the poles and ropes). The decorative is made to interact and coincide with depth, as in the linking of the foreground mast—like a flag-pole and its flag—to the white house on the far shore, and as in the thin right-hand rope (connecting bowsprit to mast) that mimics the diagonal recession of the bridge's piers. Monet was apparently fascinated with the framing of shapes by means of the arrangement of poles and ropes; in the world of the painting the water and far shore are divided into triangles of colour that

seem to slide under one another like the planes in developed analytic Cubist paintings. His interest in these shapes is further indicated in the sketchbook drawing illustrated in Plate 43.

46. *The Bridge at Argenteuil on a Grey Day*
(Le Pont d'Argenteuil, temps gris)
1874 (W. 316)
24 × 31⅝ in. (61 × 80 cm.)
Signed bottom right: Claude Monet
National Gallery of Art, Washington, D.C.

Compared to the brilliant colour and assured breadth of composition in Plate 45, this view of the river on an overcast day conveys a dour mood and seems composed of separate details pieced together. The horizontal bridge runs across the artist's line of vision, the view developed from a vantage-point on an outcrop of land on the Petit-Gennevilliers shore. Short horizontals, including that of the railway bridge further upstream, seen through the arch of the other bridge, are like a random distribution of dashes and hyphens against longer and shorter verticals. An irregular, somewhat domino-like pattern of horizontal and vertical boats gives its order— cumulatively—to the scene. Monet's floating studio is anchored at the right (cf. Fig. 16).

47. *The River Basin at Argenteuil*
(Le Bassin d'Argenteuil)
1875 (W. 371)
21¼ × 29⅛ in. (54 × 74 cm.)
Signed and dated bottom right: 75 Claude Monet
Private Collection, Madrid

The small boats and the hulking boat-hiring house in the foreground are set darkly against the view down-river at the end of the day. The boathouse was moored at the foot of the bridge on the Petit-Gennevilliers shore. This is seen, with its readily identifiable red house and poplars, on the left. Monet did two longer-range views of the site from a high vantage-point, presumably on the bridge, in 1874 (W. 334, 335, the latter recently acquired by the Indiana University Museum of Art). If the date 1875 holds (the 75 on the canvas seems rather large and somewhat out of character with the signature), then this relatively sombre, workaday, almost lugubrious painting may be related to the *Déchargeurs de charbon* (W. 364, dated by Wildenstein to 1875), that unique painting of workers unloading coal from the river barges at Asnières, and possibly to Monet's singular painting of Jean and Camille in the darkened interior of their house, *Un coin d'appartement* (Louvre, W. 365, dated 1875). As Monet wrote in 1883 to Durand-Ruel, speaking specifically about the *Déchargeurs*, all three of these paintings present, in their deep tones and interest in *contre-jour* effects, a 'separate note' in his work.

48. *Red Boats, Argenteuil*
(Les Bateaux rouges, Argenteuil)
1875 (W. 370)
21⅝ × 25⅝ in. (55 × 65 cm.)
Signed bottom left: Claude Monet
Musée du Louvre, Paris (Jeu de Paume)

This close-up view of small boats anchored off the Petit-Gennevilliers shore was painted, perhaps on his studio boat, from a vantage-point very close to that for Plate 47. It is one of three paintings (W. 368, 369, 370) offering a very similar view. Salient, and new, in all three canvases is the strength and brilliance of the red of the boats in the centre, their rusty vermilion colour set against the complementary blue of the water (and, in the present canvas, the green of grasses or algae floating on the surface). The three paintings share in the new interest in colour intensities that emerged in Monet's work in 1875 and 1876, principally in his garden scenes (see Plate 51). Prominent, also, in all three paintings, is a precise organization of repeated verticals against a sharply developed perspective. In the present painting the perspective seems to diverge to vanishing points to the right and left, directed from the prominent foreground boat just to the right of centre.

49. *View of Argenteuil, Snow*
(Vue d'Argenteuil, neige)
1875 (W. 358)
21⅝ × 26¾ in. (55 × 68 cm.)
Signed bottom left: Claude Monet
Nelson Gallery-Atkins Museum, Kansas City, Missouri

During Monet's stay in Argenteuil from 1872 to 1878 he painted more than eighty views of the river, but he devoted over fifty canvases to other aspects of the area—the town and surrounding fields—not counting the three dozen pictures of figures and gardens that are spaced throughout the period. In the winter of 1874–5 we find a concentration of about fifteen snow scenes centred on the neighbourhood in which Monet lived. This view of Argenteuil in the snow is of the area to the east of the railway line and close to the Seine. Today it is largely a factory quarter, the beginning of the process of in-dustrialization seen here in the buildings on the right. Although for the most part this seems like a thoroughly realistic description of the neighbourhood, it is possible that the somewhat contrived curve of the path with its silhouetted forms derives from Japanese prints (see, e.g., Hiroshige, *Winter Street Scene, Shiba District* from the series 'One Hundred Views of Famous Places in Edo').

50. *The Bench*

(Le Banc)

1873 or 1874 (W. 281)

$23\frac{5}{8} \times 31\frac{5}{8}$ in. (60 × 80 cm.)

Signed bottom right: Claude Monet

Mr and Mrs Walter Annenberg, U.S.A.

Charles-Claude Doncieux, Camille's father, died on 22 September 1873. Two garden paintings by Monet depict Camille dressed partially in black; they almost certainly present her in mourning for her father. *Camille au jardin avec Jean et sa bonne* (W. 280) depicts a relatively calm, almost melancholic Camille seated as if posing for her portrait; Jean and a maid are set to one side of the picture. In *The Bench* a quality of narrative is introduced, almost as if Camille is reacting to something that has just been said by the man behind her; her manner has changed to a certain agitation. The bearded man at the bench and the woman in the left background have not been identified; the man may signify the death of the father or reasonably represent a visitor offering condolences.

It is possible, however, that the painting may date not from the immediate aftermath of M. Doncieux's death but from the following spring. In this painting and *Camille au jardin avec Jean et sa bonne*, Camille is not in full black; her half-mourning costume indicates the second half of the one-year mourning period prescribed for a daughter, and the bouquet in *The Bench* may not be associated with the etiquette of a condolence call. These considerations, along with the varieties of garden flowers (difficult to identify with certainty), suggest the possibility that the paintings were done in about June of 1874. In that case the grave note in the relationship between Camille and the male visitor in *The Bench* may require some other explanation. The combination of a seated woman and a standing man leaning upon the back of a bench was frequently found in popular illustration and occasionally in painting (cf. Manet, *In the Conservatory*, 1879, Nationalgalerie, Berlin), where it almost invariably signifies flirtation or amorous conversation. Precisely what may have led Monet to provide the suggestion of that kind of intimacy with a note of agitation is something that requires further inquiry.

51. *Gladioli*

(Les Glaïeuls)

1876 (W. 414)

$23\frac{1}{2} \times 32$ in. (59.7 × 81.3 cm.)

Signed bottom right: Claude Monet

Detroit Institute of Arts

In 1875, Monet did five paintings of figures in the garden of the house to which he moved in 1874. He added ten more canvases on this theme in 1876. In the works of both years he began to emphasize the setting, often giving the richness and abundance of foliage and flowers pride of place. *Gladioli* is typical of this development; Camille is depicted in the background, in half light, overshadowed by the intensely coloured flower beds, with reds and pinks set in strong contrast to the complementary greens of leaves, stalks, and grass. One can establish through close examination an underlying network of diagonals that governs the composition, but such analysis seems relatively obtrusive and inappropriate in this case. What one is mainly aware of is the rather awkwardly dominating area of the flower bed, the experience of intense, vibrant colour overcoming the schema of compositional organization.

52. *Portrait of Camille with a Bouquet of Violets*

(Portrait de Camille au bouquet de violettes)

1876–7 (W. 436)

$45\frac{5}{8} \times 34\frac{5}{8}$ in. (116 × 88 cm.)

Private Collection, U.S.A.

Monet's earliest portraits of Camille (Plate 18 and *Camille au petit chien*, W. 64), 1866, offer a picture of a sober young woman; *Meditation* (W. 163) of 1871 shows her in a quiet, pensive mood; two paintings of 1873 depict a grave Camille in mourning (see Plate 50). Other pictures of her allow us to concentrate less on her person than her situation, whether that be conveyed through narrative, setting, or the character of light. In the early seventies, Monet received a number of visits from Renoir, who did several portraits of Camille, portraits that often seem closer and more sympathetic to his sitter than those by Monet. In this instance, however, Monet views Camille directly and portrays a woman of beauty and awareness. Her eyes, both outwardly appraising and inwardly revealing, accord with the tilt of her head to convey the sense that, however one interprets her mood, she is a woman with real thoughts and emotional substance. Monet's next portrait of Camille was done at the time of her death in 1879 (Plate 59).

53. *The Hunt*

(La Chasse)

1876 (W. 433)

$68\frac{1}{8} \times 55\frac{1}{8}$ in. (173 × 140 cm.)

Signed and dated bottom left: Claude Monet/1876

Private Collection, France

During the summer of 1876, Monet was commissioned by Ernest Hoschedé to do four paintings for the decoration of his château at Montgeron. Hoschedé was one of the earliest patrons of Monet and the other Impressionists, having begun collecting their work probably at the beginning of the 1870s. In January 1874 he was able to include three Monets at an auction sale of his collection, which included eighty paintings. Among his purchases were *The Thames below Westminster* of 1871 (Plate 32), *Impression, Sunrise* (Plate 39), bought from the first Impressionist exhibition through Durand-Ruel, and two major views of Saint-Lazare Station, including that in the Fogg Museum (Plate 60).

The four paintings done for the château are *The Turkeys*

(W. 416, Louvre), *Corner of the Garden at Montgeron* (W. 418, Hermitage, Leningrad), *The Pond at Montgeron* (Plate 58) and *The Hunt*. Monet worked at them from the summer to the autumn, much of the time spent in Montgeron as a guest of the Hoschedé family.

54. *Promenade. Woman with a Parasol*

(La Promenade. La femme à l'ombrelle)
1875 (W. 381)
39¼ × 32 in. (99·7 × 89·3 cm.)
Signed and dated bottom right: Claude Monet 75
Paul Mellon Collection, U.S.A.

This dramatic view from below, the figure of Camille set boldly against the sky, was shown at the second Impressionist exhibition in 1876. Camille is caught just as she has become aware of our presence, and turns toward us with a sudden, perhaps even startled motion. The grey wisps of her veil, stroked lightly across her face, convey the sense of movement and of the windiness of the day. The action and central position of Camille are in contrast to the mute accompanying figure of Jean. Thus, in mood—a quality of companionship and estrangement—the painting picks up some of the characteristics of the extended group of figure scenes from 1873 (see Plate 42). Monet turned to this motif again in 1886, doing two similar paintings of a woman with a parasol on a hillside; both works are now in the Louvre in Paris.

55. *Rue Saint-Denis, Celebration of 30 June 1878*

(La Rue Saint-Denis, fête du 30 juin 1878)
1878 (W. 470)
29⅞ × 20½ in. (76 × 52 cm.)
Signed bottom left: Claude Monet
Musée des Beaux-Arts, Rouen

Views of Paris appeared with increasing frequency in Monet's work during the second half of his Argenteuil period. In 1876 he did three views of the Parc Monceau and four of the Tuileries; 1877 saw approximately a dozen paintings of the Gare Saint-Lazare; in 1878 he once again did three paintings of the Parc Monceau and two canvases devoted to views of Paris streets decked out with flags and bunting in celebration of the World's Fair that had opened in the spring. From a perch on a balcony just above the street, he quickly painted the scene illustrated here and did another, similar, painting from a like vantage-point on the rue Montorgueil (W. 469). (The titles of the two paintings have for a long time been interchanged, but Daniel Wildenstein has recently established their correct designations.) These pictures continue the efforts Monet had inaugurated in 1867 with the *Garden of the Princess* (Plate 5) and developed in the *Boulevard des Capucines* of 1873 (Plate 41). From stage to stage we find a progression from description towards abstraction, towards an ever more vibrant shorthand that conveys, through pulsation of colour and

rapidity of brushstroke, something of the polysensorial character of the scene itself. And yet, despite the evidence of consistent development since 1867, Monet worked in this sketchy fashion only rarely. It may be, given the particular character of the fluid, agile, rapid touch of the *Rue Montorgueil* and *Rue Saint-Denis*, that he was deliberately emulating the flashing style of Manet and, at least in terms of the rendering of dense activity, outstripping him. Both of Monet's paintings appeared at the fourth Impressionist exhibition in 1879.

56. *Gare Saint-Lazare*

1877
Sketchbook drawing, pencil
9½ × 12¼ in. (24 × 31 cm.)
Musée Marmottan, Paris (MM5130, folio 11 recto)

Five drawings—fairly complete compositional studies—of the Gare Saint-Lazare remain in a sketchbook in the Musée Marmottan, in the same album that Monet used at Argenteuil (see Plate 43). We do not know the relationship between these drawings and the final paintings, but four of the sketches conform to existing paintings and we may assume that Monet used them as guides more fully than he did those at Argenteuil, for working on site at the station was undoubtedly more difficult than working along the river. The view is from the Pont de l'Europe toward the rue d'Amsterdam, which runs along the east flank of the station; a portion of the x-shaped Pont de l'Europe appears on the left, an angle of the roof of the station on the right.

57. *Exterior of the Gare Saint-Lazare (The Signal)*

(La Gare Saint-Lazare à l'extérieur [le signal])
1877 (W. 448)
25⅝ × 32⅛ in. (65 × 81·5 cm.)
Signed bottom left: Cl. M.
Private Collection, U.S.A.

Conforming to the previous drawing in general approach, this painted sketch develops the site with dramatic inventions in colour and composition. The circular signal set back into the centre of the drawing is now made to float—dark grey—upon the surface of the canvas, while another signal is introduced on the right. The station attendant inclining forward on the right of the drawing is transformed into a tall, rigid figure likened to the signal posts. The slight balloon of smoke in the drawing fills the sky with swirls of peppermint pink in the oil sketch. A vigorous, dark, dramatic atmosphere pervades the scene, emphasized by the liberal exploitation of warm tan canvas showing through the lower third of the painting and the use of an even darker, burnt umber undercoat beneath the area of the sky. The painting was bought from the third Impressionist exhibition by Caillebotte.

58. *The Pond at Montgeron*
(L'Etang à Montgeron)
1876 (W. 420)
67¾ × 76 in. (172 × 193 cm.)
Signed bottom right: Cl.M.
Hermitage, Leningrad

This is one of the four canvases (see also *The Hunt*, Plate 53) commissioned to decorate a room of the château of Rottenbourg at Montgeron, the country estate of Ernest Hoschedé and his family. The setting is a fairly traditional *sous-bois*, sheltered woods, the kind of subject often associated with artists of the Barbizon school. But the glimpse of the château through the foliage and the presence of members of the Hoschedé family—presumably Alice Hoschedé, fishing at the right, and three of her children—deprives the painting of any note of wildness and soon makes us aware of the domesticated temper of this corner of nature.

Furthermore, the fishing and musing convey the mood and tempo of the work. Slow, contemplative, receptive, under a maternal sway, the composition governed by the broad curve of the shore, it is in contrast to *The Hunt*, which depicts more active, male pursuits within a sharply foreshortened perspective setting. Monet offers two worlds, more surely separated in feeling and function than by the obvious differences of season. Ultimately, it was the mood of *The Pond* to which he succumbed, both in joining his life to that of Mme Hoschedé (see p. 22) and in concentrating his later painting on themes such as the Poplars (Plates 103–6) and the long series devoted to the water-lily pond from about 1900 until his death in 1926.

59. *Camille Monet on her Deathbed*
(Camille Monet sur son lit de mort)
1879 (W. 543)
35½ × 26¾ in. (90 × 68 cm.)
Musée du Louvre, Paris (Jeu de Paume)

Late in his life, in conversation with his close friend Clemenceau, Monet admitted that colour had been his lifelong preoccupation:

> It is my day-long obsession, joy and torment. To such an extent indeed that one day, finding myself at the death-bed of a woman who had been and was still very dear to me, I caught myself, with my eyes focused on her tragic temples, in the act of automatically searching for the succession, the arrangement of coloured gradations that death was imposing on her motionless face. Blue, yellow, grey tones, who knows what else? That was the point I had reached. Nothing is more natural than the urge to record one last image of a person departing this life. But even before I had the idea of recording those features to which I was so profoundly attached, my organism was already reacting to the colour sensations, and, in spite of myself, I was being involved by my reflexes in an

unconscious process in which I was resuming the course of my daily life.

Monet carried this memory like a scar and a self-reproach through the second half of his life. His relationship with Camille was undoubtedly troubled, often estranged, and very complex. That his attachment to her was still deep-rooted, although distorted by guilt, at the time of her death in September 1879 is shown by his words. The death portrait that remains and hangs today in the Louvre does not betray an automatic fascination with tonal nuances. It is a haunting, almost spectral portrait. Camille's features are evident despite the closed eyes and open mouth with lips tightly pulled back. The violets which she holds in her portrait of 1876–7 (Plate 52) have been replaced by a withering bouquet, partly covered by the gauzy web of the bedclothes.

Monet's reminiscence undoubtedly refers to Camille, but in it he does not mention her by name nor specify his wife. It is not unlikely that this image represented more than Camille, that it contained as well the memory of his mother, who died at the moment when he was about to begin his artistic career.

60. *Gare Saint-Lazare, Arrival of a Train*
(La Gare Saint-Lazare, arrivée d'un train)
1877 (W. 439)
32¼ × 39¾ in. (82 × 101 cm.)
Signed and dated bottom left: Claude Monet 1877
Fogg Art Museum, Cambridge, Massachusetts

In January 1877 Monet received permission to paint at Saint-Lazare Station. With Caillebotte's help, he rented a small flat on the rue Moncey, not far from the station. Manet had lived and worked in the area for a number of years; in 1873 he painted *The Railway* (National Gallery of Art, Washington, D.C.), a portrait of a woman and child in front of the fence above the station yard, which he submitted to the Salon of 1874. In 1876 Caillebotte did several paintings of the Pont de l'Europe, which crosses over the tracks, and a major canvas of a neighbouring square in the rain, both of which appeared with Monet's Gare Saint-Lazare paintings at the third Impressionist exhibition of 1877. Monet showed seven paintings of the station and the yard at that exhibition. The present painting is paired with the canvas in the Louvre (W. 438). The differences between them are basically those of palette and atmosphere, but others may be indicated as well: the two vary in shape, the Fogg painting seems to have been viewed from a vantage-point very slightly to the right, a connected sequence may have been intended in that the train just to the right of centre in the Louvre painting seems to have just arrived, its stack still smoking, in the Fogg painting (the increased size of the canvas seems almost like a gesture of accommodation). The palette of the Louvre painting is lighter, more pastel in range; that of the Fogg canvas is darker—blue, grey—as if in response to the arrival, the presence of the train now within the station.

The Gare Saint-Lazare paintings are often considered to be Monet's first series, but in relation to his later practice of developing a sequence of tightly interlocked variations on a theme, the paintings of the station constitute no more a series than do the multiple views of the river and bridges at Argenteuil executed during the summer of 1874. Both groups of paintings may have taken about the same length of time to execute, the Gare Saint-Lazare group having been done during the winter of 1877 and completed in time for the Impressionist exhibition at the beginning of April. Six of the paintings of the station may be broken down into pairs, a factor which relates this group to the later development of the series. For in such series as the Haystacks, Poplars, or Venice views, among others, Monet would choose various motifs or arrangements that would provide extended subdivisions within the larger whole. A somewhat more unified but only limited survey of motifs—the germ of a series—is suggested in the last views of Argenteuil (W. 450–3), of the Grande Jatte in 1878 (W. 454–8), and in several views of Vétheuil and Lavacourt (W. 538–41) during his first year there in 1879.

61. *Entrance to the Village of Vétheuil, Winter*
(Entrée du village de Vétheuil, l'hiver)
1879 (W. 509)
$23\frac{5}{8} \times 31\frac{7}{8}$ in. (60 × 81 cm.)
Signed bottom right: Claude Monet
Museum of Fine Arts, Boston

In August 1878, Monet moved to Vétheuil with Camille, Jean, and his second son, Michel, born in March. It is with this move that they and the Hoschedé family—Ernest, Alice, and their five children—decided to join together in a common household, establishing themselves in a house which is visible in this painting—the house closest to us on the left of the road. A second painting, of the same dimensions, in which the snow more fully covers the ground, depicts the same view; a third, smaller canvas comes in closer to the house (W. 508, 510). The road is that which links Vétheuil to La Roche-Guyon. Monet had worked in the area in 1868 when he painted *The River* (Plate 25) and was to settle in the region definitively when he installed himself in nearby Giverny in 1883. The stay in Vétheuil lasted from summer 1878 to November 1881.

62. *Still-life: Apples and Grapes*
(Nature morte: pommes et raisins)
1880 (W. 546)
$25\frac{3}{4} \times 32\frac{1}{4}$ in. (65·4 × 81·6 cm.)
Signed and dated top left: Claude Monet 1880
Art Institute of Chicago

From Camille's death on 5 September 1879 until the severe snow which came in December, Monet did no outdoor painting. Five still-lifes remain from that period. The present painting, begun during the autumn, presents a close-up,

angled view that has few precedents in the history of still-life painting. The tilted plane, the unceremonious cropping of the table at the right are unusual; among Monet's contemporaries, one finds only a modest hint of such an arrangement in Fantin-Latour and a firmer approach in Cézanne—although only one example (Venturi 210), of about 1877, predates Monet's *Still-life*. Monet seems to adapt the angled perspectives of Degas to the disposition of still-life, viewing the table almost as he was to view the cliffs against the sea in his paintings of Normandy in the next two to three years (see Plates 72 and 74)—landscape and still-life conceived according to the same structure, as in Cézanne and their Dutch predecessors of two centuries before.

63. *Sunset on the Seine, Winter Effect*
(Soleil couchant sur la Seine, effet d'hiver)
1880 (W. 576)
$39\frac{3}{8} \times 59\frac{7}{8}$ in. (100 × 152 cm.)
Signed and dated bottom left: Claude Monet 1880
Musée du Petit Palais, Paris

In his letter to Duret of 8 March 1880 (see note to Plate 73) Monet said he was working on three large paintings, two for the Salon and one that was 'too much to my taste' to submit to the jury. This is the canvas to which he referred. Comparison with *Lavacourt* (Plate 73), which was submitted and accepted for the Salon, is revealing. *Lavacourt* is stereometric, sculptural in the treatment of the clumps of foliage and the houses; it recedes convincingly into depth, it is fresh, engaging, realistic in colour, fine-grained in its descriptive touch. *Sunset on the Seine* offers only suggestions of form, obvious, skeletal drawing, the dash of strokes, minimizing solidity and perspective depth. In 1879 and 1880 Monet was being criticized for such qualities, considered the product of hastiness; Zola wrote in 1879 that Monet was becoming satisfied with the 'merely approximate' (*à peu près*). Durand-Ruel began to ask him for more completely finished pictures. And there is no doubt that Monet was painting rapidly in his frantic search for buyers, very likely that he might have carried some works further or scraped them out if he could have afforded to do so.

The letter to Duret makes it quite clear, however, that breadth of application was far less a result of hastiness or laziness than the product of an aesthetic decision. *Sunset on the Seine* confirms this; it is not a sketch but a painting enlarged from a sketch that deliberately seeks to preserve sketchiness. In the turn from the seventies to the eighties, Monet was seeking to push his art along new paths; in this instance, he sought a brief, summary, suggestive manner of rendering form, a handling responsive to the blurring, cohering effect of the atmospheric envelope. Monet included the painting among his entries when he returned to the Impressionist exhibitions in 1882.

64. **Floating Ice**
(*Les Glaçons*)
1880 (W. 568)
$38\frac{1}{8} \times 59\frac{1}{4}$ in. (97 × 150·5 cm.)
Signed and dated bottom right: Claude Monet 1880
Shelburne Museum, Shelburne, Vermont

Following the severe snow storms and freezing weather of December 1879, the beginning of January brought a partial thaw that was both incapacitating and dramatic, as we learn from the letters of Alice Hoschedé to her husband:

> Monday [5 January], at five in the morning, I was woken by a frightful noise, like the rumble of thunder . . . on top of this frightening roar came cries from Lavacourt [across the river]: very quickly I was at the window, and, despite considerable obscurity, saw the white masses hurled about; this time it was the débâcle, the real thing.

On Thursday 8 January, Monet wrote: 'We have had here a terrible breaking-up of the ice and naturally I have tried to make something of it.' Freezing weather returned and lasted until mid-February; during that time Monet did sixteen paintings depicting the break-up of the ice on the river. Based on a smaller canvas done partly, we may assume, at the site (W. 567) and closely related to three others (W. 569–71) that form a miniature series, *Floating Ice* was developed into an impeccably worked composition, with a palette of pinks and blues, that serves to remove it from the stark facts of the natural event. It was developed in a 'discreet' and 'bourgeois' fashion (see note to Plate 73) and submitted to the Salon of 1880, where, however, it was rejected. Monet then included it as the first entry in his one-man show at *La Vie moderne* in June.

65. **The Hills of Vétheuil**
(*Les Coteaux de Vétheuil*)
1880 (W. 591)
$24 \times 35\frac{1}{2}$ in. (61 × 90 cm.)
Signed and dated bottom right: Claude Monet 1880
Private Collection, U.S.A.

Monet seems to have taken his most complete command of Vétheuil as a place in his paintings of the town seen from across the river on the Lavacourt side. This is one of the most developed, refined, chromatically interwoven of these views. On an opaque tan, almost khaki-coloured, ground of middle value, Monet applied his flexible, somewhat wispy, fine-grained strokes, drawn from the full range of the spectrum. The tan ground colour is allowed to provide the basic tone for the hills and foreground bush, which are then lightly stroked with varied colours. There is nothing hasty about the work; in the reflections, for instance, Monet carefully distributes whites, blues, blue-violets, pinks, pale green, darker greens and greys in a warm, greyed tan matrix. The view shows, just below the church towers, the house of his landlady nestled against the hillside and, below that, at road level, his rented

house, the right-hand one of the pair. Across the road and leading down to the water is his garden, and moored just off shore we see his studio boat.

66. **Monet's Garden at Vétheuil**
(*Le Jardin de Monet à Vétheuil*)
1881 (W. 685)
$59\frac{5}{8} \times 47\frac{5}{8}$ in. (151·4 × 121 cm.)
Signed and dated bottom right: Claude Monet 80
National Gallery of Art, Washington, D.C.

Colour, structure, and mood were each Monet's concerns as he painted the garden which was situated across the road from his house, on a slope that led down to the river. Structurally, compositionally, he develops a basic alignment of horizontals and verticals with the house and garden parallel to the picture plane (Monet's house is the one to the right of the chimney). In palette, however, he heightens the colours of flowers and vegetation to the point where they seem to dance free of structure. Thus, Monet continues to explore the phenomenal situation he had emphasized in his 'gardens' at Argenteuil of 1875 and 1876 (see Plate 51). And, as with many of those scenes, going back to 1873 (Plate 42), one is again permitted to feel a mood of exaggerated quiet and estrangement within the scene. The two children are Michel Monet, now two years old, on the steps, and Jean-Pierre Hoschedé at their foot.

The canvas was dated 1880 at a later time; three other paintings, forming a miniature series, attest to the date of 1881. The present canvas is larger than the other three and may indicate that Monet was again considering exhibition at the Salon.

67. **Sunflowers**
(*Fleurs de topinambours*)
1880 (W. 629)
$39\frac{1}{4} \times 28\frac{3}{4}$ in. (99·6 × 73 cm.)
Signed and dated bottom right: Claude Monet/1880
National Gallery of Art, Washington, D.C.

Monet had sent a flower still-life to the Municipal Exhibition of Rouen in 1864; it was a work that reflected, along with his landscapes, a facet of his early training with Boudin. Although he turned to still-life intermittently in the next decade and a half, paintings specifically of flowers indoors were very rare. He began to do them with greater frequency at the end of the seventies: three appear in 1878, two flower still-lifes are among the group he did in the months after Camille's death in 1879, and then, in 1880, he did eight rich, abundant still-lifes of cut flowers in vases. The present canvas, depicting the blossoms of the Jerusalem artichoke, is fairly representative of the group— vividly, energetically brushed, intensely coloured, the flowers almost filling the format, surfaces carefully observed and recorded in their variety of hues and textures. Van Gogh's flower still-lifes, and especially his Sunflowers painted for

Gauguin's room in Arles in 1888, must have borrowed from these ebullient works by Monet. The concentration on still-life in these years may attest to what tends to seem apparent—that Monet never fully developed a consistent working relationship with the landscape around Vétheuil.

68. *Cliffs at Les Petites-Dalles*

(Les Falaises des Petites-Dalles)
1880 (W. 621)
23¼ × 29½ in. (59 × 75 cm.)
Signed and dated bottom left: Claude Monet 1880
Museum of Fine Arts, Boston

During September 1880, Monet spent a few days with his brother, Léon, in Rouen and then went to Les Petites-Dalles on the Normandy coast, just above Fécamp, where Léon had a country house. This view of the beach and cliffs recalls the early campaigns on the beaches of Honfleur and Sainte-Adresse of 1864 and 1867, when he was still working in a vein that had been struck by Boudin and especially Jongkind in preceding years (see Plates 11 and 20). This view of Les Petites-Dalles, looking south, offers a tough but engaging realism as Monet conveys something of the roughness of the sea and the bleak greyness of weather and hour.

69. *Calm Weather, Fécamp*

(Temps calme, Fécamp)
1881 (W. 650)
23⅝ × 29 in. (60 × 73.5 cm.)
Signed and dated bottom left: Claude Monet 81
Fondation Rudolf Staechelin, Basel

The adoption of interesting, often difficult angles and vantages from which to view a scene became increasingly a factor in freeing the space of painting from the conventions of traditional perspective. It is in the work of Degas, above all, during the 1870s, that the major explorations of this kind were carried forth. Monet did not paint the theatre or circus, the café or rehearsal room, but he did apply the lessons learned from Degas to still-life (see Plate 62) and, primarily and consistently, to landscape—specifically to the cliffs and sea of the Normandy coast, which he began to paint anew in 1881. The novelty, the compositional adventure of *Calm Weather, Fécamp* derives in large part from Monet's point of view in relation to the scene. He had earlier explored with clear logic the implications, phenomenal and compositional, of the vantage-points he established at the Louvre in 1867 (Plates 4 and 5) and on the Boulevard des Capucines in 1873 (Plate 41). In those works Monet assumed points of view that were unfamiliar to painting—almost startling—but were commonplaces of photography. At Fécamp in 1881 and Dieppe and Varengeville in 1882 (Plates 72 and 74) he painted the cliffs and the sea in relationships that were common in experience but rare in painting. He actively capitalized on the compositional possibilities that a conjunction of topography and point of view might yield. As he travelled over the cliffs his eye acted like a viewfinder, searching, scrutinizing, and then framing what he discovered. Who could have predicted this composition? It had first to be isolated, then recognized as possessing pictorial potential. Degas exploited dramatically the pictorial excitement yielded by his vantage-points, but his pictures, because they are of people, tend to retain the leaven of experience; Monet's topography lent itself more readily to the world of decorative abstraction.

Monet developed this motif, with variations, into a miniature series: three very similar views with differences in time, weather, and canvas shape (W. 647–9); two views in the same direction from beach level (W. 651–2); four views of the same stretch of cliffs, looking north (W. 653–6); and two related, highly dramatic—in composition and the depiction of natural effects—paintings of the surging sea against the cliffs (W. 659–60).

70. *Cliffs at Low Tide, Pourville*

1882
23½ × 32¼ in. (59.7 × 82 cm.)
Signed and dated bottom right: Claude Monet 82
Mr and Mrs David Lloyd Kreeger, Washington, D.C.

Monet left Vétheuil in November 1882 and settled with Alice Hoschedé and their combined families at Poissy on the Seine to the west of Paris. Almost half of the year was spent on the Normandy coast, however: February to April and, with the entire family, July to September at Pourville and Varengeville just south of Dieppe. Monet was fascinated by the all-but-deserted aspect of the beach, when he could concentrate his attention almost exclusively upon effects of morning and evening light, the changes in the rhythm and composition of the scene effected by the alternation of the tides. In this painting the sun is low in the sky behind the cliff; the palette is muted, ranging from the dull yellow and yellow-green of the sky to the green hills, the whited green of the water, and the red-violet and violet-grey of the beach.

Monet was at this time doing several paintings of a given site and was clearly beginning to think of them as forming an interrelated group, a potentially unified ensemble of works. In the early spring (25 March 1882) he wrote to Durand-Ruel: 'I will be in Paris for Easter; by then I will have completed, I hope, all my canvases. Five are already finished, but if it makes no difference to you I would prefer to show you the entire series of my studies at one time, desirous as I am of seeing them all together in my studio.' The present work is one of a number of paintings (three in the Kreeger collection alone) looking from the beach toward the south and the range of cliffs of the Varengeville area.

71. *Fishing Nets, Pourville*

1882

24 × 32 in. (61 × 81·3 cm.)

Signed and dated bottom left: Claude Monet 82

Gemeentemuseum, The Hague

In this painting, probably done during the winter or early spring, Monet indicates his identification both with the elements and man's ways of coping with them. He features the large, diaphanous 'sail' of the fishing net supported by thin poles that stoutly bend against the force of the wind and waves. The powerful sway of the nets is mitigated by their transparency, and the volatility of the waves is somewhat reduced by the decorative interlocking of curving shapes for both water and rocks at the bottom.

72. *Cliffs near Dieppe*

1882

26 × 32¼ in. (66 × 82 cm.)

Signed and dated bottom left: Claude Monet 82

Kunsthaus, Zurich

This is one of the more drastic compositions developed by Monet as he looked from the cliff precipitously down to the beach below. The rise of the cliff and the recession of the sea are seen as collateral shapes with little clue in the organization of the format as to the identification or relative position of forms. Those clues are given, of course, in colour, descriptive detail, modelling, and through variations in brushwork. Reading those indicators, one is aware of the dramatic shift from immediate foreground to distance, but one is aware, too, of the transposition of that difference into a new pictorial drama, in which distance and proximity, high and low, are given a variable life. This recording of experience is not unlike that conveyed by Degas in paintings such as *Au théâtre* of 1880 (Lemoisne 577), devoted to the dynamic experience and pictorial translation of the view within the theatre from box seat to stage. Compare Monet's painting of a similar site done in 1897 (Plate 118).

73. *Lavacourt*

1880 (W. 578)

38¾ × 58¾ in. (98·4 × 149·2 cm.)

Signed and dated bottom left: Claude Monet 1880

Dallas Museum of Fine Arts, Dallas, Texas

Monet made his début at the Salon in 1865, and his success was repeated in 1866; one canvas was accepted of the two submitted in 1868. In 1867, 1869, and 1870, his paintings were refused entirely. Thereupon he ceased to submit his work to the jury. In 1874 he helped to inaugurate the Impressionist exhibitions and participated in the second, third and fourth shows in 1876, 1877, and 1879. In 1880 he returned to the Salon. The decision was not an easy one: in barest outline, it resulted from financial desperation on the one hand and from

his growing disaffection with the changing character of the Impressionist group on the other. On 8 March 1880, he wrote to Théodore Duret:

> Since you are among those who have often advised me to expose myself once more to the judgement of the official jury, I must tell you that I am going to attempt this ordeal.
>
> I am working hard at three large canvases, only two of which are for the Salon, because one of the three is too much to my taste to send, and it would be refused [Plate 63], and I ought instead to do something more discreet, more bourgeois [Plates 64 and 73]. It is for high stakes that I am going to play, even without being immediately treated as a coward by the whole group, but I believe that it was in my interest to make this decision, being all but assured of doing some business ... once I get into the Salon; but it is not by preference that I do that, and it is too bad that the press and the public have not taken our little exhibitions seriously enough, for they are so preferable to this official bazaar.

Lavacourt is one of the 'more discreet' and 'bourgeois' paintings that Monet submitted to the Salon; it was accepted, although its companion, *Floating Ice* (Plate 64), was refused. It did not bring Monet the critical success that accompanied his Salon début, partly because it was hung in a very poor position, almost twenty feet high on the wall. Nevertheless, the critic Chennevières wrote in the *Gazette des Beaux-Arts* that 'its luminous and clear atmosphere makes all the neighbouring landscapes in the same gallery seem black.'

Monet's action did lead to an amelioration of his situation. In June he had his first one-man exhibition at the offices of the periodical *La Vie moderne*. Mme Charpentier, the wife of the publisher of *La Vie moderne*, then arranged to purchase Monet's rejected painting, *Floating Ice*, for 1500 francs, and Durand-Ruel bought *Lavacourt* for the same price in 1881.

74. *The Douanier's Cottage, Varengeville*

1882

25⅝ × 30¾ in. (60 × 78 cm.)

Signed and dated bottom right: Claude Monet 82

Museum Boymans-van Beuningen, Rotterdam

Monet did at least seven paintings of this site viewed from different angles, cropped and arranged differently within varied formats, each recording a distinct state of light or weather. The present canvas is one of the most harmonious of these works and of the numerous other paintings in which he sketched the curve of the cliffs against the straight line of the horizon, matching or integrating the shapes of cliff and water and sky. In format and palette, Monet offers a model for the many compositions that Cézanne painted of the bay at L'Estaque during the middle years of the 1880s. There is a simple relationship of complementary yellows, oranges, and

blues—the warm foreground against the cool distance, but with the equivalent shapes of the two areas interlocking within the rectangle of the canvas. Monet's friend and biographer Gustave Geffroy noted at an early date, as Steven Levine has pointed out, one of the great advantages of Monet's simplification of form, that it provided a ready basis for the elaboration of colour. Upon a naturalistic base, Monet could easily build his colour relationships, exaggerating and modifying as he saw fit. The formal matrix also opened the way for invention of another, allied, sort. Monet could not hope to match the details and conformations of nature within these simplified shapes; the latter served rather as fields for invention not only in palette but in brushwork and texture as well. Much of the character of the painting derives from the nature of the treatment of the painted surface.

The view here, with foreground cliff set against a stretch of sea and sky, was not in itself new, but it was offered now with an especially assured sense of design and artifice. Millet had painted similar views in the 1860s, e.g., his *Cliffs at Gruchy* and *Un bout du village de Gréville* (1866), both in the Boston Museum. Monet, himself, had painted such a composition in 1867, a year in which he pursued a number of exciting formal investigations (see Plates 4, 5, 14 and 21); the painting was *Cabanne à Sainte-Adresse* (W. 94), of which he did a drawing in 1880 to illustrate an article in *La Vie moderne* that accompanied his one-man show in that year (Fig. 18). Monet may have been in part stimulated to develop the Fécamp and Varengeville paintings of cliffs and sea in 1881 and 1882 as a result of reworking the earlier composition into the drawing of 1880.

75. *The Church, Varengeville*
1882
25$\frac{1}{2}$ × 32 in. (64·8 × 81·3 cm.)
Signed and dated bottom right: Claude Monet 82
Barber Institute of Fine Arts, University of Birmingham

In this view from the south of the church at Varengeville, perched atop the cliffs, Monet established a more conventional pictorial excitement than in Plate 72. In a composition reminiscent of Richard Wilson and his eighteenth-century contemporaries at Tivoli and other Italian sites, Monet placed two foreground trees as a foil, compositionally and dramatically, for the hazy and distant church to the left. The undulations of the tree trunks and the curving upward diagonal of their crowns is countered by the angularity of the church's outline and the undulating contour of the cliff which descends toward the right. In the midst of the most advanced formal researches, Monet found the wherewithal to create an assured homage to the tradition from which he was departing. The result is perhaps less innovative compositionally than Plate 81, *Etretat*, but it is dramatically far more successful.

76. *Bordighera*
1884
29 × 36$\frac{3}{8}$ in. (73·7 × 92·4 cm.)
Signed and dated bottom right: Claude Monet 84
Santa Barbara Museum of Art, Santa Barbara, California

Painted on the property of M. Moreno from Marseilles, this is one of a number of works featuring the palm trees and the abundant, varied flora of the Bordighera region. Monet concentrated upon a wide range of warm and cool hues keyed to the local colour of flowers and plants and emphasized the pinks of the lighted surfaces of the buildings in relation to the blue and violet shadowed faces and balconies. Gone are any traces of earth tones, as the colours of the spectrum provide him with sufficient resource for his palette. The composition tends to be stolid and cluttered; the concentration is clearly on colour. The present painting is a reduced version that probably served as a model for a larger work (Rouart Collection, Paris), which Monet did as a decoration for the home of Berthe Morisot and her husband, Eugène Manet. Early in 1884, Morisot wrote to her sister Edma: 'I am beginning to develop close friendships with my colleagues, the Impressionists. Monet insists on offering me a panel for my drawing room. You can imagine whether or not I will accept it with pleasure.'

77. *Etretat, View of the Manneporte from the South*
About 1883
Sketchbook drawing, pencil (MM 5131, sheet 24 recto)
Musée Marmottan, Paris

This drawing presents a view from the south of the Manneporte, the southernmost of the three great rock arches that embrace the beach at Etretat (see note for Plate 80). To obtain this view, Monet walked about half a mile beyond the Manneporte, along the top of the cliffs, to a prominence that juts out into the sea, not unlike the Manneporte itself. The edge of the cliff upon which he stood is sketched in at the bottom of the drawing. From that vantage he looked back towards the Manneporte, its arch almost exactly in the centre of his view. Here Monet is attempting to frame the composition with the roughed-in vertical lines to left and right (for two close-up views of the Manneporte from the north, see Plates 84 and 85).

78. *The Church at Varengeville*
1882
23$\frac{1}{2}$ × 28$\frac{1}{2}$ in. (59·7 × 72·3 cm.)
Signed and dated bottom left: Claude Monet 82
Private Collection, Texas

The only way in which Monet could achieve the vantage-point indicated for this view was by using a boat, or, as was probably the case, by walking far out from the beach over the

white rocks and seaweed exposed by low tide. There he could view the cliffs spread out before him, perpendicular to his line of vision, and brush in energetically and inventively the irregular conformations and articulations of the rock face. This scene records the considerable height of the cliffs from which Monet looked out and down for numerous other paintings (Plates 72 and 74).

79. *The Church at Varengeville*
1882
Sketchbook drawing, pencil (MM5131, sheet 20 verso)
Musée Marmottan, Paris

This pencil drawing quickly records the site from a point slightly to the left of that assumed for the painting (Plate 78). It was Monet's repeated practice in these drawings to use the full page to develop the flow of the site and then to experiment with the drawing in two specific ways, both illustrated here. He would, for one, rough-in framing lines, undoubtedly intending to delimit the scene, to determine a composition that would be suitable for a painting. Secondly, he would strengthen and simplify some of the lines within the composition, seeking to develop that simplification of form—almost always by means of carefully developed undulating lines—that we see most clearly presented in the treatment of the profile of the cliff in *The Douanier's Cottage* (Plate 74). The composition of the painting (Plate 78) was almost certainly arrived at following the procedure demonstrated in this sketch. Whether the canvas was used at the site itself we do not know, although the likelihood is that it was, at least in the beginning stages, despite the practice of doing pencil sketches of the locations he wished to develop. The oil-painting demonstrates a specific enough response to suggest that it was begun on the spot from the shoal.

80. *Etretat*
About 1883·
Sketchbook drawing, pencil (MM5131, sheet 25 recto)
Musée Marmottan, Paris

At the end of January, 1883, Monet left Poissy for a painting trip in Normandy. He spent part of February at Etretat, where he had lived with Camille and Jean during the autumn and winter of 1868–9. There he painted the beaches and the dramatic rock arches projecting into the water, as had Delacroix, Jongkind, Boudin, Courbet, Corot, Daubigny, and a host of other artists attracted to this striking region. The view in this drawing is from the beach looking towards the Porte d'Aval, the large cliff that closes the main beach at its southern end. The view is a familiar one in earlier paintings of the same scene by Monet's predecessors. Here, from a slightly raised vantage-point, presumably at the rear of the beach, he looks past the beached fishing boats and *caloges*—old hulls thatched over and used for storage of equipment—to the cliff and the

extended sea. To left and right, he tries to establish framing lines for a painted composition. At the right he offers two possibilities, both of which he may have intended for actual paintings. He often painted pairs of works, comparing the same view on canvases of different shape. In other pairs he would compare distant and close-up views of the same motif, and the framing lines in the drawing serve to offer that kind of comparison as well. To cover the right-hand section of the drawing is, in effect, to zoom in on the scene, the boats and especially the cliff attaining a greater quality of imminence.

81. *Etretat*
1884
$23\frac{1}{2} \times 28\frac{1}{2}$ in. (59·5 × 72·5 cm.)
Signed and dated bottom left: Claude Monet 84
Mr and Mrs Samuel Dorsky, New York

Here Monet took a position about as far away as one can get, along the beach, from the Porte d'Aval. In the centre and on the right are huge rocks, which have fallen from the cliff that towers above the beach. A portion of the cliff wall juts into the painting on the left. It is as if Monet was seeking a way to frame the Porte d'Aval, just as he did by testing framing lines on his sketchbook drawings (Plate 80). He may, indeed, have discovered this way of cropping the composition for the present painting by experimenting with the sketches in the book.

82. *Bordighera*
1884
$24\frac{1}{4} \times 28\frac{3}{4}$ in. (61 × 73·5 cm.)
Signed and dated bottom right: Claude Monet 84
Private Collection, U.S.A.

In December 1883, Monet and Renoir made a holiday trip to the Riviera; they travelled along the coast from Genoa to Marseilles and visited Cézanne in Aix. It was Monet's first experience of the Mediterranean since his early service in the army in Algeria in 1860, and he easily responded to the luminous brilliance of the environment. In January he returned by himself to paint at Bordighera, just across the Italian border from France. He stayed there from the third week in January until the beginning of April and then stopped at Menton for about ten days before returning to Giverny on 14 April. In the hills and the olive trees above the sea, Monet found vigorous, curving forms that related to the compositional interests he had developed at Varengeville and Etretat in the preceding two years.

83. **Rocks at Etretat**
1886
26 × 31⅞ in. (66 × 81 cm.)
Signed and dated bottom left: Claude Monet 86
Pushkin Museum, Moscow

Monet and his entire family returned to Etretat in August 1885, where they lived in the villa of the baritone Faure, one of the great early collectors of Impressionist painting. In the autumn the family returned to Giverny but Monet stayed on. In October he received a visit from Guy de Maupassant, who, watching Monet at work, described the artist as a hunter, equipped with five or six canvases at a time, lying in wait for the return of effects he sought to paint. In the following month Hugues Le Roux offered a similar description of Monet at work on the cliffs and beaches (see p. 11). Toward the end of November, Monet himself described his progress to Durand-Ruel:

> Still here, as you see, being hard on myself but not managing to finish my canvases. So many things are necessary, finding once more the effects of low and high tide, calm or turbulent sea, never I believe have I had so many difficulties, such variable weather. I am very caught up in it, but, I assure you, I need a certain strength, because I am beginning to worry about my family, about the children, who want me back. For three days now I have again been plagued by bad weather and begin to fret, but I still feel that if I push on a bit longer I'll be able to bring back some good things, at least what will seem good to me, and so I am still postponing my return.

Although the view in the painting is a distant one, the cliff is given a powerful presence, and the elemental relationship of the fishermen to the sea, the cliff, and the atmosphere of the waning day is effectively captured.

The prolonged absence from his family may have been linked to grave difficulties between Monet and Alice Hoschedé. Daniel Wildenstein has pointed out Monet's hitherto unknown return to Etretat in February 1886, apparently for the purpose of isolation and self-questioning at a time when he was contemplating a definitive break with Alice.

84. **The Manneporte, Etretat**
1886
32 × 25¾ in. (81·3 × 65·4 cm.)
Signed and dated bottom left: Claude Monet 86
Metropolitan Museum of Art, New York

85. **The Manneporte, Etretat**
1885
26 × 32¼ in. (66 × 81·9 cm.)
Signed and dated bottom left: Claude Monet 85
Mr and Mrs A. N. Pritzker, Chicago

These two paintings of the southernmost rock arch at Etretat were developed as a pair. Three elements are disposed within the rectangular format: the rock, sea, and sky. The canvas is the same size in each case. The rock mass entering the water (arched and extended like the trunk of a gigantic elephant) is centred laterally in both canvases, the horizon is set just below centre. Differences between the two are those of canvas position—vertical versus horizontal—palette, and angle of view, the Metropolitan painting (Plate 84) apparently viewed from somewhat more to the left than the Pritzker version (Plate 85). The characteristics of the comparison are identical to those established in 1867, when Monet paired his views of the Quai du Louvre done from the east front of the palace (Plates 4 and 5). But whereas in 1867 Monet experimented with chance to effect a *laissez-faire* arrangement within the frame, in 1885–6 he used the shift in canvas position to vary what was in effect a highly organized decorative composition. The preciousness, the 'designed' quality of so many of Monet's paintings of the eighties is underlined in the comparison.

86. **Storm at Belle-Ile**
1886
25¼ × 31⅞ in. (64 × 81 cm.)
Signed and dated bottom left: Claude Monet 86
Musée du Louvre, Paris (Jeu de Paume)

On 17 October 1886, Monet wrote to Durand-Ruel from Kervilahen on Belle-Ile:

> I am very upset by the bad weather we have had for several days now and it is going to hold me back a bit. For three days there has been a terrible storm and [I] have never seen such a spectacle.
>
> You know when I put myself to it nothing stops me, I am trying to make rough sketches of this turmoil, because it is wonderful, but alas it is very difficult and one is so ill at ease. I hope that after this squall I will still have a few days so that I can bring several canvases to a successful end. I do not know if what I bring back from here will be to everyone's taste, but I do know that this coast really excites me.

This vigorous sketch retains much of the turmoil that fascinated Monet, both in its rapid, energetic stroke and in its composition—open, dispersed, as if the solid rocks had been swept from the centre by the tempestuous force of the water. The resulting design has a discursive or non-hierarchical character that, in one perception, allies it to the intuitively generated compositions of much abstract expressionist painting.

87. *The Tulip Field, Holland*
1886
26 × 32¼ in. (66 × 82 cm.)
Signed and dated bottom left: Claude Monet 86
Musée du Louvre, Paris (Jeu de Paume)

In the same year that van Gogh left Holland to enter into his final, ultimately expressionist period in France, Monet went to Holland to paint the most intensely coloured, expressionist canvases in his career to that date. In April, before the Belle-Ile trip, he spent two weeks in The Hague painting the tulips. Under a normal blue-and-white sky he paints a field of colour that achieves its own, independent note. Strong yellows, yellow-greens, greens, reds and violets dominate, Monet emphasizing their clash rather than their harmony. The brushstroke, too, is quick and emphatic. In May, 1887, Pissarro wrote to his son noting that the impasto in one of Monet's Holland paintings was so thick that an artificial light was added to that recorded in the canvas; in the midst of his Neo-Impressionist phase at the time, he emphasized his dislike of the effect.

88. *View of Antibes*
1888
25¾ × 36⅜ in. (65·5 × 92·6 cm.)
Signed and dated bottom right: Claude Monet 88
Mr and Mrs Joseph S. Wohl, New York

Monet returned to the Mediterranean from January to April 1888, staying principally on Cap d'Antibes. In this view across the Baie des Anges from the area of Pointe Bacon, the old city of Antibes stretches across the left side of the canvas. It is one of at least four paintings using the same basic composition and clearly linked to each other as a miniature series within the larger group of works that he brought back from the site. Monet deploys differing variables in the four paintings, geared to differences in vantage-point (from side to side or closer to or further away from the scene), picture size and format, and time of day. The latter is developed sequentially, from the early morning of the present picture (light from the east, grey foreground tree creating a *contre-jour* against the luminous bay and the pink town) to the bright pastel of the Toledo Museum version, in which the gold-crowned tree participates in the full illumination of the entire scene.

89. *The 'Pyramids' at Port-Coton (Belle-Ile)*
1886
25¼ × 31⅞ in. (64 × 81 cm.)
Signed and dated bottom right: 86 Claude Monet
Private Collection, Switzerland

Monet foresaw a return to Etretat in late summer, 1886, but, impulsively, in early September he left for Belle-Ile off the south coast of Brittany. On this *'sombre et terrible'* island, as Monet described its atmosphere, he did a number of groups of works devoted to differing aspects of the rocky shores. The 'pyramids' or 'needles', those twisted rocks which jut out from the sea, provided him with one motif. He did at least five paintings devoted to the site, varying weather and colour, the shape of the canvas, and, to a very slight degree, his angle of view. The present canvas is unusual in its square format and in its emphasis upon the complementary brilliance of the rocks against the bright yet rich blue of the ocean.

Gustave Geffroy, who was to become Monet's close friend and principal biographer, met Monet for the first time at Belle-Ile. His account of Monet's procedure is particularly valuable:

> This rustic alchemist, always living in the outdoors, active to the point of beginning several studies of the same scene on the same afternoon in different light, has acquired a special ability to see the arrangements and effects of the tones immediately. Rapidly, he covers his canvas with the dominant values, studies their gradations, contrasts them, harmonizes them. From that derives the unity of the painting, which gives the form of the coast and the movement of the sea at the same time as it records the hour of the day, through the colours of stones and water, by the shade of the night and the disposition of the clouds.

Monet's fascination with the design and interplay of rocks and water may be a product not only of his study of the site but of his interest in Japanese art, as well. Siegfried Wichmann has compared these works to drawings of rocks and water in Hokusai's *Manga* and a woodcut from a sketchbook drawing by Harunobu depicting rocks in the surf (*World Cultures and Modern Art*, Munich, 1972, nos 705, 696).

90. *A Haystack at Giverny*
1886
24 × 31⅞ in. (61 × 81 cm.)
Signed and dated bottom right: Claude Monet 86
Hermitage, Leningrad

The site is very much like that which Monet chose for his long series of Haystacks beginning about 1890. The setting of fields, houses, trees, and distant hills is given greater prominence here than in the later works, for Monet's vantage-point is higher, the view more spacious. As with the Holland paintings, his emphasis is upon colour. Although the reds of the poppy field are scumbled quickly over the tan ground, which is allowed to show through throughout the canvas, the intensity of the colour when one steps back is considerable, the effect undoubtedly heightened by the complementary relationship to the interlayered green of the field.

91. Five Figures in a Field

1888

31 × 31¼ in. (78·7 × 79·4 cm.)

Signed and dated bottom left: Claude Monet 88

Private Collection, U.S.A.

During the second half of the 1880s, Monet returned to figure painting, which he had abandoned almost entirely with the last garden paintings at Argenteuil in 1876. From 1885 to 1889, he did about sixteen figure paintings of members of his family, some of those canvases (see Plates 99 and 100) on a fairly large scale. Grace Seiberling has noted a letter from Monet to Théodore Duret, 19 August 1887, in which he described his desire to make 'new attempts, figures in *plein air* as I understand them, done like landscapes. It is a dream . . . that still preoccupies me and that I would like finally to realize . . . I am giving myself great difficulties. It absorbs me to the point of almost making me ill.' Zola had, in 1867, described the dream of every painter as that of putting 'life-size figures in a landscape'. Monet first approached that goal and foundered in the *Déjeuner sur l'herbe* of 1865–6 (Plates 9 and 10). He tried again and failed to realize his dream when working at La Grenouillère in 1869 (Plates 27 and 29). He ultimately reduced his expectations, but it is evident that the dream continued to haunt him, albeit with a differing emphasis, one that we may also relate to Zola's words from another context. In *The Experimental Novel* (English edition, New York, 1893), Zola described the contribution of Claude Bernard to the development of scientific method and concluded in part, 'The end of all experimental method . . . is then identical for living and inanimate bodies.' In *Five Figures in a Field*, Monet attempts to treat his figures exactly as the landscape; they receive harsh blues, violets, pinks and yellows in exactly the same way as do the meadow and trees. The result is harsh, garish, and, for the figures, oddly caricatured, as if he did not know how to simplify with grace. *Five Figures* was initially paired with another figure group, studied in the same place under different light, *Promenade: temps gris*. A third painting, *Prairies à Giverny* (Hermitage, Leningrad), depicts the same bit of field without the figures.

92. Antibes

1888

25¾ × 36¼ in. (65 × 92 cm.)

Signed and dated bottom left: Claude Monet 88

Courtauld Institute Galleries, London

Monet sets the rippling diagonal line of the rising tree-trunk sharply against the undulating horizontal of the coastal range; the entire composition is presented with a calculated simplicity and directness. Each element is clearly disposed upon the surface of the canvas. Unlike Cézanne in his *Mont Sainte-Victoire* (Fig. 14), which hangs in the same gallery, Monet is not concerned here to develop alternate readings of surface and depth. Cézanne both sets his foreground trees against the deep landscape and adjusts the contour of the near foliage to the distant profile of the mountain so as to collapse depth by means of parallel arabesques. Monet has chosen, rather, to emblazon the crown of foliage, as if heraldically, against the field of the sky. The blue of the sea and sky (along with that of the lower half of the foliage) is, to an important degree, less a natural blue than a calculated blueness, almost a sign for the place. Monet expressed his distrust of the Mediterranean's delicacy and a fear of its luminous blue atmosphere, but he managed, nevertheless, to create, as here, aesthetically satisfying results that seem to resolve his anxieties into decorative certainties. In 1866 the poet Mallarmé had expressed in the poem *L'Azur* his own fear of 'the blue' as an unattainable ideal; when he saw Monet's Antibes paintings in 1888, he immediately wrote to him: 'This is your finest hour.'

93. The Umbrella Pines

1888

35½ × 43 in. (90·2 × 109·2 cm.)

Signed and dated bottom left: Claude Monet 88

Private Collection, U.S.A.

Most of Monet's paintings during his stay in the Antibes area were of the bay looking across to Antibes, but a small group of works depict the umbrella pines at La Pinède in Juan-les-Pins, on the west coast of the cape. Monet's first reaction to his new look at the Mediterranean in 1888 was reserved and negative: 'I can definitely see that this country is not my affair,' and 'It may be very beautiful but it leaves me cold.' Early in his stay he made a trip to Agay to the west along the Esterel coast, where he found 'superb things', and he indicated more than once his desire to return there to paint. Around Antibes he felt unsettled and was constantly on the lookout for satisfactory sites. By the beginning of February he was feeling more at home with the pastel colours of the Mediterranean, and he wrote to Alice Hoschedé on 2 February: 'I'll bring back from here sweetness itself, white, pink, blue, enveloped in this enchanted air; it has no relationship to Belle-Ile, but watch out for the colourations of Agay!' What had fascinated him there was undoubtedly the striking colours of the volcanic rock— blue and red, in particular—along with the deep green of vegetation, the rust red of the clay, and the blue of the sea. He hoped to return to Agay but never did; nevertheless, he surely brought its special deep and vibrant colours into the powdery setting of the gulf at Juan-les-Pins when he painted the *Umbrella Pines*. Above and against the pale sea and sky, he painted the twisting trunks: violet, green, blue, sienna, pink, yellow and buff; and the canopy of leaves and branches, with its dark and whited greens and deep rust with a scattering of blue, is set strongly against the light.

The Antibes paintings were shown at Boussod and Valadon's in Paris, under the auspices of Theo van Gogh, who described them to his brother in Arles. In reply, as Steven Levine has pointed, out, Vincent especially expressed his regret at not seeing a painting of Juan-les-Pins in which 'the red sun casts an orange or blood red reflection on the blue

green trees and the ground' (to his friend Russell, letter 501a). At least three other paintings of the subject still exist.

94. ***The Eaux-semblantes at Fresselines on the Creuse***
1889
26 × 36¾ in. (66 × 93·3 cm.)
Signed and dated bottom left: Claude Monet 89
Museum of Fine Arts, Boston

Monet visited the valley of the Creuse in central France in January 1889 with Gustave Geffroy and two other friends. Fascinated by its bleak winter aspect, he returned again in early March to spend three months painting there. Geffroy's description of the region emphasizes its wildness, its dark mood; of the spot depicted in this painting, he writes of a 'sombre circle of rocks in combat with the water', of a savage spectacle, an infinite sadness. At the end of April, Monet wrote to Geffroy about his work and his responses to the site as spring settled in, about his fanatical dependence upon the weather and the appearances of the natural setting:

I am distressed, discouraged and fatigued almost to the point of being a bit ill. I have done nothing good ... afraid that all these efforts will result in nothing. Never have I been so unlucky with the weather! Never three favourable days in a row, so that I have to make continual changes, because everything is growing and turning green. I, who dreamed of painting the Creuse as we first saw it! [Monet in fact attempted to forestall the spring by having the green shoots removed from a tree he had been painting in its winter bareness] ... and then, this river which lowers and rises, green one day, yellow the next, a little while ago dry, and tomorrow it will be a torrent after the terrible rain which is now falling. All in all, I am very upset.

The present painting does not emphasize the dark and severe side of the Creuse, but does continue, in its multicoloured, almost garish palette the expressionist heightening and mingling of colours that had become apparent in the mid-eighties (Plates 87 and 90).

95. ***The Haystack***
1891
23⅝ × 39⅜ in. (60 × 100 cm.)
Signed and dated bottom right: Claude Monet 91
Kunsthaus, Zurich

The Haystacks series follows several years in which haystacks had found their place in Monet's paintings of the fields around Giverny (see Plate 90). It may be that some of the canvases specifically associated with the series were begun as early as 1889 (at least one painting is dated 1889, another 1890), but it seems that he did not develop the group in a coordinated fashion until 1890; the first exhibition of the series, fifteen paintings, took place in May 1891. The series may be divided into four sub-categories by subject, each one illustrated in Plates 95–8: a single stack, seen close up and cut by the frame (Plate 95); a single stack set in the mid-foreground, well within the frame (Plate 97); two stacks close together, seen as overlapping (Plate 98); two stacks separated (Plate 96).

In the present work, Monet moves in to closer range than in any other Haystacks painting; he crops and frames this cyclopean image in such a way as to emphasize its power and presence (Georges Grappe wrote in 1909 of his remembrance of the Haystacks series, including those canvases where one finds, as here, the stacks 'magnified and spectral'). Grappe recognized that the Haystacks were not the first series. He noted that at Belle-Ile and Antibes, for example, Monet had treated the same site under different lighting conditions. But, he said, Monet's 'will appeared perfectly expressed only with the Haystacks ... it is they which, at the moment when the battle against the public was won, risked destroying that victory. Without weakness, without concession, the painter re-enters the fray, even though he might lose ground gained over conformity and indifference. The nobility of his character is revealed by his never having hesitated in such a situation.' The risks were indeed there, although, in fact, the success of the series proved instantaneous.

96. ***The Haystacks***
1891
23⅝ × 39⅜ in. (60 × 100 cm.)
Signed and dated bottom left: Claude Monet 91
Musée du Louvre, Paris (Jeu de Paume)

In the sub-set of the series represented by this painting we have two stacks separated from each other, one quite close, the other slightly further back. Within this basic situation, Monet varies his own position, the placing of the stacks (the foreground stack is occasionally on the left), the season, time of day (a recurrent variable in all the Haystacks paintings is the direction and relative prominence of the cast shadows), and palette. The last is of great importance; these paintings do not only reveal natural changes but also changes of taste, sensibility and judgement that are linked to a process of colour invention. In a rich yet muted fashion, Monet explores the full range of the spectrum, discovering a wide variety of tints and shades that are juxtaposed to and imbedded in one another. The surface is developed into a multi-levelled experience of colour across almost every square inch of the canvas. The effect is like that of oil glazes, yet the colour is opaque; Monet achieves a mottling and iridescence that bears a closer relationship to the surfaces of Tiffany and Gallé glass than to the paintings of any other artist of the period.

97. *Landscape with a Haystack*
1891
26 × 36¼ in. (66 × 92 cm.)
Signed and dated bottom left: Claude Monet 91
Museum of Fine Arts, Boston

In this sub-series, Monet usually kept a single haystack to the left of the composition (although at least two works deviate from that position), set before the trees and houses at the edge of the meadow and the range of hills which run across the canvas width. The variations are principally those of season, time of day, weather, including frost, sunset, fog effects. The shifting positions of the shadows keep track of the hours.

98. *Haystacks in the Snow*
1891
25½ × 39¼ in. (64·8 × 99·7 cm.)
Signed and dated bottom left: Claude Monet 91
National Gallery of Scotland, Edinburgh

At least eight of the Haystacks paintings are snow scenes; this is the only series in which the cycle of the seasons comes into play. Several paintings of the series share the basic subject seen here—two stacks, one partly obscuring another that is further back. Monet slightly alters the relationship of the stacks to each other—for instance, the rear stack may be placed to right or left of the one in the foreground—providing an additional variable within this variation on the Haystacks theme.

99. *The Pink Boat*
About 1887
53 × 69 in. (135 × 175 cm.)
Mr and Mrs Richard K. Weil, Missouri

100. *Boating on the River Epte*
About 1887
52½ × 57 in. (132 × 145 cm.)
Museu de Arte, São Paulo, Brazil

These two large compositions—unusual in their size for Monet's work at this stage in his career—have roughly the same height, but the São Paulo painting is squarer, and consequently the frame is made to crop the figure of the woman with the oars. The result is not only a more satisfactory design but a heightening of drama, the creation of an almost mysterious sense of the silent presence—the oars seem motionless, barely dipping into the water—the sudden appearance, the impending disappearance, of these figures. These paintings, depicting Suzanne and Blanche Hoschedé, have frequently brought responses to their suggestion of mood or narrative. René Gimpel, who owned *The Pink Boat*, wrote in 1926:

> They pass so swiftly, these two women, and we are on the other bank. They pass like a dream, or like desire that cannot be satisfied. All of us, in adolescence, have been in the country on such a sunlit day . . . and always we saw her whom we lacked on the opposite bank, unattainable and lovely.

Mark Roskill has noted the 'strong element of surprise to the appearance of the boat in this cut-off pocket of river . . . the whole image . . . has an almost hallucinatory effect.'

Suggestiveness is there; the drawing of the two figures, the angle of the boat within the frame—in both works—seems just right. Another quotation, quite separate from the Monet paintings, seems, nevertheless, pertinent:

> What he saw was exactly the right thing—a boat advancing round the bend and containing a man who held the paddles and a lady, at the stern, with a pink parasol. It was suddenly as if these figures, or something like them, had been wanted in the picture . . . and had now drifted into sight, with the slow current, on purpose to fill up the measure.
>
> (Henry James, *The Ambassadors*)

James offers an initial impression, a visual perception, that becomes enmeshed in the flow and meaning of his narrative. Monet has no story to tell, but the aptness of his organizing vision suggests, nevertheless, that there is more to perceive and to understand.

Grace Seiberling has offered the view that Monet may have taken up these paintings again in 1890, when he wrote to Geffroy that he had resumed 'things impossible to do: water with grass that undulates below the surface . . .'

101. *Poplars, Giverny*
About 1890
25½ × 35½ in. (64·8 × 90·2 cm.)
Signed bottom right: Claude Monet
Private Collection, U.S.A.

During the 1880s, Monet developed with consistency two modes of composition that dominated his work: one was the curvilinear, introduced at Fécamp and Varengeville in 1881 and 1882 (Plates 69, 72 and 74) and emphasized at Etretat, Belle-Ile, and in some of the Creuse paintings (Plates 84–6, 89 and 94); the other was a simple, frontal approach to the landscape, which was easily governed by an implied grid of verticals and horizontals (evident in Plate 66 and numerous paintings of the fields around Giverny that run through the second half of the eighties). *Poplars, Giverny* exemplifies the latter mode of composition, made particularly emphatic here by the great height of the strictly vertical trees and their insistent repetition. Monet's desire to bring order and structure to his rendering of the natural scene (or, at the very least, to choose motifs that would be conducive to a sense of order) is thus clearly demonstrated.

102. *The Church at Vernon*

1894

26 × 36½ in. (66 × 92·7 cm.)

Signed and dated bottom left: Claude Monet 94

Brooklyn Museum, New York

During the 1890s, Monet began to revisit some of the places that he had painted earlier, particularly during the first half of the eighties. He had painted the church at Vernon, near Giverny, in 1883. Now, in 1894, he returned to the site, painting essentially the same view from directly across the river. But whereas the composition has been retained, the treatment of colour and atmosphere has changed extraordinarily—from a sharp-focused, descriptive clarity of forms and colours to a view as if seen through a mauve filter with the lens turned slightly out of focus.

103. *Poplars on the Epte, Sunset*

1891

39⅜ × 25⅝ in. (100 × 65 cm.)

Signed and dated bottom right: Claude Monet 91

Mr and Mrs David T. Schiff, New York

The Poplars was the first series to be exhibited as a discrete unit, with no other paintings appearing along with it. Fifteen canvases were shown at Durand-Ruel's gallery in March 1892. Within the series we find, as with the Haystacks, several subdivisions, four of which are illustrated in Plates 103–6. The major one is represented by the present painting. One looks from a distance at the long row of tall, thin poplars that border the narrow Epte River as it meanders through the landscape. Their spiralling passage into depth is beautifully caught through perspective diminution, but clues as to the location and rootedness of the trees in the second and third meanders are obscured. The three-dimensional looping of the crowns of the trees is also developed as an S-curve on the surface. Against this curvature are set the regular beats of the tree-trunks and reflections—the surface governed by two contrasted curvilinear and rectilinear systems. The crowns in the sunset are a vivid orange, with admixtures of green and blue; the trunks are red or orange against the blue sky. The colour, if not the formal boldness of Fauve painting, is not far off.

104. *Poplars, Wind Effect*

1891

39⅜ × 28¾ in. (100 × 73 cm.)

Signed and dated bottom right: Claude Monet 91

Durand-Ruel Collection, Paris

For the limited sub-series represented by this canvas, Monet zoomed in, in effect, so as to crop all but the lower portion of the upper leaves seen in Plate 103 and to reduce the number of foreground trees to three. The water at the bottom is also eliminated. In his desire to record specific effects of light and weather, he here restricts his palette to a muted grey-green range and deftly depicts the leaves and grasses blowing toward the left; the effect is to capture the action of the wind and to provide a quality of nervousness to the decorative swirl.

Monet observed the trees carefully and needed their presence despite the abstract character of these carefully designed paintings. Learning at one point that the trees were to be auctioned off and cut down, he struck a bargain with the proprietor of a nearby saw mill, asking him to purchase the trees and promising to pay the difference between the price he had intended and the price he had to bid. In turn, Monet asked that the merchant should not cut down the trees until he had finished painting them.

105. *Poplars (Les Quatre Arbres)*

1891

32¼ × 32⅛ in. (81·9 × 81·6 cm.)

Signed and dated bottom left: Claude Monet 91

Metropolitan Museum of Art, New York

In this painting, unique in the series, Monet has shifted his viewpoint so that the distant curving trees fill no more than the left half of the format (and, pale yellow against pale blue, are almost obliterated in the strong light). He includes four tree-trunks, as against the three in the sub-series represented in Plate 106. William Seitz, impressed by the pristine geometry of this picture, wrote in 1957:

> Scrupulous attention is given to slight variations in the simple pattern of rectangles which divides the surface; and an even more hypersensitized concern is operative in the waving motion of the vertical trunks . . . fusing here the *oppositions* of undulation and rectilinear structure which occupied him at Bordighera, Menton, Belle-Ile and Antibes. Both atmospheric vibration and curving rhythm can symbolize the mysterious vitality of nature's essence, but here the swaying organicism of *l'art nouveau* is ordered by an architectural equivalence of the horizontal and vertical.

Monet varied the weight of the trunks: from right to left, they move from thick and dark to thinner and lighter (light catching the upper sections of the left three trunks). He describes thus a slight recession of the bank towards the left but masks it by providing spacings between the trunks that defy a simple perspective reading, and by the overall horizontal and vertical regularity of the composition, which serves to obscure the fact that the line of the bank is actually angled towards the left. The masked relationship of an oblique plane within the picture (the plane of the four trunks) to the frontal picture plane is established here, and it then becomes a standard component in the space and structure of the Rouen Cathedral paintings. The design of the square canvas is masterly, and one may reasonably affirm that no twentieth-century non-objectivist has done it any better.

106. *Poplars*

1891

$36\frac{1}{4} \times 29$ in. $(92 \times 73\cdot7$ cm.)

Signed and dated bottom right: Claude Monet 91

Philadelphia Museum of Art (Chester Dale)

With Plates 103 and 104 this represents a group within the Poplars series. Monet has now focused more closely on the scene, isolating three foreground trunks against the sky and establishing the now more prominent presence of what had been the second and third curves in Plate 103. The strip of water at the bottom has been restored to the picture, the reflections emphasizing the way in which the repeated verticals pace off the canvas from side to side. The palette, basically pink and blue, but with numerous admixtures of other hues, develops yet another colour note. One might compare the colour differences among these paintings to the different notes from a row of porcelain vases, each of a different shape. To strike each one in turn would yield a different sound; so too, in these paintings, does Monet play upon the colour spectrum.

107. *Rouen Cathedral*

1894

$39 \times 25\frac{1}{2}$ in. $(100 \times 64\cdot8$ cm.)

Signed and dated bottom left: Claude Monet 94

Museum Folkwang, Essen

Monet worked in Rouen in March and April of 1892 and during approximately the same period the following year. There his vantage-point was a first floor window of a building, 81 rue Grand Pont, on the south-west corner of the Cathedral Square (the building no longer exists). He was permitted to construct a small working space that allowed him to have numerous canvases near at hand so that he could easily take up the one he wanted in relation to the character of light or weather at a given time. He scrutinized the scene carefully, responding to minute variations in light, but he also developed a shorthand, a formula for colour that enabled him to begin his paintings quite rapidly. An unfinished sketch in the Musée Marmottan (Marmottan catalogue no. 137), depicting the cathedral in the afternoon, makes it clear that he began with an idea of colour—pink building against blue sky—which he established quickly on the white canvas. He then would work at certain areas—the recessed rose window and voussoirs of the central portal—adding oranges and blues in different proportions, mottled, soon encrusted, but, one senses, laid in according to a predetermined general formula. Why, then, did he insist upon working on canvas after canvas directly at the site? At what point did he actually make use of the phenomenal data supplied by the changing scene? It would seem that he began to record nuances and detailed reactions to the appearances of the site at what we might call a middle stage, following the initial, generalized response to the light. Undoubtedly, that middle stage was important to him; indeed, it was the core of his enterprise, it endowed his work with an authenticity, a truth to nature which might sustain the

long process of variation and invention that he knew would follow once the site was left behind. The colour of the final canvases was both observed and willed, a conscious and artfully determined variation on those essential clues from nature, in the attempt to capture which he revealed his agony and his strength.

108. *Rouen Cathedral and the Cour d'Albane, Early Morning*

1894

$41\frac{3}{4} \times 29\frac{1}{8}$ in. $(106 \times 74$ cm.)

Signed and dated bottom left: Claude Monet 94

Museum of Fine Arts, Boston

The exhibition of twenty views of Rouen Cathedral that opened at Durand-Ruel's gallery on 10 May 1895 contained paintings that were related to the passage of the day and to differing atmospheric conditions, notably grey weather and fog. Three of the paintings were of early morning (*'effet du matin'*), including the present canvas. Monet's paintings of the cathedral include several compositional variations. In most of them the façade fills the format and is set at a slight angle to the canvas surface. In this picture and several others, however, a portion of the Cour d'Albane, a group of small houses which flanked the approach to the cathedral may be seen at the left. As a consequence, the Tour St-Romain, the north tower, is seen silhouetted against an area of sky to either side of it. For the most part, Monet reserved this format for early morning effects. Evidently, in doing so, he was attempting to emphasize the luminous drama of the setting, for it is not on the façade but on the tower that the morning light is registered. Thus, in a number of these works he stressed the play of cool and warm on the tower—the cold stone receiving the glow of the rising sun—and set it against the pink or yellow aura of the eastern sky.

In the 1895 exhibition, several titles referred to the 'tour d'Albane', borrowing the name from the flanking Cour d'Albane, and that error or usage has frequently prevailed to the present day.

109. *Rouen Cathedral, West Façade, Sunlight*

1894

$39\frac{1}{2} \times 26$ in. $(100\cdot2 \times 66$ cm.)

Signed and dated bottom: Claude Monet 94

National Gallery of Art, Washington, D.C. (Chester Dale)

110. *Rouen Cathedral, Full Sunlight*

1894

$42\frac{1}{8} \times 28\frac{3}{4}$ in. $(107 \times 73$ cm.)

Signed and dated bottom right: Claude Monet 94

Musée du Louvre, Paris (Jeu de Paume, R.F. 2002)

Working in 'assembly-line' fashion, on canvas after canvas, from his window across from the cathedral, Monet could

respond with extraordinary accuracy to the appearances of the façade. Towards late morning he could begin to measure the shadows as the sun moved around from the east. One can detail quite clearly the temporal sequence of his works from roughly mid-morning to just before sunset by following the passage of shadow. Plates 109 and 110 are extremely close to each other in time, the differences in the shadows are so slight that perhaps less than fifteen minutes would separate them, with the evidence (although partly contradictory) indicating that Plate 109 records the slightly earlier hour.

These two works, however close, demonstrate one of the variations in composition that run through the series. In Plate 109 we find a gap between the upper part of the central façade and the Tour St-Romain at the left; in Plate 110 the centre section overlaps the tower. Another element of irregularity and of dynamism within this extraordinarily restricted format is also shown here; as John Coplans has observed, 'Under the viewer's gaze, the identical façade painted in divergent light appears to shift, to shimmer, to dissolve and to reform. The different views ... show the cathedral sometimes tilting forwards or backwards or at an angle.' In the present case, Plate 109 appears to lean away from us, Plate 110 to lean toward us at the top, the effect largely determined by the deviations from the vertical of the dominant rising lines of the architectural structure.

111. *Branch of the Seine near Giverny*
1897
34¼ × 38½ in. (87 × 98 cm.)
Signed and dated bottom left: Claude Monet 97
Museum of Fine Arts, Boston

112. *Morning Mists*
1897
35 × 36 in. (88·9 × 91·4 cm.)
Signed and dated bottom left: Claude Monet 97
North Carolina Museum of Art, Raleigh

The Mornings on the Seine tend to seem, on first acquaintance, the least palatable of Monet's series. Favourable reaction often seems to be an acquired taste. The Mornings are the most reduced of the series—in terms of pictorial events within the composition, in terms of the deliberately limited palette. Along with the Poplars they are the most clearly decorative of the series. Monet continued to consult nature—beginning each morning before dawn—but artificiality had begun to dominate. It is most evident in the palette. He looks at nature but he sees it through a scrim, chooses those moments that will allow him to subdue intensity of colour in favour of an aesthete's preference for rarefied combinations. In the Mornings and the *Falaises* (Plates 116–19) he has chosen a world of mother-of-pearl. Monet's letters, beginning in the eighties, convey clearly enough his manic-depressive swings, his tenacity and his discouragements; they speak about his problems with the weather, with accomplishing what he

wants, but they do not reveal his sensibility. Self-styled man of the country, scrupulous autocrat with regard to the affairs of the household, unsentimental businessman when it came to handling his finished paintings, he lived, nevertheless, when making those paintings, in a *raffiné* world of dream and caress. He was far ahead of his old friends in the pursuit of an art of artifice; Pissarro wrote to his son in May 1895 regarding the Cathedrals: 'I am very excited by this extraordinary mastery. Cézanne, whom I met yesterday at Durand-Ruel's, agrees that this is very much the work of a self-willed, level-headed person, pursuing intangible, subtle effects that I see realized by no other artist.'

113. *Mount Kolsaas, Norway*
1895
25½ × 39 in. (64·8 × 99·1 cm.)
Signed and dated bottom left: Claude Monet 95
Mr and Mrs Nathan Cummings, New York

During the winter of 1895, Monet visited his stepson Jacques Hoschedé in Norway and spent approximately two months in the town of Sandvika, near Oslo. There he worked at several groups of paintings, attempting to pursue his series idea in new surroundings and, despite his fifty-five years, in freezing weather. His fanatical insistence on working outdoors was probably never more fully demonstrated than on this trip, where he found the Norwegians more timid about the cold than he was. On 26 February he wrote to Geffroy: 'I spent part of the day painting in the snow, which fell without a stop; you would laugh to see me completely white, with my head covered in icicles like stalactites.' Geffroy found the results aesthetically satisfying and suggested a parallel to Japanese prints in terms of a freedom from the conventions of linear perspective. He was probably thinking primarily of these views of Mount Kolsaas, which seem to present a Western equivalent of Hokusai's close-up views of Mount Fuji and, perhaps, some of Hiroshige's scenes of mountains in the snow, e.g., *Evening Snow on Hira Mountain* from the series 'Eight Views of Lake Biwa'. These paintings, as well, with their undulating forms and simplified shapes, suggest a conscious desire to create an elegant Art Nouveau design.

114. *Sandvika, Norway*
1895
28⅞ × 36⅜ in. (73·3 × 92·4 cm.)
Signed and dated bottom left: Claude Monet 95
Art Institute of Chicago

This somewhat cluttered composition, representing a limited group of paintings devoted to this snow-bound setting, is at the opposite pole from the simplification of *Mount Kolsaas* (Plate 113). Here, too, however, despite what would seem to be a naturalistic retreat from a goal of elegance, one may be reminded of parallels, and very likely models, in Japanese

prints: see, for example, Hiroshige's *Kambara*, Plate 16 from the series 'Fifty-three Stages of the Tokaido', or *Temmangu Shrine of Kameido in the Snow* from the series 'Famous Places of the Eastern Capital'.

115. *The Seine at Port-Villez*
1894
25¾ × 39½ in. (65·5 × 100·2 cm.)
Signed and dated bottom left: Claude Monet 1885
Tate Gallery, London

Monet painted at Port-Villez in 1883 but apparently never did this particular motif. In 1894, however, he returned to the area, very near Giverny, and did at least four paintings devoted to the same composition. They form a close-knit, skilful, miniature series, devoted to the softening effects of fog and early morning mist on the river, those natural effects abetted and transformed by a deliberate goal of paleness and delicacy. Art or artifice is made evident, as well, in the careful symmetry of the shore and its reflection, as Monet asserts his belief, embodied in single works as well as in the series of the nineties, in the potential of abstraction, in an ideal of the beautiful aesthetic object (cf. the palette of Plate 112).

At least two of the other three paintings of the group bear the date 1894, and the Tate painting clearly belongs to that time. Ronald Alley writes in the Tate catalogue that a notation on the back of Durand-Ruel's photograph of the painting says, 'Painting executed by Monet in 1894 but dated by error by the artist: 1885.'

116. *Cliffs at Varengeville*
1897
25⅝ × 36¼ in. (65 × 92 cm.)
Signed and dated bottom left: Claude Monet 97
Musée des Beaux-Arts, Le Havre

The tortoise-shell or mother-of-pearl iridescences of so many paintings of the nineties (see Plates 96 and 112) is again revealed here with particular subtlety. There are at least two similar paintings (Metropolitan Museum, New York, and Fogg Museum, Cambridge, Massachusetts), but both of them are more plastic due to the more affirmative treatment of shadow, which helps to reveal the gorge that separates the bit of hill at the lower right from the larger stretch of cliff where one finds the house. Here light seems to fall from directly above, cancelling topographic distinctions and helping Monet to interpret the cliff and sea as almost abstract colour fields. The refined artifice of the interpretation is emphasized by a comparison with one of the paintings of 1882 (Plate 74) that served as the pictorial model or point of departure for the similar group of 1897.

117. *Cliffs near Dieppe*
1897
25 × 38¾ in. (63·5 × 98·4 cm.)
Signed and dated bottom right: Claude Monet 97
Private Collection

Monet spent from mid-February to March of 1896 revisiting and working in Dieppe, Pourville, and Varengeville, sites that he had painted fifteen years earlier when he had first begun to turn his art towards a more abstract and decorative interpretation of nature's data. He returned again in February and March of 1897 to complete what he had begun the previous year. Compared to similar paintings of the early eighties, e.g., *Calm Weather, Fécamp* (Plate 69), this later view of the cliffs and sea just below Dieppe seems far more assured in its graceful, curvilinear flow. It was in the earlier painting that he had first established the compositional importance of viewpoint for his new venture of the eighties, and in that work one can feel the strain and deliberation that went into the choice of vantage-point, one can take one's stand on the foreground prominence: the experience of the site remains. In the present work the reality of that experience seems lost; the painting takes on, by comparison, a cameo-like elegance. The picture has clearly become a decorative object composed of delicate swirls and variegated, iridescent colours. One thinks less of the reference to nature, feels no call to recreate the painter's viewpoint; one accepts the painting as a rarefied, autonomous object within the world of natural forms. This is one of at least four paintings forming a group within the larger series of *Falaises* that Monet developed from his campaign of these two years. He exhibited twenty-four paintings from the series at the Galerie Georges Petit in 1898.

118. *The Cliff, Varengeville*
1897
29 × 36 in. (73·7 × 91·4 cm.)
Signed and dated bottom left: Claude Monet 97
Mr and Mrs David Lloyd Kreeger, Washington, D.C.

The design of this canvas is a variation on an almost identically composed painting of 1882, *The Custom House at Varengeville* (Philadelphia Museum of Art). Whereas that painting was devoted largely to the colours of grass and heather on the hillside, i.e., to a descriptive authenticity, the present painting is given over to an idea of violet and green. Realistically, we might consider it to be an evening or fog effect, but the painting does not seem to ask to be evaluated in those terms. The cliff, simple in design, more so in its profile than the 1882 painting, seems to loom up as a creature of memory, something shadowy yet insistently present. Note the cottage, barely visible in this photograph at bottom centre—a flattened outlined form, it is scarcely materialized, less a house than a ghost of a house. For a similar, contemporaneous composition, however removed in style and subject, compare Sir Lawrence Alma-Tadema's *A Coign of Vantage* of 1895.

119. *The Douanier's Cottage at Varengeville*
1897
26 × 36½ in. (66 × 92·7 cm.)
Signed and dated bottom left: Claude Monet 97
Art Institute of Chicago

Here Monet zooms in dramatically on the house that appears in Plates 74 and 116. Photographic metaphors rarely seem inappropriate when one deals with Monet's work. He seems to try out things that the camera can do; near and far, i.e., views through normal and telephoto lenses, had been one of the terms for his comparisons for many years. It had, for example, been especially valuable to him in trying to come to grips with the site at Etretat, and in Plates 103–4 and 106 of the Poplars series we see a gradual moving-in from a long-distance view of the trees to a cropped, close-up treatment of three trunks from the foreground range.

120. *Vétheuil*
1901
35½ × 36¼ in. (90 × 92 cm.)
Signed and dated bottom left: Claude Monet 1901
Pushkin Museum, Moscow

In February 1902, Monet showed six views of Vétheuil at the Bernheim-Jeune gallery. These paintings, all on nearly square canvases (as were the Japanese Bridge paintings of 1899 and 1900, Plates 126–7), develop the same composition, a view of the houses and church of Vétheuil set against the hills, the lower half of the painting given over to a stretch of river. What distinguishes one painting from the next is primarily variations of palette, a palette guided, as with the paintings of the nineties, by a feeling for the most refined and rarefied combinations of colours fused into complex iridescences. For comparison with an earlier view of Vétheuil dating from his stay of 1878–81, see Plate 65.

121. *Charing Cross Bridge and Westminster*
1902
25¾ × 39½ in. (65·5 × 100·5 cm.)
Signed bottom right: Claude Monet
Baltimore Museum of Art

Eight views of Charing Cross Bridge were shown in 1904 (see note to Plate 124). They are reminiscent of *The Thames below Westminster*, which was done during his first visit to London in 1871 (Plate 32). In most of the Charing Cross paintings Monet preserves the pure horizontal and vertical structure of the early view, setting the bridge as a horizontal across, or just below, the centre of the painting and calibrating the width of the canvas by means of the short verticals of the bridge support. In this group, as with Waterloo Bridge and the Houses of Parliament (Plates 122 and 124), he developed his individual canvases in relation to changes of light and weather. When John Singer Sargent visited Monet at the Savoy Hotel, he

found him 'surrounded by some ninety canvases'. These paintings were ultimately transported, in some state of unfinish, back to Giverny, where Monet continued to work on them. There, as Steven Levine has noted, he was visited by the critic Desmond Fitzgerald, who had by then known Monet for over a decade; he reported that Monet had returned with approximately one hundred canvases, upon which he set to work, 'destroying, combining ever striving after those illusive, misty phantoms', ultimately whittling the number down to thirty-seven linked works fit for exhibition together, from which procedure Fitzgerald concluded that the series should be called 'the Studio Series'.

122. *The Houses of Parliament, Stormy Sky*
1904
32⅛ × 36¼ in. (81·5 × 92 cm.)
Signed and dated bottom left: Claude Monet 1904
Musée des Beaux-Arts, Lille

For the group of paintings devoted to the Houses of Parliament, eleven of which appeared at the exhibition of 1904, Monet took up a position at the window of a room in St Thomas's Hospital just across the river. All the views of the Houses of Parliament show the buildings in fog; hence detail is obscured or thoroughly cancelled. The buildings are four-square within the rectangular format, strictly aligned with the vertical and horizontal, thus indicating that Monet was centred directly opposite the river façade of the buildings. And yet the disposition of the towers (the tallest one considerably heightened and thinned) reveals that his line of vision must have been at an approximately forty-five degree angle to the façade, placing his room at one end of the hospital, close to Westminster Bridge. Nevertheless, the design of the Parliament buildings (as with the Poplars and Rouen Cathedral, Plates 105 and 107–10) denies this angle, the fog obscures the oblique orientation of the towers and makes the building seem a perfectly flat silhouette. Monet achieves the aim which finally came to dominate the London series as a whole—he attains a degree of artifice, of aesthetic unity, that takes precedence over the vagaries of nature. And yet nature is powerfully present in this work—storm and fiery sunset become the generators of an agitated brushwork and intense palette that makes this painting one of the most expressionist in the series.

123. *Leicester Square by Night*
About 1901–4
31½ × 25¼ in. (80 × 64 cm.)
Studio stamp bottom right
Private Collection, France

In this and at least two other similar views Monet returned to depicting the active life of the city, a pursuit that he had forsaken since the late 1870s (Plates 4, 5, 41 and 55). The views

of Leicester Square are all night scenes, characterized by a freely sketched and highly suggestive treatment of the lights and activity within the scene. It has been suggested, on the basis of a note on the stretcher of one of these paintings, that they may date as late as 1918. There would seem, however, to be no other basis for such a dating. Grace Seiberling has recently pointed out, based on information from Robert Gordon, in her dissertation (Yale University) that Monet wrote several letters from London to his wife Alice in 1901, saying that he hoped to do some paintings from a club in the evening. The Leicester Square views are probably the result of just that intention.

124. *Waterloo Bridge, London*
1903
25⅜ × 39½ in. (64·5 × 100·3 cm.)
Signed and dated bottom right: Claude Monet 1903
Museum of Art, Carnegie Institute, Pittsburgh

From 9 May to 4 June 1904, at Durand-Ruel's gallery in Paris, Monet showed thirty-seven paintings comprising a *Série de vues de la Tamise à Londres (1900–1904)*. The catalogue contained an essay by Octave Mirbeau, who wrote that the exhibition was the result of 'four years of reflective observation, strenuous effort, prodigious labour'. Eighteen of the paintings, the largest group in the show, depicted Waterloo Bridge, seen at an angle from above, as Monet viewed it from a balcony (no longer existing) of the Savoy Hotel. The glow of the bridge and the treatment of people and carriages set against the industrial aura of the violet sky, links the present painting to an earlier view of the Thames, Turner's *Burning of the Houses of Parliament* in the Philadelphia Museum. The Thames paintings reflect the direct experience of the three seasons in London and reveal the elaborations and inventions that took place during three years of work at Giverny. That combination of observation and imagination was captured in words by the critic Charles Morice, who described the London that appeared in Monet's paintings as the 'dark and smoking capital of another world'. For an extensive presentation of the London views, see the catalogue of the exhibition *The Impressionists in London*, sponsored by the Arts Council of Great Britain in 1973.

125. *The Artist's House at Giverny*
1902
28¾ × 28¾ in. (73 × 73 cm.)
Signed and dated bottom left: Claude Monet 1902
Private Collection

Among the numerous paintings of the garden in front of his house at Giverny that tend to cluster in the years between 1900 and 1905 are a limited group viewing the house at an angle from the left front, almost losing it behind the foliage and flowers that abounded throughout the garden (cf. Fig. 19). Monet designed and organized the garden with the greatest care, and as early as 1898 Maurice Guillemot recognized that the colours of the flowers were combined as if Monet was arranging a palette. He intended both the house garden and the water-lily garden to provide him with a never-ending source of motifs, and he created and arranged them to that end. In the course of the years at Giverny he built a second studio (the first was within the house itself) to the left of the house and, from 1914–16, a large studio in which to paint the Water-lilies cycle to the right (Fig. 25). Two hothouses, in which he cultivated tropical plants, including several varieties of orchids, were built near the second studio. On the ground floor below the second studio a dark room was eventually introduced (see Figs. 26 and 27).

As a result of Monet's presence, and as early as the end of the eighties, numerous painters, led by a contingent of Americans, came to Giverny to work and transformed the tiny village into a fully-fledged artists' colony, from which, however, Monet stayed almost entirely separate.

126. *Water-lily Pond, the Water Irises*
1900
35 × 36¼ in. (89 × 92 cm.)
Signed and dated bottom right: Claude Monet 1900
Private Collection, Paris

In six Japanese Bridges done in 1900, Monet developed a more 'Baroque', oblique view of the bridge over the pond, using the foreground foliage at the left as a *repoussoir* to set the bridge firmly in space. Monet never entirely ceased to develop paintings in pairs within limited series; another canvas from exactly the same vantage-point but more horizontal in shape explores the same composition.

127. *The Japanese Bridge*
1899
35⅛ × 36¾ in. (89·2 × 93·3 cm.)
Signed and dated bottom right: Claude Monet 99
Philadelphia Museum of Art (Tyson Collection)

In November-December 1900, Monet exhibited thirteen paintings of the *Bassin aux Nymphéas* at Durand-Ruel's galleries. Their principal motif was the Japanese bridge which he had constructed over the water-lily pond in the lower garden at Giverny. This garden was just the other side of a railway line and road below his house. The bridge was constructed on an axis with the main path that led from the house to the road. In this view Monet faced the bridge squarely, perhaps viewing it from a boat on the pond itself, and stretched it across the picture plane, setting it against a background of weeping willows and alders. The blue and green of the bridge are rather matt in quality; they seem to sit, as does the bridge, comfortably on the picture surface. The establishment of this effect was deliberate and gave Monet satisfaction, it would seem, and yet he delights as well in the

power of illusion. The bush at the left suddenly sets the bridge back into fictitious space, as does, then, the perspective of the pond surface, which advances towards us. At the left one can easily read foreshortening; at the right one must strain to do so, a flattened reading seems more appropriate. Stereometry and planimetry, conceived as ways of seeing and as aspects of painting practice—Monet never ceased to be fascinated by the possibilities that their interaction offered.

128. *The Japanese Bridge*

About 1923–5
$35\frac{1}{8} \times 45\frac{3}{4}$ in. (89·2 × 116·2 cm.)
Studio stamp bottom right
Minneapolis Institute of Arts

The Japanese bridge had changed considerably in appearance since 1900 (Plates 126–7). In about 1910, the arched superstructure was added, and soon the wisteria wove its canopy over the bridge and cloaked its uprights. The view here is, as William Seitz pointed out, from further away than that in Plates 126–7, for only the lower arch in this late painting corresponds to what we see in those earlier canvases; the upper arch represents the canopy of wisteria. It is as if Monet's painting was composed of different materials from those traditional oil pigments used in Plate 127. Along with the proliferation of foliage has come a magnificent painterly intensity, a breakthrough to another kind of painting. Foreshortening, clear spatial structure are no longer a part—as they manifestly are in Plate 127—of the experience and content of the painting. That content is made up of many parts: it is conditioned by Monet's eye problems (including the partial recovery that followed his cataract operation early in 1923, or, if this painting is to be considered, as it often has been, as preceding his operation, the aggravated situation that had already been emerging for several years), by the history of expressionist tendencies within his own career, and by his thirty-year absorption in the water garden. But, as well, it must surely be a product of his desire to enmesh his lifelong experience of nature in his abiding fascination with paint.

129. *Water-lilies*

1904
$31\frac{5}{8} \times 36\frac{1}{4}$ in. (89 × 92 cm.)
Signed and dated bottom right: Claude Monet 1904
Musée des Beaux-Arts, Le Havre

After the completion of the Japanese Bridge series in 1900, Monet undertook to enlarge the water-lily pond. In the succeeding years—intermittently at first, along with the paintings of Vétheuil, the house garden, and the completion of the London series, and steadily after 1904—he elaborated a long and complex series of paintings devoted primarily to the surface of the pond with its floating lily pads and blossoms. They were exhibited in 1909 as '*Les Nymphéas, série de paysages*

d'eau', a unified exhibition of forty-eight paintings. This canvas of 1904 represents the first stage of the series: a restricted stretch of pond, elongated ovals of water-lily pads striating the water and taking us back in recession to the bank, seen in the top one-eighth of the canvas. Here the pads range in colour from chalky, whited greens at the bottom to yellow-greens near the shore; the water and reflections within it are painted darkly as if with a patina of deep violets, blues, greens, and alizarin. The effect of foreshortening is developed impeccably and powerfully; it becomes, as always, increasingly effective as one steps away from the canvas (or places this illustration further away from the eyes).

130. *Water-lilies*

1905
$35\frac{1}{2} \times 39\frac{3}{8}$ in. (90 × 100 cm.)
Signed and dated bottom right: Claude Monet 1905
Museum of Fine Arts, Boston (Gift of Edward Jackson Holmes)

In 1905, Monet eliminated the strip of shore from the upper portion of his canvases. Louis Gillet described the result in 1909:

A painting without borders, a liquid surface, a mirror without frame. All that is drawing, positive form, horizon, disappears. Without the two or three groups of aquatic foliage strewn on to this mirror, nothing would indicate what fragment of infinite extension one is dealing with: no other landmark by which to determine the point of view and the angle of the perspective. In animating this neutral space, the artist limits himself strictly to reflections, with the result that one has a painting turned upside-down. The (invisible) trees are announced only by their reflections. The sky, instead of being a vault, touches the lower edge of the frame, and the lightest element, commonly at the top, is here at the base.

131. *Water-lilies*

About 1920–2
$78\frac{3}{4} \times 167\frac{3}{4}$ in. (200 × 426 cm.)
Studio stamp bottom left
Cleveland Museum of Art

As Monet expanded the size of his water-lily canvases he incorporated new effects or had a chance to explore or exaggerate others with which he had earlier been concerned. Here, although the sense of depth is great, it tends to be superseded by the quality of breadth, of lateral expansion. Although the control of foreshortening is powerfully asserted, it is coupled with the 'bending down' of the water (indicated by the rounder shape and the placement of the lily pads) toward the bottom. Thus the ideal of perfect pictorial recession is coupled with the reality of the experience of the immediately

proximate. In the process, the space curves away from the viewer, stretches upward from the bottom edge and, so to speak, into foreshortening. The painting, of course, in its size (half the width of Plates 132 and 150), also lives an expanded decorative life as a vast field of softly brushed, somewhat iridescent colour, on to which are pinned the floating accents of broadly applied pigment that articulate its surface.

132. **Green Reflections** (Room 1, east panel)
 1916–23
 77½ in. × 27 ft. 10½ in. (197 × 850 cm.)
 Musée de l'Orangerie, Paris

This panel of the Water-lilies cycle (see note to Plate 146) is perhaps the most accessible painting of the entire decoration. Its size is manageable, one has no difficulty viewing the whole, one can, in relation to it, assume a variety of distances and angled vantage-points within the room without losing a sense of the work in its entirety. It is the classical expression of the water-lily theme. It offers nothing but water surface and reflection. The water-lilies are distributed across the surface in a balanced, almost symmetrical fashion and are impeccably foreshortened so as to form an oval ring round a central cluster of lily pads. In its perspective plan it mirrors, then, the scheme of the room itself, that endless oval which revolves about the viewer centred within it. It is both ideal and referential; it reveals the purity of Monet's design and the factor of experience—the perception/reception of the viewer—without which the design is not complete.

This panel, as the whole decoration, gives articulated form to the idea that had emerged in Monet's mind during the 1890s, the first decade of his active involvement with the water-lily garden as an entity in itself and as a model for a future decoration. Maurice Guillemot, after visiting Monet in 1898, was the first to give public expression to Monet's plan:

> Imagine a circular room in which the wall . . . would be entirely occupied by a horizon of water spotted with these plants [the water-lilies], the walls of a transparency now green, now mauve, the calm and silence of the still water reflecting the flowering display; the tones are imprecise, deliciously subtle, as delicate as a dream.

133. **Water-lilies**
 1907
 35½ × 28½ in. (89·5 × 72·8 cm.)
 Signed and dated bottom right: Claude Monet 1907
 Private Collection, New York

In 1907, Monet shifted his attention from square or nearly-square canvases to elongated vertical rectangles, producing in that year a sub-series of at least fourteen paintings. The composition of each of these works adheres closely to that illustrated here. The arrangement of water-lilies is retained in almost identical fashion from canvas to canvas; the shape of the reflection of trees in the water, while basically the same throughout, is established with individual variations from work to work. The reflections, with the trees divided by a path of light in the centre, create the effect of an avenue of trees, as if seen in perspective (cf. Plate 3). The lily pads tend to line up in horizontal strata, as if measuring the surface. But, in reality, it is the lily pads that are strongly foreshortened (as is the invisible plane of the water on which they float), and it is the reflection that hovers in a (somewhat indeterminate) position roughly parallel to the picture plane. Monet plays with the contradictory effects of surface and depth in order—this would seem at least to be one of his aims—to convey the phenomenal complexity of the water-lily pond with its ceaseless interchange of substance and illusion; he does so, as well, in order to convey and demonstrate the phenomenal complexity of *painting* with *its* capacity for a ceaseless interchange of substance and illusion.

134. **Water-lilies**
 1908
 36¼ × 35 in. (92 × 89 cm.)
 Signed and dated bottom right: Claude Monet 1908
 Private Collection, Zurich

By 1907, Monet was actively thinking of an exhibition of his Water-lilies paintings but concluded that he was not yet ready. In April he wrote to Durand-Ruel:

> I am very sorry not to be able to exhibit the Water-lilies series this year! . . . At best, I have only five or six possible canvases and have just destroyed at least thirty, and that to my great satisfaction.
>
> I always find great pleasure in doing them, but with time I can easily see which canvases are good and which ought not to be preserved. . . . It would be very bad to show as little as I now have of this new series, the whole effect can only be produced by an exhibition of the ensemble. Moreover, I must have the completed ones in front of me in order to compare them with those I am about to do.

Monet was still working at the series in 1908, and the exhibition of the ensemble took place only in 1909.

Monet's series paintings, from the nineties on, tended to be understood in two different ways: as a potentially endless series of instants derived from nature, or as a finite, decorative unity, in which the various moments (separate canvases) were geared to an aesthetic whole. By stressing the latter view, the importance of the ensemble, Monet was stating explicitly that a series *had to be limited*, that it had to be restricted to just the number of *paintings* that would produce the desired poetic or aesthetic experience. The artificial nature of Monet's enterprise, its autonomy as a work of art independent of nature,

was thus demonstrated. In the twenty-year phase of his career from about 1890 to about 1912, it was only through the series that Monet could attain that autonomy for his art that he had been seeking ever since the 1860s, that awareness of the separateness of art from the world that he had begun to perceive in the process of building up his definitive, large canvas of the *Déjeuner sur l'herbe* (Plates 9 and 10) and which he elaborated in terms of a dynamic interplay between the means of art and the appearances of nature in the Grenouillère paintings of 1869 (Plates 27, 29 and 30). He achieved fully in the series of the nineties what he had begun to speak of in his letters as early as 1882—autonomy through the seeking of the ensemble. During the eighties, at one site and another, he developed coherent groupings of motifs and paintings. In the series of the nineties and thereafter, the difference is slight but magisterially convincing; by limiting his motif so drastically, he arrived at the terms that made his intentions clear and his design complete.

135. *The Doge's Palace, Venice*

1908–12
$28\frac{1}{2} \times 36\frac{1}{4}$ in. $(73 \times 92$ cm.$)$
Signed and dated bottom right: Claude Monet 1908
Kunsthaus, Zurich (on loan)

The spring of 1908 brought illness and eye trouble to Monet, and in the autumn he travelled with Alice to Venice, where, initially, they stayed with Mr and Mrs Ralph Curtis, friends of Sargent. They later settled in the Grand Hotel Britannia on the Riva degli Schiavoni until their return to Giverny in December. A second visit followed a year later in the autumn of 1909. Monet hoped to return the next year, but Alice's illness prevented it. She died on 19 May 1911, after which Monet entered into a period of deep mourning and never went back to Venice. In May 1912, twenty-nine views of Venice were shown at Bernheim-Jeune's gallery. Monet responded to praise of his paintings by saying: 'They are horrid. They are worthless . . . I went to Venice with my wife. I took notes and should have gone back there. But my wife died and I never had the courage. So I finished them off from memory . . . and nature has had its revenge.' Monet insisted on this point, on the value of working from nature, but it must be realized that his procedure seems to have been very little different from that practised for the London series (Plates 121–2 and 124). The present view is from the Dogana just across the mouth of the Grand Canal. In comparison to the powerful foreshortening preserved within the decorative confines of the *Nymphéas* paintings, here the broad, panelled reflection of the palace defeats any attempt to read the water as a foreshortened plane.

The colours in the Venice series range from the interplay of warm and cool pastels seen here to fiery sunset hues. In his preface to the catalogue of the exhibition, Octave Mirbeau stressed Monet's mastery of light and colour, asserting that 'all the painters today owe their palette to Claude Monet. No painter in the future will be able to be free of the problems that Claude Monet has solved or posed.'

136. *The Doge's Palace, Venice, seen from San Giorgio Maggiore*

1908–12
$25\frac{3}{4} \times 36\frac{1}{2}$ in. $(65 \cdot 1 \times 92 \cdot 1$ cm.$)$
Signed and dated bottom right: Claude Monet 1908
Metropolitan Museum of Art, New York

Five paintings of this design were included in the exhibition of the Venice series. In each of them the dark shape of the embankment in front of San Giorgio Maggiore juts into the painting at an angle in the foreground, seeming almost to penetrate underneath the hovering, advancing area of the lighter-coloured water. Its effect—to make the upper zone, through dark/light contrast, seem to advance—is the very opposite of a *repoussoir*. It is as if the embankment provides a rude note of reality in a painting which is otherwise as pretty as a picture.

137. *Grand Canal, Venice*

1908–12
$28\frac{7}{8} \times 36\frac{3}{8}$ in. $(73 \cdot 3 \times 92 \cdot 4$ cm.$)$
Signed and dated bottom right: Claude Monet 1908
California Palace of the Legion of Honor, San
 Francisco

Six paintings of this design were shown in 1912. The view is from a vantage-point on the Grand Canal looking east toward Santa Maria della Salute. The poles in the foreground act somewhat like a *repoussoir* and effectively divide the canvas in two: to the left we have a perspective alley created by the poles; to the right a quality of breadth that serves to minimize depth.

138. *Twilight, San Giorgio Maggiore, Venice*

1908–12
$25\frac{3}{4} \times 36\frac{3}{8}$ in. $(65 \cdot 5 \times 92 \cdot 4$ cm.$)$
Signed and dated bottom right: Claude Monet 1908
National Museum of Wales, Cardiff

Five paintings at the exhibition of 1912 depicted S. Giorgio Maggiore as the primary identifiable landmark; another canvas in which the church appeared was called *Twilight*. The present work is related to the latter painting. Monet took the motif as an opportunity to silhouette the church darkly against the expressionist glow of the sunset sky.

139. *Palazzo da Mula, Venice*

1908–12
$24\frac{1}{2} \times 31\frac{7}{8}$ in. (62 × 81·1 cm.)
Signed and dated bottom left: Claude Monet 1908
National Gallery of Art, Washington, D.C.

The exhibition of 1912 contained two views each of the Palazzo da Mula and Palazzo Contarini and three views of the Palazzo Dario. The present work is representative of the group as a whole. Monet set up his easel just across from the palace and used its horizontal and vertical subdivisions as a grid with which to rule the design of the entire canvas, including the area of the water below, which assumes quite strictly a position parallel to the picture surface. William Seitz noted the connections between the abstract design of these canvases and the formal innovations, occurring at the same time as the series was exhibited, in the works of Mondrian and the Cubists.

140. *Water-lilies*

1917
$39\frac{3}{8} \times 78\frac{3}{4}$ in. (100 × 200 cm.)
Signed and dated bottom right: Claude Monet 1917
Musée des Beaux-Arts, Nantes

The size of the Water-lilies canvases up to the exhibition of the series in 1909 never exceeded three and a half feet in any dimension. The largest of the Venice paintings, with which Monet was primarily occupied until 1912, stayed just short of that. For that matter, with only rare exceptions, Monet had been a devotee of the small easel painting from about 1870 on. But in the years after 1912, when Monet began to give consideration to the idea of a large-scale decorative cycle based on the water garden, he began to increase the size of his canvases. This occurrence coincided, as well, with the final excavations and enlargement of the pond itself, which took place in 1910, almost quintupling the area of the pond as it had been at the time of the first Japanese Bridge paintings in 1899 (see Plates 126–7).

The present painting is of a moderate size, one half the width and height of the canvases he used for the final *Nymphéas* decoration in the Orangerie (Plates 132 and 146–50). In character it seems to come between the pre-1909 Water-lilies series and the mural cycle. All the ingredients of the earlier and the later works are there—blossoms and pads floating on the foreshortened surface of the water, grasses growing beneath the surface and occasionally projecting above the water level, the reflections of sky and trees. The palette in this canvas is somewhat exceptionally reduced in contrast: the colours are closely adjusted to each other in value, and distinctions between them tend to be those between warm and cool. Similarly, the edges of forms are relatively soft and feathery. Monet creates a seamless flow of one thing into another, a field of colour that silently reconciles the most antagonistic experiences—of depth and surface, solid and void, tangible and intangible.

As far back as 1937, when these paintings were relatively new and very little known, Meyer Schapiro referred to: '. . . the Water Lilies, with their remarkable spatial forms, related in some ways to contemporary abstract art.' Schapiro did not at the time specify the twentieth-century art he had in mind. But Monet's works have not failed since to suggest comparisons with and, beginning in the 1950s, influences on large-scale contemporary painting. Possibly Jackson Pollock and Morris Louis, certainly Philip Guston and Milton Resnick, created paintings in the first half of the 1950s (or the very end of the forties in Pollock's case) that were linked to the experience of Monet's Water-lilies. And it is specifically to paintings like the Nantes canvas (which was exhibited at the Museum of Modern Art, New York, in 1960), that one can point in suggesting parallels to or stimuli for the colour-field painting of Jules Olitski and Kenneth Noland, among others, in the second half of the 1960s.

141. *Water-lilies*

About 1918–21
$78\frac{3}{4} \times 70\frac{7}{8}$ in. (200 × 180 cm.)
Musée Marmottan, Paris

Monet's enlargement of the water-lily pond was the culmination of twenty years of work and planning that saw the complete replanting of the area, the introduction of numerous, often rare species of water-lilies and other flowers and plants, the importation of several species of bamboo, Japanese apple and cherry trees (which would complement the Japanese bridge), and the planting of fast-growing weeping willows. The willows played a large part in allowing Monet to vary the vocabulary of numerous works that accompanied his central, obsessive, direct concentration on the water/mirror itself. And the weeping willow—the trunks and the descending leaves—came to assume a prominent place in the final decoration. They appear all round the second oval room in the Orangerie and help to measure, as does the passage of time through the day, the way through the all-but-continuous circling of the four panels (Plates 147–50). The present work, brisk and crisp in handling, plays the pattern of leaves (vertical) against the disposition of lily pads (horizontal) and provides perspective and a land-based viewpoint through the triangle of bank (diagonal) at the lower left.

142. *Wisteria*

About 1919–25
$39\frac{3}{8} \times 118\frac{1}{2}$ in. (100 × 301 cm.)
Musée Marmottan, Paris

After the enlargement of the water-lily garden in 1910, Monet erected an arched framework over the Japanese bridge, from which he hung a crown of lilac and white wisteria imported from China and Japan. In several canvases he isolated the wisteria as a separate motif and envisaged including them in the final *Nymphéas* decoration as a frieze that would have run

along the walls above the main panels. The plan was ultimately abandoned, but this and one other painting in the Musée Marmottan, long horizontal rectangles, provide a record of what Monet had in mind as well as being paintings of a free-floating, fanciful delicacy in their own right.

143. *Water-lilies*
About 1919–25
$39\frac{3}{8} \times 118\frac{1}{8}$ in. (100 × 300 cm.)
Musée Marmottan, Paris

This unfinished painting indicates something of Monet's procedure as he attacked the large Water-lilies canvases. A picture this size would not have been attempted outdoors, although he did work on large canvases, up to about seven feet in width, from numerous vantage-points that he had established around the periphery of the water-lily pond (cf. Fig. 24). The present painting was undoubtedly begun, however, in the large studio (Fig. 25). On a white canvas he laid down extremely broad, flexible strokes designed to sketch in as quickly as possible the basic colours and shapes. In this case, although he did not develop the sketch towards a clear descriptive definition, the vertical strokes towards the left and the clusters along the top edge probably represent wisteria hanging above the horizontally brushed water. The size and shape of the canvas conform with Plate 142.

144. *Weeping Willow*
About 1919
$39\frac{7}{8} \times 47\frac{1}{4}$ in. (100 × 120 cm.)
Musée Marmottan, Paris

Six paintings remain depicting the large weeping willow at the north edge of the pond, close to the Japanese bridge. These works are tangled and clotted with paint; the thickness of pigment, its tactile presence almost seeming to cancel any possibility of reading air or space in the painting, is characteristic of a number of works from the early twenties, including several views of the house and garden (Musée Marmottan catalogue nos. 38–41, using the same vantage-point as in Plate 125, and nos. 56–7) and, from the period about 1923–5, more than fourteen paintings of the Japanese bridge (Plate 145). The energy and expressive force that derives from the impasto and manipulation of the paint likens it to other paintings of the twenties of the most expressionist character, for instance, the work of Soutine.

145. *The Japanese Bridge*
About 1919 or about 1923–5
$39 \times 78\frac{3}{8}$ in. (99 × 199 cm.)
Musée Marmottan, Paris

Ever since the paintings of the Gare Saint-Lazare of almost a

half century earlier, Monet had been treating the immaterial—clouds, air, water, fog—as plastically as the material, albeit without the assertiveness of the *Weeping Willow* (Plate 144) and the Japanese Bridge paintings of the 1920s (see also Plate 128). In the present work he extends the arch of the bridge across the full width of a canvas generally reserved, in size and shape, for studies for the Water-lilies murals. The skin of pigment is uniform—thick, matted, and granular; the interstices between the uprights of the superstructure refer to yellow light and a somewhat distant background of foliage, but these areas insist upon, grab the surface with considerable tenacity. The agony of Monet's years spent under the cloud of cataract would seem to be indicated here; it is almost as if the palpability of paint was called upon to make up for whatever uncertainties were generated by his failing vision.

146. *Water-lilies decoration* (Room 1, looking north)
1916–23
North panel: $77\frac{1}{2}$ in. × 41 ft. (197 × 1275 cm.)
Musée de l'Orangerie, Paris

Although there is no actual record of it among Monet's remaining paintings, he was apparently actively working at a decorative cycle, approaching that which is seen here, during the late 1890s. In an article published in 1898, following a visit to Monet, Maurice Guillemot wrote that Monet had already begun some large studies, which he showed to Guillemot in his studio. The next fifteen years, however, were taken up with the London, Water-lilies, and Venice series. But the idea had not been discarded. In 1914, encouraged by Clemenceau and by an apparent amelioration of the problems with his sight that had troubled him on and off since at least 1908, he put aside a general weariness and a depression that had persisted since the death of his wife Alice in 1911, and he made plans for the construction of a large studio in which he could carry out the Water-lilies decoration (Fig. 25). Most of the work was done from 1916 to 1923. In October 1920 it was announced that the government would build a pavilion on the ground of the Hôtel Biron (the Musée Rodin) to house the decoration which Monet had offered to the state. Within the next two years the site was changed; in April 1922 a new announcement specified the Orangerie, located at the far end of the Tuileries Gardens from the Musée du Louvre and recently annexed to the museum, as the destined home for the murals. The rooms, situated at ground level on the south side of the building, were designed by the architect Camille Lefevre according to plans that had been proposed by Monet himself. Five months after the artist's death, on 16 May 1927, the two oval rooms were opened to the public for the first time.

The first room contains two smaller murals on the east and west walls and two larger ones to the north and south. The south may represent morning, the north evening—dark at the periphery, closed lilies on their pads floating against a field of white-clouded sky; the west represents the setting sun, its colours prominently pink and yellow, the only deviation from

a pervading blue and green softness throughout the decoration. The view in all the panels of Room 1 is directly down and into the water. The action is primarily one of mirroring the larger world around and above the pond, and the mood is, similarly, reflective.

147. *The Two Willows* (Room 2, east panel)
1916–23
77½ in. × 55 ft. 9¼ in. (197 × 1700 cm.)
Musée de l'Orangerie, Paris

This is the longest panel in the two rooms at the Orangerie. Placed at the narrow end of the room, it has the most acute curvature. One can stand close to the centre of the panel and have to turn one's head to both sides fully to take in its extremities. The flanking trees, concave curves near the lateral edges of the panel, are like homeless parentheses, seeming almost to have lost track of what they were meant to enclose. This panel, above all, tends to reduce any sense of simulation; rather, as we look out to its edges, we are dealing with real distances, real measurements. It is not a painting that one can take in all at once, just as one could not take in the pond all at once.

148. *Water-lilies decoration* (Room 2, installation view, looking east)
1916–23
Musée de l'Orangerie, Paris

Room 2 is more expansive than Room 1. Monet sets the trunks and hanging leaves of the weeping willows within the panels, suggesting that the viewer is looking past them toward a distant vista; and yet no indication of shore is given—the final vastness is, once again, entirely a product of reflection. The trees are decorative and arbitrary in placement; at the same time, they help to frame and cadence the wide curving panels. The panels do not in colour represent the times of day; the north, south and east share a palette of chalky violets and blues, while in the panel to the west the same hues are offered in deep shades. The east (Plate 147) is like a new dawn, an unmeasured world. The flanking panels to north (Plate 149) and south, with their heavy tree-trunks and repeated fall of willow leaves, give a sense of spatial and temporal measure. The west (Plate 150) is like a coda, as the evening brings the bright and panoramic day to a dark, quiet close.

149. *Water-lilies decoration* (Room 2, looking north)
1916–23
North panel: 77½ in. × 39 ft. 4½ in. (197 × 1200 cm.)
Musée de l'Orangerie, Paris

The paintings both to north and south present a vast stretch of water, suggesting an expanse beyond what the pond at Giverny offered. The tree-trunks, one to either side, and the carefully spaced verticals of the willow leaves provide a degree of measure in relation to the comparatively uninterrupted flow of the water. Compare one of the studies for these panels (Plate 141).

150. *Water-lilies decoration* (Room 2, looking west)
1916–23
West panel: 77½ in. × 27 ft. 10½ in. (197 × 850 cm.)
Musée de l'Orangerie, Paris

In the west the day has closed. The tree-trunk in the centre has relinquished its decorative, measuring function and is seen as reflection within the darkened pond. The palette is composed largely of deep blues and violets. It provides a fitting and welcome contrast to the chalky, daylight brightness of the other three panels which dominate the room.

BIBLIOGRAPHICAL NOTE

Catalogues

A complete catalogue (*catalogue raisonné*) of Monet's paintings and drawings, to be published in three volumes, is being prepared by Daniel Wildenstein. The first volume, covering the work up to 1881, was published in 1974 (*Claude Monet. Biographie et catalogue raisonné*, Lausanne-Paris); it contains entries and illustrations for the paintings, a carefully detailed biographical essay, and all the published (plus a number of previously unpublished) letters by Monet from those years. It has immediately become the major biographical and documentary source on Monet's early career. Until the remaining volumes are published, one will turn, for the late works, to the catalogue of Monet's paintings of his water-lily garden published in D. Rouart and J.-D. Rey, *Monet Waterlilies* (New York, 1974; French edition, Paris, 1972). Of considerable importance, as well, are the catalogues of the Monet collection in the Musée Marmottan, Paris, composed principally of paintings by Monet and other artists that were retained by the family after Monet's death and bequeathed to the Institut de France in 1966 (*Monet et ses amis*, 1971; *Monet et ses amis, nouveaux enrichissements*, 1972).

Letters

The three-volume catalogue by Daniel Wildenstein will, when completed, become the definitive source for Monet's letters. Until the second and third volumes appear one may consult primarily his letters to his dealer Durand-Ruel, written over a fifty-year period from 1876 to 1926, published in vol. 1 of L. Venturi, *Les Archives de l'impressionnisme* (Paris-New York, 1939).

Biographies and Monographs

The major monograph covering Monet's entire career remains that written by his close friend Gustave Geffroy (*Claude Monet, sa vie, son oeuvre*, 2 vols, Paris, 1924; 1-vol. ed., 1922). Among other surveys of Monet's life and work one may cite M. de Fels, *La Vie de Claude Monet* (Paris, 1929); D. Wildenstein, *Monet, impressions* (Lausanne, 1967); D. Wildenstein, *Claude Monet* (Paris, 1974); D. Rouart and L. Degand, *Claude Monet* (Geneva, 1958), in English; and C. M. Mount, *Monet* (New York, 1966). More limited aspects of Monet's career are presented in a number of other books, including George Clemenceau's *Claude Monet, les nymphéas* (Paris, 1928), a reminiscence and appreciation drawn from a close friendship covering the last thirty years of Monet's life. That period is treated as well with impressive documentation, both written

and pictorial, in C. Joyes, *Monet at Giverny* (London, 1975), based upon information drawn from family archives and copiously illustrated with photographs of Monet and his environment at Giverny. Monet's earlier life is integrated admirably into the general development of Realism and Impressionism in France by John Rewald in his *History of Impressionism* (4th revised ed., New York, 1973). A recent, exhaustive and scholarly study of the criticism of Monet's work throughout his career is S. Levine, *Monet and his Critics* (New York, 1976).

Interviews and Witness Accounts

During the course of his life Monet granted numerous interviews to writers, and one finds a string of articles dating from 1880 to after his death in which his life and habits are described and his ideas recorded. Listed in chronological order are some of the more important interviews: E. Taboureux, 'Claude Monet,' *La Vie moderne*, 2 (12 June 1880, 380–2); W. Byvanck, *Un Hollandais à Paris en 1891* (Paris, 1892), which includes a brief account of a chance meeting with Monet at the opening of the Haystacks exhibition in 1891; M. Guillemot, 'Claude Monet,' *La Revue illustrée*, 13 (15 March 1898); Thiébault-Sisson, 'Claude Monet: les années d'épreuve,' *Le Temps* (26 November 1900; English trans., *Art News Annual*, 26, 1957, 127–8, 196–9), the earliest full reminiscence of his career; L. Vauxcelles, 'Un après-midi chez Claude Monet,' *L'Art et les artistes*, 2 (November 1905, 85–90); A. Arnyvelde, 'Chez le peintre de la lumière,' *Je sais tout*, 10 (15 January 1914, 29–38); M. Pays, 'Une visite à Claude Monet dans son ermitage de Giverny,' *Excelsior*, 26 (January 1921); Duc de Trévise, 'Le Pèlerinage à Giverny,' *La Revue de l'art ancien et moderne*, 51 (January, February, 1927, 42–50, 121–34).

A number of other articles based on visits to Monet at Giverny and including a record or paraphrase of his words are, nevertheless, more descriptive accounts by the author than interviews as such: H. Le Roux, 'Silhouettes parisiennes. L'exposition de Claude Monet,' *Gil Blas* (3 March 1889); W. Dewhurst, 'Claude Monet—Impressionist. An Appreciation,' *Pall Mall Magazine*, 21 (June 1900, 209–24); R. Marx, 'Les "Nymphéas" de M. Claude Monet,' *Gazette des Beaux-Arts*, 4th series, 1 (June 1909, 523–32), in the article long quotations, supposedly presenting Monet's thoughts, are quite evidently embellished by those of the author; M. Elder, *A Giverny, chez Claude Monet* (Paris, 1924); L. C. Perry, 'Reminiscences of Claude Monet from 1889 to 1909,' *American Magazine of Art*, 18 (March 1927, 119–25); R. Barotte,

'Blanche Hoschedé nous parle de Claude Monet,' *Comoedia* (24 October 1942), an interview with Monet's stepdaughter, who was his painting companion and assistant during most of the Giverny years; F. Lewison, 'Theodore Robinson and Claude Monet,' *Apollo*, 78 (September 1963, 208–11), this article is based largely on Robinson's diary of the early nineties preserved in the Frick Art Reference Library, New York; R. Gimpel, *Diary of an Art Dealer* (New York, 1966; French edition, 1963).

Stylistic and Critical Studies

Of the studies devoted to the analysis of Monet's development and accomplishments as a painter we may single out among the earlier works the books by G. Grappe, *Claude Monet* (Paris [1909]), and L. Gillet, *Trois variations sur Claude Monet* (Paris, 1927), and, more recently, that by W. Seitz, *Claude Monet* (New York, 1960).

Several catalogues from major Monet exhibitions held during the past twenty years contain brief but valuable essays: Arts Council of Great Britain, *Claude Monet*, Tate Gallery, London, 1957, essay by D. Cooper; St Louis, City Art Museum, *Claude Monet*, 1957, essay by W. Seitz; W. Seitz, *Claude Monet, Seasons and Moments*, Museum of Modern Art, New York, 1960; Paris, Durand-Ruel, *Claude Monet*, 1970, essay by D. Wildenstein; Arts Council of Great Britain, *The Impressionists in London*, Hayward Gallery, 1973, essays by A. Bowness and A. Callen; Art Institute of Chicago, *Paintings by Monet*, 1975, essay on Monet's stylistic development by G. Seiberling.

During this same period, a number of essays and articles in books and journals have provided important interpretations of more limited aspects of Monet's career. On his early work one article of 1927, however, still provides valuable insights: R. Régamey, 'La Formation de Claude Monet,' *Gazette des Beaux-Arts*, 5th series, 15 (February 1927, 65–84). More recent studies are: W. Seitz, 'Monet and Abstract Painting,' *College Art Journal*, 16 (Fall 1956, 34–46); J. Isaacson, 'Monet's Views of Paris,' *Allen Memorial Art Museum Bulletin*, 24 (Fall 1966, 5–22); Isaacson, *Monet: Le Déjeuner sur l'herbe* (London, 1972); K. Champa, *Studies in Early Impressionism* (New Haven, 1973). Specific aspects of Monet's work, mainly from the seventies and eighties, are discussed in R. Goldwater, 'Symbolic Form: Symbolic Content,' *Problems of the 19th and 20th Centuries* (Princeton, 1963, 111–21), and S. Levine, 'Monet's Pairs,' *Arts Magazine*, 49 (June 1975, 72–5). On the series paintings of the nineties and beginning of the twentieth century, see G. H. Hamilton, *Claude Monet's Paintings of Rouen Cathedral* (London, 1960); J. Coplans, *Serial Imagery* (Pasadena Art Museum, 1968); J. Elderfield, 'Monet's Series,' *Art International*, 18 (15 November 1974), 28, 45–6); S. Levine, 'Décor/Decorative/Decoration in Claude Monet's Art,' *Arts Magazine*, 51 (February 1977, 136–9). On the water-lily garden at Giverny and the late, large paintings based on it, see R. Gordon, 'The Lily Pond at Giverny: the Changing Inspiration of Claude Monet,' *Connoisseur*, 184 (November 1973, 154–65), and C. Greenberg, 'The Later Monet,' *Art News Annual*, 26 (1957, 132–48, 194–6), reprinted in Greenberg, *Art and Culture* (Boston, 1961).

The most complete bibliography of the literature on Monet is offered in J. Rewald, *The History of Impressionism* (4th revised ed., New York, 1973).

ACKNOWLEDGEMENTS

The author and publishers would like to thank all museums, institutions and private collectors for permission to reproduce works of art in their possession. The owners of the paintings reproduced are credited in the captions and the notes to the plates. The following list gives the sources of those photographs which were not supplied directly by the owners:

Thos Agnew, London: 31
Acquavella Galleries, New York: 133
Aurora Publishers, Leningrad: 41
Bibliothèque Nationale, Paris: Figs. 2, 3, 18
Bulloz, Paris: 19, 53, 63
Christie's, London: 17, 35
Country Life Ltd: Figs 20, 21, 22
Courtauld Institute, London: 34
Durand-Ruel, Paris: 3, 20, 38, 82, 125, 126, 134
Fernand Hazan, Editeur, Paris: 146
Joel Isaacson: Figs. 11, 23

Kunstmuseum, Basel: 69
Phaidon Press Archives, Oxford: 32, 115, Fig. 12
Service Photographique de la Réunion des Musées Nationaux, Paris: 12, 13, 14, 36, 42, 48, 59, 86, 87, 96, 110, 132, 146, 148, 149
Aron Scharf: Fig. 9
Sotheby's, London: 47, 89, 117
Sunday Times: Figs. 26, 27, 28 (© Mme Piquet)
Agency Top, Paris: 55
Thames and Hudson, London: Fig. 5 (From R. Cogniat: *Monet and his world*)
Roger Viollet, Paris: 9, 155
National Gallery of Art, Washington: 1, 45, 54
Wildenstein, Paris: 22, 43, 52, 57, 65, 123

Fig. 7 was taken from V. Hefting: *Jongkind*, Paris 1975
Figs. 24 and 29 were taken from C. Joyes: *Monet at Giverny*, London 1975, (© Mme Piquet)
Plate 27 was taken from E. Waldmann: *Realismus und Impressionismus*

Agay, 219
Aix-en-Provence, 216
Algeria, 13, 216
Alley, Ronald, 225
Alma-Tadema, Sir Lawrence, 225
Amsterdam, 204; Plate 37
Annenberg, Mr and Mrs Walter, 208
Antibes, 38, 40, 41, 218, 219–20, 222; Plates 88, 92
Antibes, 38, 219; Plate 92
Argenteuil, 19–22, 38, 47, 195, 203–7, 209, 211, 212; Plates 34, 35, 40, 44–9
Argenteuil, the Bridge under Reconstruction, 19, 203; Plate 34
Arles, 213
Art Nouveau, 43
The Artist's House at Giverny, 45, 227, 232; Plate 125
Asnières, 204, 207
Aurier, Albert, 41
Autumn Effect, Argenteuil, 21, 205, 206; Plate 44

Baltimore Museum of Art, 226
Barbizon, 195
Barbizon school, 13, 196, 210
Les Barques régates à Argenteuil, 204
Basel, Fondation Rudolf Staechelin, 213
Bateaux de pêche en mer, 198
Baudelaire, Charles, 16, 194
Bazille, Frédéric, 12, 13, 14, 17, 19, 195, 197–8, 199, 200
The Beach at Trouville, 18, 19, 201; Plate 26
Belle-Ile, 24, 38, 41, 217–22; Plates 86, 89
The Bench, 20, 198, 208; Plate 50
Berlin, Galerie Thannhauser, 201
Berlin, Nationalgalerie, 194
Bernard, Claude, 219
Bernheim-Jeune gallery, 226, 230
Birmingham, Barber Institute of Fine Arts, 215
Der Blaue Reiter, 47
Block, Mr and Mrs Leigh B., 193
Boating on the River Epte, 37, 39, 221; Plate 100
Boats at Petit-Gennevilliers, 20, 206, 207; Plate 43
Bordighera, 37, 38, 206, 215, 216, 222
Bordighera (Private Collection, U.S.A.), 37, 38, 216; Plate 82
Bordighera (Santa Barbara Museum of Art), 37, 38, 206, 215; Plate 76

Boston, Museum of Fine Arts, 194–5, 211, 213, 220, 221, 223, 224, 228
Boudin, Eugène, 12, 195, Fig. 4; beach paintings, 13, 18, 213, 216; Monet paints with, 13, 18, 201; influence on Monet, 14, 212; *Jetée du Havre*, 198; on Monet, 203; *White Clouds over the Estuary*, Fig. 6
Boudin, Mme, 201
Bougival, 17, 196, 200, 201; Plates 14, 23
The Boulevard des Capucines, 16, 21, 22, 23, 204, 205, 209, 213; Plate 41
Boussod and Valadon, 219
Branch of the Seine near Giverny, 40, 42–3, 206, 224; Plate 111
Braque, Georges, 46
Braun, Adolphe, 16; Fig. 9
Bremen, Kunsthalle, 198
The Bridge at Argenteuil, 20, 22, 204, 206–7; Plate 45
The Bridge at Argenteuil on a Grey Day, 20, 207; Plate 46
The Bridge at Bougival, 17, 200, 202; Plate 23
Brittany, 24, 37, 38, 218
Die Brücke, 47
Bürger, W. (Théophile Thoré), 193
Butler, Lord, 203
Byvanck, Willem, 40, 42

Cabanne à Sainte-Adresse, 215
Caillebotte, Gustave, 22, 209, 210
Calm Weather, Fécamp, 23, 43, 213, 221, 225; Plate 69
Cambridge, Mass., Fogg Art Museum, 208, 210, 225
Camille, 14, 193, 194, 198–9, 208; Plates 18, 19
Camille au jardin avec Jean et sa bonne, 205–6, 208
Camille au petit chien, 208
Camille et Jean Monet au jardin d'Argenteuil, 206
Camille Monet on her Deathbed, 23, 208, 210; Plate 59
Cap d'Antibes, 38, 218
Cardiff, National Museum of Wales, 230
Cardon, Emile, 204
Castagnary, Jules, 204
Cézanne, Paul, 20, 45, 47, 200, 211, 214–15, 216, 219; Figs. 14, 30
Chailly, 193, 195; Plate 3
Charing Cross Bridge and Westminster, 43, 226; Plate 121
Le Charivari, 204

Charpentier, Mme, 214
Chennevières, 214
Chesneau, Ernest, 204, 205
Chicago, Art Institute, 200, 211, 224, 226
The Church, Varengeville (Barber Institute, Birmingham), 23, 37, 215; Plate 75
The Church at Varengeville (Musée Marmottan, Paris), 23, 37, 216; Plate 79
The Church at Varengeville (Private Collection, Texas), 23, 37, 43, 215–16; Plate 78
The Church at Vernon, 222; Plate 102
Clemenceau, Georges, 12, 42, 46, 210, 232
Cleveland Museum of Art, 228
The Cliff, Varengeville, 40, 42, 43, 214, 225; Plate 118
Cliffs at Les Petites-Dalles, 23, 213; Plate 68
Cliffs at Low Tide, Pourville, 23, 37, 213; Plate 70
Cliffs at Varengeville, 40, 42, 43, 206, 225; Plate 116
Cliffs near Dieppe (1882, Kunsthaus, Zurich), 23, 37, 43, 213, 214, 221; Plate 72
Cliffs near Dieppe (1897, Private Collection), 40, 42, 43, 225; Plate 117
Un coin d'appartement, 207
Colombes, 206
Copenhagen, Ordrupgaardsammlingen, 193
Coplans, John, 224
Corner of the Garden at Montgeron, 209
Corot, Jean-Baptiste Camille, 17, 20, 216; Fig. 13
Courbet, Gustave, 14, 15, 193, 198, 216
Creuse Valley, 24, 38, 41, 47, 220, 221
Croissy, 17
Cubism, 46, 207, 231
Cummings, Mr and Mrs Nathan, 224
Curtis, Mr and Mrs Ralph, 230
The Custom House at Varengeville (1882), 225

Daguerre, Louis Jacques Mandé, 41, 205
Dallas Museum of Fine Arts, 214
Daubigny, Charles-François, 202, 216
Déchargeurs de charbon, 207
Degas, Hilaire-Germain-Edgar, 18, 20, 201, 204, 211, 213, 214
Le Déjeuner sur l'herbe, 14, 15, 16, 17, 193, 195–6, 199, 219, 230; Plates 8–10
Delacroix, Eugène, 216
Detroit Institute of Arts, 208
Déville, 202

Dieppe, 42, 213, 225; Plates 72, 117
Dinner, 17, 20, 197; Plate 15
The Doge's Palace, Venice, 45, 230; Plate 135
The Doge's Palace, Venice, seen from San Giorgio Maggiore, 45, 230; Plate 136
Doncieux, Charles-Claude, 20, 208
Dorsky, Mr and Mrs Samuel, 216
The Douanier's Cottage, Varengeville (1882, Museum Boymans-van Beuningen, Rotterdam), 23, 37, 38, 43, 213, 214–15, 216, 221, 225; Plate 74
The Douanier's Cottage at Varengeville (1897, Art Institute of Chicago), 40, 42, 43, 226; Plate 119
Durand-Ruel, Paul, 45, 208, 211, 225; Monet meets, 202; sells Impressionists' paintings, 20–1; Monet's letters to, 24, 37, 38, 43–4, 207, 213, 217, 229; exhibits Monet's paintings, 39–40, 41, 42, 46, 204, 222, 223, 227; buys *Lavacourt*, 214
Duret, Théodore, 11, 37, 38, 211, 214, 219

The Eaux-semblantes at Fresselines on the Creuse, 38, 220, 221; Plate 94
Edinburgh, National Gallery of Scotland, 220
England, 19, 202–3
Entrance to the Village of Vétheuil, Winter, 23, 211; Plate 61
Epte, River, 11, 41, 42, 222; Plates 100, 103
Essen, Museum Folkwang, 223
L'Estaque, 214–15
Esterel, 219
Etretat, 11, 17, 23, 37–8, 197, 215–17, 221, 226; Plates 77, 80, 81, 83–5
Etretat (about 1883, Musée Marmottan, Paris), 37, 216; Plate 80
Etretat (1884, Mr and Mrs Samuel Dorsky, New York), 37, 215, 216; Plate 81
Etretat, View of the Manneporte from the South, 43, 215; Plate 77
Eugène Boudin working at Le Havre, Fig. 4
Exterior of the Gare Saint-Lazare (The Signal), 22, 209; Plate 57

Falaises series, 43, 206, 224, 225–6; Plates 116–19
Fantin-Latour, Henri, 211
Faure, 217
Fauves, 47
Fécamp, 23, 37, 40, 42, 213, 215, 221; Plate 69
Fishing Nets, Pourville, 23, 37, 214; Plate 71
Fitzgerald, Desmond, 226
Five Figures in a Field, 39, 219; Plate 91
Floating Ice, 23, 197, 212, 214; Plate 64
Fontainebleau, Forest of, 14, 193, 195
Fort Worth, Texas, Kimbell Art Museum, 196
Fox Talbot, William Henry, 205
Franco-Prussian War, 18–19, 202
Frankfurt, Städelsches Kunstinstitut, 197
Fresselines, Plate 94

Galerie Georges Petit, 40, 225
The Garden of the Princess, 15, 16, 21, 23, 194, 198, 199, 203, 209, 213, 217; Plate 5, Fig. 10
Gare Saint-Lazare (Musée Marmottan, Paris), 22, 206, 209; Plate 56
Gare Saint-Lazare, Arrival of a Train (Fogg Art Museum), 22, 45, 208, 210–11; Plate 60
Gaudibert family, 197
Gaudibert, M., 17
Gauguin, Paul, 15, 39, 41, 213
Gazette des Beaux-Arts, 214
Geffroy, Gustave, 42; Monet's letters to, 37, 38, 40, 221, 224; on Monet, 39, 41, 215, 218; visits Creuse valley, 220
Genoa, 216
Gillet, Louis, 228
Gimpel, René, 221
Giverny, 23, 37–47 *passim*, 211, 220, 221, 226, 227–8, 231–3; Plates 90, 101, 125–34, 140–50; Figs. 19–22, 24–7
Gladioli, 20, 21, 38, 208; Plate 51
Gleyre, Charles, 12, 13, 17, 19
Gloton, 17, 200
Goncourt brothers, 18
Gordon, Robert, 227
Grand Canal, Venice, 45, 230; Plate 137
Grande Jatte, 211
Grappe, Georges, 24, 220
Green Park, 19, 203; Plate 33
Green Reflections, 45, 47, 229, 231; Plate 132
La Grenouillère, 17–18, 19, 38, 196–7, 201–2, 219; Fig. 15
La Grenouillère (1869, whereabouts unknown), 17, 21, 196, 201, 219, 230; Plate 27
La Grenouillère (1869, Metropolitan Museum of Art, New York), 17–18, 19, 21, 22, 45, 196–7, 201–2, 203, 219, 230; Plates 29, 30
Guillaumin, Armand, 204
Guillemot, Maurice, 11, 42, 227, 229, 232
Guston, Philip, 231

The Hague, 218
The Hague, Gemeentemuseum, 194, 214
Hamilton, George Heard, 42
Harunobu, 218
Le Havre, 13, 16, 21, 196, 198, 199, 204–5; Plates 17, 39
Le Havre, Musée des Beaux-Arts, 225, 228
The Haystack (1891, Kunsthaus, Zurich), 39, 40, 220; Plate 95
A Haystack at Giverny (1886, Hermitage, Leningrad) 38, 39, 218; Plate 90
The Haystacks (1891, Louvre, Paris), 39, 40, 206, 220, 225; Plate 96
Haystacks in the Snow, 39, 40, 221; Plate 98
Haystack series, 13, 39, 40–1, 42, 206, 211, 220–1; Plates 95–8
Hill-Stead Museum, 198
The Hills of Vétheuil, 23, 212; Plate 65
Hiroshige, 197, 207, 224, 225; Figs. 11, 12

Hokusai, 218, 224
Holland, 19, 24, 38, 47, 203–4, 218
Honfleur, 13, 15, 193, 201, 213; Plates 2, 6, 7
Hoschedé family 209, 210
Hoschedé, Alice, 212, 217; relationship with Monet, 22–3, 39, 211; marries Monet, 39; in Monet's paintings, 210; Monet's letters to, 219, 227; visits Venice, 230; death, 230, 232
Hoschedé, Blanche, 40, 221
Hoschedé, Ernest, 21–3, 37, 39, 208, 210, 211
Hoschedé, Jacques, 224
Hoschedé, Jean-Pierre, 212
Hoschedé, Suzanne, 221
The Houses of Parliament, Stormy Sky, 43, 226; Plate 122
The Hunt, 21–2, 208–9, 210; Plate 53
Hut at Sainte-Adresse, Fig. 18
Huysmans, J.-K., 24
Hyde Park, 203

Ice-floes on the Seine at Bougival, 196–7; Plate 14
Ile de Croissy, 196, 200
Ile Marante, 20, 205, 206
Impression, Sunrise, 21, 204–5, 208; Plate 39
Impressionist exhibitions, 1st (1874), 14, 19, 21, 198, 204, 205, 208, 214; 2nd (1876), 205, 214; 3rd (1877), 209, 210, 211, 214; 4th (1879), 21, 199, 209, 214; 5th (1880), 21, 24; 1882, 211
Indiana University Museum of Art, 207
Ingres, Jean August Dominique, 39
Italy, 216

James, Henry, 221
The Japanese Bridge (1899, Philadelphia Museum of Art), 23, 45, 227–8; Plate 127
The Japanese Bridge (about 1919 or about 1923–5, Musée Marmottan, Paris), 45, 46, 47, 232; Plate 145
The Japanese Bridge (about 1923–5, Minneapolis), 45, 46, 47, 228; Plate 128
The Jetty of Le Havre in Bad Weather, 16, 198; Plate 17
Jongkind, Johann-Barthold, 13, 14, 18, 19, 193, 196, 199, 213, 216; Fig. 7
Juan-les-Pins, 38, 219–20

Kansas City, Nelson Gallery-Atkins Museum, 205, 207
Kervilahen, 217
Kreeger, Mr and Mrs David Lloyd, 213, 225

Laferrière, Louis Fortuné Adolphe, Fig. 3
Lafont, 198
Laforgue, Jules, 24
Landscape with a Haystack, 39, 40, 221; Plate 97
Lavacourt, 23, 211, 212
Lavacourt, 23, 38, 211, 214; Plate 73
Lecadre, Sophie, 199, 201
Lefevre, Camille, 232

Leicester Square by Night, 226–7; Plate 123
Leningrad, Hermitage, 209, 210, 218, 219
Le Roux, Hugues, 11, 37, 217
Leroy, Louis, 204, 205
Levine, Stephen, 203, 215, 226
The Lieutenance at Honfleur, 13, 195
Lille, Musée des Beaux-Arts, 226
London, 19, 21, 47, 202–3, 226–7, 228; Plates 32, 33, 121–4
London, Courtauld Institute Galleries, 206, 219
London, Kemeys-Pennington Mellor Trust, 202
London, National Gallery, 201, 202
London, Tate Gallery, 225
London series, 13, 43–4, 230, 232; Plates 121, 122, 124
Los Angeles, Norton Simon Foundation, 193
Louis, Morris, 231
Louveciennes, 201
The Luncheon (1868, Städelsches Kunstinstitut, Frankfurt), 17, 20, 21, 193, 197–8, 201; Plate 16
The Luncheon (1873, Louvre, Paris), 20, 205–6; Plate 42

The Magpie, 17, 200; Plate 22
La Maison de l'artiste, 205
Mallarmé, Stéphane, 43, 219
Manchester, New Hampshire, Currier Gallery of Art, 200
Manet, Edouard, 203, 208, 210; *Olympia*, 12; *Déjeuner sur l'herbe*, 14, 15, 195; influence on Monet, 15, 198, 209; Japanese influences, 16; works with Monet, 19, 21; *The Fifer*, Fig. 8; *Monet painting in his Studio Boat*, Fig. 16
Manet, Eugène, 215
The Manneporte, Etretat (1885, Mr and Mrs A. N. Pritzker, Chicago), 37–8, 217, 221; Plate 85
The Manneporte, Etretat (1886, Metropolitan Museum of Art, New York), 37–8, 217, 221; Plate 84
Mannheim, Kunsthalle, 194
Mantz, Paul 12
Marseilles, 216
Martin, 198
Marx, Roger, 46
Matisse, Henri, 46; Fig. 23
Maupassant, Guy de, 24, 201, 217
Meditation, 208
Mediterranean, 24, 37, 38, 216, 218, 219
Menton, 216, 222
Millet, Jean François, 215
Minneapolis Institute of Arts, 228
Mirbeau, Octave, 41, 44, 227, 230
Mondrian, Piet, 231
Monet, Adolphe, 13, 15, 16, 199
Monet, Alice, *see* Hoschedé, Alice
Monet, Camille, 19; Monet's paintings of, 14,

17, 18, 20, 195, 197, 198–9, 200, 205–10; Plates 18, 19, 52, 54, 59; Monet's father refuses to help, 15, 16; in Paris, 196, 199; in Etretat, 17; marriage, 18, 198, 201; goes to England, 202; at Argenteuil, 19; at Vétheuil, 22–3, 211; death, 39, 210, 211, 212
Monet, Jean, 17, 18, 19, 22, 196, 197, 200, 201, 202, 211; Monet's paintings of, 20, 198, 205–6, 207, 208, 209; death, 46
Monet, Léon, 202, 213
Monet, Louise-Justine, 13
Monet, Michel, 22–3, 206, 211, 212
Monet's Garden at Vétheuil, 212, 221; Plate 66
Montgeron, 21–2, 208–9, 210; Plate 58
Moreno, M., 38, 215
Morice, Charles, 227
Morisot, Berthe, 38, 204, 215
Morisot, Edma, 215
Morning Mists, 40, 42–3, 206, 224, 225; Plate 112
Morning on the Seine series, 40, 42–3, 206, 224; Plates 111, 112
Moscow, Pushkin Museum, 195, 205, 217, 226
Mount Kolsaas, Norway, 42, 224; Plate 113

Nabis, 15
Nadar, 21, 205
Nantes, Musée des Beaux-Arts, 231
Nathan, F. and P., 199
New York, Brooklyn Museum, 222
New York, Metropolitan Museum of Art, 199, 201, 217, 222, 225, 230
New York, Museum of Modern Art, 231
Noland, Kenneth, 231
Normandy, 43; Monet's paintings of, 11–12, 37, 39, 42, 193, 197, 199, 211, 213, 216; Monet's painting trips to, 23, 24
Norway, 42, 224–5
Les Nymphéas, série de paysages d'eau, 44–8, 228–30; Plates 129–34, 140, 143, 146–50

Oberlin, Allen Memorial Art Museum, 194
Olitski, Jules, 231
Oslo, 224
Oxford, Walzer Collection, 201

Palazzo da Mula, Venice, 45, 231; Plate 139
Paris, 12, 15–16, 22, 194, 196, 198, 204, 205, 209, 210–11; Plates 4, 5, 41, 55–7, 60
Paris, Durand-Ruel, 222, Figs. 19, 25
Paris, Musée de l'Orangerie, 229, 232–3
Paris, Louvre, 15, 193, 195, 196, 197, 203, 205, 207, 209, 210, 217, 218, 220, 223
Paris, Musée du Petit Palais, 211
Paris, Musée Marmottan, 204, 206, 209, 215, 216, 223, 231–2
Paris, Rouart Collection, 215
The Pavé de Chailly, 14, 193; Plate 3
Perry, Lilla Cabot, 41
Petit-Gennevilliers, 206, 207; Plate 43

Les Petites-Dalles, 213; Plate 68
Le Phare de l'Hospice, 193
Philadelphia Museum of Art, 203, 204, 223, 225, 227
Picasso, Pablo, 46
Pigalle, 193
La Pinède, 219
The Pink Boat, 37, 39, 221; Plate 99
Pissarro, Camille, 39, 42, 200, 201, 202, 204, 218, 224
Pissarro, Lucien, 42, 218, 224
Pittsburgh, Carnegie Institute, 227
The Pointe de la Hève at Low Tide, 12, 13, 14, 193, 195, 196, 199; Plate 11
Poissy, 213, 216
Pollock, Jackson, 231
The Pond at Montgeron, 21, 22, 209, 210; Plate 58
Poplars series, 39–40, 41, 42, 44, 206, 210, 211, 222–3, 226; Plates 103–6
Poplars (1891, Philadelphia Museum of Art), 40, 41, 206, 223; Plate 106
Poplars, Giverny (About 1890, Private Collection, U.S.A.), 221; Plate 101
Poplars (Les Quatre Arbres, 1891, Metropolitan Museum of Art, New York), 40, 41, 222, 226; Plate 105
Poplars on the Epte, Sunset (1891, Mr and Mrs David T. Schiff, New York), 40, 41, 222, 223; Plate 103
Poplars, Wind Effect, (1891, Durand-Ruel, Paris), 40, 41, 222, 223; Plate 104
Port-Coton, Plate 89
Port-Villez, 225; Plate 115
Portrait of Camille with a Bouquet of Violets, 198, 208, 210; Plate 52
Portrait of Mme Gaudibert, 197
Pourville, 23, 37, 40, 213, 214, 225; Plates 70, 71
Prairies à Giverny, 219
Pre-Raphaelites, 13
Pritzker, Mr and Mrs A. N., 217
Private Collections, 225, 227
 Chicago, 201
 France, 196, 200, 204, 208, 226
 Madrid, 207
 New York, 229
 Paris, 195, 227
 Switzerland, 193, 198, 203, 218
 Texas, 215
 U.S.A., 208, 209, 212, 219, 221
 Zurich, 229
The Promenade, Argenteuil, 19, 38, 206; Plate 40
Promenade: temps gris, 219
Promenade, Woman with a Parasol, 20, 21, 198, 209; Plate 54
Proust, Marcel, 43
Prouvaire, Jean, 205
Prussia, war with France, 18–19, 202
The 'Pyramids' at Port-Coton (Belle-Ile), 24, 38, 218, 221; Plate 89

The Quai du Louvre, 15, 16, 21, 23, 194, 198, 199, 203, 213, 217; Plate 4

Raleigh, North Carolina Museum of Art, 224
Raphael, 39
Red Boats, Argenteuil, 21, 207; Plate 48
Renoir, Auguste, 13, 39, 201, 204; works with Monet, 17, 18, 19, 21, 38, 201–2; helps Monet to get his first one-man show, 23; paintings of Paris, 194; portraits of Camille Monet, 208; visits the Riviera, 38, 216; *La Grenouillère*, Fig. 15
Resnick, Milton, 231
Rewald, John, 204
Rhode Island School of Design, 203
The River, 17, 18, 19, 197, 200, 211; Plates 24, 25
The River Basin at Argenteuil, 20, 207; Plate 47
Riviera, 38, 216
The Road to Louveciennes, Snow Effect, 201; Plate 28
Robinson, Theodore, 41
Robinson, John, 41–2
La Roche-Guyon, 211
Rocks at Etretat, 37, 217; Plate 83
Rodin, Auguste, 41
Roskill, Mark, 221
Rotterdam, Museum Boymans-van Beuningen, 214
Rouen, 202, 213
Rouen, Musée des Beaux-Arts, 209
Rouen Cathedral series, 13, 40, 41–2, 222, 223–4; Plates 107–10
Rouen Cathedral (1894, Museum Folkwang, Essen), 40, 42, 223, 226; Plate 107
Rouen Cathedral and the Cour d'Albane, Early Morning (1894, Museum of Fine Arts, Boston), 40, 42, 223, 226; Plate 108
Rouen Cathedral, Full Sunlight (1894, Louvre, Paris), 40, 42, 223–4, 226; Plate 110
Rouen Cathedral, West Façade, Sunlight (1894, National Gallery of Art, Washington, D.C.), 40, 42, 223–4, 226; Plate 109
Rouen Municipal Exhibition, 1864, 212
Rubens, Sir Peter Paul, 194
Rue de la Bavolle, Honfleur, (Kunsthalle, Manheim), 13, 193, 194–5; Plate 6
Rue de la Bavolle, Honfleur (Museum of Fine Arts, Boston), 13, 193, 194–5; Plate 7
Rue Montorgueil, 22, 209
Rue Saint-Denis, Celebration of 30 June, 1878, 22, 209; Plate 55

Sainte-Adresse, 16, 193, 194, 196, 199–200, 213; Plates 20, 21; Figs. 7, 18
Sainte-Adresse, 16, 19, 197, 199; Plate 20
Saint-Germain l'Auxerrois, 15, 16
Saint-Michel, 201
Salons, 1865, 12, 13–14, 193, 196, 200, 214; 1866, 14, 15, 193, 200, 214; 1867, 14, 15, 200, 214; 1868, 194, 198, 200, 214; 1869, 17, 200, 214; 1870, 198, 200, 201, 214; 1880, 212, 214

Salon des Refusés, 1863, 14
San Francisco, California Palace of the Legion of Honor, 230
Sandvika, 224
Sandvika, Norway, 42, 224–5; Plate 114
Santa Barbara Museum of Art, 215
São Paulo, Museu de Arte, 221
Sargent, John Singer, 226, 230
Schapiro, Meyer, 231
Scharf, Aaron, 16, 41
Schiff, Mr and Mrs David T., 222
Seiberling, Grace, 219, 221, 227
Seine, River, 11, 19–20, 21, 42–3, 196–7, 201–2, 206–7, 211, 224; Plates 14, 23–5, 38, 45–8, 63, 64, 111, 112, 115
The Seine at Asnières, 204; Plate 38
The Seine at Port-Villez, 225; Plate 115
The Seine Estuary at Honfleur, 12, 14, 193, 195, 196; Plate 2
Seitz, William, 47, 200, 202, 222, 228, 231
Série de vues de la Tamise à Londres (1900–1904), 227
Seurat, Georges, 15, 39
Shelburne Museum, 212
Sisley, Alfred, 13, 19, 204
Society of Arts of Edinburgh, 41–2
Soutine, Chaim, 232
Still-life: Apples and Grapes, 23, 211; Plate 62
Still-life with Bottle, Carafe, Bread and Wine, 193; Plate 1
Storm at Belle-Ile, 24, 38, 217, 221; Plate 86
Studies of Trees, Fig. 2
Study of Trees, Fig. 1
Sunflowers, 212–13; Plate 67
Sunset on the Seine, Winter Effect, 23, 211, 214; Plate 63
Symbolists, 41, 43

Terrace at Sainte-Adresse, 16, 199–200; Plate 21
Thames, River, 19, 21, 43, 45; Plates 32, 121, 124
The Thames below Westminster, 19, 202, 208, 226; Plate 32
Thiébault-Sisson, 47, 196
Thoré, Théophile, 11, 193, 194, 198
Tivoli, 215
Toledo Museum, 218
The Train, 202; Plate 31
Trouville, 18, 202; Plate 26
The Tulip Field, Holland, 38, 218; Plate 87
The Turkeys, 208–9
Turner, Joseph Mallord William, 202, 227
Twilight, 230
Twilight, San Giorgio Maggiore, Venice, 45, 230; Plate 138
The Two Willows, 45, 46, 47, 233; Plate 147

The Umbrella Pines, 38, 219–20; Plate 93
U.S.A., Paul Mellon Collection, 206, 209

Van Gogh, Theo, 219

Van Gogh, Vincent, 15, 39, 47, 212–13, 218, 219–20
Varengeville, 23, 37, 38, 40, 213, 214–16, 221, 225; Plates 74, 75, 78, 79, 116, 118, 119
Velazquez, 15, 194
Venice, 45, 47, 211, 230–1, 232; Plates 135–9
Vernon, 222; Plate 102
Vétheuil, 22–3, 38, 39, 45, 197, 211, 212, 213, 226, 228; Plates 61, 65, 66, 120
Vétheuil, 45, 226; Plate 120
La Vie moderne, 23, 212, 214, 215
View of Antibes, 38, 218; Plate 88
View of Argenteuil, Snow, 20, 207; Plate 49
Ville-d'Avray, 14–15, 196; Fig. 13

Washington, National Gallery of Art, 205, 207, 212, 231
Water-lilies (1904, Musée des Beaux-Arts, Le Havre), 23, 45, 48, 228; Plate 129
Water-lilies (1905, Museum of Fine Arts, Boston), 23, 45, 48, 228; Plate 130
Water-lilies (1907, Private Collection, New York), 23, 45, 48, 229; Plate 133
Water-lilies (1908, Private Collection, Zurich), 23, 45, 48, 229–30; Plate 134
Water-lilies (1917, Musée des Beaux-Arts, Nantes), 45, 46, 231; Plate 140
Water-lilies (about 1918–21, Musée Marmottan, Paris), 46, 231; Plate 141
Water-lilies (about 1919–25, Musée Marmottan, Paris), 45, 46, 232; Plate 143
Water-lilies (about 1920–2, Cleveland Museum of Art), 45, 46, 228–9; Plate 131
Water-lilies decoration (1916–23, Musée de l'Orangerie, Paris), 45, 46, 47–8, 231, 232–3; Plates 146, 148–50
Water-lilies series, 44–8, 210, 228–30, 232–3; Plates 129–34, 140, 143, 146–50
Water-lily Pond, the Water Irises, 23, 227, 228; Plate 126
Waterloo Bridge, London, 43, 226, 227; Plate 124
Weeping Willow, 45, 46, 232; Plate 144
Weil, Mr and Mrs Richard K., 221
Whistler, J. A. M., 21, 202, 204; Fig. 17
Whitney, J. H., 206
Wildenstein, Daniel, 193, 195, 197, 199, 201, 204–5, 206, 207, 209, 217
Wilson, Richard, 215
Wisteria, 46, 231–2; Plate 142
Wohl, Mr and Mrs Joseph S., 218
Women in the Garden, 14–15, 16, 17, 19, 21, 194, 195, 196, 198, 200; Plates 12, 13
The Wooden Bridge, 19, 203; Plate 35
World's Fair, 1867, 15; 1878, 22, 209

Zaandam, 19, 203
Zaandam, 19, 21, 203; Plate 36
Zola, Emile, 194, 198, 200, 211, 219
The Zuiderkerk at Amsterdam, 204; Plate 37
Zurich, Bührle Foundation, 197
Zurich, Kunsthaus, 214, 220, 230

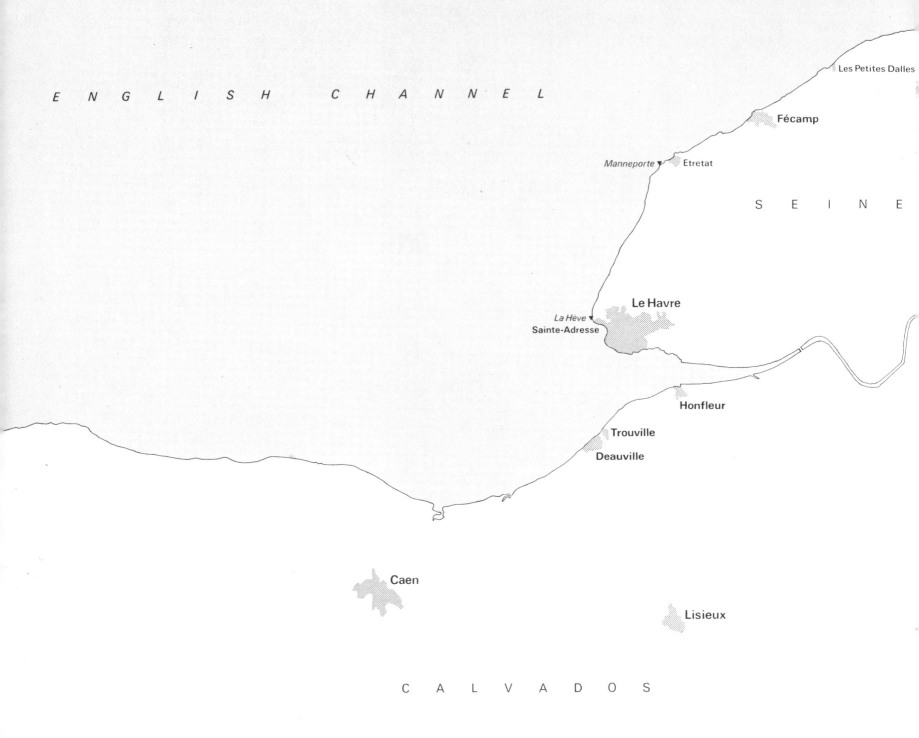

ENGLISH CHANNEL

Les Petites Dalles

Fécamp

Manneporte ▾ ◇ Etretat

S E I N E

Le Havre

La Hève ▾
Sainte-Adresse

Honfleur

Trouville

Deauville

Caen

Lisieux

C A L V A D O S

Map of Seine Valley showing places associated with Claude Monet

0 10 20 30 miles

0 10 20 30 40 50 kilometres